3
1   12

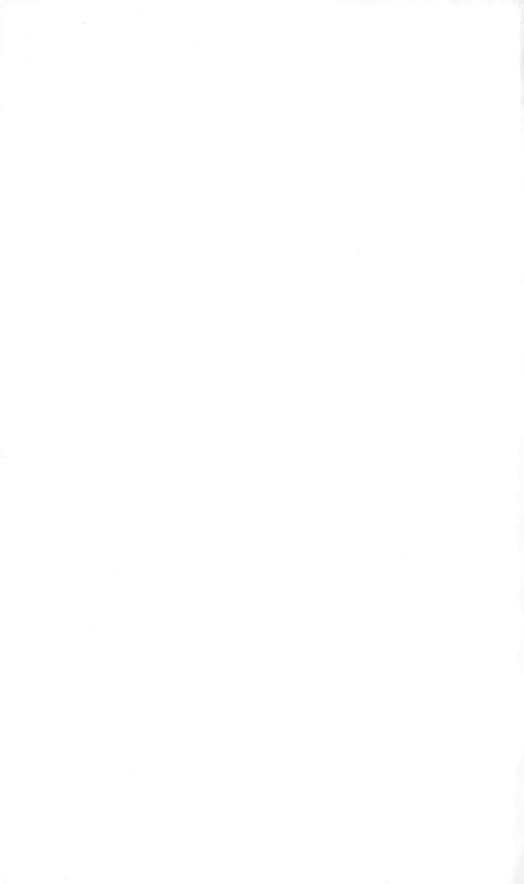

# THE SOVIET MIND

# THE SOVIET MIND

*Russian Culture under Communism*

## ISAIAH BERLIN

*Edited by* HENRY HARDY
*Foreword by* STROBE TALBOTT
*Glossary by* HELEN RAPPAPORT

BROOKINGS INSTITUTION PRESS
*Washington, D.C.*

Copyright Isaiah Berlin 1949, 1952, 1956
© Isaiah Berlin 1957, 1980, 1989
© The Isaiah Berlin Literary Trust 1997, 2000, 2004
Introduction © Strobe Talbott 2004
Glossary of Names © Helen Rappaport 2004
Editorial matter © Henry Hardy 2004
Photograph of Stalin copyright James Abbe 1932
Photographs of documents © The Isaiah Berlin Literary Trust 2004

All rights reserved. No part of this publication may be reproduced or transmitted in any form or by any means without permission in writing from the Brookings Institution Press, 1775 Massachusetts Avenue, N.W., Washington, D.C. 20036 (fax: 202/797-6195 or e-mail: permissions@brookings.edu).

*Library of Congress Cataloging-in-Publication data*
Berlin, Isaiah, Sir.
 The Soviet mind : Russian culture under communism / Isaiah Berlin ; edited by Henry Hardy ; foreword by Strobe Talbott.
  p.  cm.
Includes bibliographical references and index.
 ISBN 0-8157-0904-8 (alk. paper)
 1. Soviet Union—Intellectual life.  2. Arts—Political aspects—Soviet Union.  3. Berlin, Isaiah, Sir—Travel—Soviet Union.
I. Hardy, Henry.  II. Title.
DK266.4.B47 2003
700'.947'09045—dc22                                    2003023297

9 8 7 6 5 4 3 2 1
The paper used in this publication meets minimum requirements of the American National Standard for Information Sciences—Permanence of Paper for Printed Library Materials: ANSI z39.48-1992.

Typeset in Stempel Garamond

Printed by R. R. Donnelley
Harrisonburg, Virginia

*For Pat Utechin*

*The American photojournalist James Abbe scored a publishing coup in 1932
by talking his way into the Kremlin for a private photo-session with Stalin.
The results included this rare personal shot of the Soviet leader,
at a time when he was becoming increasingly reclusive.*

The task of a Communist educator is [. . .] principally that of Stalin's engineer – of so adjusting the individual that he should only ask those questions the answers to which are readily accessible, that he shall grow up in such a way that he would naturally fit into his society with minimum friction [. . .] Curiosity for its own sake, the spirit of independent individual enquiry, the desire to create or contemplate beautiful things for their own sake, to find out truth for its own sake, to pursue ends because they are what they are and satisfy some deep desire of our nature, are [. . .] damned because they may increase the differences between men, because they may not conduce to harmonious development of a monolithic society.

<div align="right">

ISAIAH BERLIN
'Democracy, Communism and the Individual'
Talk at Mount Holyoke College, 1949

</div>

# CONTENTS

# FOREWORD

*Strobe Talbott*

ISAIAH BERLIN believed that ideas matter, not just as products of the intellect but as producers of systems, guides to governance, shapers of policy, inspirations of culture and engines of history. That makes him a figure of iconic importance for the Brookings Institution and others like it in Washington. Whatever their differences, these organisations are dedicated to the importance of ideas in public life. They're in the business of thinking about the hardest problems facing our society, nation and world – and thinking up solutions. That's why they're called think tanks.

Berlin probably would have had something gently teasing to say about these outfits (and their nickname), not least because of his scepticism about the quintessentially Yankee conceit that all questions have answers, and that any problem can be completely solved. But Berlin would have enjoyed an occasional visit to our own building at 1775 Massachusetts Avenue. He'd feel right at home, since from 1942 until 1946 he worked up the street at 3100 Mass. Ave., in the British Embassy. As a prodigious and exuberant conversationalist, he would have found the cafeteria on the first floor particularly hospitable. Every day, from noon to two, it's teeming with Brookings scholars and others from up and down Think Tank Row, who gather regularly to field-test their own latest ideas over lunch. It would have been fun to have Sir Isaiah in our midst, not least because fun was yet another ingredient of life – including the life of the mind – that he both dispensed and appreciated in others. His stepson, Peter Halban, recalls Berlin teaching him to play a Russian version of tiddlywinks. He loved wordplay, storytelling

and gossip. His commentary on the human condition was often freewheeling and playful.

Berlin would have spent some time in the library on the third floor as well. He believed that ideas, like civilisations, States and individuals, owe much to their forebears. Those ideas live on in books. He called himself not a philosopher but a historian of ideas. He saw himself not so much as a promulgator of new truths as a student, critic, synthesiser and explicator of old ones. He put a premium on scholarship – on analysing the empirical evidence, pondering work others had done before him, and mastering its implications for their time and our own.

One quality anyone who knew Berlin, whether in person or through his writings, associates with him is open-mindedness. He had respect not just for the views of others but for the complexity of reality – and of morality. 'Pluralism' was one of the rare words with that suffix that, in his vocabulary, had a favourable connotation. Most other *isms* were somewhere between suspect and anathema. He was a champion of the spirit of openness and tolerance, whereby a community – a university common room, a gathering of townspeople or a nation – encourages different and often competing ideas of what is good, true and right.

The last time I met Berlin was in 1994, a little over two years before his death. I was serving in the State Department at the time and gave a lecture in Oxford on the promotion of democracy as an objective of American foreign policy. It was unnerving to look down from the lectern and see him there, in the front row, fully gowned, eyes riveted on me, brows arched. After I finished, he came up to me and, along with several courtesies, offered his favourite piece of advice from someone who was not, I suspect, his favourite statesman: Talleyrand. 'Surtout pas trop de zèle,' he said. I had the impression that he was not so much reproving me as letting me in on what he felt was a home truth about pretty much everything American, notably including our foreign policy.

What he called 'the unavoidability of conflicting ends' was the '*only* truth which I have ever found out for myself'.[1] 'Some of the

---

[1] Letter to Jean Floud, 5 July 1968; cited by Michael Ignatieff in *Isaiah Berlin: A Life* (London and New York, 1998), p. 246.

Great Goods cannot live together . . . We are doomed to choose, and every choice may entail an irreparable loss.'[1] It's a kind of corollary to his concept of pluralism, and of liberalism.

Thus, for him, all interesting issues are dilemmas. The only thing worse than making a mistake was thinking you couldn't make one. He believed we must face the inevitability of undesirable, potentially hazardous consequences even if we make what we are convinced is the right choice.

Had Berlin taken the matter that far and no further, he would have left all of us – including those of us in the think-tank business – in a cul-de-sac, a state of ethical and intellectual paralysis, not to mention chronic indecision.

But he did not leave us there. He argued that the *difficulty* of choice does not free us from the *necessity* of choice. Recognising a dilemma is no excuse for equivocation, indecision or inaction. We must weigh the pros and cons and decide what to do. If we don't, others will decide, and the ones who do so may well act on the basis of one pernicious *ism* or another. All in all, the making of choices, especially hard ones, is, he believed, an essential part of 'what it means to be human'.

Perhaps the best-known phrase associated with Berlin's view of the world and humanity is the one used as the title for his essay, *The Hedgehog and the Fox.* It comes from a fragment of Greek poetry by Archilochus: 'The fox knows many things, but the hedgehog knows one big thing.' As he applied this saying to the major actors of history, Berlin was not praising one beast and condemning the other. Everyone combines both, although in different proportions and interactions. In that sense, the proverb doesn't quite work as a bumper-sticker for life – which is appropriate, since Berlin was wary of slogans and nostrums.

He did, however, have one big idea of his own – his own personal hedgehog – and it was (also appropriately) paradoxical: beware of big ideas, especially when they fall into the hands of political leaders.

The antonym of pluralism is monism, which holds that there is

---

[1] 'The Pursuit of the Ideal', in *The Crooked Timber of Humanity*, ed. Henry Hardy (London, 1990), p. 13.

one overarching answer to who we are, how we should behave, how we should govern and be governed. It's when the powers-that-be claim to have a monopoly on the good, the right and the true that evil arises. Monism is the common denominator of other *isms* that have wrecked such havoc through history, including the two totalitarianisms of the twentieth century. One is associated with the name of Hitler, the other with that of Stalin, the photograph of whom on page vi shows him sitting beneath a portrait of that Big-Idea-monger, Karl Marx. Stalin looms in the background, and sometimes the foreground, of all Berlin's essays on Soviet politics and culture, including those written after the tyrant's death in 1953.

After perusing the manuscript of this book, George Kennan had this to say: 'I always regarded Isaiah, with whom I had fairly close relations during my several periods of residence in Oxford, not only as the outstanding and leading critical intelligence of his time, but as something like a patron saint among the commentators on the Russian scene, and particularly the literary and political scene.'

Berlin himself was not ethnically a Russian but a Jew (a distinction that has mattered all too much in Russian society); he was born not in Russia proper but in Riga, on the fringes of the empire; he was only eleven when his family emigrated from Petrograd to England, where he spent his long life; and he returned to Russia only three times. Yet he was, in many ways, a uniquely insightful observer of that country. As a boy, he had been able to dip into leather-bound editions of Tolstoy, Turgenev and Pushkin in his father's library and hear Chaliapin sing the role of Boris Godunov at the Mariinsky Theatre. And, of course, he retained the language, which gave him access to all those minds – Soviet, pre-Soviet, post-Soviet, un-Soviet and anti-Soviet – that informed what he thought and what you are about to read.

Throughout his life, as Berlin's own mind ranged over the centuries and around the world, he continued to think, read, listen, talk and write about Russia, both as the home of a great culture and as a laboratory for a horrible experiment in monism.

In pondering how that experiment might turn out, Berlin rejected the idea of historic inevitability, not least because that itself

was monistic. Instead, he believed in what might be called the pluralism of possibilities. One possibility was that Russia, over time, would break the shackles of its own history. He asserted that belief in 1945, immediately after his first meeting with the poet Anna Akhmatova, recounted in 'A Visit to Leningrad' and 'Conversations with Akhmatova and Pasternak'. He returned from Leningrad to the British Embassy in Moscow, where he was working at the time, and wrote a visionary dispatch to the Foreign Office in London. It expressed a hope that the vitality and magnificence of Russian culture might withstand, and eventually even overcome, what he called the 'blunders, absurdities, crimes and disasters' perpetrated by a 'most hateful despotism'; in other words, that the best in Russia's dualism might win out over the worst.

Akhmatova wrote Berlin into her epic *Poem without a Hero* as 'the Guest from the Future'. Yet in real life, his powers did not include that of prophecy. He did not expect to outlive the Soviet Union. In 1952, in an essay included here, he advanced the concept of 'the artificial dialectic', the ingenious tactical flexibility in the Communist party line that would, he believed, never allow 'the system to become either too limp and inefficient or too highly charged and self-destructive'. It was 'Generalissimo Stalin's original invention, his major contribution to the art of government' – and part of the tyranny's survival manual. He feared it would work:

> [S]o long as the rulers of the Soviet Union retain their skill with the machinery of government and continue to be adequately informed by their secret police, an internal collapse, or even an atrophy of will and intellect of the rulers owing to the demoralising effects of despotism and the unscrupulous manipulation of other human beings, seems unlikely . . . Beset by difficulties and perils as this monstrous machine may be, its success and capacity for survival must not be underestimated. Its future may be uncertain, even precarious; it may blunder and suffer shipwreck or change gradually or catastrophically, but it is not, until men's better natures assert themselves, necessarily doomed.

Some might find in this judgement evidence that Berlin was blind to the handwriting on the wall, or at least less far-sighted than Kennan, who had, in 1947, discerned in the USSR 'tendencies

which must eventually find their outlet in either the break-up or the gradual mellowing of Soviet power'.[1]

Another interpretation may be closer to the mark. For one thing, the wall was a lot more solid-looking than anything written on it in the last year of Stalin's reign. For another, 'not necessarily doomed' may not be a diagnosis of terminal illness but it's not a certification of good health either. And finally, most pertinently, Berlin did not believe in certainty – especially, to paraphrase Yogi Berra, about the future.

I interviewed Berlin in the summer of 1968, just after Soviet tanks overran Czechoslovakia and crushed the Prague Spring. He talked, at breakneck speed and in a baroque, erudite manner, but with great clarity, about how the invasion proved the weakness of a regime that relied so utterly on brute strength, and how it revealed the 'decrepitude' of the Soviet system and of its ideology.

Yet he – like myself and virtually everyone else I knew – still expected that system to hang on for a long time to come. In the mid-1980s, Margaret Thatcher chided Berlin for being a pessimist when he suggested that it would take a war to bring about what now would be called 'regime change' in Moscow.

Even in the Year of Miracles, 1989 – when the wall (literally and figuratively) came tumbling down – while others saw the end of history, Berlin was not ready to pronounce the end of anything. In 'The Survival of the Russian Intelligentsia' he hails the Russians for their part in the peaceful revolution that was spreading throughout the Soviet bloc. They are, he wrote, 'a great people, their creative powers are immense, and once they are set free there is no telling what they may give to the world'.

But even amidst what he calls his 'astonishment, exhilaration, happiness' about what was happening in Central Europe, he recalls Madame Bonaparte's comment when congratulated on being the mother to an emperor, three kings and a queen: 'Oui, pourvu que ça dure.' There's an echo of that caution at the end of the essay –

---

[1] 'The Sources of Soviet Conduct', *Foreign Affairs* 25 No 4 (July 1947), pp. 566–82, at p. 582. The article was published under the pseudonym 'X' in what the editor described to Berlin as 'our normal series of anonymous articles signed with an initial' (see p. xxxvi below).

which concludes: 'A new barbarism is always possible, but I see little prospect of it at present. That evils can, after all, be conquered, that the end of enslavement is in progress, are things of which men can be reasonably proud.'

He believed that history, including the history of ideas, is always 'in progress'. At moments when the direction seems positive, progress can be acknowledged, even celebrated – but without excessive zeal, or certainty.

This much can be said with total certainty: to be associated with the publication of this book is a cause for all of us to be more than reasonably proud.

THIS BOOK, like much that bears the Brookings imprint, is the result of collaboration. Along with Bob Faherty, the director of the Brookings Press, I wish to express our gratitude to Henry Hardy of Wolfson College, Oxford, who edited these essays, lectures and other writings by Isaiah Berlin. Henry accomplished that task with the same skill and care that he has brought to fourteen earlier collections of Berlin's work, including five since Berlin's death in 1997. There are more to come, beginning with the first volume (1928–46) of Berlin's letters, published in the same season as this book.

I join Henry in expressing appreciation to Aline Berlin for supporting this project, and for contributing, along with Peter Halban, to a roundtable discussion of the manuscript, convened on 7 July 2003 under the auspices of St Antony's College – an event made possible by the kindness of the Warden, Sir Marrack Goulding, and Polly Friedhoff, the College's Public Relations and Development Officer. That session brought together scholars, colleagues and friends of Berlin's who shared with us their reminiscences of him and their knowledge of his work. The other participants were: Sir Rodric Braithwaite, Professor Archie Brown, Professor Cao Yiqiang, Larissa Haskell, Camilla Hornby, Professor Peter Oppenheimer, Dr Alex Pravda, Helen Rappaport, Professor Robert Service, Brooke Shearer, Dr Harry Shukman and Pat Utechin.

# PREFACE

*Henry Hardy*

he possesed a clever but also cruel look and all his countenence bore an expression of a phanatic he signed death verdicts, without moving his eyebrow. his leading motto in life was "The purpose justifies the WAYS" he did not stop before anything for bringing out his plans.

Isaiah Berlin, 'The Purpose Justifies the Ways' (1921)[1]

I HAVE LONG KNOWN that this book ought to exist. Isaiah Berlin's scattered writings on the Soviet era of Russian politics and culture are substantial both in quality and in quantity, as well as being unlike those from any other hand.

In 1991, after the successful publication of *The Crooked Timber of Humanity*, and in response to the collapse of Communism in Russia and Eastern Europe, I suggested to Berlin that a collection of his pieces on the Soviet Union might be especially timely, but he demurred, saying that most of the items in question were occasional, lightweight and somewhat obsolete. I returned to the fray, setting out the arguments in favour of the proposal. He replied as follows:

No good. I realise that all you say is perfectly sensible, but this is the wrong time, even if these things are to be published. [. . .] I think at the moment, when the Soviet Union has gone under, to add to works which dance upon its grave would be inopportune – there is far too much of this going on already – the various ways of

---

[1] In his *The First and the Last* (New York/London, 1999), pp. 9–19, at p. 17.

showing the inadequacies of Marxism, Communism, Soviet organisation, the causes of the latest putsch, revolution etc. And I think these essays, if they are of any worth, which, as you know, I permanently doubt, had much better be published in ten or fifteen years' time, perhaps after my death – as interesting reflections, at best, of what things looked like to observers like myself in the '50s, '60s, '70s etc. Believe me, I am right.

More than a decade later, and some six years after Berlin's death, it seems right to put these hesitations aside, especially since developments in the former Soviet Union have not followed the swift path towards Western liberal democracy that so many (not including Berlin himself) rashly predicted; it is a commonplace that much of the Soviet mentality has survived the regime that spawned it. As for Berlin's doubts about the value – especially the permanent value – of his work, I am used to discounting these with a clear conscience, and his phrase 'observers like myself' splendidly understates the uniqueness of his own vision.

What has brought the project to fruition at this particular juncture is the welcome proposal by my friend Strobe Talbott that the pieces in question be made the subject of a seminar on Berlin's contribution to Soviet studies and published by the Brookings Institution Press. Strobe's foreword expertly places the contents of the book in the context of Berlin's oeuvre as a whole.

All the footnotes to the essays are editorial except those to which 'I.B.' is appended. A few supplementary remarks now follow on the circumstances in which the essays I have included came to be written.

## The Arts in Russia under Stalin

In the autumn of 1945 Berlin, then an official of the British Foreign Office, visited the Soviet Union for the first time since he had left it in 1920, aged eleven. It was during this visit that his famous meetings with Anna Akhmatova and Boris Pasternak took place. He did not record his memories of these encounters until thirty-five years later.[1]

[1] A shortened version of his account appears in this volume.

But he also wrote two official reports at the time. At the end of his period of duty he compiled a remarkable long memorandum on the general condition of Russian culture, giving it the characteristically unassuming title 'A Note on Literature and the Arts in the Russian Soviet Federated Socialist Republic in the Closing Months of 1945'.

He also understated the coverage of his report. He enclosed a copy of it with a letter dated 23 March 1946 to Averell Harriman, US Ambassador to the USSR, congratulating him on his appointment as Ambassador to Britain. In the letter, written from the British Embassy in Washington, he told Harriman:

> I enclose a long and badly written report on Russian literature etc. which I am instructed to forward to you by Frank Roberts.[1] I doubt whether there is anything in it that is either new or arresting – here only Jock Balfour[2] has read it, in the Foreign Office I doubt if anyone will. It is confidential only because of the well-known consequences to the possible sources of the information contained in it, should its existence ever become known to 'them'. I should be grateful if you could return it to me via the Foreign Office bag addressed to New College, Oxford, in the dim recesses of which I shall think with some nostalgia but no regret of the world to which I do not think I shall ever be recalled.

Berlin's self-effacing account of his despatch is of course quite misleading. As Michael Ignatieff writes in his biography of Berlin:

> Its modest title belied its ambitions: it was nothing less than a history of Russian culture in the first half of the twentieth century, a chronicle of Akhmatova's fateful generation. It was probably the first Western account of Stalin's war against Russian culture. On every page there are traces of what she – Chukovsky and Pasternak as well – told him about their experiences in the years of persecution.[3]

---

[1] British Minister in Moscow.
[2] British Minister in Washington.
[3] Michael Ignatieff, op. cit. (p. xii above, note 1), p. 161

## A Visit to Leningrad

The other piece written contemporaneously with the events of 1945 is a more personal account of his historic visit to Leningrad from 13 to 20 November, less than two years after the lifting of the German siege. He deliberately underplays, indeed slightly falsifies, his encounter with Akhmatova on (probably) 15–16 November. But in a letter to Frank Roberts, the British Chargé d'Affaires in Moscow, thanking him for his hospitality, he writes that when he called on Akhmatova again on his way out of the Soviet Union at the end of his visit, she 'inscribed a brand new poem about midnight conversations for my benefit, which is the most thrilling thing that has ever, I think, happened to me'.[1]

## A Great Russian Writer

On 28 January 1998 'An American Remembrance' of Isaiah Berlin was held at the British Embassy in Washington. One of the tributes delivered on that occasion was by Robert Silvers,[2] co-editor of the *New York Review of Books*, and a friend of Berlin's for more than thirty years. In the course of his remarks he spoke of the circumstances under which the next essay was written, and of his own reaction to Berlin's writing:

> The prose of the born storyteller – that seems to me quintessential in comprehending Isaiah's immensely various work. I felt this most directly [in autumn 1965] when he was in New York, and a book appeared on the work of the Russian poet Osip Mandel'shtam, and Isaiah agreed to write on it. The days passed, and he told me that he was soon to leave, and we agreed he would come to the *Review* offices one evening after dinner, and he would dictate from a nearly finished draft. As I typed away, I realised that he had a passionate, detailed understanding of the Russian poetry of this century. [...] When he finished and we walked out on 57th Street, with huge, black

---

[1] Letter of 20 February 1946. The poem is the second in the cycle *Cinque*.

[2] The whole tribute is posted under 'Writing on Berlin' in *The Isaiah Berlin Virtual Library* (hereafter IBVL), the website of The Isaiah Berlin Literary Trust, *http://berlin.wolf.ox.ac.uk/*.

like the heroes of Turgenev, Tolstoy and Chekhov, stands at the edges of his society, is involved in its direction and fate, but is not identified with it, and preserves his human shape, his inner life and his sense of truth under the impact of violent events which pulverise his society, and brutalise or destroy vast numbers of other human beings.

As in his poetry, Pasternak melts the barriers which divide man from nature, animate from inanimate life; his images are often metaphysical and religious; but efforts to classify his ideas, or those of the characters of the novel, as specifically social or psychological, or as designed to support a particular philosophy or theology, are absurd in the face of the overwhelming fullness of his vision of life.

To the expression of his unitary vision the author devotes a power of evocative writing, at once lyrical and ironical, boldly prophetic and filled with nostalgia for the Russian past, which seems to me unlike any other, and in descriptive force today unequalled.

It is an uneven book: its beginning is confused, the symbolism at times obscure, the end mystifying. The marvellous poems with which it ends convey too little in English. But all in all it is one of the greatest works of our time.[1]

He returned to the book in 1995 when asked by the same newspaper to choose a book for their 'On the Shelf' column. Because his comments add significantly to what he says in 'Conversations with Akhmatova and Pasternak', I reproduce them here:

A book that made a most profound impression upon me, and the memory of which still does, is *Doctor Zhivago* by Boris Pasternak. In 1956, I was in Moscow with my wife, staying at the British Embassy. (I had met Pasternak when I was serving in the embassy in 1945, and I made friends with him then, and saw him regularly.) I went to see him in the writers' village of Peredelkino, and among the first things he told me was that he had finished his novel (of which I had read one chapter in 1945) and that this was to be his testament, far more so than any of his earlier writings (some of them undoubted works of genius, of which he spoke disparagingly).

[1] *Sunday Times*, 21 December 1958, p. 6.

He said that the original typescript of the novel had been sent the day before to the Italian publisher Feltrinelli, since it had been made clear to him that it could not be published in the Soviet Union. A copy of this typescript he gave to me. I read it in bed throughout the night and finished it late in the morning, and was deeply moved – as I had not been, I think, by any book before or since, except, perhaps *War and Peace* (which took more than one night to read).

I realised then that *Doctor Zhivago* was, as a novel, imperfect – the story was not properly structured, a number of details seemed vivid and sharp, but artificial, irrelevant, at times almost crudely cobbled together. But the description of the public reception of the February Revolution was marvellous; I was in Petrograd at that time, at the age of seven, and I remembered the reactions of my aunts, cousins, friends of my parents and others – but Pasternak raised this to a level of descriptive genius. The pathetic efforts of moderates and liberals were described with sympathy and irony. The crushing, elemental force, as he saw it, of the Bolshevik takeover is described more vividly than in any other account known to me.

But what made the deepest impression upon me, and has never ceased to do so, was the description of the hero and heroine, surrounded by howling wolves in their snow-swept Siberian cottage – a description that is virtually unparalleled.

Love is the topic of most works of fiction. Nevertheless, what the great French novelists speak of is often infatuation, a passing, sometimes adversarial, interplay between man and woman. In Russian literature, in Pushkin and Lermontov, love is a romantic outburst; in Dostoevsky, love is tormented, and interwoven with religious and various other psychological currents of feeling. In Turgenev, it is a melancholy description of love in the past which ends, sadly, in failure and pain. In English literature, in Austen, Dickens, George Eliot, Thackeray, Henry James, Hardy, D. H. Lawrence, even Emily Brontë, there is pursuit, longing, desire fulfilled or frustrated, the misery of unhappy love, possessive jealousy, love of God, nature, possessions, family, loving companionship, devotion, the enchantment of living happily ever after. But passionate, overwhelming, all-absorbing, all-transforming mutual love, the world forgotten, vanished – this love is almost there in Tolstoy's *Anna Karenina* (not in *War and Peace* or the other masterpieces), and then, in my experience, only in *Doctor Zhivago*. In this novel it

is the authentic experience, as those who have ever been truly in love have always known it; not since Shakespeare has love been so fully, vividly, scrupulously and directly communicated.

I was terribly shaken, and when I went to see the poet the next day, his wife begged me to persuade him not to publish the novel abroad, for fear of sanctions against her and their children. He was furious, and said that he did not wish me to tell him what to do or not to do, that he had consulted his children and they were prepared for the worst. I apologised. And so that was that. The later career of the novel is known; even the American film conveyed something of it. This experience will live with me to the end of my days. The novel is a description of a total experience, not parts or aspects: of what other twentieth-century work of the imagination could this be said?[1]

## Why the Soviet Union Chooses to Insulate Itself

A month after his return in early April 1946 from his wartime duties in the USA Berlin was invited to speak to the Royal Institute of International Affairs at Chatham House in London on 'Soviet insulationism'. He sought and received assurances about the composition of his audience and the confidentiality of the proceedings, and gave his talk on 27 June, under the title used here. This piece is the text of the talk as it appears in the minutes of the meeting, edited for inclusion in this volume. I have omitted the introductory remarks by the chairman, Sir Harry Haig, and the discussion period, which are posted on the official Isaiah Berlin website as part of the original minutes, written in the third person, in indirect speech. I have here translated this into direct speech for the sake of readability; but the result should not be taken as a full verbatim transcript of Berlin's remarks.

[1] *Sunday Times*, 7 November 1995, section 7 ('Books'), p. 9. Readers may like to have a note of Berlin's other shorter publications on Pasternak: 'The Energy of Pasternak', a review of Pasternak's *Selected Writings*, appeared in the *Partisan Review* 17 (1950), pp. 748–51, and was reprinted in Victor Erlich (ed.), *Pasternak: A Collection of Critical Essays* (Englewood Cliffs, NJ, 1978); and there is a letter on Pasternak, written in reply to an article by Gabriel Josipovici, in the *Times Literary Supplement*, 16–22 February 1990, p. 171.

## The Artificial Dialectic

The story of the articles from *Foreign Affairs* included here is best told by quotation from Berlin's entertaining letters to the journal's editor, Hamilton Fish Armstrong, to whom Berlin's readers owe a great debt of gratitude for his tireless attempts over more than two decades to extract articles from this reluctant author. He succeeded four times, and two of his successes appear below.

The trail that leads to 'The Artificial Dialectic' begins on 29 June 1951, when Armstrong presses Berlin to write for him again, following the critical acclaim that greeted 'Political Ideas in the Twentieth Century' in 1950. Berlin replies that he does in fact have a 'piece' that might do, and explains its origins in a letter dated 16 August 1951:

> The circumstances are these: months & months & months ago [Max] Ascoli wrote, not once but repeatedly, reproaching me for writing for you & for the N.Y. Times & for the Atlantic Monthly, but never for him. I have, I must admit, no great opinion of his 'Reporter', but him I like quite well. At any rate, bullied in this way, I sat down, wrote a piece, & sent it him, explaining that though it might be too long for him, I wd rather have it rejected & forever unpublished, than cut or edited (he criticised the piece in *Foreign Affairs* for being too long, filled with truisms which he cd have cut out, etc.). He replied eulogistically, sent me a handsome turkey for Christmas, then fell ill & there was a long silence. I took (I am ashamed to say) the opportunity of the silence, & wrote (not altogether truthfully) that I wanted the piece back in order to lengthen it, which wd doubtless make it still more unsuitable for him. He returned it, I did add a line or two in ink (as in MS enclosed) & asked me to give it back to him in October. This I am determined not to do whatever happens. I am not keen to appear in the *Reporter*; my obligation vis a vis Ascoli is now discharged; I wd rather always be printed by yourself, or if you don't want it, by the N.Y.T., or if they don't, by nobody. After doing nothing with the piece for 3 or 4 months (although he assured me it was scheduled for publication in August) Ascoli can have no claims.
>
> The second point is more difficult: as I have (I hope still) relations in the U.S.S.R., & as I visited innocent littérateurs there, I

have always followed the policy of publishing nothing about the Sov. Union directly under my own name, because that might easily lead to something frightful being done to people I talked to there. I needn't enlarge on that prospect. Hence if I am to publish anything about Uncle Joe [Stalin] it must be (a) anonymously or under a pseudonym (b) the identity of the author must be really, & not as in George Kennan's case, only notionally secret. I invented the name of John O. Utis for the 'Artificial Dialectic'. OUTIS means 'nobody' in Greek & you will recall elaborate puns about this in the Odyssey where Odysseus deceives the one-eyed ogre by this means. Also it sounds vaguely like a name which a Lithuanian D.P., let us say, or a Czech or Slovene cd have: & so, plausible for the author of such a piece. Ascoli & possibly a confidential typist may know the secret. Nobody else; & he will certainly be honourable & lock it in his breast, whatever his feelings about where & how the piece is published. Do you ever publish anonymous pieces? if not, I shall, of course, fully understand: since lives depend upon it, I wd obviously rather suppress altogether than compromise on this – I really have no choice. There is only one other person to whom I showed it – Nicholas Nabokov – who has begged it for his 'Preuves' – some Paris anti-Soviet institution. If you do want it, I shd be grateful if you cd give me permission to have it translated, after U.S. publication, into German (The Monat) & French etc.: I shall, of course, never read it aloud myself to anybody: my authorship must remain a secret from as many as possible: but I may let Nabokov have a copy, provided he promises formally not to have it published anywhere (until you reply) but only uses it for informal discussion as a letter from an unknown source, offering various loose ideas. I apologise for this rigmarole – these queer conditions – the recital of the past etc. I hope you'll like it, but I've no opinion, as you know, of anything I write: & if you'd rather have nothing to do with the piece, pray forget this letter.

Armstrong replies on 30 August. He feels that 'people will see through the disguise', but agrees to the pseudonymity. Shortly thereafter a colleague reads the piece, finding its style difficult and its conclusion unsatisfactory. Armstrong makes these points, tactfully, to Berlin on 10 September, and Berlin (who is in Maine) replies two days later:

You let me off much too gently, of course. Well do I know that, like my unintelligible speech, my prose, if such it can be called, is an opaque mass of hideously under-punctuated words, clumsy, repetitive, overgrown, enveloping the reader like an avalanche. Consequently, of course I shall, as last time, accept your emendations with gratitude for the labour they inevitably cost you. You are the best, most scrupulous, generous & tactful editor in the world: & I shall always, if occasion arises, be prepared to submit to civilising processes – judicious pruning you kindly call it – at your hands [. . .]

Although you are no doubt right about impossibility of real concealment, there is, I think, from the point of view of repercussions on my acquaintances & relations in the U.S.S.R., a difference between suspected authorship & blatant paternity. Hence I think it best to stick to a pseudonym. If you think O. Utis (no "John") is silly – I am attracted to it rather – I don't mind anything else, provided you & your staff really do refuse to divulge & guard the secret sacredly. So that I am [open] to suggestions. [. . .]

I don't know whether 'Artificial Dialectic' is at all a good title, or 'Synthetic Dialectic' either: if you cd think of something simpler & more direct – I'd be very grateful. [. . .]

I have just had a line from Ascoli wanting to see the piece again – but he shan't – I'll deal with that & it needn't concern you at all.

Armstrong (17 September) thanks Berlin for his 'untruthful flattery', and shortly afterwards sends an edited script, explaining in more detail the case for revision of the conclusion. After some desperate cables from Armstrong, Berlin writes (30 October):

Do forgive me for my long delay, but Mr Utis has been far from well and overworked. He will be in New York next Saturday, but too briefly – for a mere 4 to 5 hours – to be of use to anyone. But he will, under my firm pressure, complete his task, I think, within the next fortnight and you shall have the result as soon as possible. I is displaying a curious aversion to social life at present, but it is hoped that the completion of some, at any rate, of his labours will restore his taste for pleasure, at any rate by mid-December. I shall certainly keep you posted about the movement of this highly unsatisfactory figure.

All this was composed before your telegram – the technique of your communication has by now, I perceive, been established in a

firm and not unfamiliar pattern of the patient, long-suffering, but understanding editor dealing with an exceptionally irritating and unbusinesslike author who does, nevertheless, in the end respond, apologise, and produce, although after delays both maddening and unnecessary, which only the most great-hearted editor would forgive. But in this case, I should like to place the following considerations before you:

(a) Mr Utis would like a little time in which to incorporate ideas induced in him by casual conversations with intelligent persons – e.g. that the rhythm of Soviet scientific theories is induced by extra-scientific considerations – this being a point useful for consumption by local scientists of an anti-anti-Soviet cast of mind. Also, he feels the need to say something, however gently, to deflate the optimism, which surely springs from the heart rather than the head, of those who like Mr X[1] argue that some things are too bad to last, and that enough dishonour must destroy even the worst thieves; Mr Utis does not believe in inner corrosion, and this, pessimistic as it may seem, seems to be worth saying; he is prepared to withdraw the story about the waiter-steward as being perhaps in dubious taste unless it could fitly appear as an epigraph to the whole, in which form he will re-submit it, but will not have the faintest objection if it is eliminated even in this briefer and more mythological guise;[2]

(b) It would surely be most advisable for the piece to appear after Mr Utis's friend is out of the country and is not put to unnecessary embarrassment or prevarication. He intends to sail back to his monastery towards the end of March or the beginning of April;

(c) A plus B would have the added advantage of making it possible for the incorporation of any new evidence which may crop up in the intermediate period. However, Mr Utis sticks to his original resolution; the manuscript shall be in the hands of the editor within two or three weeks in a completed form ready to print as it stands. Any additions or alterations – which at this stage are neither likely nor unlikely – could be embedded by mutual consent only if there was something really tempting. Mr Utis's name is O. Utis.

I hope this is not too much for you – do not, I beg you, give me up as altogether beyond the bounds of sweet reasonableness and accommodation. I really think that the arrangement proposed is the best all round.

---

[1] See p. xvi above, note 1.
[2] The story has been added below (p. 98) as an epigraph, as Berlin suggests.

The revised script is acknowledged by a relieved and satisfied Armstrong on 16 November, though he wonders again whether anyone will be taken in by the pseudonym; on 20 November Berlin sends further thoughts:

I see that a somewhat different analysis of U[ncle] J[oe] is presented by Mr A. J. P. Taylor in the *New York Times* this last Sunday,[1] but Mr Utis sticks to his views. I think the signature had better remain as arranged. All things leak in time and there are at least a dozen persons in the world now who know the truth. Nevertheless, the difference from the point of view of possible victims in the country under review seems to me genuine; and so long as the real name is not flaunted, and room for doubt exists, their lives (so I like to think) are not (or less) jeopardised. More thought on these lines would make me suppress the whole thing altogether on the ground that you must not take the least risk with anyone placed in so frightful a situation. (Never have so many taken so much for so long from so few. You may count yourself fortunate that this sentence is not a part of Mr Utis's manuscript.) So, I drive the thought away and Mr Utis is my thin screen from reality behind which I so unconvincingly conceal my all too recognisable features.

Only one thing has occurred to Mr Utis since his last letter to you; and that is whether some added point might not be given to the bits scrawled in manuscript concerning the chances of survival of the artificial dialectic. Perhaps something might be said about how very like a permanent mobilisation – army life – the whole thing is for the average Soviet citizen and that considering what people do take when they are in armies – particularly Russians and Germans – provided that things really are kept militarised and no breath of civilian ease is allowed to break the tension, there is no occasion for surprise that this has lasted for so long, nor yet for supposing that its intrinsic wickedness must bring it down (as our friend Mr X seems to me too obstinately to believe). I was much impressed by what someone told me the other day about a conversation with one of the two Soviet fliers – the one who did not go back. He was asked why his colleague who returned did so (I cannot remember the names, one was called, I think, Pigorov, but I do not know whether this is the man who stayed or the man who

---

[1] A. J. P. Taylor, 'Stalin as Statesman: A Look at the Record', *New York Times Magazine* (*New York Times*, section 6), pp. 9, 53–60.

returned). He replied that after they had been taken for a jaunt around Virginia, they were dumped in an apartment in New York, provided with an adequate sum of money, but given nothing very specific to do. The flier who ultimately returned found that this was more intolerable than a labour camp in the Soviet Union. This may be exaggerated, but obviously contains a very large grain of truth. Apparently the people here who were dealing with some of the 'defectors' found the same problem – how to organise them in a sufficiently mechanical, rigid and time-consuming manner, to prevent the problem of leisure from ever arising.

If you think well of the military life analogy, could I ask you – you who now know Mr Utis and his dreadful style and grammar[1] so intimately – to draft a sentence or two, to be included in the proof in the relevant place, saying something to the effect that the question of how long the lives either of executive officials or the masses they control can stand the strain of a system at once so taut and so liable to unpredictable zigzags is perhaps wrongly posed; once the conditions of army life and army discipline have been imposed, human beings appear to endure them for what seems to the more comfort-loving nations a fantastic length of time; provided they are not actually being killed or wounded, peasant populations show little tendency to revolt against either regimentation or arbitrary disposal of their lives; the decades of service in the army which Russian peasants in the eighteenth or nineteenth centuries had to endure led to no serious rebellions and the emancipation of the serfs less than a century ago had less psychological effect than is commonly assumed, or civilised persons hoped it would have. The possibility of cracking under the strain is smaller in a system where everything obeys a dead routine, however inefficient and costly in lives and property, than one in which ultimate responsibility rests in nervous or fumbling fingers; hence, the prospect of upheavals and revolt, etc. when M. Stalin (I hope you will keep the 'M.')[2] is succeeded is greater than during his years of power, however oppressive,

---

[1] Berlin annotates: 'Did you know that "grammar" is the same word as "glamour"? It proceeds via "grimoire". If further explanation is needed, I shall provide it when I see you.'

[2] He did; I haven't. So long after Stalin's death, the appellation (used throughout the piece) loses whatever point it had. Even Armstrong had his doubts (28 November): 'I didn't mind the ironical courtesy – indeed, rather liked it – but have a dislike of using a French term in speaking of another nationality. However, to put "Mr" looked ridiculous, so "M." it is.'

arbitrary, and brutal. But perhaps I have said this already in the article. If so, I apologise for repeating myself this way.

With well repressed resignation Armstrong accepts, on 28 November, the expansion, even though he had asked Berlin for a cut; another piece is shortened to make room for it. And with that the dust settles and the article is printed.

### Four Weeks in the Soviet Union

This piece is based on an unfinished draft of an account of Berlin's visit to the USSR in 1956 with his wife Aline, whom he had married five months earlier. They were the guests of the British Ambassador, Sir William Hayter, at the British Embassy in Moscow. If Berlin had any plans to publish this piece, they appear to have been abandoned after he incorporated some of its contents, in a somewhat altered form, in the last section of the following essay; but much was omitted in this process, and not the least interesting material, so that it is well worth preserving this more personal narrative in full.

Particularly toward its end, the typescript, made from recorded dictation by a secretary, contains gaps (some large) and uncertainties; these I have edited out to provide a continuous text, without, I trust, altering Berlin's intended meaning. At the very end of the typescript there was a sentence that evidently did not belong there, but was probably an afterthought intended for insertion earlier: it does not seem to fit exactly anywhere, but it appears in the least unsuitable place I could find, as a footnote to p. 127.

### Soviet Russian Culture

This essay was originally published as two articles, one pseudonymous, in *Foreign Affairs*, but is here restored to its original unitary form. For its history we return to Berlin's correspondence with Armstrong, beginning with Berlin's letter of 6 February 1957, responding to an invitation from Armstrong to apply the thesis of 'The Artificial Dialectic' to recent events:

My friend Mr Utis is, as you know, a poor correspondent and liable to be distracted by too many small and mostly worthless preoccupations. Your praise acted upon him as a heady wine, but his moods are changeable, and although, as his only dependable friend, I am trying to act as his moral backbone – an element which he conspicuously lacks – it is difficult to make any promises on his behalf, and the prospect of a decision by him on the subject of which you wrote, especially by the first week in August, is by no means certain. It would therefore be a *far far* safer thing not to anticipate its arrival *too* confidently. I will bring what pressure I can upon my poor friend, but I need not tell you, who have had so many dealings with him in the past, that his temperament and performance are unsteady and a source of exasperation and disappointment to those few who put any faith in him. I shall report to you, naturally, of what progress there may be – there is, alas, no hope of a permanent improvement in his character. Utis is under the queer illusion that his very unreliability is in itself a disarming and even amiable characteristic. Nothing could be further from the truth, but he is too old to learn, and if it were not for the many years of association with him which I have had to suffer, I should have given up this tiresome figure long ago. Nor could I, or anyone, blame you if you resolved to do this; there is no room for such behaviour in a serious world, without something more to show for it than poor Utis has thus far been able to achieve. You are too kind to him; and he, impenitently, takes it all too much for granted.

Armstrong nags gently over the ensuing months, and is rewarded with a script, not totally unrelated to the subject he had suggested, a mere six months later. Its original title had been 'The Present Condition of Russian Intellectuals', but this has been altered, with typical Berlinian understatement, to 'Notes on Soviet Culture'. In his acknowledgement, dated 28 August, Armstrong writes: 'I have accepted your suggestion [presumably in a letter that does not survive] and am running the first six sections under your name, and running section seven as a separate short article, signed O. Utis, under the title "The Soviet Child–Man".' This seems to give us the best of two worlds.'

It is clear from Armstrong's next letter (4 September) that Berlin cabled disagreement about the title of the Utis piece and – lest anyone suspect that he was the author – the re-use of Utis as

a pseudonym. Armstrong tells Berlin that it is too late to make changes, as printing of the relevant part of the journal has already occurred. Berlin must have begged or insisted (or both), since on 9 September Armstrong writes that he has now 'made the changes you wanted', adopting 'L' as the pseudonym, which 'puts the article in our normal series of anonymous articles signed with an initial'. To accommodate Berlin he had had to stop the presses, and he withheld the honorarium for 'The Soviet Intelligentsia' as a contribution to the costs involved.

The only sign of what must by this point have been firmly gritted teeth is Armstrong's remark in a letter of 20 September that he 'only didn't quite see why if there was to be no Utis it mattered what Mr L called his article, but doubtless you had a good reason for protecting him too'.

As an example of editorial forbearance this episode would surely be hard to beat. I conclude my account of it with a splendid account that Berlin sends Armstrong (17 December) of the feedback he has received to the pieces:

> I have had two delightful letters from unknown correspondents in the USA: one from a lady who encloses a letter she wrote to John Foster Dulles, commenting on his articles in the same issue, and drawing his attention to the deeper truths of mine – so far so good. She goes on however to say that the article by the unknown 'L' seems to her to give a truer picture of some of these things than even my own otherwise flawless work – and wishes to draw my attention to an article from which I have to learn, she hopes she is not hurting my feelings, but she does think it a good thing to be up to date, my own article is somewhat historical, the other article is on the dot and on the whole a better performance altogether. I am oscillating between humbly expressing my admiration for the genius of 'L' and jealously denouncing him as a vulgar impressionist who is trading on people's ignorance and giving an account which no one can check, which is, when examined, no better than a tawdry fantasy, which has unfortunately taken innocent persons like her – and perhaps even Mr John Foster Dulles – in. The other letter is from an Indian at Harvard who praises my article and denounces that of 'L' as a typical American journalistic performance unworthy to stand beside the pure and lofty beauty of my deathless prose. I thought these reflections might give you pleasure.

## *The Survival of the Russian Intelligentsia*

This comment on the post-Soviet situation provides an interesting postscript to the previous essay, recording Berlin's delight and surprise that the intelligentsia had emerged so unscathed from the depredations of the Soviet era, contrary to his rather gloomy expectations. In subsequent years his confidence that the death of that era was truly permanent steadily increased, despite the immense problems of its aftermath, some of them only too reminiscent of those engendered by Communism.

## *Glossary of Names*

Rather than sprinkle the text with possibly distracting footnotes identifying the large number of individuals named by Berlin in these essays, I invited Helen Rappaport, already an expert in this area as the author of *Joseph Stalin: A Biographical Companion*,[1] to compile a glossary, concentrating on the Russians, for readers not already familiar with the people referred to. I could not have done this myself, and those who find the glossary invaluable, as I do, are greatly in her debt. Three persons in particular caused problems: the Jewish bookseller Gennady Moiseevich Rahklin in 'A Visit to Leningrad', the Jewish Soviet literary scholar Naum Yakovlevich Berkovsky in 'A Great Russian Writer', and the historian Professor Kon in 'The Artificial Dialectic'; information from readers that would enable us to identify these more fully, and to say whether Rakhlin and Kon survived the Stalinist era, would be gratefully received, as would additional information about Nikolay Osipovich Lerner and Vladimir Nikolaevich Orlov.

## *Bibliographical*

The sources and original publication details of the pieces I have included are as follows:

'The Arts in Russia Under Stalin' is based on a text held, in the form in which it was printed for internal circulation, in the

---

[1] Oxford, 1999; published in the USA (Santa Barbara, California, 1999) as *Josef Stalin: A Biographical Companion.*

British Public Record Office file FO 371/56725. (A copy of the original typescript, dated 27 December 1945, is in the Berlin Papers, MS Berlin 571, fols 328–43.) The version published here incorporates two sets of revisions made by the author – one probably not many years later (including a few references to post-1945 developments), apparently in preparation for a talk; the other in 1992, in response to a request that the memorandum should be published in Russian. A partial Russian translation by Galina P. Andreevna appeared as 'Literatura i iskusstvo v RSFSR' ('Literature and Art in the RSFSR'), *Nezavisimaya gazeta*, 16 December 1997, in the supplement *Kulisa NG* No 2, December 1997, 4–5; this was reprinted with the cuts restored, and with an introduction by Nina V. Koroleva, in *Zvezda*, 2003 No 7 (July), 126–42. A cut version of the English text was published under the present title in the *New York Review of Books*, 19 October 2000; the cut material was posted on their website. The full English text appears in print here for the first time. The title and the notes (which incorporate information supplied by Helen Rappaport, to whom I am in this case particularly indebted) are mine.

'A Visit to Leningrad' is to be found in the British Public Record Office file FO 371/56724; this lightly edited version appeared in *The Times Literary Supplement*, 23 March 2001, 15–16.

'A Great Russian Writer' is a review of Osip Mandelstam, *The Prose of Osip Mandelstam*, trans. Clarence Brown, and appeared in the *New York Review of Books*, 23 December 1965, 3–4.

'Conversations with Akhmatova and Pasternak' – a shortened version of 'Meetings with Russian Writers in 1945 and 1956', which was published in the author's *Personal Impressions* (London, 1980; New York, 1981; 2nd ed. London, 1998; Princeton, 2001) – appeared in the *New York Review of Books*, 20 November 1980, 23–35, and in the author's collection *The Proper Study of Mankind: An Anthology of Essays* (London, 1997; New York, 1998).

'Boris Pasternak' and 'Why the Soviet Union Chooses to Insulate Itself' have not previously been published.

'The Artificial Dialectic: Generalissimo Stalin and the Art of Government' appeared under the pseudonym 'O. Utis' (from 'outis', Greek for 'no one') in *Foreign Affairs* 30 (1952). The present subtitle served as its title on that occasion; the main title is Berlin's.

'Four Weeks in the Soviet Union' appears here for the first time.

'Soviet Russian Culture' was published in *Foreign Affairs* 36 (1957), the first six sections as 'The Silence in Russian Culture' under Berlin's own name, the last section as a separate article, entitled 'The Soviet Intelligentsia', under the pseudonym 'L.'.

'The Survival of the Soviet Intelligentsia' was an untitled contribution to 'The State of Europe: Christmas Eve 1989' in *New Europe!*, the title of *Granta* 30 (Winter 1990).

Naturally enough, there are some overlaps between the essays, independently composed as they were, over a long period. These I have deliberately not tampered with, in order not to damage the internal structure of each piece.

## Acknowledgements

First and foremost, my thanks are due to Strobe Talbott, whose inspired initiative in suggesting the roundtable discussion of this collection of essays provided the timely opportunity to pull it off the shelf, blow the dust away, and put it into final publishable form. Otherwise it might have waited a good deal longer before seeing the light. His splendid foreword adds largesse to beneficence. I am also grateful to Aline Berlin for accepting his suggestion, and its publishing implications.

Andreas Xenachis, Strobe's Assistant, and Serena Moore, my own Assistant, have given all manner of help at all stages. Betty

Colquhoun typed the texts. Helen Rappaport not only compiled the masterly glossary, but also answered numerous queries about points in the text, providing draft notes when requested, with good humour in the face of my relentless pressure to explain every detail. A number of the other participants in the round-table, in particular Rodric Braithwaite, Archie Brown, Larissa Haskell and Harry Shukman, have made valuable suggestions and corrected errors in a draft of the book. Michael Hughes, Archivist of the Berlin Papers at Oxford's Bodleian Library, has kindly winkled out for me some of the background information I draw on above. David King of the David King Collection gener-ously provided the photographs of Osip Mandel'shtam on pages 46 and 47. To all these, and any others whom I have forgotten to mention, I record my grateful thanks.

Finally a word on the dedicatee. Pat Utechin was Isaiah Berlin's secretary from before the time I met him (in 1972) until his death in 1997. For all those years she was endlessly helpful and supportive to me in my work, which could hardly have been done without her. I have long wanted to dedicate one of Berlin's collections of essays to her: this one is a perfect candidate, given her marriage to a Russian whose expertise on its subject-matter is reflected in her own knowledge and interests. Thus I salute her.

HENRY HARDY

*Tisvilde Lunde, Nordsjælland, Denmark, August 2003*

THE SOVIET MIND

# THE ARTS IN RUSSIA UNDER STALIN

*December 1945*

THE SOVIET literary scene is a peculiar one, and in order to understand it few analogies from the West are of use. For a variety of causes Russia has in historical times led a life to some degree isolated from the rest of the world, and never formed a genuine part of the Western tradition; indeed her literature has at all times provided evidence of a peculiarly ambivalent attitude with regard to the uneasy relationship between herself and the West, taking the form now of a violent and unsatisfied longing to enter and become part of the main stream of European life, now of a resentful ('Scythian') contempt for Western values, not by any means confined to professing Slavophils; but most often of an unresolved, self-conscious combination of these mutually opposed currents of feeling. This mingled emotion of love and of hate permeates the writing of virtually every well-known Russian author, sometimes rising to great vehemence in the protest against foreign influence which, in one form or another, colours the masterpieces of Griboedov, Pushkin, Gogol, Nekrasov, Dostoevsky, Herzen, Tolstoy, Chekhov, Blok.

The October Revolution insulated Russia even more completely, and her development became perforce still more self-regarding, self-conscious and incommensurable with that of its neighbours. It is not my purpose to trace the situation historically, but the present is particularly unintelligible without at least a glance at previous events, and it would perhaps be convenient, and not too misleading, to divide its recent growth into three main stages – 1900–1928; 1928–1937; 1937 to the present – artificial and over-simple though this can easily be shown to be.

## 1900–1928

The first quarter of the present century was a time of storm and stress during which Russian literature, particularly poetry (as well as the theatre and the ballet), principally (although one is not allowed to say so today) under French and, to some degree, German influence, attained its greatest height since its classical age of Pushkin, Lermontov and Gogol. Upon this the October Revolution made a violent impact, but it did not dam the swelling tide. Absorbed and inexhaustible preoccupation with social and moral questions is perhaps the most arresting single characteristic of Russian art and thought as a whole; and this largely shaped the great Revolution, and after its triumph led to a long, fierce battle between, on one side, those primarily artistic rebels who looked to the Revolution to realise their own most violent 'anti-bourgeois' attitudes (and attitudinising) and, on the other, those primarily political men of action who wished to bend all artistic and intellectual activity directly to the social and economic ends of the Revolution.

The rigid censorship which shut out all but carefully selected authors and ideas, and the prohibition or discouragement of many non-political forms of art (particularly trivial genres such as popular love, mystery and detective stories, as well as all varieties of novelettes and general trash), automatically focused the attention of the reading public on new and experimental work, filled, as often before in Russian literary history, with strongly felt and often quaint and fanciful social notions. Perhaps because conflicts in the more obviously dangerous waters of politics and economics might easily be thought too alarming, literary and artistic wars became (as they did in German countries a century earlier under Metternich's police) the only genuine battlefield of ideas; even now the literary periodicals, tame as they necessarily are, for this very reason make livelier reading than the monotonously conformist daily, and purely political, press.

The main engagement of the early and middle 1920s was fought between the free and somewhat anarchist literary experimenters and the Bolshevik zealots, with unsuccessful attempts at

a truce by such figures as Lunacharsky and Bubnov.[1] This culminated, by 1927–8, first in the victory, and then, when it seemed to the authorities too revolutionary and even Trotskyist, in the collapse and purge (during the 1930s), of the notorious RAPP (Revolutionary Association of Proletarian Writers), led by the most uncompromising fanatic of a strictly collectivist proletarian culture, the critic Averbakh. There followed, during the period of 'pacification' and stabilisation organised by Stalin and his practically-minded collaborators, a new orthodoxy, directed principally against the emergence of any ideas likely to disturb and so divert attention from the economic tasks ahead. This led to a universal dead level, to which the only surviving classical author of the great days, Maxim Gorky, finally and, according to some of his friends, with reluctant despair, gave his blessing.

<div align="center">1928–1937</div>

The new orthodoxy, which became finally established after Trotsky's fall in 1928, put a firm end to the period of incubation during which the best Soviet poets, novelists and dramatists, and, indeed, composers and film producers too, produced their most original and memorable works. It marked the end of the turbulent middle and late 1920s, when Western visitors were astonished and sometimes outraged by Vakhtangov's stage;[2] when Eisenstein, not yet a film producer, directed his amusing futuristic experiments on stages discovered in the disused palaces of Moscow merchants, and the great producer Meyerhold, whose artistic life is a kind of microcosm of the artistic life of his country, and whose genius is still only secretly acknowledged, conducted his most audacious and memorable theatrical experiments.

---

[1] The first two holders of the post of People's Commissar for [Culture and] Education (the translation of the Russian word 'prosveshchenie', whose meaning includes culture and education, is problematic): for their details see Glossary.

[2] Evgeny Bagrationovich Vakhtangov (1883–1923), actor, director and drama teacher, pupil of Stanislavsky, was famous for his innovative work in the Moscow Arts Theatre in the early 1920s.

There occurred, before 1928, a vast ferment in Soviet thought, which during those early years was genuinely animated by the spirit of revolt against, and challenge to, the arts of the West, conceived as the last desperate struggle of capitalism, presently to be overthrown on the artistic as well as every other front by the strong, young, materialist, earthbound, proletarian culture, proud of its brutal simplicity and its crude and violent new vision of the world, which the Soviet Union, agonised but triumphant, was bringing to birth.

The herald and chief inspiring force of this new Jacobinism was the poet Mayakovsky, who, with his disciples, formed the famous LEF[1] association. While there may have been a great deal that was pretentious, counterfeit, coarse, exhibitionist, childish and merely silly during this period, there was also much that was brimming with life. It was not, as a rule, didactically Communist so much as anti-liberal, and had in that respect points of resemblance with pre-1914 Italian futurism. This was the period of the best work of such poets as the popular 'tribune' Mayakovsky, who, if he was not a great poet, was a radical literary innovator and emancipator of prodigious energy, force and, above all, influence; the age of Pasternak, Akhmatova (until her silence in 1923), Sel'vinsky, Aseev, Bagritsky, Mandel'shtam; of such novelists as Aleksey Tolstoy (who returned from Paris in the 1920s), Prishvin, Kataev, Zoshchenko, Pil'nyak, Babel', Il'f and Petrov; of the dramatist Bulgakov, of established literary critics and scholars like Tynyanov, Eikhenbaum, Tomashevsky, Shklovsky, Lerner, Chukovsky, Zhirmunsky, Leonid Grossman. The voices of such émigré writers as Bunin, Tsvetaeva, Khodasevich, Nabokov were heard only faintly. The emigration and return of Gorky is another story.

State control was absolute throughout. The only period of freedom during which no censorship existed in modern Russian history was from February to October 1917. In 1934 the Bolshevik regime tightened old methods by imposing several stages of supervision – first by the Writers' Union, then by the appropriate State-appointed commissar, finally by the Central Com-

---

[1] Short for 'Levyi front isskustva' (Left Front of Art).

mittee of the Communist Party. A literary 'line' was laid down by the Party: at first the notorious Proletkul't, which demanded collective work on Soviet themes by squads of proletarian writers; then the worship of Soviet or pre-Soviet heroes. Nevertheless, arresting and original artists were not, until 1937, always brought to heel by the omnipotent State; sometimes, if they were prepared to take sufficient risks, they might manage to convert the authorities to the value of an unorthodox approach (as the dramatist Bulgakov did); sometimes unorthodoxy, provided that it was not positively directed against the Soviet faith, was given some latitude of expression, as a not unwelcome seasoning, at times exceedingly sharp, of the flat daily fare of normal Soviet life (for example, the early, gay, malicious satires of Tynyanov, Kataev and, above all, Zoshchenko). This was not, of course, permitted to go far or occur too often, but the possibility of it was always present, and the genius of writers was to a certain extent stimulated by the very degree of ingenuity which they had to exercise in order to express unconventional ideas without breaking the framework of orthodoxy or incurring outright condemnation and punishment.

This continued for some time after Stalin's rise to power and the imposition of the new orthodoxy. Gorky died only in 1935; and as long as he was alive, some distinguished and interesting writers were to a certain degree shielded from excessive regimentation and persecution by his immense personal authority and prestige; he consciously played the role of 'the conscience of the Russian people' and continued the tradition of Lunacharsky (and even Trotsky) in protecting promising artists from the dead hand of official bureaucracy. In the field of official Marxism an intolerant and narrow 'dialectical materialism' did indeed hold sway, but it was a doctrine concerning which internal disputes were permitted, between, for example, the followers of Bukharin and the followers of the more pedantic Ryazanov or Deborin; between various brands of philosophical materialism; between those 'menshevisers' who saw Lenin as a direct disciple of Plekhanov, and those who stressed their differences.

Witch-hunts occurred; heresy, both on the right and the left, was continually being 'unmasked' with grisly consequences to

the convicted heretics; but the very ferocity of such ideological disputes, the uncertainty as to which side would be condemned to liquidation, communicated a certain grim life to the intellectual atmosphere, with the result that both creative and critical work during this period, while suffering from one-sidedness and exaggeration, was seldom dull, and indicated a state of continuing ferment in all spheres of thought and art. Well might the sympathetic observer of the Soviet scene compare such activity favourably with the slow decline of such of the older generation of émigré Russian writers in France as Vyacheslav Ivanov, Bal'mont, Merezhkovsky, Zinaida Gippius, Kuprin and others, though their literary technique was, at times, admitted, even in Moscow, to be often superior to that of a good many of the Soviet pioneers.

## 1937 TO THE PRESENT DAY

Then came the great débâcle which to every Soviet writer and artist is a kind of St Bartholomew's Eve – a dark night which few of them seem ever completely to forget, and which is scarcely ever today spoken of otherwise than in a nervous whisper. The Government, which evidently felt its foundations insecure, or feared a major war in, and possibly with, the West, struck at all supposedly 'doubtful' elements, and innumerable innocent and harmless persons besides, with a violence and a thoroughness to which the Spanish Inquisition and the Counter-Reformation alone offer remote parallels.

The great purges and trials of the years 1937 and 1938 altered the literary and artistic scene beyond all recognition. The number of writers and artists exiled or exterminated during this time – particularly during the Ezhov terror – was such that Russian literature and thought emerged in 1939 like an area devastated by war, with some splendid buildings still relatively intact, but standing solitary amid stretches of ruined and deserted country. Men of genius like Meyerhold the producer and Mandel'shtam the poet, and of talent like Babel', Pi'nyak, Yashvili, Tabidze, the then recently returned London émigré Prince D. S. Mirsky, the critic Averbakh (to take the best-known names alone) were

'repressed', that is, killed or done away with in one way or another. What occurred after that no one today seems to know. Not a trace of any of these writers and artists has been sighted by the outside world. There are rumours that some of them are still alive, like Dora Kaplan, who shot and wounded Lenin in 1918, or Meyerhold, who is said to be producing plays in the Kazakhstan capital Alma-Ata; but these seem to be circulated by the Soviet Government and are, almost certainly, quite false.[1] One of the British correspondents, whose sympathies were all too clear, tried to persuade me that Mirsky was alive and writing in Moscow incognito. It was obvious that he did not really believe this. Nor did I. The poetess Marina Tsvetaeva, who returned from Paris in 1939 and fell into official disfavour, committed suicide, probably early in 1942.[2] The rising young composer Shostakovich was criticised in 1937 so harshly, from a quarter so high, for 'formalism' and 'bourgeois decadence', that for two years he was neither performed nor mentioned, and then, having slowly and painfully repented, adopted a new style in closer accord with present-day official Soviet demands. He has on two occasions since then had to be called to order and to repent; so has Prokofiev. A handful of young writers unknown in the West, who are said to have showed promise during this period, have, so one was told, not been heard of since; they are unlikely to have survived, although one cannot always tell. Before this the poets Esenin and Mayakovsky had committed suicide. Their disillusionment with the regime is still officially denied. So it goes on.

The death of Gorky had removed the intellectuals' only powerful protector, and the last link with the earlier tradition of the relative freedom of Revolutionary art. The most eminent survivors of this period today sit silent and nervous for fear of committing some fatal sin against the Party line, which anyhow was none too clear during the critical years before the war, nor thereafter. Those to fare worst were the writers and authors in closest

[1] Dora (her given name was Fanya) Kaplan was indeed shot four days after her arrest, on 4 September 1918. Meyerhold was shot on 2 February 1940.

[2] In fact on 31 August 1941.

contact with Western Europe, that is, France and England, since the turning of Soviet foreign policy away from Litvinov's policy of collective security, and towards the isolationism symbolised by the Russo-German Pact, involved individuals regarded as links with Western countries in the general discredit of pro-Western policy.

Bending before authority exceeded all previously known bounds. Sometimes it came too late to save the heretic marked for destruction; in any case it left behind it painful and humiliating memories from which the survivors of this terror are never likely completely to recover. Ezhov's proscriptions, which sent many tens of thousands of intellectuals to their doom, had clearly, by 1938, gone too far even for internal security. A halt was finally called when Stalin made a speech in which he declared that the process of purification had been overdone. A breathing-space followed. The old national tradition re-acquired respectability; the classics were once again treated with respect, and some old street names replaced the Revolutionary nomenclature. The final formulation of faith, beginning with the constitution of 1936, was completed by the *Short History of the Communist Party* of 1938. The years 1938 to 1940, during which the Communist Party made even greater strides in the strengthening and centralisation of its power and authority – tight enough before this – remained, during the slow convalescence from the wounds of 1938, blank so far as the creative and critical arts were concerned.

## The Patriotic War

Then war broke out and the picture altered again. Everything was mobilised for war. Such authors of distinction as survived the Great Purge, and managed to preserve their liberty without bowing too low before the State, seemed to react to the great wave of genuine patriotic feeling if anything even more profoundly than the orthodox Soviet writers, but evidently had gone through too much to be capable of making their art the vehicle of direct expression of the national emotion. The best war poems of Pasternak and Akhmatova sprang from the most profound feel-

ing, but were too pure artistically to be considered as possessing adequate direct propaganda value, and were consequently mildly frowned upon by the literary mandarins of the Communist Party, who guide the fortunes of the official Writers' Union.

This disapproval, with undertones of doubt about his fundamental loyalty, did finally get under Pasternak's skin to so effective a degree that this most incorruptible of artists did produce a handful of pieces close to direct war propaganda which had been too obviously wrung out of him, sounded lame and unconvincing, and were criticised as weak and inadequate by the Party reviewers. Such *pièces d'occasion* as the *Pulkovo Meridian* by Vera Inber, and her war diary of the Leningrad blockade, and the more gifted work by Olga Berggolts, were better received.

But what did emerge, possibly somewhat to the surprise of both the authorities and the authors, was an uncommon rise in popularity with the soldiers at the fighting fronts of the least political and most purely personal lyrical verse by Pasternak (whose poetic genius no one has yet ventured to deny); of such wonderful poets as Akhmatova among the living, and Blok, Bely and even Bryusov, Sologub, Tsvetaeva and Mayakovsky among the (post-Revolutionary) dead. Unpublished works by the best of the living poets, circulated privately in manuscript to a few friends, and copied by hand, were passed to one another by soldiers at the front with the same touching zeal and deep feeling as Ehrenburg's eloquent leading articles in the Soviet daily press, or the favourite conformist patriotic novels of this period. Distinguished but hitherto somewhat suspect and lonely writers, especially Pasternak and Akhmatova, began to receive a flood of letters from the front quoting their published and unpublished works, and begging for autographs and confirmation of the authenticity of texts, some of which existed only in manuscript, and for the expression of their authors' attitudes to this or that problem.

This eventually could not fail to impress itself upon responsible Party leaders, and the official attitude towards such writers grew somewhat softer. It was as if their value as institutions of which the State might one day be proud began to be realised by

the bureaucrats of literature, and their status and personal security became improved in consequence. This is not likely to last, however: Akhmatova and Pasternak are not loved by the Party and its literary commissars. To be non-propagandist and survive you must be inconspicuous: Akhmatova and Pasternak are too obviously popular to escape suspicion.

## THE PRESENT

The more benevolent, if no less watchful, attitude of the official State censors has enabled the better thought of among the established writers to adjust themselves in what they plainly hope is a series of relatively secure niches; some have avowedly harnessed themselves, with varying degrees of conviction, into the service of the State, and declare that they conform as faithfully as they do, not because they must, but because they are true believers (as Aleksey Tolstoy did with his radical revision of his famous early novel *The Road to Golgotha*, which originally contained an English hero, and his play about Ivan the Terrible, which, in effect, is a justification of the purges). Others apply themselves to nice calculation of how much they can afford to give up to the demands of State propaganda, how much being left to personal integrity; yet others attempt to develop a friendly neutrality towards the State, not impinging, and hoping not to be impinged upon, careful to do nothing to offend, satisfied if they are suffered to live and work without reward or recognition.

The Party line has suffered a good many changes since its inception, and the writers and artists learn of its latest exigencies from the Central Committee of the Communist Party, which is ultimately responsible for its formulation, through various channels. The final directive is today officially produced by a member of the Politburo, Mikhail Suslov, who for this purpose replaced Georgy Aleksandrov. Aleksandrov was removed, so one is told, for writing a book in which Karl Marx was represented only as the greatest of philosophers, instead of someone different from and greater in kind than any philosopher – an insult, I suppose, rather similar to describing Galileo as the greatest of astrologers.

Suslov is responsible to the Party for propaganda and publicity; the members of the Writers' Union who adapt this to the needs of their colleagues are the Chairman and in particular the Secretary, a direct nominee of the Central Executive Committee of the Party, and often not a writer at all (thus the late Shcherbakov, a purely political figure, a powerful member of the Politburo at the time of his death in 1945, was at one time secretary of the Writers' Union).

When, as occasionally happens, reviewers of books or plays or other 'cultural phenomena' make mistakes, that is, stray from the Party's path in some particular, this is put right not merely by bringing the possible consequences of his errors home to the individual reviewer, but by publishing a kind of counter-review of the original review, pointing out its errors and laying down the authoritative 'line' about the original work under review. In some cases stronger action occurs. The last chairman was the old-fashioned but none too enterprising poet, Nikolay Tikhonov. He was ousted for permitting so-called pure literature to appear: and the politically totally committed Fadeev succeeded him.

Writers are generally considered as persons who need a good deal of watching, since they deal in the dangerous commodity of ideas, and are therefore fended off from private, individual contact with foreigners with greater care than the less intellectual professionals, such as actors, dancers and musicians, who are regarded as less susceptible to the power of ideas, and to that extent better insulated against disturbing influences from abroad. This distinction drawn by the security authorities seems fundamentally correct, since it is only by talking with writers and their friends that foreign visitors (for example, the author of this memorandum) have been able to obtain any degree of coherent insight, as opposed to brief and fitful glimpses, into the working of the Soviet system in the spheres of private and artistic life – other artists have largely been conditioned into automatic avoidance of interest in, let alone discussion of, such perilous topics. Known contact with foreigners does not in all cases lead to disgrace or persecution (although it is usually followed by sharp interrogation by the NKVD), but the more timorous among the writers, and particularly those who have

not thoroughly secured their position and become mouthpieces of the Party line, avoid discoverable individual meetings with foreigners – even with the Communists and fellow-travellers of proven loyalty who arrive on official Soviet-sponsored visits.

Having protected himself adequately against suspicion of any desire to follow after alien gods, the Soviet writer, whether imaginative or critical, must also make certain of the correct literary targets at any given moment. The Soviet Government cannot be accused of leaving him in any uncertainty in this matter. Western 'values', which unless avowedly anti-Soviet or considered reactionary, used at one time not to be thought too disreputable and were left alone, largely glossed over in silence, are once again under attack. The classical authors alone seem to be beyond political criticism. The heyday of earlier Marxist criticism, when Shakespeare or Dante – as well as Pushkin and Gogol and, of course, Dostoevsky – were condemned as enemies of popular culture or of the fight for freedom, is today regarded with distaste as a childish aberration. The great Russian writers, including such political reactionaries as Dostoevsky and Leskov, were, at any rate by 1945, back on their pedestals and once more objects of admiration and study. This applies to a large degree to foreign classics, even though such authors as Jack London, Upton Sinclair and J. B. Priestley (as well as such, to me, little-known figures as James Aldridge and Walter Greenwood) enter the pantheon on political rather than literary merit.

The main burden of Russian critical writing is at present directed to the rehabilitation of everything Russian, particularly in the region of abstract thought, which is represented as owing as little as possible to the West; and to the glorification of Russian (and occasionally non-Russian) scientific and artistic pioneers active within the historic limits of the Russian empire. This is modified by the fact that lately there have occurred signs of awareness that the Marxist approach was in danger of being abandoned too far in favour of excessive wartime Russian nationalism, which, if it spread, as it showed signs of doing, into regional nationalism, would act as a disruptive force. Consequently historians like Tarlé and others – and particularly Tatar,

Bashkir, Kazakh and other ethnic minority historians – have been officially reproved for a non-Marxist deviation towards nationalism and regionalism.

The greatest binding force of the Union, apart from historic association, is still Marxist, or rather 'Leninist-Stalinist', orthodoxy, but above all the Communist Party – the healer of the wounds inflicted by Russia on her non-Russian subjects in Tsarist days. Hence the paramount need for re-emphasising the central egalitarian Marxist doctrine, and the fight against any tendency to fall into easy nationalism. The greatest attack of all was launched on everything German; the origins of Marx and Engels could hardly be denied, but Hegel, whom earlier Marxists, including Lenin, naturally enough regarded with the piety due to a direct ancestor, is today, with other German thinkers and historians of the Romantic period, subjected to violent assaults as a Fascist in embryo and pan-German, from whom little if anything is to be learnt, and whose influence in Russian thought, which can scarcely be altogether concealed, has been either superfluous or deleterious.

By comparison, French and English thinkers get off more favourably, and the careful Soviet author, both historian and littérateur, may still continue to permit himself to offer a little cautious homage to the anti-clerical and 'anti-mystical' empiricists, materialists and rationalists of the Anglo-French philosophical and scientific tradition.

After every care has been exercised, every step taken to avert official disapproval, the most distinguished among the older authors still find themselves in a peculiar condition of being at once objects of adulation to their readers, and half-admiring, half-suspicious toleration to the authorities; looked up to, but imperfectly understood by, the younger generation of writers; a small and decimated but still distinguished Parnassus, oddly insulated, living on memories of Europe, particularly of France and Germany, proud of the defeat of Fascism by the victorious armies of their country, and comforted by the growing admiration and absorbed attention of the young. Thus the poet Boris Pasternak told me that when he reads his poetry in public, and occasionally

halts for a word, there are always at least a dozen listeners present who prompt him at once and from memory, and could clearly carry on for as long as may be required.

Indeed there is no doubt that, for whatever reason – whether from innate purity of taste, or from the absence of cheap or trivial writing to corrupt it – there probably exists no country today where poetry, old and new, good and indifferent, is sold in such quantities and read so avidly as it is in the Soviet Union. This naturally cannot fail to act as a powerful stimulus to critics and poets alike. In Russia alone does poetry literally pay; a successful poet is endowed by the State, and is relatively better off than, for example, an average Soviet civil servant. Playwrights are often exceedingly prosperous. If a rise in quantity, as Hegel taught, leads to a change in quality, the literary future of the Soviet Union ought to be brighter than that of any other country; and indeed there is perhaps evidence for this proposition better and more solid than a priori reasoning by a German metaphysician, discredited even in the Russia whose thought he affected for so long and so disastrously.

The work of the older writers, with roots in the past, is naturally affected by the political uncertainties by which they are surrounded. Some break a total silence very occasionally to write a late lyric, or a critical article, and otherwise subsist in timid silence on pensions, in houses in town or country with which the State, in cases of real eminence, provides them. Some have taken to a politically inoffensive medium, such as children's or nonsense verse; Chukovsky's children's rhymes, for example, are nonsense verse of genius, and bear comparison with Edward Lear. Prishvin continues to write what seem to me excellent animal stories. Another avenue of escape is the art of translation, into which much splendid Russian talent at present flows, as, indeed, it always has. It is a slightly odd thought that in no country are these innocent and unpolitical arts practised with greater perfection. Lately there has been a drive against them too.

The high standard of translation is, of course, due not merely to its attraction as a distinguished vehicle of escape from politically dangerous views, but also to the tradition of highly artistic rendering from foreign tongues, which Russia, a country intellec-

tually long dependent on foreign literature in the past, developed in the nineteenth century. The result is that persons of exceptional sensibility and literary merit have translated the great classical works of the West, and hack translations (which the majority of English versions of Russian still are) are virtually unknown in Russia. In part, such concentration on translation is due also to the emphasis at present laid on the life of outlying regions of the Soviet Union, and the consequent political premium put upon translations from such fashionable languages as Ukrainian, Georgian, Armenian, Uzbek, Tadjik, at which some of the most gifted Russian authors have tried their hand with brilliant effect and much resultant inter-regional good will. Indeed, this will probably turn out to be the most valuable single contribution which Stalin's personal influence will have made to the development of Russian letters.

As for fiction, the commonest path is that taken by such steady, irretrievably second-rate novelists as Fedin, Kataev, Gladkov, Leonov, Sergeev-Tsensky, Fadeev and such playwrights as Pogodin and (the recently deceased) Trenev, some of whom look back on variegated personal Revolutionary pasts.[1] All of them today make their bow in the manner prescribed by their political directors, and in general produce work of high mediocrity modelled on late nineteenth-century archetypes, written with professional craftsmanship, long, competent, politically *bien pensant*; earnest, at times readable, but on the whole undistinguished. The purges of 1937 and 1938 appear to have stamped out that blazing fire of modern Russian art to which the Revolution of 1917 had added fuel and which the recent war could scarcely have extinguished so swiftly if political causes had not begun to do so earlier.

Over the entire scene of Russian literature there broods a curious air of total stillness, with not a breath of wind to ruffle the waters. It may be that this is the calm before the next great tidal wave, but there are few visible signs as yet of anything new or original about to be born in the Soviet Union. There is no satiety

---

[1] These writers, now largely forgotten and unread, were among the most successful and widely read exponents of socialist realism (for details see Glossary).

with the old and no demand for new experience to stimulate a jaded palate. The Russian public is less blasé than any other in Europe, and the cognoscenti, so far as there are any, are only too well pleased if there are no worrying political clouds on the horizon, and they are left in peace. The climate is not propitious to intellectual or artistic enterprise; and the authorities, who would eagerly welcome invention and discovery in the technological field, do not seem aware of the indivisibility of the freedom of enquiry, which cannot be kept within prescribed frontiers. Invention seems for the present to have been sacrificed to security; unless and until this changes, Russia is scarcely likely to make a crucial contribution, at any rate in the field of humane arts and studies.

And, it may be asked, the younger writers? No foreign observer of the Russian literary scene can fail to be struck by the gap between the older writers, loyal but melancholy figures of no possible danger to the stability of this, to all appearance, thoroughly stable regime, and the immensely prolific younger writers, who appear to write faster than thought itself (perhaps because so many of them are free from it), and rehearse the same patterns and formulae so tirelessly and with such apparent sincerity and vigour that it is scarcely thinkable that they can ever have been assailed by any real doubts, either as artists or as human beings.

Perhaps the immediate past explains this. The purges cleared the literary ground, and the war provided the new subject and the mood; there sprang into being a brood of writers, facile, naïve and copious, varying from crude and wooden orthodoxy to considerable technical skill, capable at times of moving, at others of genuinely gay, and often vivid, journalistic reportage. This applies to prose and verse, novels and plays. The most successful and most representative figure of this type is the journalist, playwright and poet Konstantin Simonov, who has poured out a flood of work of inferior quality but impeccably orthodox sentiment, acclaiming the right type of Soviet hero, brave, puritanical, simple, noble, altruistic, entirely devoted to the service of his country. Behind Simonov there are other authors of the same genre; authors of novels dealing with exploits in kolkhozes, fac-

tories or at the front; writers of patriotic doggerel or of plays which guy the capitalist world or the old and discredited liberal culture of Russia itself, in contrast with the simple, now wholly standardised, type of tough, hearty, capable, resolute, single-minded young engineers or political commissars ('engineers of human souls'), or army commanders, shy and manly lovers, sparing of words, doers of mighty deeds, 'Stalin's eagles', flanked by passionately patriotic, utterly fearless, morally pure, heroic young women, upon whom the success of all five-year plans ultimately depends.

The older authors do not conceal their opinion of the value of this kind of conscientious but commonplace literary mass-production, related to literature much as posters are to serious art. Nor would they be as critical as they are if, side by side with the inevitable mushroom growth of such work, inspired by, and directly ancillary to, the needs of the State, there were also something profounder and more original to be found among the younger writers – among those, let us say, who are under forty. They point out that there is intrinsically no reason why contemporary Soviet life should not generate genuine and serious 'socialist realism' – after all, Sholokhov's *Quiet Don*, dealing as it did with Cossacks and peasants during the civil war, was on all sides recognised as a genuine, if sometimes dull, lumbering and overweighted, work of imagination.

The obvious criticism which these older writers urge – and such 'self-criticism' is allowed to appear in print – is that out of shallow facility and the easy orthodoxy of standardised hero-worship no genuine work of art can ever be born; that the war heroes themselves have won the right to subtler and less hackneyed analysis; that the experience of the war is a profound national experience which only a more intense, sensitive and scrupulous art can adequately express, and that the majority of the war novels now published are crude travesties and a hideous insult to the soldiers and civilians whose ordeal they purport to describe; finally (this is never said in print) that the inner conflict which alone makes an artist has been too easily resolved by the over-simple rules of an artificially flattened political schema, which allows no doubts about ultimate purpose, and not much

disagreement about means, and which has, perhaps as a result of the purges and their physical and moral consequences, so far failed to create its own artistic canons, standards in the light of which something no less strictly conformist but also no less devout and profound than the religious art of the Middle Ages could evolve in Russia today. Nor do I see much hope of that at the present time. The cry by the poet Sel'vinsky for socialist romanticism[1] – if socialist realism, then why not socialist romanticism? – was ruthlessly suppressed.

Meanwhile the financial rewards of these fashionable younger authors, unaffected as they are by the strictures of the critics, entitle them to be considered the equivalent of best-sellers in Western countries; no literal equivalent exists since fiction and poetry, good or bad, is sold and distributed immediately on publication – such is the hunger of the public and the inadequacy of the supply. The subjects of historical novels, since *romans de moeurs* are scarcely safe, tend, apart from war and post-war propaganda themes, to be the lives of such officially approved heroes from the Russian past as Tsars Ivan IV and Peter I, soldiers and sailors like Suvorov, Kutuzov, Nakhimov and Makarov, honest patriots and true Russians, too often plagued and frustrated by the intrigues of sycophantic courtiers and disloyal noblemen. Their character and exploits offer opportunities of combining a pleasantly romantic and patriotic historical background with political or social sermons only too clearly applicable to contemporary needs.

This fashion was not indeed begun, but was given its strongest fillip, by the late Aleksey Tolstoy (he died this year [1945]), who alone, perhaps, had the makings of, and the ambition to be, the Virgil of the new empire which had excited his rich imagination and brought his remarkable literary gift into play.

The same gap between the young and old is perceptible in the other arts, in the theatre, in music, in the ballet. Whatever has

---

[1]More accurately 'socialist symbolism', which would have allowed writers to treat a wider range of subject-matter – beyond tractors and blast furnaces – without compromising their political loyalty.

grown without a definite break from a rich past and leans on a pre-Revolutionary tradition has, by firmly clinging to such old and tried supports, managed to preserve its standards into the present. Thus the Moscow Arts Theatre, while universally acknowledged to have declined from the extraordinary level of its golden age, when Chekhov and Gorky wrote for it, nevertheless preserves a remarkable standard of individual acting and of inspired ensemble playing which rightly continues to make it the envy of the world. Its repertoire, since the post-1937 era, is confined either to old plays or to such tame new, conformist pieces as have relatively little character of their own, and simply act as vehicles in which gifted naturalistic actors can exhibit their superb, old-fashioned skills; what the public remembers is for the most part the acting and not the play. Similarly the Maly (Little) Theatre continues to give admirable performances of Ostrovsky's comedies, which were its mainstay in the nineteenth century; the acting of plays attempted since the Revolution, whether classical or modern, at the Maly tends too often to sink to the level of the repertory companies directed by Ben Greet or Frank Benson. One or two of the smaller Moscow theatres perform classical plays with verve and imagination, for example Ermolova's theatre and the Transport Theatre in Moscow, and one or two of the little theatres in Leningrad. The best performances given even in these theatres are of classical pieces; for example, Goldoni, Sheridan, Scribe; modern plays go less well, not so much because of old-fashioned methods of acting, as because of the inevitable tameness of the material itself.

As for opera and ballet, wherever past tradition exists to guide it, it acquits itself honourably, if dully. When something new is put on, for example the new ballet *Gayaneh* by the Armenian composer Khachaturyan, playing in Leningrad this year, it is capable of displaying exuberance and temperament, which disarm the spectator by the gusto and delight in the art of the dancers. But it is also, particularly in Moscow, capable of sinking to depths of vulgarity of décor and production (and of music too) which can scarcely ever have been surpassed even in Paris under the Second Empire; the inspiration of the scenes of clumsily

heaped-up opulence with which the Bolshoy Theatre in Moscow is so lavish derives at least as much from the tawdry splendours of the early Hollywood of ten and even twenty years ago, as from anything conceived in Offenbach's day; and such crude display is made to seem all the more grotesque and inappropriate by the individual genius of a truly great lyrical and dramatic dancer like Ulanova, or of such impeccable new virtuosi as Dudinskaya, Lepeshinskaya and the ageing Semenova, Preobrazhensky, Sergeev and Ermolaev. In either case it lacks the fusion of undeviatingly precise, inexorable discipline with imaginative originality and wide range, and that combination of intensity, lyricism and elegance which had raised the Russian ballet to its former unattainable height.

There are still fewer signs of new life in the two great opera houses of Moscow and Leningrad, which confine themselves to a highly stereotyped repertory of the best-known Russian and Italian works, varied by occasional performances of, for example, *Carmen*. Minor theatres, in search of politically innocent amusement, offer their clients operettas by Offenbach, Lecocq and Hervé, performed with more gusto than finish, but vastly welcomed as a contrast with the drab monotony of daily Soviet life. The contrast between age and youth is again noticeably present, not so much in the ballet (which could not exist without a perpetual recruitment of young dancers), as on the dramatic stage, where few, if any, outstanding actors or actresses have come forward during the last ten years. The audiences seem clearly aware of this, and whenever I hinted at this to my anonymous neighbours in the Moscow theatres, it was invariably assented to so rapidly that it must be a very obvious commonplace. Such casual neighbours in the theatre almost invariably expand dolefully on the regrettable absence among the younger people of dramatic talent, and even more of the right sensibility – with which the older actors, still on the stage (some whose careers go back to the early years of the century), are so richly endowed – and one or two have wondered whether the theatres of the West do not produce better young actors than the Soviet Union. Perhaps 'the tradition is not so rigid and oppressive there'. Even the Arts Theatre seems to have stopped dead in technique and

feeling – or else has been forced to go back to the days before the First World War.

This combination of discouragement of all innovation – the name of the purged producer Meyerhold is scarcely spoken aloud – together with a considerable encouragement of the stage as such is bound, unless something occurs to interrupt the process, to lead in the relatively near future to a widening chasm between accomplished but unreal, and contemporary but commonplace and provincial, styles of acting. On the other side it must be said that the childlike eagerness and enthusiasm of Soviet readers and Soviet theatrical audiences is probably without parallel in the world. The existence of State-subsidised theatres and opera, as well as of regional publishing houses, throughout the Soviet Union is not merely a part of a bureaucratic plan, but responds to a very genuine and insufficiently satisfied popular demand. The vast increase in literacy under the stimulus provided by the earlier period when Marxism was in ferment, as well as the immense circulation of Russian and to some degree of foreign classics, particularly in translation into the various languages of the 'nationalities' of the USSR, has created a public the responsiveness of which should be the envy of Western writers and dramatists. The crowded bookshops with their understocked shelves, the eager interest displayed by the Government employees who run them, the fact that even such newspapers as *Pravda* and *Izvestiya* are sold out within a few minutes of their rare appearance in the kiosks, is further evidence of this hunger.

If, therefore, political control were to alter at the top, and greater freedom of artistic expression were permitted, there is no reason why, in a society so hungry for productive activity, and in a nation still so eager for experience, still so young and so enchanted by everything that seems to be new or even true, and above all endowed with a prodigious vitality which can carry off absurdities fatal to a thinner culture, a magnificent creative art should not one day once again spring into life.

To Western observers the reaction of Soviet audiences to classical plays may seem curiously naïve; when, for example, a play by Shakespeare or by Griboedov is performed, the audience is apt to react to the action on the stage as if the play was drawn from

contemporary life; lines spoken by the actors meet with murmurs of approval or disapproval, and the excitement generated is wonderfully direct and spontaneous. These are perhaps not far removed from the kind of popular audiences for which Euripides and Shakespeare wrote, and the fact that soldiers at the front have so often compared their leaders with the stock heroes of patriotic Soviet novels, that fiction is to them, as often as not, part of the general pattern of daily life, seems to show that they still look on the world with the shrewd imagination and unspoilt eye of intelligent children, the ideal public of the novelist, the dramatist and the poet. This fertile soil, still so little ploughed, in which even the poorest seed seems to sprout so quickly and so generously, can scarcely fail to inspire the artist, and it is probable that it is the absence of precisely this popular response that has made the art of England and France often seem mannered, anaemic and artificial.

As things are, the contrast between the extraordinary freshness and receptivity, critical and uncritical, of the Soviet appetite, and the inferiority of the pabulum provided, is the most striking phenomenon of Soviet culture today.

Soviet writers in articles and *feuilletons* love to emphasise the extraordinary enthusiasm with which the public has received this or that book, this or that film or play, and, indeed, what they say is largely true; but two aspects of the case are, not unnaturally, never mentioned. The first is that, despite all official propaganda, strongly felt and perhaps almost instinctive discrimination between good and bad art – for example, between nineteenth-century classics and the very few surviving literary masters on the one hand, and routine patriotic literature on the other – has not been wholly obliterated, and standardisation of taste does not, so far at least, seem to have occurred on the scale which might have been expected, and which the best members of the Soviet intelligentsia (such as survive) still fear.

The second qualification is the continued existence, although under difficult conditions and in dwindling numbers, of a real nucleus of ageing but articulate intellectuals, deeply civilised, sensitive, fastidious and not to be deceived, who have preserved unimpaired the high critical standards, in certain respects the

purest and most exacting in the world, of the pre-Revolutionary Russian intelligentsia. These people, now to be found in politically unimportant Government posts, universities, publishing houses, if not positively catered for by the State, are not vastly harried either; they tend to be gloomy or sardonic because they see few successors to themselves in the succeeding generation, and this is said to be mainly due to the fact that such young men or women as show any signs of independence and originality are ruthlessly uprooted and dispersed in the north or central Asiatic regions, as an element disturbing to society.

A good many of the young who showed signs of talent as independent artists and critics are said to have been swept away in 1937–8 ('as with a broom', as a young Russian said to me at a railway station, where he felt unobserved). Nevertheless, a few such are still to be found in universities or among translators from foreign languages or ballet librettists (for whom there is great demand), but it is difficult to estimate whether by themselves they are sufficient to carry on the vigorous intellectual life upon which, for example, Trotsky and Lunacharsky used to lay such stress, and for which their successors seem to care so little. The older intellectuals, when they speak with candour, make no bones about the atmosphere in which they live; most of them still belong to the class of what are known as 'the scared', that is, those who have not fully recovered from the nightmare of the great purges – but a few are showing signs of emerging once again into the light of day. They point out that official control, while no longer as fiercely devoted to heresy-hunts as before, is so complete in all spheres of art and life, and the caution exercised by the timid and largely ignorant bureaucrats in control of art and literature so extreme, that whatever is new and original among the ambitious young naturally tends to flow into non-artistic channels – the natural sciences or the technological disciplines – where more encouragement to progress and less fear of the unusual obtains.

As for other arts, there was never much to be said for or about Russian painting – today that which is exhibited seems to have fallen below the lowest standards of nineteenth-century Russian naturalism or impressionism, which did at least possess

the merit of illustrating, with a great deal of life, social and polit-
ical conflicts and the general ideals of the time. As for pre- and
post-Revolutionary modernism, which continued and flowered
during the early Soviet period – of that not a whisper, so far as I
could tell.

The condition of music is not very different. Apart from the
complicated cases of Prokofiev and Shostakovich (political pres-
sure upon the latter seems scarcely to have improved the style of
his work, although there may well be vigorous disagreement
about this – and he is still young), either it is again largely a dull
academic reproduction of the traditional 'Slav' or 'sweet'
Tchaikovsky–Rachmaninov pattern, now worn very thin (as in
the case of the endlessly fertile Myaskovsky and the academic
Glier), or it has taken to lively, shallow and occasionally skilful,
at times even brilliantly entertaining, exploitation of the folk song
of the constituent republics of the USSR, along the simplest pos-
sible lines – perhaps, to put it at its lowest, with an ultimate view
to possible performances by balalaika orchestras. Even such
moderately competent composers as Shebalin and Kabalevsky
have taken this line of least resistance, and have, with their imita-
tors, become monotonous and tirelessly productive purveyors of
routine music of remorseless mediocrity.

Architecture in its turn is engaged either in the admirably
done restoration of old buildings and occasional supplementa-
tion of these by competently executed pastiche, or in the erec-
tion of vast, dark, bleak buildings, repulsive even by the worst
Western standards. The cinema alone shows signs of genuine life,
although the golden age of the Soviet film, when it was genuinely
Revolutionary in inspiration and encouraged experiment, seems,
with some notable exceptions (for example Eisenstein and his
disciples, still active), to have yielded to something cruder and
more commonplace.

In general, intellectuals still seem haunted by too many fresh
memories of the period of purges succeeded by rumours of war,
succeeded by war and famine and devastation; regret as they
might the flatness of the scene, the prospect of a new 'revolution-
ary situation', however stimulating to art, could scarcely be wel-
come to human beings who have lived through more than even

24

the normal Russian share of moral and physical suffering. Consequently there is a kind of placid and somewhat defeatist acceptance of the present situation among most of the intellectuals. There is little fight left even in the most rebellious and individualistic; Soviet reality is too recalcitrant, political obligation too oppressive, moral issues too uncertain, and the compensations, material and moral, for conformity too irresistible. The intellectual of recognised merit is materially secure; he or she enjoys the admiration and fidelity of a vast public; his or her status is dignified; and if the majority long, with an intensity not to be described, to visit Western countries (of whose mental and spiritual life they often entertain the most exaggerated notions), and complain that 'things are screwed up too tight in this country', some, and by no means the least distinguished, tend to say that State control has its positive aspects as well. While it hems in creative artists to an extent unparalleled even in Russian history, it does, a distinguished children's writer said to me, give the artist the feeling that the State and the community in general are, at any rate, greatly interested in his work, that the artist is regarded as an important person whose behaviour matters a very great deal, that his development on the right lines is a crucial responsibility both of himself and of his ideological directors, and that this is, despite all the terror and slavery and the humiliation, a far greater stimulus to him than the relative neglect of his brother artists in bourgeois countries.

Doubtless there is something in that, and certainly art has, historically, flourished under despotism. It may be a particularly unrealistic moral fallacy, so long as glory and high position are the rewards of success, that no form of intellectual or artistic genius can flourish in confinement. But facts, in this case, speak more loudly than theory. Contemporary Soviet culture is not marching with its old firm, confident or even hopeful step; there is a sense of emptiness, a total absence of winds or currents, and one of the symptoms of this is the fact that creative talent is so easily diverted into such media as the popularisation and the study, sometimes both scholarly and imaginative, of the 'national' cultures of the constituent republics, particularly those in Central Asia. It may be that this is merely a trough between high crests, a

temporary period of weariness and mechanical behaviour after too much effort spent on crushing the internal and external enemies of the regime. Perhaps. Certainly there is today not a ripple on the ideological surface. There are appeals to cease reading the Germans, to cultivate national Soviet (and not local or regional) pride, above all to cease to uncover non-Russian origins of Russian institutions or alien sources of Russian thought; to return to orthodox Leninism–Stalinism, and to abstain from the vagaries of non-Marxist patriotism, which luxuriated during the war; but there is nothing remotely resembling the fierce, often crude but still sometimes profoundly and passionately felt ideological Marxist controversies of, say, Bukharin's lifetime.

Yet this account would be misleading if it did not include the fact that, despite the difficult and even desperate situation in which persons of independent temper and education at times find themselves in Russia, they are capable of a degree of gaiety, intellectual as well as social, and of enthusiastic interest in their internal and external affairs, combined with an extravagant and often delicate sense of the ridiculous, which makes life not merely bearable to them but worthwhile; and makes their bearing and their conversation both dignified and delightful to the foreign visitor.

Certainly the present aspect of the Soviet artistic and intellectual scene suggests that the initial great impulse is over, and that it may be a considerable time before anything new or arresting in the realm of ideas, as opposed to steady competence and solid achievement firmly set by authority within the framework of established tradition, is likely to emerge from the USSR. The old Russia, the condition of which preoccupied and indeed obsessed her writers, was, in a certain obvious sense, an Athenian society in which a small élite, endowed with a combination of remarkable intellectual and moral qualities, rare taste and an unparalleled sweep of imagination, was supported by a dark mass of idle, feckless, semi-barbarous helots, about whom much was said, but, as Marxists and other dissidents justly observed, exceedingly little was known, least of all by the men of good will who talked most about them and, as they supposed, to them and for their benefit.

look more pathetically tattered than on the cruder and more corn-fed inhabitants of Moscow. The streets are a good deal emptier than in Moscow, save the Nevsky (the main thorough-fare), which at times is as crowded as the Okhotny Ryad in Moscow; the trolley-buses are, as everywhere in the Soviet Union, filled to overflowing. As for trams, they present a gro-tesque appearance, crawling slowly like gigantic disabled wasps, covered with human barnacles, some of whom tend inevitably to be knocked off by persons attempting to get on or off, and then with loud imprecations and groans hoist and squeeze themselves back on to their very inadequate footholds. In consequence trams are frighteningly close to being literal death-traps, as I al-most discovered to my cost. Even at 4 a.m. and 7.30 a.m. I found all seats occupied.

More persons are said to be arriving from the country in Len-ingrad every day, and the housing problem, although perhaps not quite as acute as in Moscow, is grim enough. Rooms – at any rate those inhabited by the writers I visited – are at once handsomer and emptier than their equivalents in Moscow, the former because Leningrad in general is a better-built city than the more provincial Moscow, the latter because, so I was told, a great deal of furniture, some of it old and beautiful, was used for fuel dur-ing the blockade, and there is little likelihood of early replace-ment. Fuel is conspicuously short in Leningrad still; the Astoria Hotel, not to speak of public museums and galleries like the Hermitage, is not adequately heated, and Miss Tripp[1] found that in one scientific institute there was no heating at all provided in the library, and that such warmth as existed was to be found in two small rooms, yielded by tiny improvised stoves lit by the librarians themselves each morning. Miss Tripp obtained the impression that private individuals could get logs for their stoves only in exchange for bread rations or such belongings as they

---

[1] Brenda Muriel Howard Tripp (b. 1906), British Council representative in the Soviet Union (arranging exchange of non-military scientific articles with the Academy of Sciences), was formally a FO cultural attaché with diplomatic status, since the British Council was not officially allowed to function in the Soviet Union at that time.

could sell in the market. Prices appeared considerably lower than those in Moscow (despite rumours to the contrary), from carpets and grand pianos in the Commission shops, and second-hand books (which cost approximately one-third of their price in Moscow), to carrots and sunflower seeds in the market on Vasil'evsky Island.

As for the outskirts, I was informed that Tsarskoe Selo (referred to mostly as 'Pushkin' by Intourist guides) and Peterhof were both still in ruins, Gatchina still gutted; and transport to Pavlovsk, which is a mass of destruction, seemed difficult. At any rate my own suggestion of a visit there was regarded as quite impracticable: 'The trains are very bad and it is very far', though it is only a very few miles beyond Tsarskoe Selo. The poetess Vera Inber said on a later occasion that the Pavlovsk palaces were being very rapidly restored and would be finished by New Year. My suggestion about visiting Oranienbaum was even less well received and I therefore dropped the subject.

Despite the Intourist lady's open scepticism about the quality of the performances, I saw *Ivan Susanin* at the Mariinsky Theatre, now back in its traditional blue and gold; the opera was more poorly sung and acted than anything at the Bolshoy Theatre in Moscow. The orchestra scores still called it *Life for the Tsar* and this was remarked sardonically by my Red Army neighbour. The Leningrad ballet is, however, a notable one. *Sleeping Beauty*, which I saw with Miss Tripp, and *Gayaneh*, an Armenian ballet by the popular composer Aram Khachaturyan, which I saw with Miss Tripp and Mr Randolph Churchill, were superior to the usual Moscow performances, particularly *Gayaneh*, the libretto of which is a fairly normal version of the orthodox kolkhoz–Boy-Scout morality play, brought to life by a series of national dances of the Caucasian and Caspian peoples, danced with very uncommon spirit and skill. This contrasted with the dull pomp and routine competence with which even Tchaikovsky ballets are performed in Russia nowadays, and is rightly put forward by Leningrad today as one of its major claims to fruitful artistic activity.

There is a good deal of wounded *amour propre* about Leningrad, a coldly handsome and once arrogant old capital, now

viewed as something of a back number by the Moscow *arrivistes*, and responding with sharp but not altogether self-confident disdain. People appear poorer and less cared for than in Moscow; the writers I saw looked less prosperous, and their appearance and general tone was sadder and more genteel and weary than that of their Moscow colleagues. On the other hand life seems politically easier. I was not, so far as I could tell, followed by anyone in Leningrad, and contact with Soviet citizens seemed less difficult than in Moscow. During three long evenings which I was permitted to spend among writers, occasionally tête-à-tête, the most timorous among them told me that he was most careful to avoid foreign contacts in Moscow, and generally to exercise a degree of caution not called for anywhere else, for example in Leningrad. I met these writers through the kind offices of the manager of the Writers' Bookshop in the Nevsky, a ripe character who deserves a few words to himself.[1]

Gennady Moiseevich Rakhlin is a small, thin, gay, baldish, red-haired Jew, noisy, shrewd, immensely and demonstratively affable, and probably the best-informed, best-read and most enterprising bookseller in the Soviet Union. Although, like other managers of State bookshops, he makes no official commission on his sales, and says that he subsists entirely on his official salary, his interest in and passion to promote the sale of books is at least as intense as that of any bookseller in the Western world. As the manager of the two most important bookshops in Leningrad, he is the official dictator of book prices in the city, and is evidently able to get books from other shops at very short notice, and thus to supply the needs of his clients more efficiently than any other known agent. Having certain vaguely romantic literary ambitions, founded on the memory of the famous booksellers of the nineteenth century who acted at once as the publishers, distributors and patrons of literature – his own bookshop is on the site of Smirdin's famous establishment – he has converted one of the rooms in his bookshop into a kind of club for writers and other favoured visitors, and in this room, which

---

[1] Rakhlin was almost certainly an agent of the NKGB (later the KGB), Anatoly Naiman informs me.

Miss Tripp and I were kindly invited to frequent, I was enabled not only to purchase books with a degree of comfort unknown in Moscow, but to make the acquaintance of several well-known literary persons, such as Zoshchenko, Akhmatova, Orlov, Dudin. Whenever I called, there were some three or four people in the room – artists, academic persons, writers – ostensibly looking round the bookshelves, but, as they very rarely carried anything away, perhaps more anxious to meet their friends in a warm room during the winter weather than to make any purchases. Conversation ran easily and freely in this little salon on literary, academic and even political subjects, and it was as the result of an acquaintance formed there that I visited an eminent literary personage[1] at home, and there met other members of the Leningrad intelligentsia. Rakhlin himself took a lively part in these conversations, though it was quite evident that his clients did not look upon him as an intellectual equal, but rather as an exceedingly capable literary factotum (which he is) with whom it was a good thing to keep in, since he acted as a kind of general Leningrad Figaro, procured theatre tickets, arranged lectures, gave monthly literary suppers, carried intelligence, disseminated gossip, and in general performed innumerable small services which made life more interesting, agreeable and indeed tolerable.

Rakhlin, who spoke of his frequent and lavish entertainment in Moscow by Mr Lawrence and Mr Reavey[2] with great gratitude and pleasure, seemed most anxious to continue contacts of this type with members of the British Embassy, and spoke with pride of the number of books which he had succeeded in selling to British and American officials and journalists since 1942. He did display a certain social sensitiveness on the subject and complained, with bitterness, of a British journalist who had made a disparaging reference to him in a recent book, which he thought uncalled for and unjust. He spoke of his plans for opening a bookshop in Moscow with at least five rooms, one of which

[1] Anna Akhmatova.

[2] (Later Sir) John Lawrence, press attaché, and George Reavey, translator from Russian.

would be devoted to the foreign colony, whence his foreign buyers would be able to circulate through the other rooms and thus perhaps meet distinguished Muscovites with similar interests. He seemed totally unaware of the kind of difficulties which seemed likely to be put in the way of such a project for promoting easier contact between foreigners and Soviet citizens, and indeed such unawareness of the degree of segregation in Moscow seemed to emerge from the conversations of most of the Leningrad writers with whom I spoke.

As Mr Randolph Churchill expressed a desire to see the 'inside of a Soviet home', which he had not succeeded in doing in Moscow, I asked Mr Rakhlin, who happened to be in bed with a cold, whether he would care to be visited by Mr Churchill and talk to him about his experiences during the blockade, on which he is very interesting. Rakhlin seemed to welcome the suggestion and Mr Churchill and I visited him on 16 November at about 3 o'clock in the afternoon. Rakhlin was in bed but talked with irrepressible vivacity about himself and the blockade, and answered all Mr Churchill's questions with great readiness and ease. His wife presently entertained us handsomely with vodka and a solid meal of fish and chicken. The flat, which is off the Nevsky, consisted of three rooms; it was small and gloomily but not uncomfortably furnished, and was approximately such as might have been found in Clerkenwell or Islington, though very much barer, furnished with the heavy German furniture of the 1880s and '90s common in Russia, with no bric-à-brac of any kind. Rakhlin spoke of the days during the siege when 125 grams of bread and no other food was the maximum and total ration allowed civilians, and of the fact that although a great many books were sold to him at that period by families of the dead and evacuated, his customers were too feeble for lack of food to be able to carry away heavy books, and chose either thin volumes or tore chapters out of novels or histories to carry away separately through the frozen streets. He gave gruesome details of the difficulties of burial of the dead, and a very graphic account of the taste of carpenters' glue, which he used to dilute with a little cold water to drink as a soup.

Although stories have reached Moscow that Popkov[1] and not Zhdanov was regarded by the citizens as the saviour of Leningrad, Rakhlin confirmed the general view that Zhdanov was regarded as having been, more than any other man, responsible for keeping up morale in the city, and said that without Zhdanov's convoys across the frozen Lake Ladoga, he, Rakhlin, could not have saved the life of his old mother, who had miraculously survived. Old people and children died in their thousands during this period, everyone assured us, the total number of dead from hunger alone being somewhere in the neighbourhood of 200,000 to 300,000.[2] Among his customers Rakhlin proudly claimed Molotov, Beriya (the head of the NKVD), the Patriarch Aleksis,[3] and the Leningrad Rabbi – he said that he himself frequently attended services at the Central Synagogue in Leningrad, which was normally very crowded and was getting a particularly good 'cantor' from Odessa that year – and wondered if he could be invited to England one day to see how 'real' bookshops were run. Towards the end of the visit he presented Mr Churchill with a volume on Leningrad for himself, and one published in 1912 and commemorating the retreat of Napoleon in 1812 for Mr Winston Churchill, who, his son had earlier remarked, was a passionate collector of Napoleoniana.

Rakhlin's harrowing story of the blockade was more than confirmed by others. The critic Orlov told me that virtually all children born during that period had died. He himself had been able to keep alive only as a result of the special rations issued to intellectuals thought to deserve them, for example himself as well as

[1] Petr S. Popkov, as First Secretary of Leningrad's Provincial Committee (i.e. mayor of Leningrad), was responsible for maintaining the supply lines across Lake Ladoga, organising rationing and evacuating writers. Stalin, who had always felt theatened by the power of the government in Leningrad, and jealous of Popkov's status as local hero, later had him liquidated – along with most of Leningrad's wartime city government. Popkov was shot after being tried in the famous 'Leningrad Affair' of 1949–50.

[2] This estimate was far too low: today the figure is believed to be nearer one million.

[3] Aleksis Shimansky, Metropolitan of Leningrad, elected Patriarch February 1945.

Rakhlin, who was rated for rationing purposes as a 'second-rate writer' (the 'first-rate' and 'classical' authors are relatively well off). The only persons actually evacuated by special aircraft first across the German lines to Moscow and later to Tashkent were Zoshchenko, the short-story writer, and the poetess Akhmatova, on direct orders of Stalin. Both had at first refused to leave but ultimately bowed to authority. They and Orlov said that most of their friends died during the blockade, since, being non-essential civilians, they were virtually condemned to death by the order of priorities for food and fuel. One of them remarked that to him personally Leningrad was now a graveyard. Miss Tripp was told that many people who had been through the blockade were still subject to fits of giddiness, and that general health had steeply declined as a result – a rise in mortality was expected during the next few years, unless nutritional measures are taken to prevent this, which seems unlikely.

All the writers to whom I spoke begged for English books, which they said had been singularly difficult to obtain through VOKS,[1] which was an inefficient and obstructive organisation; and indicated methods by which this might be done. We talked at great length about English and American literature, and three out of the four writers with whom I had more than casual conversations spoke of Mr Priestley's recent visit and address to the Writers' Club; and indicated very insistently that they did not rate him too highly as a writer, although he did obviously possess a high degree of professional skill. They found it hard to believe that he was really regarded in England as one of the greatest of her authors, and the heir to the great Dickens's mantle – though he told them that that had been said of him. While they found him affable enough personally they thought it queer that in his article for the Moscow *Literary Gazette*, in dealing with the present state of English letters, he should have damned every one of his contemporaries with praise of varying degrees of faintness, conveying throughout that their later works invariably represented a decline from sometimes promising

[1] Acronym of 'Vsesoyuznoe obshchestvo kul'turnoi svyazi s zagranitisei' (All-Union Society for Cultural Relations with Foreign Countries).

beginnings. One of them finally asked outright why His Majesty's Government should have chosen Mr Priestley, whose achievement as a dramatist is neither ideologically nor artistically so very important (his novels are not known widely), as the literary ambassador of Britain. I tried to explain that it was VOKS and not His Majesty's Government which had arranged Mr Priestley's trip, but this was met with scepticism both in Leningrad and in Moscow, where Mr Priestley's criticisms of the British social order did not seem to register and very similar views of him are to be heard, at any rate among the well-established writers.

During one or two frank conversations about the condition of Russian life and letters which I had with the Leningrad writers, they said that they knew of no exceptionally gifted Russian authors under forty, although there was a great deal of enthusiasm and energy and considerable industry among them. The 'line' at present was to devote attention to the lesser-known parts of the Soviet Union, such as Siberia or Tadjikistan, as the nursery of much brilliant new talent about to spring to life with the advance of education and civic consciousness; and that while this might be repaid in the long run, it led for the moment to the encouragement of, and publicity for, a mass of pseudo-archaic lyrics and bogus ballads and epics and official poetry generally, which were driving out whatever originality there was among these primitive or semi-medieval peoples. They asserted with much pride that the Leningrad literary papers were commendably free from this incubus, which cluttered up the pages of the Moscow literary weekly, although they made an exception in favour of Georgian and Armenian literature, which contained works of true genius. For their own part they are not ashamed of the tradition of Pushkin and Blok, Baudelaire and Verhaeren, and would not exchange them for all the poetical treasures of Uzbekistan or Azerbaijan, whatever might be the fashion 'in Moscow'; and more on the same lines.

They spoke of the difficulties of educating their children according to the 'European' standards which they had known before the war, and said that in Leningrad it was in spite of all difficulties easier than in Moscow, because the number of well-

educated persons outside the State schools continued to be greater than elsewhere, and that children therefore came under civilised influence, which prevented them from becoming the standardised technical experts – even in literature – which they were otherwise in danger of turning into. There was much talk about the 'values of humanism' and general culture as opposed to 'Americanism' and 'barbarism', which are thought to be the main perils at present. Indeed, I can say from my personal meetings with one young member of the Red Army, lately back from Berlin and son of a person liquidated many years ago, that he was at least as civilised, well-read, independent and indeed fastidious, to the point almost of intellectual eccentricity, as the most admired undergraduate intellectuals in Oxford or Cambridge. But I gathered this case was a very exceptional one, although perhaps less so in Leningrad than anywhere else in the Soviet Union. As the young man in question gave evidence of having read both Proust and Joyce in the original (although he had never left the confines of the Soviet Union), I can well believe that this is so, and that no generalisation can possibly be drawn from one astonishing example.

I cautiously touched with my newly made acquaintances among the writers on the degree of political conformity which they had to observe in order not to get into trouble. They said that the difference between Communists and non-Communists was still pretty well marked. The main advantage of belonging to the Party was the better material conditions, due to the high proportion of orders placed with reliable Party men by the State publishing firms and literary journals, but the main disadvantage consisted in the duty of grinding out a great deal of lifeless government propaganda at frequent intervals and of appalling length (this was said in a mild, evasive fashion, but the sense was quite unmistakable). When I asked what view was taken, for example, of so faithful a Party member as the poet Tikhonov, the President of the Writers' Union, the answer was that he was 'the boss' (*nachalstvo*) and consequently undiscussable. I obtained the general impression that there are few real illusions about the actual quality of the work of Soviet writers, and that pretty frank discussions of this went on, but were scarcely ever published in so

many words. Thus everyone seemed to take it for granted, for example, that Boris Pasternak was a poet of genius and that Simonov was a glib journalist and little more.

Possibilities of travel were, I learnt, somewhat confined, as no writer could travel, for example, to Moscow of his own free will without a formal invitation from either the President of the Writers' Union or its Communist Party secretary, and although this could of course occasionally be wangled by indirect means, it was humiliating as well as difficult to do so at all frequently. The writers enquired with the greatest eagerness about writers abroad, particularly Richard Aldington and John Dos Passos. Hemingway was the most widely read of the serious novelists in English, and, of the English authors, Dr Cronin, although the highbrows did think him a somewhat commercial author, though superior to some. Knowledge of English literature obviously depends on what is accepted for translation and, to a smaller degree, on what VOKS permits to be supplied to individual readers of foreign languages. The results are occasionally eccentric: thus in Leningrad, for example, the names of Virginia Woolf and E. M. Forster (mentioned in Priestley's article) were not known, but everyone had heard of Mason, Greenwood and Aldridge. The source of foreign books was in Moscow, but they were very difficult to obtain even there, and if some method of supplying them with the imaginative literature of the Anglo-Saxon countries could be devised they would be most grateful. Anna Akhmatova was particularly pleased by an article which had appeared in the *Dublin Review* on her verse and by the fact that a doctoral thesis on her work had been accepted by the University of Bologna. In both cases the authors had corresponded with her.

The more eminent Leningrad writers are magnificently housed in the old Fountain Palace ('Fontanny Dom') of the Sheremetevs,[1]

---

[1] This is a confusion. The Union of Soviet Writers occupied the other Palace of the Sheremetevs, almost opposite to the Bolshoy Dom on Liteiny, the NKGB Headquarters. Akhmatova lived in Fontanny Dom (named after the Fontanka canal) because she was the wife (and then ex-wife) of the art historian and critic Nikolay Punin (her third husband), who occupied an apartment in the house. I owe this information to Anatoly Naiman.

a kind of Holland House on the Fontanka, often visited by
Pushkin – indeed the most famous of all the portraits of him had
been painted in its morning room – a building of the late eigh-
teenth century fronted by an exquisite ironwork grille and gates
constructed round a wide quadrangle filled with trees from
which thin, narrow staircases go up towards a series of high,
well-constructed, well-lighted rooms. The problem of food and
fuel is still fairly acute, and the writers I saw there could not be
said to be living with any degree of real comfort – indeed their
lives were still semi-obsessed by household needs. They hoped, I
thought rather pathetically, that, as Leningrad developed into a
port communicating with the outside world, more information
and perhaps more foreigners would begin to visit their city and
so bring them in touch with the world, isolation from which they
appear to feel very deeply. My own visits, though arranged quite
openly through one of my bookshop acquaintances, had been the
first, literally the first, I was told, made by any foreigner since
1917, and I got the impression that it would be as well if I did not
mention the fact at all widely. The writers in question said that
they read *Britansky soyuznik* with great avidity, and any refer-
ences to Russian literary achievement in it, for example reviews
of books and the like, were most warmly appreciated.

I found no trace of that xenophobia in Leningrad signs of
which are discernible in the minds of some of even the most
enlightened intellectuals in Moscow, not to speak of Government
officials and the like. Leningrad looks upon itself as, and indeed
still is to some degree, the home of Westward-looking intellectual
and artistic life. The writers in the literary newspapers, the actors
in the theatres and the assistants in the half-dozen or so book-
shops at which I bought books, as well as passengers in trams and
buses, seem slightly better bred and educated than their cosier
but more primitive equivalents in Moscow. Any seeds that we
could plant in this ground would sprout more gratefully, if my
impression is correct, than in any other part of the Soviet Union.
Whether this is practical – whether for example, if a British
Consulate were established in Leningrad, contact would still be
relatively as easy and almost informal as it seems at present, is, of

course, another and very real question. Present freedom of circulation may well be due to the absence of resident representatives of foreign institutions and countries, which makes the task of surveillance of those who pass through the inescapable (and surprisingly comfortable) turnstile of the Astoria Hotel relatively easier, and less worrying to the authorities.

# A GREAT RUSSIAN WRITER

## 1965

OSIP EMILIEVICH MANDEL'SHTAM was born in St Petersburg in 1891 and died in a Soviet prison camp. He belonged to a generation of Russian writers who revolted against the unbridled mysticism, the self-dramatising metaphysical dreams, and the conscious 'decadence' of the Russian Symbolist writers. Their master was the remarkable and still under-valued poet Innokenty Annensky, the withdrawn fastidious classical schoolmaster who taught Greek in the famous Lycée in Tsarskoe Selo. An absorbed and patient craftsman, remote from the political passions of his day, austere, aesthetic, and contemplative, Annensky was a preserver and re-creator of what, for want of a better term, may be described as the classical tradition in Russian verse, which descends in a direct line from the godlike figure to whom all Russian writers pray, from which they all stem, and against whose authority no rebellion ever succeeded – Pushkin himself. In the years before the First World War these poets called themselves Acmeists and sometimes Adamists. They were a Petersburg sect, nor is it extravagant to suppose that the formal lines of that solidly beautiful city were not without influence upon their writing. Annensky's most gifted followers, Nikolay Gumilev, Anna Akhmatova and Mandel'shtam, founded the Guild of Poets, the very title of which conveys their conception of poetry not as a way of life and a source of revelation but as a craft, the art of placing words in lines, the creation of public objects independent of the private lives of their creators. Their verse with its exact images and firm, rigorously executed structure was equally remote from the civic poetry of the left-wing poets of the nineteenth century, the visionary, insistently personal, at times

violently egotistic art of the Symbolists, the lyrical self-intoxicated verse of the peasant–poets, and the frantic gestures of the Ego-Futurists, the Cubo-Futurists and other self-conscious revolutionaries. Among them Mandel'shtam was early acknowledged as a leader and a model. His poetry, although its scope was deliberately confined, possessed a purity and perfection of form never again attained in Russia.

There are poets who are poets only when they write poetry, whose prose could have been written by someone who had never written a line of verse, and there are poets (both good and bad) whose every expression is that of a poet, sometimes to the detriment of their work as a whole. Pushkin's stories, histories, letters, are classical models of beautiful and lucid prose. When he is not writing poetry he is not a poet any more than Milton or Byron or Vigny or Valéry or Eliot or Auden are in their prose; unlike, that is to say, Yeats, D'Annunzio and, for the most part, Aleksandr Blok. All that Mandel'shtam wrote is written by a poet. His prose is a poet's prose – this he has in common with Pasternak. This, but little else. Pasternak, his friend, contemporary, rival (as writers, they felt no great sympathy for each other), was only too acutely conscious of the history of his time, of his own place in it, of his function as a man, a genius, a spokesman, a prophet. He was, or became, a political being whatever his *naïvetés* and aberrations. His relationship to Russia and Russian history was an agonising problem to him – from first to last he addresses his people, testifies and, in his last years, bears the full weight of a terrible public responsibility. Only fanatics blinded by socialist realism or a party line, inside and outside the Soviet Union, have denied this and have attacked him for being 'Parnassian', aesthetic, remote from Russian or Soviet reality, and so on.

This common charge is hardly worth discussing. Mandel'shtam is the precise opposite. Poetry was his whole life, his entire world. He scarcely had any personal existence outside it. He resembles his exact Western contemporaries, the imagists and the neo-classical poets; his self-imposed discipline derives ultimately from Greek and Roman, French and Italian models. If this conveys the notion of something cold and marmoreal, the impression is misleading. Concentration and intensity of experi-

ence, the combination of an exceptionally rich inner life, nour-
ished by a vast literary culture with a clear vision of reality, as
agonised and undeluded as Leopardi's, divided him from his
more subjective and self-expressive Russian contemporaries.

He began, of course, as they did, in the shadow of French
Symbolism, but emancipated himself exceedingly early. Perhaps
it was a conscious opposition to everything vague and indetermi-
nate that caused him to cut his cameos so fiercely, to lock his
images so firmly, sometimes a shade too firmly, in an exact,
unyielding verbal frame. This tendency toward objectivity and
his intimate relation to the great classical poets of Europe made
him an original and somewhat Western figure in a country
educated to confessional literature, and insistence and over-
insistence on the social and moral responsibility of the artist. It
was this that was described as lack of contact with reality, self-
estrangement from the national life and the people, for which he
and his Acmeists have been condemned since the early years of
the Revolution.

Clarence Brown, in the Introduction to his skilful and accurate
translations of Mandel'shtam's strange but very fascinating prose
pieces,[1] tells us a good deal – although by no means everything –
that is known of Mandel'shtam's life. He was born into a middle-
class Jewish family, received a normal Petersburg education in the
celebrated Tenishev school, went to St Petersburg University, and
travelled in Germany, Switzerland and France. Early in life
he became a passionate defender of poetry against those who
made attempts upon it. Kaverin's account (cited by Brown) of
Mandel'shtam's urgent pleas to him not to become a poet, his pas-
sionate insistence upon the appalling demands and enormous,
indeed absolute, rights of poetry, show him as a fanatical cham-
pion of art against the ungifted and the presumptuous.

His first collection of poems appeared in 1913 and again in
1916 (he was for some reason not conscripted into the army)
under the title *Stone*. He believed in sculpture, architecture, the
fixed, the firm, in all that is the work of human hands according to
rule and form: this enemy of flux and the undetermined, in his

---

[1] *The Prose of Osip Mandelstam*, trans. Clarence Brown (Princeton, 1965).

convictions and his practice, had clear affinities with his contem-
poraries, Pound, Eliot and Wyndham Lewis. The October
Revolution, not surprisingly, proved fatal to him. Unwilling, and
indeed unable, to adjust himself and adapt his talents to the new
demands, he could not talk himself into collaborating with trib-
unes, organisers, builders of a new life. Timid, frail, affectionate,
always in love, infinitely vulnerable, compared by his friends to
an elegant but slightly ludicrous small bird, he was capable of
astonishing acts; this shy and easily terrified man had a fund of
mad heroic courage. Brown, whose thorough and scrupulous
research seems to me totally reliable, corroborates a remarkable
story. One evening early in the Revolution he was sitting in a café
and there was the notorious Socialist Revolutionary terrorist
Blyumkin (who later assassinated the German ambassador Mir-
bach). Blyumkin, at that time an official of the Cheka, was drunk-
enly copying the names of men and women to be executed on to
blank forms already signed by the head of the secret police.
Mandel'shtam suddenly threw himself at him, seized the lists, tore
them to pieces before the stupefied onlookers, then ran out and
disappeared. On this occasion he was saved by Trotsky's sister.
But it was not likely that such a man would survive long in deeply
disturbed conditions. He knew that he was condemned to perpet-
ual exile. His next collection is appropriately called *Tristia*. He
was an inner émigré, an Ovid helpless before the omnipotent dic-
tator. In 1934 he wrote an epigram in verse about Stalin.[1] It is a
magnificent and blood-chilling poem that needs no commentary;
and may well be the immediate cause of the tyrant's rage against
the poet. He was persecuted relentlessly until he died, in condi-
tions of unutterable horror, in a prison camp near Vladivostok,
probably in 1938. The circumstances were such that no friend of

---

[1]Robert Lowell has composed an incomparably more magnificent transla-
tion of it than that quoted by Brown. I.B. [Lowell's translations, made with
Olga Carlisle, of this and eight other poems by Mandel'shtam appear on
pp. 5–7 of the same issue of the *New York Review of Books* that contains
Berlin's essay (see p. xxxviii above), and are reprinted in Olga Carlisle (ed.),
*Poets on Street Corners* (New York, 1968), pp. 140–63, and in Lowell's
*Collected Poems*, ed. Frank Bidart and David Gewanter, with the editorial
assistance of DeSales Harrison (New York, 2003), pp. 906–23.]

his who has any direct knowledge of them will speak of what occurred if he can avoid it.

On successive pages Brown provides two photographs of Mandel′shtam. One was taken circa 1936. The first shows the childlike, naïve, charming face, with dandyish, slightly pretentious sideburns of a rising young intellectual of nineteen; the other is that of a broken tormented, dying old tramp, but he was only forty-five at the time. The contrast is literally unbearable, and tells more than the memoirs of his friends and contemporaries. The lives of Russian poets have often ended badly: Ryleev was hanged; the Decembrist poets died in Siberia or were broken there; Pushkin and Lermontov were killed in duels; Esenin, Mayakovsky and Tsvetaeva committed suicide; Blok and Pasternak died in misery and official disfavour. But Mandel′shtam's fate was the most terrible of all. Indeed his whole life was haunted by the image of helpless innocent men, tormented by enemies and crushed by them. Perhaps, like Pushkin in *Eugene Onegin*, he had some premonition of his inevitable end.

Some of Brown's best pages in his truly valuable introductory essay trace the parallels between the hero of Mandel′shtam's quasi-surrealist story, 'The Egyptian Stamp', with those other victims in Russian literature – Evgeny in Pushkin's *Bronze Horseman* (beautifully translated by Edmund Wilson), the absurd hero of Gogol's 'The Nose', the victim of Dostoevsky's *The Double*, and above all the minor official in Gogol's 'The Overcoat', which Brown is the first to adduce as a source for Mandel′shtam's story. The nightmare became real and for Mandel′shtam became incorporated in the figure of the Kremlin's 'mountaineer', who slowly and remorselessly (not without some assistance from at least one writer of considerable gifts and a vindictive disposition) hounded him to death. No doubt it would be better to read these haunted stories without bearing in mind the fate of the author (as the poet himself would surely have wished one to do), but it is not easy to achieve detachment. Yet no matter how macabre the fantasies which Mandel′shtam wrote in his peculiar prose, they achieve the tranquillity of harmonious art – the Hellenic ideal which he inherited from Annensky and, ultimately, the early German romantics. Some of the most ironical

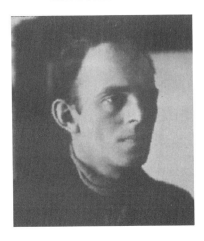

*The originals of the photographs described in the text, both given to Clarence Brown by Nadezhda Mandel'shtam (or in one case possibly by Anna Akhmatova) are missing. These substitutes tell the same story. The first photograph was taken in 1922; the others are the mugshots taken in the Lubyanka (the NKGB headquarters) in Moscow after Mandel'shtam's arrest in 1938.*

and most civilised of his poems were composed during the darkest hours of exile and persecution. No doubt despotic regimes create 'inner émigrés' who can, like stoic sages, remove themselves from the inferno of the world, and out of the very material of their exile build a tranquil world of their own. Mandel'shtam paid an almost unimaginable price for the preservation of his human attributes. He welcomed the Revolution, but in the 1930s compromised less than anyone, so far as is known, with the inevitable consequences. I can think of literally no other case of a poet who resisted the enemy to a greater degree.

Mandel'shtam had nothing to conceal, was filled with no inner panic, save about his health: towards the end he imagined that Stalin's agents were bent on poisoning him. The vendetta began in 1934. The best known episode in it is a famous midnight telephone call which Pasternak received from Stalin. Several versions of this are in circulation. Brown, relying, it seems to me, on dubious authority, gives a mild and peaceful version from which Stalin emerges as an ironical but not at all malevolent despot,

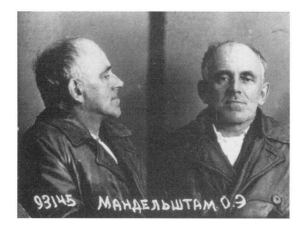

who behaves creditably. This tallies with the account given by Robert Payne. The story that Pasternak himself told a reliable witness in later years is somewhat different from that given by Brown.[1] Stalin asked Pasternak whether he was present at a reading of the notorious epigram. Pasternak evaded the question and explained how important it was for him to meet Stalin, for there were many problems which they must discuss. Stalin coldly repeated his question, and finally said 'If I had been Mandel'shtam's friend, I should have known better how to defend him', and laid down the receiver. With this memory (whether it was accurate or touched up by his own fantasy) Pasternak was forced to live for the rest of his life. He told it with moving candour and anguish to at least one visitor.

Mandel'shtam was exiled to Voronezh but was allowed to return to Leningrad for a short while. There he quarrelled with the politically influential Aleksey Tolstoy (although this may have happened earlier – our sources differ on this). This was followed by expulsion from the capital cities, re-arrest,

[1] Berlin means himself: see below, pp. 63–4. More material about this episode has since been published. All the (conflicting) accounts are well summarised by Pasternak's lover Olga Ivinskaya in her book *A Captive of Time: My Years with Pasternak, The Memoirs of Olga Ivinskaya* (London, 1978): see 'The Telephone Call: 1934', pp. 64–71.

imprisonment in Moscow, transfer to camps in the Far East, savage beatings by guards and fellow prisoners (for stealing their rations from fear that his own were poisoned), hunger, emaciation, physical and mental collapse, death. Official oblivion descended upon him. Until very recently he was still an unperson, although now there is said to be a prospect (experts differ on the degree of its likelihood) that, like the once ignored Esenin, Mandel'shtam too will come fully into his own. No socialist society has (or at any rate, should have) anything to fear from unfettered powers of creation; so at least Gorky taught us, and his views carry more official weight in the Soviet Union than Plato's. Yet today this noble classical poet is still read in clandestine manuscript versions throughout the length and breadth of his country. Perhaps like other *maîtres cachés* he too will be allowed to emerge into the light of day.

Brown has translated the three prose works of Mandel'shtam – 'The Noise of Time', 'Theodosia' and 'The Egyptian Stamp' – and provided them with clearly written and highly informative critical introductions and brief notes that deal with some of the more esoteric allusions in the text. It seems to me the most illuminating commentary on Mandel'shtam in English at the present moment. It is a work of impeccable scholarship, throws light on dark places (no authors require this more than the Russian writers of the first third of this century – Bely, Khlebnikov, Mayakovsky and, especially in his early prose writings, Pasternak, with whom Brown – rightly for this purpose – classifies Mandel'shtam), and the entire volume is well produced. Nevertheless, these pieces may be described as prose only in the sense in which Novalis' novels or *The Waves* are prose. 'The Noise of Time' is a poetic sketch for an autobiography, 'Theodosia' is half reminiscence, half fiction, and 'The Egyptian Stamp' is a fantasy. Brown is a learned and sensitive student of the period and its atmosphere, and seems to me to make no error of fact or perception. His renderings are always accurate, often skilful and ingenious, the result of the most devoted care and a wonderfully good ear for the nuances of Russian *Kunstprosa*. Yet how is it possible to translate this kind of writing? How can one convey the fan-

tastically complex web of local, historical, literary, but above all personal references and allusions, play on words, play on names? What would a contemporary Russian reader make of Auden's *The Orators?* Auden's poetry could be conveyed to them more successfully than his prose writings of the 1930s; and this for analogous reasons seems to me to apply to Mandel'shtam. Robert Lowell, in his translations, seems to me to have accomplished what Pasternak did for the poets of Georgia: both transform poetry from a wholly unfamiliar language and perform the task of imaginative utterance in the persona of another as expressively and profoundly as it can be done. The similarity between the classical interests of Lowell and his original may have played its part. The result is beautiful and moving.

Mandel'shtam's prose is scarcely translatable. The verse with all its fearful complexity and the tiers of meaning packed into the miraculously chosen words is, despite everything, more capable of being reproduced in an alien medium than his wildly eccentric, although rigorously disciplined, 'prose'. He intended to write in what he himself called 'wild parabolas'. He succeeded more often than not and to an astonishing extent. 'A manuscript is always a storm,' he wrote. But the writer keeps his head and dominates the storm. Sometimes he fails: then we have passages of brilliant virtuosity, the galloping wild horses of an exultant and disordered poetic imagination. But because Mandel'shtam is a marvellous rider the wild leaps, even when they seem to vanish in mid-air, are exhilarating and never degenerate into a mere exhibition of skill or vitality. More often these pages obey a rigorous pattern; Brown seems to me right about this as against the learned Soviet scholar Berkovsky, whom he quotes in his book with justified approval. For the cascades of Mandel'shtam's glittering or tranquil images leaping out of one another, the historical, psychological, syntactical, verbal allusions, contrasts, collisions, whirling at lightning speed, dazzle the imagination and the intellect, not as an impressionist or surrealist cavalcade of haphazard violently contrasted elements, a brilliant chaos, but as a composition, as a harmonious and noble whole. Brown speaks of Mandel'shtam's 'patterned selection of incongruous images'.

But it seems to me that they are seldom incongruous. They are bold, violent, but fused into a disturbing, often agonised, but demonstrably coherent unity – a complex, twisted, over-civilised world (needing a sophisticated and widely read observer) in which there are no loose ends. All the strands are interwoven, often in grotesque patterns, but everything echoes everything else, colours, sounds, tastes, shapes, tactile properties are related not by symbolic but literal – sensory and psychological – correspondences. It is all the product of a remorselessly ordering mind. The description of him by Russian critics as 'architectural' is perfectly just.

In the centre there is always a suffering hero – the martyr pursued by the mob, a descendant not only of Gogol's and Dostoevsky's humble victims but (whether consciously or not) also of Büchner's Woyzeck (and very like Berg's Wozzeck). The suffering hero of 'The Egyptian Stamp' is a Russian Jew. His prose is populated with figures and images of his Jewish environment, treated with neither condescension nor irony nor aggressive self-identification, indeed no self-consciousness of any kind. This evidently remained his natural world until the end.

Two motifs run persistently through these strange pieces: one, that of a wistful, timorous, Jewish victim of men and circumstances. Literary historians will surely one day devote chapters and perhaps volumes to this stock figure of our time and trace his evolution from his gentile ancestors, from Peter Schlemihl to Hoffmann's terrorised creatures, from Dostoevsky to Andrea, until we reach Mandel'shtam's Parnok, an obscure ancestor of Bellow's Herzog. Mandel'shtam identifies himself with poor Parnok and at the same time prays passionately to be delivered from his characteristics and his fate. Pasternak took a different and much solider path to salvation in *Doctor Zhivago*.

The other motif is that of music and composers, Bach, Mozart, Beethoven, Schubert, and, at a different level, Tchaikovsky and Skryabin, the characteristics of whose art haunted Mandel'shtam much as they did Pasternak; and are constantly used by him to describe other things. They are similes for nature, ideas, human beings: the comparison between Alexander Herzen's stormy

political rhetoric and a Beethoven sonata in 'The Noise of Time' is one of the most typical and brilliant of these. The two themes come together in the marvellous description of the contrast between two Baltic seaside resorts – the German resort where Richard Strauss is played before an audience from which Jews have been excluded, and the Jewish resort full of Tchaikovsky and violins; still more, in what is, if not the best, the most directly emotional of all his lyrics, the poem about the gloomy Jewish musician Herzevich (the play on *Herz* and *serdtse* – the Russian for 'heart' – and Scherzo can scarcely be conveyed in English). It is a poignant and profoundly upsetting piece, like the single Schubert sonata which the musician practises over and over again. (Vladimir Wendell has written well about it.)

In 'The Egyptian Stamp' the hero's enemy – his alter ego descended from Hoffmann and Chemise – is the stupid, brutal, handsome, insolent soldier, the *miles gloriosus* who steals the hero's shirts, persecutes him, is admired while the hero is despised, and robs the hero of what he most ardently longs for. He is the terrible Double – the *Doppelgänger* – of the paranoiac imagination of the early German romantics, the Drum Major in *Wozzeck*, the symbol of detestable strength and success, the mocking dismissal of all forms of inner life.

'The Noise of Time' in its own euphemistic way looks back to the dying Jewish bourgeois world, the office-study of Mandel'shtam's father, the leather-merchant, a succession of tutors, Jewish and Gentile, the mingling of the Petersburg liberal intelligentsia with socialist conspirators – the world from which the Revolution sprang. It vividly recalls the not wholly dissimilar world of Pasternak's youth in Moscow, although there the Jewish element is much more remote.

As for 'The Egyptian Stamp', although the fantasy derives from nineteenth-century romanticism, it has points of similarity both with the phantasmagoria of Bely's *Petersburg* and the logic of Kafka's *Castle*. No wonder that this book, like much imaginative Russian writing of its time, was not held propitious to the social and political policies of the Soviet State in the late 1920s and early 1930s.

The first and second Five-Year Plans swept all this away. It swept away the writer too. The day will dawn, it may not be far off, when a new generation of Russians will be allowed to know what a rich and marvellous world existed in the midst of the hunger and desolation of the early years of the Soviet Republic; that it did not die a natural death, but is still crying for fulfilment, and is not therefore buried in some irrevocable past.

# CONVERSATIONS WITH
# AKHMATOVA AND PASTERNAK

*1980*

I

IN THE SUMMER of 1945 the British Embassy in Moscow reported that it was short-handed, especially in the matter of officials who knew Russian, and it was suggested that I might fill a gap for four or five months. I accepted this offer eagerly, mainly, I must admit, because of my great desire to learn about the condition of Russian literature and art, about which relatively little was known in the West at that time. I knew something, of course, of what had happened to Russian writers and artists in the 1920s and '30s. The Revolution had stimulated a great wave of creative energy in Russia, in all the arts; bold experimentalism was everywhere encouraged: the new controllers of culture did not interfere with anything that could be represented as being a 'slap in the face' to bourgeois taste, whether it was Marxist or not. The new movement in the visual arts – the work of such painters as Kandinsky, Chagall, Soutine, Malevich, Klyun, Tatlin, of the sculptors Arkhipenko, Pevsner, Gabo, Lipchitz, Zadkine, of the theatre and film directors Meyerhold, Vakhtangov, Tairov, Eisenstein, Pudovkin – produced masterpieces which had a powerful impact in the West; there was a similar upward curve in the field of literature and literary criticism. Despite the violence and devastation of the Civil War, and the ruin and chaos brought about by it, Revolutionary art of extraordinary vitality continued to be produced.

I remember meeting Sergey Eisenstein in 1945; he was in a state of terrible depression: this was the result of Stalin's condemnation of the original version of his film *Ivan the Terrible*,

*Berlin's diplomatic pass, issued in Moscow on 15 September 1945, and signed
by the Soviet foreign minister, V. M. Molotov*

because that savage ruler, with whom Stalin identified himself,
faced with the need to repress the treachery of the boyars, had, so
Stalin complained, been misrepresented as a man tormented to
the point of neurosis. I asked Eisenstein what he thought were
the best years of his life. He answered without hesitation, 'The
early '20s. That was the time. We were young and did marvellous
things in the theatre. I remember once, greased pigs were let
loose among the members of the audience, who leapt on their
seats and screamed. It was terrific. Goodness, how we enjoyed
ourselves!'

This was obviously too good to last. An onslaught was deliv-
ered on it by leftist zealots who demanded collective proletarian
art. Then Stalin decided to put an end to all these politico-literary
squabbles as a sheer waste of energy – not at all what was needed
for Five-Year Plans. The Writers' Union was created in the mid-
1930s to impose orthodoxy. There was to be no more argument,
no disturbance of men's minds. A dead level of conformism fol-
lowed. Then came the final horror – the Great Purge, the political

show trials, the mounting terror of 1937–8, the wild and indiscriminate mowing down of individuals and groups, later of whole peoples. I need not dwell on the facts of that murderous period, not the first, nor probably the last, in the history of Russia. Authentic accounts of the life of the intelligentsia in that time are to be found in the memoirs of, for example, Nadezhda Mandel'shtam, Lydia Chukovskaya, and, in a different sense, in Akhmatova's poem *Requiem*. In 1939 Stalin called a halt to the proscriptions. Russian literature, art and thought emerged like an area that had been subjected to bombardment, with some noble buildings still relatively intact, but standing bare and solitary in a landscape of ruined and deserted streets.

Then came the German invasion, and an extraordinary thing happened. The need to achieve national unity in the face of the enemy led to some relaxation of the political controls. In the great wave of Russian patriotic feeling, writers old and young, particularly poets, whom their readers felt to be speaking for them, for what they themselves felt and believed – these writers were idolised as never before. Poets whose work had been regarded with disfavour by the authorities, and consequently published seldom, if at all, suddenly received letters from soldiers at the fronts, as often as not quoting their least political and most personal lines. Boris Pasternak and Anna Akhmatova, who had for a long time lived in a kind of internal exile, began to receive an astonishingly large number of letters from soldiers quoting from both published and unpublished poems; there was a stream of requests for autographs, for confirmation of the authenticity of texts, for expressions of the author's attitude to this or that problem. In the end this impressed itself on the minds of some of the Party's leaders. The status and personal security of these frowned-upon poets were, in consequence, improved. Public readings by poets, as well as the reciting from memory of poetry at private gatherings, had been common in pre-Revolutionary Russia. What was novel was that when Pasternak and Akhmatova read their poems, and occasionally halted for a word, there were always, among the vast audiences gathered to hear them, scores of listeners who prompted them at

once with lines from works both published and unpublished, and in any case not publicly available. No writer could help being moved by and drawing strength from this most genuine form of homage.

The status of the handful of poets who clearly rose far above the rest was, I found, unique. Neither painters nor composers nor prose writers, nor even the most popular actors, or eloquent, patriotic journalists, were loved and admired so deeply and so universally, especially by the kind of people I spoke to in trams and trains and the underground, some of whom admitted that they had never read a word of their writings. The most famous and widely worshipped of all Russian poets was Boris Pasternak. I longed to meet him more than any other human being in the Soviet Union. I was warned that it was very difficult to meet those whom the authorities did not permit to appear at official receptions, where foreigners could meet only carefully selected Soviet citizens – the others had had it very forcibly impressed upon them that it was neither desirable nor safe for them to meet foreigners, particularly in private. I was lucky. By a fortuitous concatenation of circumstances, I did contrive, very early during my stay, to call upon Pasternak at his country cottage in the writers' village of Peredelkino, near Moscow.

## II

I went to see him on a warm, sunlit afternoon in September 1945. The poet, his wife and his son Leonid were seated round a rough wooden table at the back of the dacha. Pasternak greeted me warmly. He was once described by his friend, the poet Marina Tsvetaeva, as looking like an Arab and his horse – he had a dark, melancholy, expressive, very *racé* face, familiar from many photographs and from his father's paintings. He spoke slowly in a low tenor monotone, with a continuous even sound, something between a humming and a drone, which those who met him almost always remarked upon: each vowel was elongated as if in some plaintive aria in an opera by Tchaikovsky, but with far more concentrated force and tension.

Almost at once Pasternak said, 'You come from England. I was in London in the '30s – in 1935, on my way back from the Anti-Fascist Congress in Paris.' He then said that during the summer of that year he had suddenly received a telephone call from the authorities, who told him that a congress of writers was in session in Paris and that he was to go to it without delay. He said that he had no suitable clothes – 'We will see to that,' said the officials. They tried to fit him out in a formal morning coat and striped trousers, a shirt with stiff cuffs and a wing collar, and black patent leather boots, which fitted perfectly. But he was, in the end, allowed to go in ordinary clothes. He was later told that André Malraux, the organiser of the congress, had insisted on getting him invited; Malraux had told the Soviet authorities that although he fully understood their reluctance to do so, yet not to send Pasternak and Babel' to Paris might cause unnecessary speculation; they were very well-known Soviet writers, and there were not many such in those days so likely to appeal to European liberals. 'You cannot imagine how many celebrities were there,' Pasternak said – 'Dreiser, Gide, Malraux, Aragon, Auden, Forster, Rosamond Lehmann, and lots of other terribly famous people. I spoke. I said to them "I understand that this is a meeting of writers to organise resistance to Fascism. I have only one thing to say to you: do not organise. Organisation is the death of art. Only personal independence matters. In 1789, 1848, 1917 writers were not organised for or against anything. Do not, I implore you, do not organise."

'I think they were surprised, but what else could I say? I thought I would get into trouble at home after that, but no one ever said a word to me about it, then or now. Then I went to London and travelled back in one of our boats, and shared a cabin with Shcherbakov, who was then the secretary of the Writers' Union, tremendously influential, and afterwards a member of the Politburo. I talked unceasingly, day and night. He begged me to stop and let him sleep. But I went on and on. Paris and London had awoken me. I could not stop. He begged for mercy but I was relentless. He must have thought me quite deranged: it may be that this helped me afterwards.' He meant, I

think, that to be thought a little mad, or at least extremely eccentric, may have helped to save him during the Great Purge.

Pasternak then asked me if I had read his prose, in particular *The Childhood of Luvers*. 'I see by your expression', he said, most unjustly, 'that you think that these writings are contrived, tortured, self-conscious, horribly modernist – no, no, don't deny it, you do think this, and you are absolutely right. I am ashamed of them – not of my poetry, but of my prose – it was influenced by what was weakest and most muddled in the Symbolist movement, fashionable in those years, full of mystical chaos – of course Andrey Bely was a genius – *Petersburg*, *Kotik Letaev* are full of wonderful things – I know that, you need not tell me – but his influence was fatal – Joyce is another matter – all that I wrote then was obsessed, forced, broken, artificial, no use [*negodno*]; but now I am writing something entirely different: something new, quite new, luminous, elegant, well-proportioned [*stroinoe*], classically pure and simple – what Winckelmann wanted, yes, and Goethe; and this will be my last word, my most important word, to the world. It is, yes, it is what I wish to be remembered by; I shall devote the rest of my life to it.'

I cannot vouch for the complete accuracy of all these words, but this is how I remember them. This projected work later became *Doctor Zhivago*. He had by 1945 completed a draft of a few early chapters, which he asked me to read, and send to his sisters in Oxford; I did so, but was not to know about the plan for the entire novel until much later. After that, Pasternak was silent for a while; none of us spoke. He then told us how much he liked Georgia, Georgian writers, Yashvili, Tabidze, and Georgian wine, how well received there he always was. After this he politely asked me about what was going on in the West; did I know Herbert Read and his doctrine of personalism? Here he explained that his belief in personal freedom was derived from Kantian individualism – Blok had misinterpreted Kant completely in his poem *Kant*. There was nothing here in Russia about which he could tell me. I must realise that the clock had stopped in Russia (I noticed that neither he nor any of the other writers I met ever used the words 'Soviet Union') in 1928 or so, when relations with the outer world were in effect cut off; the description

of him and his work in, for instance, the Soviet Encyclopaedia bore no reference to his later life or writings.

He was interrupted by Lydia Seifullina, an elderly, well-known writer, who broke in while he was in mid-course: 'My fate is exactly the same,' she said: 'the last lines of the Encyclopaedia article about me say "Seifullina is at present in a state of psychological and artistic crisis" – the article has not been changed during the last twenty years. So far as the Soviet reader is concerned, I am still in a state of crisis, of suspended animation. We are like people in Pompeii, you and I, Boris Leonidovich, buried by ashes in mid-sentence. And we know so little: Maeterlinck and Kipling, I know, are dead; but Wells, Sinclair Lewis, Joyce, Bunin, Khodasevich – are they alive?' Pasternak looked embarrassed and changed the subject. He had been reading Proust – French Communist friends had sent him the entire masterpiece – he knew it, he said, and had reread it lately. He had not then heard of Sartre or Camus, and thought little of Hemingway ('Why Anna Andreevna [Akhmatova] thinks anything of him I cannot imagine,' he said).

He spoke in magnificent slow-moving periods, with occasional intense rushes of words. His talk often overflowed the banks of grammatical structure – lucid passages were succeeded by wild but always marvellously vivid and concrete images – and these might be followed by dark words when it was difficult to follow him – and then he would suddenly come into the clear again. His speech was at all times that of a poet, as were his writings. Someone once said that there are poets who are poets when they write poetry and prose-writers when they write prose; others are poets in everything that they write. Pasternak was a poet of genius in all that he did and was. As for his conversation, I cannot begin to describe its quality. The only other person I have met who talked as he talked was Virginia Woolf, who made one's mind race as he did, and obliterated one's normal vision of reality in the same exhilarating and, at times, terrifying way.

I use the word 'genius' advisedly. I am sometimes asked what I mean by this highly evocative but imprecise term. In answer I can only say this: the dancer Nijinsky was once asked how he managed to leap so high. He is reported to have answered that he saw

no great problem in this. Most people when they leaped in the air came down at once. 'Why should you come down immediately? Stay in the air a little before you return, why not?' he is reported to have said. One of the criteria of genius seems to me to be precisely this: the power to do something perfectly simple and visible which ordinary people cannot, and know that they cannot, do – nor do they know how it is done, or why they cannot begin to do it. Pasternak at times spoke in great leaps; his use of words was the most imaginative that I have ever known; it was wild and very moving. There are, no doubt, many varieties of literary genius: Eliot, Joyce, Yeats, Auden, Russell did not (in my experience) talk like this. I did not wish to overstay my welcome. I left the poet, excited, and indeed overwhelmed, by his words and by his personality.

After Pasternak returned to Moscow I visited him almost weekly, and came to know him well. I cannot hope to describe the transforming effect of his presence, his voice and gestures. He talked about books and writers; he loved Proust and was steeped in his writings, and *Ulysses* – he had not, at any rate then, read Joyce's later work. He spoke about French Symbolists, and about Verhaeren and Rilke, both of whom he had met; he greatly admired Rilke, both as a man and a writer. He was steeped in Shakespeare. He was dissatisfied with his own translations: 'I have tried to make Shakespeare work for me,' he said, 'but it has not been a success.' He grew up, he said, in the shadow of Tolstoy – for him an incomparable genius, greater than Dickens or Dostoevsky, a writer who stood with Shakespeare and Goethe and Pushkin. His father, the painter, had taken him to see Tolstoy on his deathbed, in 1910, at Astapovo. He found it impossible to be critical towards Tolstoy: Russia and Tolstoy were one. As for Russian poets, Blok was of course the dominant genius of his time, but he did not find him sympathetic. Bely was closer to him, a man of strange and unheard-of insights – magical and a holy fool in the tradition of Russian Orthodoxy. Bryusov he considered a self-constructed, ingenious, mechanical musical-box, a clever, calculating operator, not a poet at all. He did not mention Mandel'shtam. He felt most tenderly towards Marina Tsvetaeva, to whom he had been bound by many years of friendship.

His feelings towards Mayakovsky were more ambivalent: he had known him well, they had been close friends, and he had learned from him; he was, of course, a titanic destroyer of old forms, but, he added, unlike other Communists, he was at all times a human being – but no, not a major poet, not an immortal god like Tyutchev or Blok, not even a demigod like Fet or Bely. Time had diminished him. He was needed in his day, he was what those times had called for. There are poets, he said, who have their hour, Aseev, poor Klyuev – liquidated – Sel'vinsky – even Esenin. They fulfil an urgent need of the day, their gifts are of crucial importance to the development of poetry in their country, and then they are no more. Mayakovsky was the greatest of these – *The Cloud in Trousers* had its historical importance, but the shouting was unbearable: he inflated his talent and tortured it until it burst. The sad rags of the multi-coloured balloon still lay in one's path, if one was a Russian. He was gifted, important, but coarse and not grown up, and ended as a poster-artist. Mayakovsky's love-affairs had been disastrous for him as a man and a poet. He, Pasternak, had loved Mayakovsky as a man; his suicide was one of the blackest days of his own life.

Pasternak was a Russian patriot – his sense of his own historical connection with his country was very deep. He told me, again and again, how glad he was to spend his summers in the writers' village, Peredelkino, for it had once been part of the estate of that great Slavophil, Yury Samarin. The true line of tradition led from the legendary Sadko to the Stroganovs and the Kochubeys, to Derzhavin, Zhukovsky, Tyutchev, Pushkin, Baratynsky, Lermontov, Fet, Annensky, to the Aksakovs, Tolstoy, Bunin – to the Slavophils, not to the liberal intelligentsia, which, as Tolstoy maintained, did not know what men lived by. This passionate, almost obsessive, desire to be thought a true Russian writer, with roots deep in Russian soil, was particularly evident in his negative feelings towards his Jewish origins. He was unwilling to discuss the subject – he was not embarrassed by it, but he disliked it: he wished the Jews to disappear as a people.

His artistic taste had been formed in his youth and he remained faithful to the masters of that period. The memory of Skryabin – he had thought of becoming a composer himself –

was sacred to him. I shall not easily forget the paean of praise offered by both Pasternak and Neuhaus (the celebrated musician, and former husband of Pasternak's wife Zinaida) to Skryabin, and to the Symbolist painter Vrubel', whom, with Nicholas Roerich, they prized above all contemporary painters. Picasso and Matisse, Braque and Bonnard, Klee and Mondrian, seemed to mean as little to them as Kandinsky or Malevich.

There is a sense in which Akhmatova and her contemporaries Gumilev and Marina Tsvetaeva are the last great voices of the nineteenth century – perhaps Pasternak occupies an interspace between the two centuries, and so, perhaps, does Mandel'shtam. They were the last representatives of what can only be called the second Russian renaissance, basically untouched by the modern movement, by Picasso, Stravinsky, Eliot, Joyce, Schoenberg, even if they admired them; for the modern movement in Russia was aborted by political events (the poetry of Mandel'shtam is another story). Pasternak loved Russia. He was prepared to forgive his country all its shortcomings, all, save the barbarism of Stalin's reign; but even that, in 1945, he regarded as the darkness before the dawn which he was straining his eyes to detect – the hope expressed in the last chapters of *Doctor Zhivago*. He believed himself to be in communion with the inner life of the Russian people, to share its hopes and fears and dreams, to be its voice as, in their different fashions, Tyutchev, Tolstoy, Dostoevsky, Chekhov and Blok had been (by the time I knew him he conceded nothing to Nekrasov).

In conversation with me during my Moscow visits, when we were always alone, before a polished desk on which not a book or a scrap of paper was to be seen, he repeated his conviction that he lived close to the heart of his country, and sternly and repeatedly denied this role to Gorky and Mayakovsky, especially to the former, and felt that he had something to say to the rulers of Russia, something of immense importance which only he could say, although what this was – he spoke of it often – seemed dark and incoherent to me. This may well have been due to lack of understanding on my part – although Anna Akhmatova told me that when he spoke in this prophetic strain, she, too, failed to understand him.

It was when he was in one of these ecstatic moods that he told me of his telephone conversation with Stalin about Mandel'shtam's arrest, the famous conversation of which many differing versions circulated and still circulate. I can only reproduce the story as I remember that he told it me in 1945. According to his account he was in his Moscow flat with his wife and son and no one else when the telephone rang, and a voice told him that it was the Kremlin speaking, and that comrade Stalin wished to speak to him. He assumed that this was an idiotic practical joke, and put down his receiver. The telephone rang again, and the voice somehow convinced him that the call was authentic. Stalin then asked him whether he was speaking to Boris Leonidovich Pasternak. Pasternak said that it was indeed he. Stalin asked whether he was present when a lampoon about himself, Stalin, was recited by Mandel'shtam. Pasternak answered that it seemed to him of no importance whether he was or was not present, but that he was enormously happy that Stalin was speaking to him; that he had always known that this would happen; that they must meet and speak about matters of supreme importance. Stalin then asked whether Mandel'shtam was a master. Pasternak replied that as poets they were very different; that he admired Mandel'shtam's poetry but felt no affinity with it; but that, in any case, this was not the point at all.

Here, in recounting the episode to me, Pasternak again embarked on one of his great metaphysical flights about the cosmic turning-points in the world's history; it was these that he wished to discuss with Stalin – it was of supreme importance that he should do so. I can easily imagine that he spoke in this vein to Stalin too. At any rate, Stalin asked him again whether he was or was not present when Mandel'shtam read the lampoon. Pasternak answered again that what mattered most was his indispensable meeting with Stalin, that it must happen soon, that everything depended on it, that they must speak about ultimate issues, about life and death. 'If I were Mandel'shtam's friend, I should have known better how to defend him,' said Stalin, and put down the receiver. Pasternak tried to ring back but, not surprisingly, failed to get through to the leader. The episode evidently preyed deeply upon him. He repeated to me the version I have just recounted

on at least two other occasions, and told the story to other visitors, although, apparently, in different forms. His efforts to rescue Mandel'shtam, in particular his appeal to Bukharin, probably helped to preserve him at least for a time – Mandel'shtam was finally destroyed some years later – but Pasternak clearly felt, it may be without good reason, but as anyone not blinded by self-satisfaction or stupidity might feel, that perhaps another response might have done more for the condemned poet.[1]

He followed this story with accounts of other victims: Pil'nyak, who anxiously waited ('was constantly looking out the window') for an emissary to ask him to sign a denunciation of one of the men accused of treason in 1936, and because none came, realised that he, too, was doomed. He spoke of the circumstances of Tsvetaeva's suicide in 1941, which he thought might have been prevented if the literary bureaucrats had not behaved with such appalling heartlessness to her. He told the story of a man who asked him to sign an open letter condemning Marshal Tukhachevsky. When Pasternak refused and explained the reasons for his refusal, the man burst into tears, said that the poet was the noblest and most saintly human being whom he had ever met, embraced him fervently; and then went straight to the secret police, and denounced him.

Pasternak went on to say that despite the positive role which the Communist Party had played during the war, and not in Russia alone, he found the idea of any kind of relationship with it increasingly repellent: Russia was a galley, a slave-ship, and the Party men were the overseers who whipped the rowers. Why, he wished to know, did a British Commonwealth diplomat then in Moscow, whom I surely knew, a man who knew some Russian and claimed to be a poet, and visited him occasionally, why did this person insist, on every possible and impossible occasion, that he, Pasternak, should get closer to the Party? He did not need gentlemen who came from the other side of the world to tell him what to do – could I tell the man that his visits were unwelcome? I promised that I would, but did not do so, partly

---

[1] Akhmatova and Nadezhda Mandel'shtam agreed to give him four out of five for his behaviour in this case. I.B.

for fear of rendering Pasternak's none too secure position still more precarious.

Pasternak reproached me, too; not, indeed, for seeking to impose my political or any other opinions on him – but for something that to him seemed almost as bad. Here we both were, in Russia, and wherever one looked, everything was disgusting, appalling, an abominable pigsty, yet I seemed to be positively exhilarated by it: 'You wander about', he said, 'and look at every-thing with bemused eyes' – I was no better (he declared) than other foreign visitors who saw nothing, and suffered from absurd delusions, maddening to the poor miserable natives.

Pasternak was acutely sensitive to the charge of accommodat-ing himself to the demands of the Party or the State – he seemed afraid that his mere survival might be attributed to some unwor-thy effort to placate the authorities, some squalid compromise of his integrity to escape persecution. He kept returning to this point, and went to absurd lengths to deny that he was capable of conduct of which no one who knew him could begin to conceive him to be guilty. One day he asked me whether I had heard any-one speak of his wartime volume of poems *On Early Trains* as a gesture of conformity with the prevailing orthodoxy. I said truth-fully that I had not heard this, that it was an absurd suggestion.

Anna Akhmatova, who was bound to him by the deepest friendship and admiration, told me that, at the end of the War, when she was returning from Tashkent, to which she had been evacuated from Leningrad, she stopped in Moscow and visited Peredelkino. Within a few hours of arriving she received a mes-sage from Pasternak that he could not see her – he had a fever – he was in bed – it was impossible. On the next day the message was repeated. On the third day he appeared before her looking unusually well, with no trace of any ailment. The first thing he did was to ask her whether she had read this, the latest book of his poems. He put the question with so painful an expression on his face that she tactfully said that she had not, not yet; at which his face cleared, he looked vastly relieved, and they talked happily. He evidently felt ashamed, needlessly, of these poems. It seemed to him a kind of half-hearted effort to write civic poetry – there was nothing he disliked more intensely than this genre.

Yet, in 1945, he still had hopes of a great renewal of Russian life as a result of the cleansing storm that the War had seemed to him to be – a storm as transforming, in its own terrible fashion, as the Revolution itself, a vast cataclysm beyond our puny moral categories. Such vast mutations cannot, he held, be judged. One must think and think about them, and seek to understand as much of them as one can, all one's life; they are beyond good and evil, acceptance or rejection, doubt or assent; they must be accepted as elemental changes, earthquakes, tidal waves, transforming events which are beyond all ethical and historical categories. So, too, the dark nightmare of betrayals, purges, massacres of the innocents, followed by an appalling war, seemed to him a necessary prelude to some inevitable, unheard-of victory of the spirit.

I did not see him again for eleven years. By 1956 his estrangement from his country's political establishment was complete. He could not speak of it, or its representatives, without a shudder. By that time his friend Olga Ivinskaya had been arrested, interrogated, maltreated, sent to a labour camp for five years. 'Your Boris,' the Minister of State Security, Abakumov, had said to her, 'your Boris detests us, doesn't he?' 'They were right,' Pasternak said: 'she could not and did not deny it.' I had travelled to Peredelkino with Neuhaus and one of his sons by his first wife, who was now married to Pasternak. He repeated over and over again that Pasternak was a saint: that he was too unworldly – his hope that the Soviet authorities would permit the publication of *Doctor Zhivago* was plainly absurd – martyrdom of the author was far more likely. Pasternak was the greatest writer produced by Russia for decades, and he would be destroyed, as so many had been destroyed, by the State. This was an inheritance from the tsarist regime. Whatever the differences between the old and the new Russia, suspicion and persecution of writers and artists were common to both. His former wife Zinaida – now Pasternak's wife – had told him that Pasternak was determined to get his novel published somewhere. He had tried to dissuade him, but his words were in vain. If Pasternak mentioned the matter to me, would I – it was important – more than important – perhaps

a matter of life and death, who could tell, even in these days? – would I try to persuade him to hold his hand? Neuhaus seemed to me to be right: Pasternak probably did need to be physically saved from himself.

By this time we had arrived at Pasternak's house. He was waiting for us by the gate and let Neuhaus go in, embraced me warmly and said that in the eleven years during which we had not met much had happened, most of it very evil. He stopped and added, 'Surely there is something you want to say to me?' I said, with monumental tactlessness (not to say unforgivable stupidity), 'Boris Leonidovich, I am happy to see you looking so well. But the main thing is that you have survived. This seemed almost miraculous to some of us' (I was thinking of the anti-Jewish persecution of Stalin's last years). His face darkened and he looked at me with real anger: 'I know what you are thinking,' he said. 'What am I thinking, Boris Leonidovich?' 'I know, I know it, I know exactly what is in your mind,' he replied in a breaking voice – it was very frightening – 'do not prevaricate. I can see more clearly into your mind than I can into my own.' 'What am I thinking?' I asked again, more and more disturbed by his words. 'You think – I know that you think – that I have done something for *them*.' 'I assure you, Boris Leonidovich,' I replied, 'that I never conceived of this – I have never heard this suggested by anyone, even as an idiotic joke.' In the end he seemed to believe me. But he was visibly upset. Only after I had assured him that admiration for him, not only as a writer, but as a free and independent human being, was, among civilised people, worldwide, did he begin to return to his normal state. 'At least', he said, 'I can say, like Heine, "I may not deserve to be remembered as a poet, but surely as a soldier in the battle for human freedom."'[1]

He took me to his study. There he thrust a thick envelope into my hands: 'My book,' he said, 'it is all there. It is my last word. Please read it.' I read *Doctor Zhivago* during the following night and day, and when, two or three days later, I saw him again, I

---

[1] Cf. *Heinrich Heines Sämtliche Werke*, ed. Oskar Walzel (Leipzig, 1911–20), vol. 4, p. 306.

asked what he intended to do with it. He told me that he had given it to an Italian Communist, who worked in the Italian section of the Soviet radio, and at the same time was acting as an agent for the Communist Italian publisher Feltrinelli. He had assigned world rights to Feltrinelli. He wished his novel, his testament, the most authentic, most complete of all his writings – his poetry was nothing in comparison (although the poems in the novel were, he thought, perhaps the best he had written) – he wished his work to travel over the entire world, to lay waste with fire (he quoted Pushkin's famous biblical line), to lay waste the hearts of men.

After the midday meal was over, his wife, Zinaida Nikolaevna, drew me aside and begged me with tears in her eyes to dissuade him from getting *Doctor Zhivago* published abroad. She did not wish her children to suffer; surely I knew what 'they' were capable of? Moved by this plea, I spoke to the poet at the first opportunity. I promised to have microfilms of his novel made, to bury them in the four quarters of the globe, to bury copies in Oxford, in Valparaiso, in Tasmania, Cape Town, Haiti, Vancouver, Japan, so that copies might survive even if a nuclear war broke out – was he resolved to defy the Soviet authorities, had he considered the consequences?

For the second time during that week he showed a touch of real anger in talking to me. He told me that what I said was no doubt well-intentioned, that he was touched by my concern for his own safety and that of his family (this was said a trifle ironically), but that he knew what he was doing; that I was worse than that importunate Commonwealth diplomat eleven years ago. He had spoken to his sons. They were prepared to suffer. I was not to mention the matter again. I had read the book, surely I realised what it, above all its dissemination, meant to him. I was shamed into silence.

After an interval, we talked about French literature, as often before. Since our last meeting he had procured Sartre's *La Nausée*, and found it unreadable, and its obscenity revolting. Surely after four centuries of creative genius this great nation could not have ceased to generate literature? Aragon was a time-server, Duhamel, Guéhenno were inconceivably tedious; was

Malraux still writing? Before I could reply, one of his guests, a gentle, silent woman, a teacher who had recently returned after fifteen years in a labour camp, to which she had been condemned solely for teaching English, shyly asked whether Aldous Huxley had written anything since *Point Counter Point*. Was Virginia Woolf still writing? – she had never seen a book by her; but from an account in an old French newspaper which in some mysterious fashion had found its way into her camp, she thought that she might like her work.

It is difficult to convey the pleasure of being able to bring news of art and literature of the outer world to human beings so genuinely eager to receive it, so unlikely to obtain it from any other source. I told her and the assembled company all that I could of English, American, French writing. It was like speaking to the victims of shipwreck on a desert island, cut off for decades from civilisation. All they heard they received as new, exciting and delightful. The Georgian poet Titsian Tabidze, Pasternak's great friend, had perished in the Great Purge. His widow, Nina Tabidze, who was present, wanted to know whether Shakespeare, Ibsen and Shaw were still great names in the Western theatre. I told her that interest in Shaw had declined, but that Chekhov was greatly admired and often performed, and added that Akhmatova had said to me that she could not understand this worship of Chekhov. His world was uniformly drab. The sun never shone. No swords flashed. Everything was covered by a horrible grey mist. Chekhov's universe was a sea of mud with wretched human creatures caught in it helplessly. It was a travesty of life. Pasternak said that Akhmatova was wholly mistaken. 'Tell her when you see her – we cannot go to Leningrad freely, as you probably can – tell her from all of us here, that all Russian writers preach to the reader: even Turgenev tells him that time is a great healer and that kind of thing; Chekhov alone does not. He is a pure artist – everything is dissolved in art – he is our answer to Flaubert.' He went on to say that Akhmatova would surely talk to me about Dostoevsky and attack Tolstoy. But Tolstoy was right about Dostoevsky, that his novels were a dreadful mess, a mixture of chauvinism and hysterical religion: 'Tell Anna Andreevna that, and from me!' But when I saw Akhmatova again, in Oxford in 1965, I thought it best not to

report his judgement: she might have wished to answer him. But Pasternak was in his grave. In fact, she did speak to me of Dostoevsky with the most passionate admiration.

<div align="center">III</div>

This brings me to my meeting with the poet Anna Akhmatova. I had been introduced to her poems by Maurice Bowra, and longed to meet her. In November 1945 I went from Moscow to Leningrad. I had not seen the city since 1920, when I was eleven years old and my family was allowed to return to our native city of Riga, the capital of a then independent republic. In Leningrad my recollections of childhood became fabulously vivid. I was inexpressibly moved by the look of the streets, the houses, the statues, the embankments, the market places, the suddenly famil-iar, still broken, railings of a little shop in which samovars were mended, below the house in which we had lived. The inner yard of the house looked as sordid and abandoned as it had done dur-ing the first years of the Revolution. My memories of specific events, episodes, experiences came between me and the physical reality. It was as if I had walked into a legendary city, myself at once part of the vivid, half-remembered legend, and yet, at the same time, viewing it from some outside vantage-point. The city had been greatly damaged, but still in 1945 remained indescrib-ably beautiful (it seemed wholly restored by the time I saw it again, eleven years later). I made my way to the Writers' Bookshop in the Nevsky Prospekt. While looking at the books I fell into casual conversation with a man who was turning over the leaves of a book of poems. He turned out to be a well-known critic and literary historian. We talked about recent events. He described the terrible ordeal of the siege of Leningrad and the martyrdom and heroism of many of its inhabitants, and said that some had died of cold and hunger, others, mostly the younger ones, had survived. Some had been evacuated. I asked him about the fate of writers in Leningrad. He said, 'You mean Zoshchenko and Akhmatova?' Akhmatova to me was a figure from the remote past. Maurice Bowra, who had translated some of her poems, spoke about her to me as someone not heard of since the

First World War. 'Is Akhmatova still alive?' I asked. 'Akhmatova, Anna Andreevna?' he said: 'Why yes, of course. She lives not far from here on the Fontanka, in Fontanny Dom [Fountain House]; would you like to meet her?' It was as if I had suddenly been invited to meet Miss Christina Rossetti. I could hardly speak. I mumbled that I should indeed like to meet her. 'I shall telephone her,' my new acquaintance said. He returned to tell me that she would receive us at three that afternoon. I was to return to the bookshop, and we would go together.

I returned at the appointed hour. The critic and I left the bookshop, turned left, crossed the Anichkov Bridge, and turned left again, along the embankment of the Fontanka. Fountain House, the palace of the Sheremetevs, is a magnificent late baroque building, with gates of exquisite ironwork for which Leningrad is famous, and built around a spacious court – not unlike the quadrangle of a large Oxford or Cambridge college. We climbed up one of the steep, dark staircases, to an upper floor, and were admitted to Akhmatova's room. It was very barely furnished – virtually everything in it had, I gathered, been taken away – looted or sold – during the siege. There was a small table, three or four chairs, a wooden chest, a sofa, and, above the unlit stove, a drawing by Modigliani. A stately, grey-haired lady, a white shawl draped about her shoulders, slowly rose to greet us.

Anna Andreevna Akhmatova was immensely dignified, with unhurried gestures, a noble head, beautiful, somewhat severe features, and an expression of immense sadness. I bowed. It seemed appropriate, for she looked and moved like a tragic queen. I thanked her for receiving me, and said that people in the West would be glad to know that she was in good health, for nothing had been heard of her for many years. 'Oh, but an article on me has appeared in the *Dublin Review*,' she said, 'and a thesis is being written about my work, I am told, in Bologna.' She had a friend with her, an academic lady of some sort, and there was polite conversation for some minutes. Then Akhmatova asked me about the ordeal of London during the bombing: I answered as best I could, feeling acutely shy and constricted by her distant, somewhat regal manner. Suddenly I heard what sounded like my first name being shouted somewhere outside. I ignored this for a

while – it could only be an illusion – but the shouting became louder and the word 'Isaiah' could be clearly heard. I went to the window and looked out, and saw a man whom I recognised as Randolph Churchill. He was standing in the middle of the great court, looking like a tipsy undergraduate, and screaming my name. I stood rooted to the floor for some seconds. Then I collected myself, muttered an apology, and ran down the stairs. My only thought was to prevent Churchill from coming to the room. My companion, the critic, ran after me anxiously. When we emerged into the court, Churchill came towards me and greeted me effusively: 'Mr X,' I said mechanically, 'I do not suppose that you have met Mr Randolph Churchill?' The critic froze, his expression changed from bewilderment to horror, and he left as rapidly as he could. I have no notion whether I was followed by agents of the secret police, but there could be no doubt that Randolph Churchill was. It was this untoward event that caused absurd rumours to circulate in Leningrad that a foreign delegation had arrived to persuade Akhmatova to leave Russia; that Winston Churchill, a lifelong admirer of the poet, was sending a special aircraft to take Akhmatova to England, and so on.

Randolph, whom I had not met since we were undergraduates at Oxford, subsequently explained that he was in Moscow as a journalist on behalf of the North American Newspaper Alliance. He had come to Leningrad as part of his assignment. On arriving at the Hotel Astoria, his first concern had been to get the pot of caviar which he had acquired into an icebox: but, as he knew no Russian, and his interpreter had disappeared, his cries for help had finally brought down a representative of the British Council. She saw to his caviar and, in the course of general conversation, told him that I was in the city. He said that I might make an excellent substitute interpreter, and unfortunately discovered from the British Council lady where I was to be found. The rest followed. When he reached Fountain House, he adopted a method which had served him well during his days in Christ Church (his Oxford college), and, I dare say, on other occasions; 'and', he said with a winning smile, 'it worked'. I detached myself from him as quickly as I could, and after obtaining her number from the bookseller, telephoned

*'. . . after obtaining her number from the bookseller . . .' – the slip of paper
on which Akhmatova's telephone number, address and name were
written down for Berlin*

Akhmatova to offer an explanation of my precipitate departure, and to apologise for it. I asked if I might be allowed to call on her again. 'I shall wait for you at nine this evening,' she answered.

When I returned, a learned lady, an Assyriologist, was also present who asked me a great many questions about English universities and their organisation. Akhmatova was plainly uninterested and, for the most part, silent. Shortly before midnight the Assyriologist left, and then Akhmatova began to ask me about old friends who had emigrated – some of whom I might know. (She was sure of that, she told me later. In personal relationships, she assured me, her intuition – almost second sight – never failed her.) I did indeed know some of them. We talked about the composer Artur Lurie, whom I had met in America during the War. He had been an intimate friend of hers, and had set to music some of her, and of Mandel'shtam's, poetry. She asked about Boris Anrep, the mosaicist (whom I had never met): I knew little about him, only that he had decorated the floor of the entrance hall of the National Gallery with the figures of celebrated

persons – Bertrand Russell, Virginia Woolf, Greta Garbo, Clive Bell, Lydia Lopokova and the like. Twenty years later I was able to tell her that an image of herself had been added to them by Anrep. She showed me a ring with a black stone which Anrep had given her in 1917.

She had, she said, met only one foreigner – a Pole – since the First World War. She asked after various other friends – Salome Andronikova, to whom Mandel'shtam dedicated one of his most famous poems; Stravinsky's wife, Vera; the poets Vyacheslav Ivanov and Georgy Adamovich. I answered as best I could. She spoke of her visits to Paris before the First World War, of her friendship with Amedeo Modigliani, whose drawing of her hung over the fireplace – one of many (the rest had perished during the siege). She described her childhood on the shores of the Black Sea, a pagan, unbaptised land, she called it, where one felt close to an ancient, half-Greek, half-barbarian, deeply un-Russian culture. She spoke of her first husband, the celebrated poet Gumilev. She was convinced that he had not taken part in the monarchist conspiracy for which he had been executed; Gorky, who had been asked by many writers to intervene on his behalf, apparently did nothing to save him. She had not seen him for some time before his condemnation – they had been divorced some years before. Her eyes had tears in them when she described the harrowing circumstances of his death.

After a silence, she asked me whether I would like to hear her poetry. But before doing this, she said that she wished to recite two cantos from Byron's *Don Juan* to me, for they were relevant to what would follow. Even if I had known the poem well, I could not have told which cantos she had chosen, for although she read English fairly freely, her pronunciation of it made it impossible to understand more than a word or two. She closed her eyes and spoke the lines from memory, with intense emotion. I rose and looked out of the window to conceal my embarrassment. Perhaps, I thought afterwards, that is how we now read classical Greek and Latin. Yet we, too, are moved by the words, which, as we pronounce them, might have been wholly unintelligible to their authors and audiences. Then she read from her

book of poems – 'Anno Domini', 'The White Flock', 'Out of Six Books' – 'Poems like these, but far better than mine,' she said, 'were the cause of the death of the best poet of our time, whom I loved and who loved me . . .' – whether she meant Gumilev or Mandel'shtam I could not tell, for she broke down in tears, and could not go on reading.

There are recordings of her readings, and I shall not attempt to describe them. She read the (at that time) still unfinished *Poem Without a Hero*. I realised even then that I was listening to a work of genius. I do not suppose that I understood that many-faceted and most magical poem and its deeply personal allusions any better than when I read it now. She made no secret of the fact that it was intended as a kind of final memorial of her life as a poet, to the past of the city – St Petersburg – which was part of her being, and, in the form of a Twelfth Night carnival procession of masked figures en travesti, to her friends, and to their lives and destinies and her own – a kind of artistic *nunc dimittis* before the inescapable end which would not be long in coming. It is a mysterious and deeply evocative work: a tumulus of learned commentary is inexorably rising over it. Soon it may be buried under its weight.

Then she read the *Requiem*, from a manuscript. She broke off and spoke of the years 1937–8, when both her husband and her son had been arrested and sent to prison camps (this was to happen again), of the queues of women who waited day and night, week after week, month after month, for news of their husbands, brothers, fathers, sons, for permission to send food or letters to them. No news ever came. No messages ever reached them. A pall of death in life hung over the cities of the Soviet Union, while the torture and slaughter of millions of innocents were going on. She spoke in a dry, matter-of-fact voice, occasionally interrupting herself with 'No, I cannot, it is no good, you come from a society of human beings, whereas here we are divided into human beings and . . .'. Then a long silence: 'And even now . . .'. She would once more be silent. I asked about Mandel'shtam: she paused, her eyes filled with tears, and she begged me not to speak of him: 'After he slapped Aleksey Tolstoy's face, it was all

over . . .'. It took some time for her to collect herself. Then in a totally changed voice, she said, 'Aleksey Tolstoy wore lilac shirts *à la russe* when we were in Tashkent. He spoke of the marvellous time he and I would have together when we came back. He was a very gifted and interesting writer, a scoundrel, full of charm, and a man of stormy temperament. He is dead now. He was capable of anything, anything. He was a wild adventurer. He liked only youth, power, vitality. He didn't finish his *Peter the First* because he said that he could only deal with Peter as a young man; what was he to do with all those people when they grew old? He was a kind of Dolokhov. He called me Annushka. That made me wince, but I liked him very much, even though he was the cause of the death of the best poet of our time, whom I loved, and who loved me.' (Her words were identical with those she had used earlier; it now seemed clear to me to whom, on both occasions, she was referring.)

It was, I think, by now about three in the morning. She showed no sign of wishing me to leave, and I was far too moved and absorbed to stir. She left the room and came back with a dish of boiled potatoes. It was all she had, and she was embarrassed at the poverty of her hospitality. I begged her to let me write down the *Poem without a Hero* and *Requiem*: she said there was no need for that. A volume of her collected verse was due to appear the next February. It was all in proof. She would send me a copy. The Party, as we know, ruled otherwise. She was denounced by Zhdanov (in a phrase which he had not invented) as 'half nun, half harlot'.[1] This put her beyond the official pale.

We talked about Russian literature. After dismissing Chekhov because of the absence in his world of heroism and martyrdom, of depth and darkness and sublimity, we talked about *Anna Karenina*. 'Why did Tolstoy make her commit suicide? As soon as she leaves Karenin, everything changes. She suddenly turns

[1] A similar formula had been used, in a very different context, by the critic Boris Eikhenbaum, in *Anna Akhmatova: opyt analiza* (Petersburg, 1923), p. 114, to describe the mingling of erotic and religious motifs in Akhmatova's early poetry. It reappeared in 1930, in a caricatured form, in an unfriendly article on her in the Soviet Literary Encyclopaedia, whence it found its way into Zhdanov's anathema of 1946.

into a fallen woman, a *traviata*, a prostitute. Who punishes Anna? God? No, not God – society – that same society whose hypocrisies Tolstoy is constantly denouncing. In the end he tells us that Anna repels even Vronsky. Tolstoy is lying. He knew better than that. The morality of *Anna Karenina* is the morality of Tolstoy's Moscow aunts, of philistine conventions. It is all connected with his personal vicissitudes. When Tolstoy was happily married he wrote *War and Peace*, which celebrates the family. After he started hating Sophia Andreevna, but could not divorce her, because divorce is condemned by society, and maybe by the peasants too, he wrote *Anna Karenina*, and punished Anna for leaving her husband. When he was old, and felt guilt for still lusting violently after peasant girls, he wrote *The Kreutzer Sonata* and forbade sex altogether.'

These were her words. I do not know how seriously they were meant, but Akhmatova's dislike of Tolstoy's sermons was genuine – she regarded him as a monster of vanity, and an enemy of freedom. She worshipped Dostoevsky and, like him, despised Turgenev. And, after Dostoevsky, Kafka, whom she read in English translations. ('He wrote for me and about me,' she told me years afterward in Oxford – 'Kafka is a greater writer than even Joyce and Eliot. He did not understand everything; only Pushkin did that.') She then spoke to me about Pushkin's *Egyptian Nights*, and about the pale stranger in that story who improvised verse on themes supplied by the audience. The virtuoso, in her opinion, was the Polish poet Adam Mickiewicz. Pushkin's relation to him became ambivalent. The Polish issue divided them. But Pushkin always recognised genius in his contemporaries. Blok was like that – with his mad eyes and marvellous genius, he too could have been an *improvisateur*. She said that Blok had never liked her, but that every schoolmistress in Russia believed, and would doubtless go on believing, that they had had a love-affair. Historians of literature believed this too. All this, in her opinion, was based on her poem *A Visit to the Poet*, dedicated to Blok; and, perhaps, also on the poem on the death of *The Grey-Eyed King*, although that was written more than ten years before Blok died. Blok liked none of the Acmeists, of whom she was one. He did not like Pasternak either.

She then spoke about Pasternak, to whom she was devoted. After Mandel'shtam's and Tsvetaeva's deaths, they were alone. The knowledge that the other was alive and at work was a source of infinite comfort to both of them. They criticised each other freely, but allowed no one else to do so. The passionate devotion of countless men and women in the Soviet Union who knew their verse by heart, and copied it and circulated it, was a source of pride to them. But they both remained in exile. The thought of emigration was hateful to both. They longed to visit the West, but not if it meant that they would be unable to return. Their deep patriotism was not tinged by nationalism. Akhmatova was not prepared to move. No matter what horrors might be in store, she would never abandon Russia.

She spoke of her childhood, her marriages, her relationships with others, of the rich artistic life in Petersburg before the First World War. She had no doubt that the culture of the West, especially now, in 1945, was far superior to it. She spoke about the great poet Annensky, who had taught her more even than Gumilev, and died largely ignored by editors and critics, a great forgotten master. She spoke about her loneliness and isolation. Leningrad, after the War, was for her nothing but the graveyard of her friends – it was like the aftermath of a forest fire, the few charred trees made the desolation still more desolate. She lived by translating. She had begged to be allowed to translate the letters of Rubens, not those of Romain Rolland. After unheard-of obstacles, permission was finally granted. I asked her what the Renaissance meant to her – was it a real historical past, or an idealised vision, an imaginary world? She replied that it was the latter. She felt nostalgia for it – that longing for a universal culture of which Mandel'shtam had spoken, as Goethe and Schlegel had thought of it – a longing for what had been transmuted into art and thought – nature, love, death, despair and martyrdom – a reality which had no history, nothing outside itself. She spoke in a calm, even voice, like a remote princess in exile, proud, unhappy, unapproachable, often in words of the most moving eloquence.

The account of the unrelieved tragedy of her life went beyond anything which anyone had ever described to me in spoken

words; the recollection of it is still vivid and painful to me. I asked her whether she intended to compose a record of her literary life. She replied that her poetry was that, in particular the *Poem without a Hero*, which she read to me again. Once more I begged her to let me write it down. Once again she declined. Our conversation, which touched on intimate details of both her life and my own, wandered from literature and art, and lasted until late in the morning of the following day. I saw her again when I was leaving the Soviet Union to go home by way of Leningrad and Helsinki. I went to say goodbye to her on the afternoon of 5 January 1946, and she then gave me one of her collections of verse, with a new poem inscribed on the flyleaf – the poem that was later to form the second in the cycle entitled *Cinque*. I realised that this poem, in this, its first version, had been directly inspired by our earlier meeting. There are other references and allusions to our meetings, in *Cinque* and elsewhere.

I did not see her on my next visit to the Soviet Union, in 1956. Her son, who had been re-arrested, had been released from his prison camp earlier that year, and Pasternak told me that she felt acutely nervous about seeing foreigners except by official order, but that she wished me to telephone her; this was far safer, for all her telephone conversations were monitored. Over the telephone she told me something of her experiences as a condemned writer; of the turning away by some whom she had considered faithful friends, of the nobility and courage of others. She had reread Chekhov, and said that at least in *Ward No 6* he had accurately described her situation, and that of many others. Meanwhile her translations from the classical Korean verse had been published – 'You can imagine how much Korean I know; it is a selection; not selected by me. There is no need for you to read it.'

When we met in Oxford in 1965 Akhmatova told me that Stalin had been personally enraged by the fact that she had allowed me to visit her: 'So our nun now receives visits from foreign spies,' he is alleged to have remarked, and followed this with obscenities which she could not at first bring herself to repeat to me. The fact that I had never worked in any intelligence organisation was irrelevant. All members of foreign missions were spies to Stalin. Of course, she said, the old man was by then out of his

mind, in the grip of pathological paranoia. In Oxford she told me that she was convinced that Stalin's fury, which we had caused, had unleashed the Cold War – that she and I had changed the history of mankind. She meant this quite literally and insisted on its truth. She saw herself and me as world-historical personages chosen by destiny to play our fateful part in a cosmic conflict, and this is reflected in her poems of this time. It was intrinsic to her entire historico-philosophical vision, from which much of her poetry flowed.

She told me that after her journey to Italy in the previous year, when she had been awarded a literary prize, she was visited by officials of the Soviet secret police, who asked her for her impressions of Rome. She replied that Rome seemed to her to be a city where paganism was still at war with Christianity. 'What war?' she was asked. 'Was the USA mentioned? Are Russian émigrés involved?' What should she answer when similar questions were put to her about England and Oxford? For to Russia she would return no matter what awaited her there. The Soviet regime was the established order of her country. With it she had lived, and with it she would die. This is what being a Russian meant.

We returned to Russian poetry. She spoke contemptuously of well-known young poets, favoured by the Soviet authorities. One of the most famous of these, who was in England at the time, had sent her a telegram to Oxford to congratulate her on her honorary doctorate. I was there when it arrived. She read it, and angrily threw it in the waste-paper basket – 'They are all little bandits, prostitutes of their gifts, and exploiters of public taste. Mayakovsky's influence has been fatal to them all. Mayakovsky shouted at the top of his voice because it was natural to him to do so. He could not help it. His imitators have adopted his manner as a genre. They are vulgar declaimers with not a spark of true poetry in them.'

There were many gifted poets in Russia now: the best among them was Joseph Brodsky, whom she had, she said, brought up by hand, and whose poetry had in part been published – a noble poet in deep disfavour, with all that that implied. There were others, too, marvellously gifted – but their names would mean nothing to me – poets whose verses could not be published, and

whose very existence was testimony to the unexhausted life of the imagination in Russia: 'They will eclipse us all,' she said, 'believe me, Pasternak and I and Mandel'shtam and Tsvetaeva, all of us are the end of a long period of elaboration which began in the nineteenth century. My friends and I thought we spoke with the voice of the twentieth century. But these new poets constitute a new beginning – behind bars now, but they will escape and astonish the world.' She spoke at some length in this prophetic vein, and returned again to Mayakovsky, driven to despair, betrayed by his friends, but, for a while, the true voice, the trumpet, of his people, though a fatal example to others; she herself owed nothing to him, but much to Annensky, the purest and finest of poets, remote from the hurly-burly of literary politics, largely neglected by avant-garde journals, fortunate to have died when he did. He was not read widely in his lifetime, but then this was the fate of other great poets – the present generation was far more sensitive to poetry than her own had been: who cared, who truly cared about Blok or Bely or Vyacheslav Ivanov in 1910? Or, for that matter, about herself and the poets of her group? But today the young knew it all by heart – she was still getting letters from young people, many of them from silly, ecstatic girls, but the sheer number of them was surely evidence of something.

Pasternak received even more of these, and liked them better. Had I met his friend Olga Ivinskaya? I had not. She found both Pasternak's wife, Zinaida, and his mistress equally unbearable, but Boris Leonidovich himself was a magical poet, one of the great poets of the Russian land: every sentence he wrote, in verse and prose, spoke with his authentic voice, unlike any other she had ever heard. Blok and Pasternak were divine poets; no modern Frenchman, no Englishman, not Valéry, not Eliot, could compare with them – Baudelaire, Shelley, Leopardi, that was the company to which they belonged. Like all great poets, they had little sense of the quality of others – Pasternak often praised inferior critics, discovered imaginary hidden gifts, encouraged all kinds of minor figures – decent writers but without talent – he had a mythological sense of history, in which quite worthless people sometimes played mysterious significant roles – like Evgraf in *Doctor Zhivago* (she vehemently denied that this mysterious figure was

in any respect based on Stalin; she evidently found this impossible to contemplate). He did not really read contemporary authors he was prepared to praise – not Bagritsky or Aseev, not even Mandel'shtam (whom he could not bear, though of course he did what he could for him when he was in trouble), nor her own work – he wrote her wonderful letters about her poetry, but the letters were about himself, not her – she knew that they were sublime fantasies which had little to do with her: 'Perhaps all great poets are like this.'

Pasternak's compliments naturally made those who received them very happy, but this was delusive; he was a generous giver, but not truly interested in the work of others: interested, of course, in Shakespeare, Goethe, the French Symbolists, Rilke, perhaps Proust, but 'not in any of us'. She said that she missed Pasternak's existence every day of her life; they had never been in love, but they loved one another deeply and this irritated his wife. She then spoke of the 'blank' years during which she was officially out of account in the Soviet Union – from the mid-1920s until the late '30s. She said that when she was not translating, she read Russian poets: Pushkin constantly, of course, but also Odoevsky, Lermontov, Baratynsky – she thought Baratynsky's *Autumn* was a work of pure genius; and she had recently reread Velimir Khlebnikov – mad but marvellous.

I asked her if she would ever annotate the *Poem without a Hero*: the allusions might be unintelligible to those who did not know the life it was concerned with; did she wish them to remain in darkness? She answered that when those who knew the world about which she spoke were overtaken by senility or death, the poem would die too; it would be buried with her and her century; it was not written for eternity, nor even for posterity: the past alone had significance for poets – childhood most of all – those were the emotions that they wished to re-create and re-live. Vaticination, odes to the future, even Pushkin's great epistle to Chaadaev, were a form of declamatory rhetoric, a striking of grandiose attitudes, the poet's eye peering into a dimly discernible future, a pose which she despised.

She knew, she said, that she had not long to live. Doctors had made it plain to her that her heart was weak. Above all, she did

not wish to be pitied. She had faced horrors, and had known the most terrible depths of grief. She had exacted from her friends the promise that they would not allow the faintest gleam of pity for her to occur; hatred, insult, contempt, misunderstanding, persecution she could bear, but not sympathy if it was mingled with compassion. Her pride and dignity were very great.

The detachment and impersonality with which she seemed to speak only partially disguised her passionate convictions and moral judgements, against which there was plainly no appeal. Her accounts of personalities and lives were compounded of sharp insight into the moral centre of characters and situations (she did not spare her friends in this respect) together with fixed ideas, from which she could not be moved. She knew that our meeting had had serious historical consequences. She knew that the poet Georgy Ivanov, whom she accused of having written lying memoirs after he emigrated, had at one time been a police spy in the pay of the tsarist government. She knew that the poet Nekrasov in the nineteenth century had also been a government agent; that the poet Annensky had been hounded to death by his literary enemies. These beliefs had no apparent foundation in fact – they were intuitive, but they were not senseless, not sheer fantasies; they were elements in a coherent conception of her own and her nation's life and fate, of the central issues which Pasternak had wanted to discuss with Stalin, the vision which sustained and shaped her imagination and her art. She was not a visionary; she had, for the most part, a strong sense of reality. She described the literary and social scene in Petersburg before the First World War, and her part in it, with a sober realism and sharpness of detail which made it totally credible.

Akhmatova lived in terrible times, during which, according to Nadezhda Mandel'shtam, she behaved with heroism. She did not in public, nor indeed to me in private, utter a single word against the Soviet regime. But her entire life was what Herzen once described Russian literature as being – one continuous indictment of Russian reality. The worship of her memory in the Soviet Union today, undeclared but widespread, has, so far as I know, no parallel. Her unyielding passive resistance to what she regarded as unworthy of her country and herself transformed her

into a figure (as Belinsky once predicted about Herzen) not merely in Russian literature, but in the Russian history of our time.

My meetings and conversations with Boris Pasternak and Anna Akhmatova; my realisation of the conditions, scarcely describable, under which they lived and worked, and of the treatment to which they were subjected; and the fact that I was allowed to enter into a personal relationship, indeed, friendship, with them both, affected me profoundly and permanently changed my outlook. When I see their names in print, or hear them mentioned, I remember vividly the expressions on their faces, their gestures and their words. When I read their writings I can, to this day, hear the sound of their voices.

# BORIS PASTERNAK

## *1958*

BORIS LEONIDOVICH PASTERNAK is the greatest Russian writer of our day. No one, not even his bitterest political or personal critics, has dared to deny that he is a lyrical poet of genius whose verse has achieved immortality in his own lifetime, and whose unique position in Russian literature the verdict of posterity is unlikely to alter. The publication abroad of his novel *Doctor Zhivago* has brought him world-wide fame such as no Russian writer since Gorky has enjoyed. Like Gorky (with whom he otherwise has little in common) he accepted the Revolution. Unlike Gorky and other gifted writers of the Revolution – Aleksey Tolstoy, Ehrenburg, Bunin, Kuprin – he never became an émigré. He remained in his own country and shared the sufferings of his nation to the full.

He never ceased writing: when the great persecutions of art and literature began under Stalin in the 1940s his works were virtually suppressed, and he was allowed to publish very little. Nevertheless the mere existence among them of a man of magnificent and undisputed genius continued to have a profound moral effect upon literate Russians and upon a good many of those who knew of his achievement only by hearsay but looked on him as a secular saint and martyr who remained faithful to his beliefs and his art against appalling pressure, which broke many other writers.

His position today is extraordinary: like Tolstoy towards the end of his life he is a world-famous writer disapproved of by the government of his country, but regarded even by his critics with a peculiar admiration not unmixed with awe, which genius sometimes inspires. He is a man wholly absorbed in his poetry: his writing and his way of life serves his ideal with a most single-

hearted purity and devotion. Not even the most captious critics have ever maintained against him that he has made his art serve any ulterior ends, personal or political, or any end but that of pure artistic creation. Everyone who has ever met him knows how inconceivable it is that he should ever take part in a movement or campaign or deviation towards the right or towards the left in any political or literary alignment or intrigue. He is a solitary, innocent, independent, wholly dedicated figure. His integrity and innocence have been known to move even the most hardened and cynical bureaucrats, upon whose favour his survival has inevitably depended.

Soviet critics have for many years accused him of being esoteric, sophisticated, over-elaborate, remote from contemporary Soviet reality. What they mean, I think, is that his poetry has been neither propagandist nor decorative. But if what is meant is that his writing is concerned with a private world, or that he speaks in a private language, or is in any sense turned in upon himself, deliberately insulated from the world in which he lives, the charge is wholly groundless. From his earliest years, both as a poet and as a playwright, Pasternak has written out of his direct experience, personal or social or indeed political, in the central tradition of all great Russian writing. And if his poetry is not transparently autobiographical, as is that, for example, of his contemporary, the poetess Akhmatova, that is because it is in the nature of his art to transmute and not to record. It has been said that all Russian writing is a personal confession, an *aveu*: Pasternak may be a Westerner in the sense that he does not address direct sermons to the reader as Gogol or Dostoevsky or Tolstoy or even Turgenev often do. Whatever a writer has to say must be turned into his art and not be attached to it as an extra artistic appendage or lay sermon outside the world created by the artist. In this respect he follows Chekhov, who transmutes anything, without residue, into the story itself. But his writing, like that of Chekhov, and of all his great predecessors, including the great Symbolist poets of whom he is a younger contemporary, is penetrated by the sense of the responsibility of the artist.

The artist is not a priest or a purveyor of beautiful objects but speaks the truth in public, founded directly upon his own imme-

diate experience: in the face of this truth he is merely more impressionable, more responsive, a more penetrating and articulate critic and exponent than ordinary men. In this sense his art and his conception of it is far closer to the classical 'social' doctrine of the artist as the most heightened expression of his time and milieu, the classical doctrine of Belinsky and Herzen, than are the later aesthetically 'pure' critics and poets. He looked upon this attitude – which Marxism absorbed – as too close to vulgar utilitarianism. In this sense Pasternak is not at all close to the purists and aesthetes of St Petersburg. He was born in Moscow and has lived the greater part of his life there, and the influences by which he is moulded, the imaginative and humane impressionism of his father's paintings, his family friendship with Tolstoy, which deeply coloured his childhood and early youth, the metaphysical attitudes of Skryabin, from whom he took lessons in musical composition at a time when he thought that he wished to write music, the social and religious doctrines of Andrey Bely, and the revolutionary futurism of his great friend Mayakovsky, the laureate of the Lenin era of Bolshevism, militated violently against disinterested aestheticism of this type.

Pasternak has never abandoned this direction, he has never retreated into any private citadel or sought to escape from reality in any sense of the words. During his most experimental period, when like the other young revolutionary poets he wrote in a broken, violently distorted, episodic manner, of which there are plenty of analogues in the West, this was a means and nothing more than a means of expressing and reconstructing the real world of action, social upheaval and politics in which he fully lived. The fact that *Doctor Zhivago* has taken the Western world by storm is due in part to the fact that its readers are as a rule not acquainted with the author's earlier work, to which it is vastly superior but with which it has obvious affinity. The earlier biographical fragment *Safe Conduct* and the stories written in the 1920s, on which the author is said now to look with little favour, create worlds of experience, they are not mere exercises in craft or virtuoso pieces. The gift that Pasternak possesses beyond all other writers of his generation is that of conveying the organic quality, the pulsation of life within any object in the universe that

he creates. No artist has ever exemplified more vividly the Renaissance theory of the artist as creator, as a rival to nature herself. Stones, trees, earth, water are endowed with a life of their own in an almost mystical vision which fills his poetry from its earliest beginnings. This vision gives its own independent vitality to the human characters who populate his pages, to the buildings which they inhabit, the streets they walk, the three-dimensional social and political situations in which they find themselves. This supreme genius for infusing life into impersonal events – revolutions, wars, the rooms in which human beings speak or sleep or think – is at the very opposite pole to realism and naturalism, still remoter from photographic fidelity or journalism.

The contrast between Pasternak and other Soviet writers (with certain honourable exceptions) is not that he is unpolitical, whereas they are involved in the fortunes of their country or their creed; but that their gifts are small, their techniques crude, and the characters whom they create dead from the start. This is borne out all too vividly by the personality of the poet as he has now been described by numerous foreign visitors, with his magnificently expressive and handsome face (one described by one of his contemporaries as looking like 'an Arab and his horse'), the extraordinary quality of his language, even in the most ordinary conversation, rich with similes and images, with which this tense, passionate and inwardly secure man of genius delights, moves and overwhelms all who come to see him in his little house in the writers' village near Moscow. There is something astonishing and profoundly moving in this spectacle of an entirely honest, very gifted man living in the midst of a revolution which he has never opposed, speaking across the heads of his fellow citizens to the world. His language, which is the more effective because of a certain old-fashioned sublimity which disappeared from the Western world long ago, reminds one painfully of what it once was to be a great man.

There are writers – great poets among them – whose poetry is distinct from their life and their prose. The life, the other activities, of Browning or Malory or T. S. Eliot are not specifically those of poets. In Pasternak these divisions do not occur. Everything that he says, writes is poetical: his prose is not that of a

prose-writer but of a poet, with all its merits and defects; his views, his sense of life, his politics, his faith in Russia, in the Revolution, in the new world to come, which is very deep, have the clarity and the concreteness of a poetical vision. He is the last and one of the greatest representatives of the so-called 'Silver Age' of Russian literature. It is difficult to think of any figure comparable to him in gifts, vitality, impregnable integrity and moral courage and solidity anywhere in the world. Whether they agree or disagree with his point of view, the vast majority of Soviet citizens who have heard of him feel a pride in him and feel him, whatever his critics may say, to be at one with them in all the phases of their difficult lives. He has the respect of Communists, non-Communists and anti-Communists alike. No writer has achieved a comparable status in our time.

# WHY THE SOVIET UNION
# CHOOSES TO INSULATE ITSELF

*1946*

SINCE MY QUALIFICATIONS FOR speaking on the Soviet Union are nothing more than a knowledge of the language, and a period of four months[1] spent in Russia, mine are fugitive impressions only. I have used the word 'insulate' rather than 'isolate' because, while 'isolationist' correctly describes that section of American opinion which desires to dissociate itself entirely from the outside world, this is not Russia's attitude. She is ready to take a part in international relations, but she prefers other countries to abstain from taking an interest in her affairs: that is to say, to insulate herself from the rest of the world without remaining isolated from it.

I will not go over the general background of eighteenth- and nineteenth-century Russian history. The general reasons for Russia's mistrust of the West are familiar: that she has never for long been a part of Europe, has not mingled frequently with the European nations, and, in consequence, feels dangerously inferior. It is interesting to note that, with the possible exception of Turgenev, there is no great Russian writer who did not suffer from xenophobia, amounting at times to acute hatred of the West. There is a permanent neurosis resulting from this uneasy position which Russia feels she occupied – 'Scythians' belonging neither to East nor West. Economic backwardness is generally advanced as the main reason for her inferiority complex, but I wonder if it is perhaps more complicated than that.

One peculiar cause of Russia's disquiet about the West, which I have noticed in talks with Soviet officials and journalists, is the

---

[1] Mid-September 1945 to early January 1946.

method by which they themselves account for the traditional Russian attitude towards Europe – and towards Great Britain in particular. Her present-day attitude is an inheritance from the only possible explanation – in Russian eyes – of the immense nineteenth-century expansion of imperial Britain. How, the Russians ask, did so small a country manage to spread itself over the face of the earth? There can be only one answer; within the boundaries of this small island there is a tremendous concentration of intellect and energy serving a long-term, Machiavellian plan. For the Russians, regarding themselves as clumsy giants, born muddlers gifted with great emotional resources, this theory has gradually hardened into fact – they assume that every thoughtless British step is part of some long-term scheme: if it is not so, they argue, how can Britain have acquired such power?

One may remark, with some amusement, that this is far from commonly the case; ours is a hand-to-mouth policy, operating by fits and starts, and often an absent-minded one at that. Yet into this theory, this hypothetical pattern of long-term policy, the Russians dovetail each piece of evidence. Forced into so unnatural a schema, British policy is bound to appear malevolent and, naturally, counter-measures have to be taken by the Russians: from Russian counter-measures spring British counter-measures, and so the vicious circle of misunderstanding continues. The 'long-term plan' theory of British policy is strengthened by Marxism, which leads officials to interpret British motives in terms of conscious or unconscious class warfare. A fantastic interpretation of the case of Hess as an elaborate piece of double-crossing by Winston Churchill convinces them of superior British cunning – yet if one asks them for proof of any such theory they can produce no concrete evidence, but will merely say that the British deceived others and themselves. The British do not understand the inexorable governing laws of their history, and are mistaken in imagining that they obey ephemeral impulses. British policy obeys the laws of capitalism hurrying to its doom. Any attempt to refute this shows the author to be a fool or a knave. It is difficult to shake the Russians out of this hypothesis, since, whichever way the evidence points, it is supported equally by positive and negative instances.

It is impossible to wonder at the Russians for taking counter-measures, once the complete acceptance of these fixed ideas has been understood. I have heard it said that the Russians have ceased to be conscious Marxists and have become nationalist and opportunist. I do not agree: there is still a universal adherence to a very crude and simple form of Marxism – there might be a change of tactics, perhaps, but there is no change of strategy. This, I feel, is an important fact, because of the fundamental beliefs involved in an acceptance of Marxism – if the rulers of a nation believe in the inevitable internal conflict of capitalism, that belief will have its effect on the nation's foreign policy. Russia's attitude towards Britain is not strictly one of suspicion – this is an illusion on the part of the British. There are plenty of shrewd people in the Soviet Union who know the British well. 'Suspicion' implies that closer acquaintance will bring warmer feelings. This assumption springs from national vanity: there is no reason to think that when the Russians know our true face (and vice versa) they may not distrust it even more than they do now. Suspicion feeds on ignorance, disapproval, which is what many Russians feel, not on knowledge. The more they know the less they forgive. It may as well be faced that they think a non-capitalist world society will in time become a reality, and that this is a fact which is bound to drive other countries against them. Soviet foreign policy is in this sense ideological – I doubt whether the possession, in itself, of Trieste, for example, or the Straits is a basic point; it involves the assumption that Russia wants these places for military purposes. This, I think, is not quite so – their particular demands vary with the regime that is in control of these areas. The Soviet Union still regards Italy as a potentially pro-Fascist country, and is therefore urgent in her demands that Trieste should go to Yugoslavia: for the same reason she raises difficulties with Turkey by way of 'Armenian' or 'Georgian' claims.

There is one point I want to make: the security of the Russian system is uppermost in the Russian official mind; it is not a question of frontier security but of something more intangible. The Russians may be cynical about the means with which they achieve these ends, but they are not cynical about the ends them-

selves: they really do believe in the basic principles on which their State is founded, and while other systems exist which might compete with theirs, and until their principles are generally accepted, they will remain nervous and security-conscious. It is thus a little simple of the British Government and public opinion, I think, to imagine that the Russians can react to the difference between a liberal and illiberal Britisher, and that by sending to Moscow people who might be supposed to be sympathetic to the Soviet Union any real understanding can be achieved. To them the British are capitalists, and vastly cunning; the subtle distinction between broad and narrow views means no more than that between right-wing and left-wing Communists does to us.

The Soviet Union is most usefully viewed as an educational establishment. It is not a prison – that is a distortion. Its citizens feel much as boys at school, and the main purpose of the school is to educate the Russians into equality with the West as soon as possible. The main point, sometimes admitted by officials, is that the Russians are half barbarian, and they have to be made conscious of Western civilisation and civilised values. This cannot be done by kindness in a school of two hundred million pupils. It is the same principle as that of the old headmaster: to make men out of callow boys you beat them at regular intervals; otherwise they will be done down by their maturer fellows.

The simplified form of Marxism held by most ordinary people in the USSR is extraordinarily like public school religion, actively believed in by a small minority, passively held by the rest. The Soviet Press may be said to pursue aims similar to those of the school magazine, and, to pursue the analogy further, visitors to the Soviet Union are treated much as strangers found loitering round a school and talking to the boys. As the stranger is not necessarily suspected of warping a boy's mind, so the visitor is not always suspected of spying and plotting – but of wasting the boy's time by distracting his attention. To talk of other standards, political or cultural, to a Russian is thought to deflect him from his purpose and waste his energy. Taken in its context, this is a rational attitude for the Soviet authorities to assume, when they are trying to build up a new society in an imaginary race against time and in a ring of jealous enemies.

It is an attitude relaxed, perforce, during the war, but lately it has been tightened up. The West was surprised at the wartime relaxation of security, but the position was analogous to a Field Day for the school OTC. School regulations are forgotten while uniforms are worn – smoking and even rude language are tolerated – and so it was for the Soviet armies abroad. On their return, like boys again, officials fear lest they have become too independent to accept what is still very necessary school discipline. It is difficult to say whether an end will ever be put to these stringent precautions. Officials say that the bonds of discipline will eventually be relaxed, but I wonder whether the means are not so rigid that the ends they are designed to further become thereby less and less attainable.

There was a typical conversation between a high-ranking Soviet official and an MP visiting Russia with a parliamentary delegation. The MP spoke of the wall of suspicion that had existed between the two peoples, how it would break down and how friendship would grow up in its place. 'But,' said he, 'close though we may come, a certain friction is always inevitable.' 'Ah yes,' replied the official, 'no matter how much we limit our people's contacts, as we always shall.' This shows how much real meaning the Russians attach to routine benevolent patter of this kind.

In face of the Russians' tendency to invent a simple formula to explain the British, the British respond with an equally misleading misreading of Soviet motives. The USSR is not to be interpreted purely in terms of Ivan the Terrible and Peter the Great plus an oriental outlook. Their economic and social views and practices are fundamental. But even these are not the crucial issue between them and us. The main point of conflict is the problem of civil liberties: in the Soviet Union civil liberties are a matter of arbitrary decision, like privileges allowed to schoolboys, and they see the British insistence on them as a political defence against the liquidation of capitalist society – doomed by history but able in its own way. This came out very clearly over Indonesia. There was nothing in the Soviet papers for a week to ten days: a brutal massacre of the rebels, with the streets swimming in gore, would have been interpreted as a traditional bout of powerful imperial-

ism – and the Russians, fearing British force, would then have had to temporise. As the British had behaved in an enlightened way, the Russians had seen in forbearance the seeds of decadence and uncertainty – Kerenskyism, an imperialism no longer sure of itself, and therefore ripe for dissolution, and worth attacking at once and quite hard.

This country has undergone a profound change of sentiment towards Russia – from being the Red Menace she became our ally in a long war. There was the guilt of Munich to reinforce this change – but lately our public has felt deceived by what it has interpreted as a change for the worse in Russian foreign policy. Britain has developed a formula which describes the Russians as expansionist imperialists, but it has become plain that this is not so, and the disillusion following the failure of the formula is so great that our journals and their readers do not know which way to turn. Both countries are using inadequate formulae to explain each other's attitudes.

The reason for Russia's present 'tough' behaviour is possibly that she feels herself quite genuinely deceived. Britain at first appeared to wish to play with Russia, then came Munich, which they saw as a betrayal, in the first instance, of themselves. And so to some degree it undoubtedly was. Then, in spite of an apparently general Russian expectation of a British switch to co-belligerency with Germany, or, at best, to neutrality, Britain surprised her by offering alliance. Then came the period of the Big Three, and the dominance of Roosevelt and Churchill, which Stalin seemed to understand and believe in; then the death of Roosevelt and the defeat of Churchill – never understood in Russia. The Russians do not now know where they are: they would have understood a division of Europe into spheres of influence, and a cynical and complete disregard of UNO, but they do not understand a system of democratic co-operation on the part of powers of glaringly unequal strength and influence, because this means the League, and the League means an Anglo-Saxon anti-Russian hegemony.

At the end of 1945 there may have come a moment when a crucial decision had to be taken on economic relations with the West. I do not believe that there are two 'ideological' schools of

thought in Russia, one which favours co-operation with the West and one which does not: any systematic minority school of thought would long ago have been eliminated. Co-operation with the West is no doubt something pressed by specific departments, for example, the Foreign Ministry, or that of Foreign Trade – a functional, departmental line, not a political one – and is resisted by, say, the Security Police, probably for similarly professional motives: there is no evidence of any ideological basis for this line. In the same way there is no concrete evidence that the atomic bomb has made any difference to Russian policy. Yet it is interesting that Stalin chose December 1945 to announce another Fifteen-Year Plan. After all, the Russians suffered severe casualties during the war – millions of men lost – and great agricultural and industrial areas were ravaged and disordered. It was a moment when they might reasonably have hoped for some relaxation of material conditions – yet Stalin chose that moment to ask for a further tightening of the Russian belt. This called for great psychological courage, in my view, because although there might not exist such a thing as public opinion in Russia, there is public sentiment. It could have been done only if there appeared no alternative to reliance on their own economic and military power, and done on the ground that Marxism and the sacrifices which it calls for are the only concrete and valid defence in a world full of fools manipulated by 'reactionary' knaves.

I conclude with a criticism of British policy towards Russia. It is necessary to remember that the Russians do not believe a word we say, because they think they understand us more clearly than we do ourselves. Talk, especially soft talk, does no manner of good; and I think Ernest Bevin's truculence works no better, because it serves only to irritate the Russians without frightening them: they do not believe that we have the resources to back our strong words. The only way to convince them that the British mean no harm is simply by not meaning any: they will always judge behaviour by deeds and not by words. If we follow an undeviating policy with whatever we believe right for its end, making concessions where possible, but not letting the end out of sight, and if we treat the Russians as any other great power,

despite their odd non-reciprocating behaviour, and do not answer back, despite their intolerable provocation, but firmly contrive to work for whatever seems in our, and the world's, crucial interest, then we may hope for success. Otherwise the wrangle of policies will become an ideological, ultimately armed, conflict, and end in a war between principles equally unacceptable to liberal persons.

# THE ARTIFICIAL DIALECTIC

*Generalissimo Stalin and the Art of Government*

*1952*

There was once a man who had taken employment as a steward on a seagoing ship. It was explained to him that, in order to avoid breaking plates when the ship was rolling in heavy weather, he must not walk in a straight line, but try to move in a zigzag manner: this was what experienced seamen did. The man said that he understood. Bad weather duly came, and presently there was heard the terrible sound of breaking plates as the steward and his load crashed to the ground. He was asked why he had not followed instructions. 'I did,' he said. 'I did as I was told. But when I zigged the ship zagged, and when I zagged the ship zigged.'

Capacity for careful co-ordination of his movements with the dialectical movement of the Party – a semi-instinctive knowledge of the precise instant when zig turns into zag – is the most precious knack that a Soviet citizen can acquire. Lack of facility in this art, for which no amount of theoretical understanding of the system can compensate, has proved the undoing of some of the ablest, most useful and, in the very early days, most fanatically devoted and least corrupt supporters of the regime.[1]

I

WE ARE LIVING in an age when the social sciences claim to be able to predict more and more accurately the behaviour of groups and individuals, rulers and ruled. It is strange, then, to find that

[1] These two paragraphs formed the original conclusion of the essay: see p. xxxi above.

98

one of the political processes which still causes the greatest perplexity is to be found not in some unexplored realm of nature, nor in the obscure depths of the individual soul, intractable to psychological analysis, but in a sphere apparently dominated by iron laws of reason, from which, supposedly, the influence of random factors, human whims, unpredictable waves of emotion, spontaneity, irresponsibility, anything tending to loosen the rigorously logical nexus, has been remorselessly eliminated. The process to which I refer is the 'general line' of the Communist Party of the Union of Soviet Socialist Republics. Its abrupt and violent changes of direction puzzle not merely the outside world, but Soviet citizens; and not merely Soviet citizens, but members of the Communist Party itself at home and abroad – to whom, as often as not, it occasions disconcerting, violent and even fatal surprise.

Inability to predict the curious movements of the line is a crucial failure in a Communist. At best it upsets all his personal calculations; at worst, it brings total ruin upon him. Thus the history of Communist Parties outside Russia – and notably of the German Party – provides many instances where sudden switches of the Moscow 'line' have involved these Parties in major disasters. The spate of books by such well informed ex-Communists as Barmine, Ciliga, Rossi and Ruth Fischer, as well as the *romans-à-clef* by gifted authors who have turned against the Soviet regime, such as Arthur Koestler, Humphrey Slater and Victor Serge, deal vividly with this phenomenon. Both in the ideological realm and in the concrete economic and political aspects of Communist foreign policy, much of this uncertainty can doubtless be put down to the predominance of Russia's national interest over the interests of world Communism in general, or of the local Parties in particular. Moreover, since even the Soviet leaders are not all of them men from Mars, they must be credited with the normal coefficient of miscalculation, stupidity, inefficiency and bad luck. But even allowing for disparate factors such as nationalism, human fallibility and the confusion of human affairs in general, the irregular path traversed by the ideological policy of the Soviet Union still remains abnormally puzzling.

Here perhaps some recourse to Marxist doctrine is inevitable, for it is reasonable to assume that Soviet leaders do not merely profess to judge events in the light of some form of Marxism, but in fact sometimes do so. No doubt the intelligence of the members of the Politburo is of a practical rather than a theoretical bent; nevertheless, the fundamental categories in terms of which the outside world is apprehended, and policies are framed, continue to derive from the cluster of theories put forward by Marx and Hegel, and adapted by Lenin, Trotsky, Stalin, Tito and others, as well as, in a distorted and inverted fashion, by Fascist dictators. According to this developed Marxist theory one must distinguish between 'crests' and 'troughs' – periods when 'history' appears to be in a state of rising ferment and moving toward a revolutionary climax, and, on the other hand, those more frequent times when things tend, or at least seem to tend, to be quiescent and stable. And while, of course, the theory teaches that underneath the placid surface there is always a clash of factors that will ultimately lead to the inevitable collision (which constitutes progress), the process may at times still be latent, invisible – the revolution still burrowing away, in Marx's (and Hegel's) image from *Hamlet*, like the old mole underground.[1] These are the periods when revolutionary parties should husband and consolidate their resources rather than spend their strength in battle. This theory of alternating phases, which is at least as old as Saint-Simon, appears to be the only hypothesis which offers a plausible explanation of Stalin's policies in the late 1920s and the 1930s.

One of the best examples of the halting of an 'activist' policy is found in the liquidation of Trotsky's aggressive line in China. The reasoning of Stalin and his allies seems to have led to the

---

[1] 'Well said, old mole. Canst work i' th' earth so fast?' says Hamlet to the Ghost in Shakespeare's play (act 1, scene 5, line 162). 'Well grubbed, old mole,' says Marx at the end of *The Eighteenth Brumaire of Louis Bonaparte* (1852): Karl Marx and Frederick Engels, *Collected Works*, vol. 11 (London etc., 1979), p. 185. Hegel appears not to have used the image directly, though the tenor of Marx's remarks is broadly Hegelian.

conclusion that one of the 'quiescent' periods had begun, and that as a result the making or support of violent revolution would 'necessarily' lead to frustration. Conversely, the most spectacular example of a call to arms is the notorious directive to German Communists in 1932 to concentrate their fire upon the Social Democrats as being more dangerous enemies than Hitler. Stalin's speeches of that period are very instructive in this respect: he seems clearly to have assumed that after a long trough of despond in the 1920s the crest of the revolution was beginning to rise once more. He looked upon the economic crisis of 1929–31 as the most violent indication which had yet occurred that the contradictions of the capitalist system were at last about to perform their historic task of finally blowing up the entire rickety capitalist structure. (Nor, incidentally, was it to him alone that the situation appeared in this lurid light; many observers, in lands far apart and belonging to many shades of political opinion, spoke at this time in terms no less dramatic.) In a so-called 'revolutionary' situation the Communist Party advances. The period of quiet incubation during which it is obliged to lull potential rivals and enemies into false security is over; it drops all pretence of solidarity with other left-wing and 'progressive' forces. Once cracks have visibly begun to appear in the capitalist order, the decisive moment cannot be very far off, and Lenin's preparation for his coup in September–October 1917 becomes the proper model to follow. The Communist Party, bold, strong, alone knowing what it wants and how to get it, breaks off its false (but at an earlier stage tactically necessary) relationship with the 'soft' and confused mass of fellow-travellers, fellow wanderers, temporary allies and vague sympathisers. It takes the great leap across the precipice to the conquest of power for which it alone is – and knows that it is – adequately organised.

The order to advance which Stalin issued to his German allies in 1932 had consequences fatal to them and nearly as fatal for himself – consequences, indeed, familiar enough to the entire world, which has been paying ever since with incredible suffering. Yet even this did not shake Communist faith in the simple formula. It remains unaltered and says again and again: In

revolutionary situations, liquidate your now worthless allies and then advance and strike; in non-revolutionary situations, accumulate strength by ad hoc alliances, by building popular fronts, by adopting liberal and humanitarian disguises, by quoting ancient texts which imply the possibility, almost the desirability, of peaceful mutually tolerant coexistence. This last will have the double advantage of compromising potential rivals by taking them further than they wish to go or are aware of going, while at the same time embarrassing the right-wing oppositions – the forces of reaction – by ranging against them all the best and sincerest defenders of liberty and humanity, progress and justice.

And indeed it may be that this simple maxim will to some extent account for the oscillations of Soviet propagandist policy after 1946, when Soviet planners began by expecting a vast world economic crisis and became correspondingly aggressive and uncompromising. There followed a gradual and reluctant realisation (prematurely foretold by the Soviet economist Varga, who was duly rebuked for ill-timed prescience) that the crisis was not materialising fast enough, and might not come either at the moment or with the violence expected. This may account for attempts in the last two years to replace (at least for foreign export) straightforward propaganda, framed in old-fashioned, uncompromising Marxist terms, with non-Communist values, such as appeals to the universal desire for peace, or to local or national pride in the face of American dictation, or to alleged traditions of friendship between, let us say, Russia and France as contrasted with no less traditional hostility between, for example, France and England. Soviet reliance on this historical schema of alternating periods of quiescence and crisis (which has a respectable pre-Marxist pedigree) may not be a complete key to all the convolutions of its ideological policies abroad, but without some such hypothesis these policies become totally unintelligible, and can be accounted for only by assuming a degree of blindness or stupidity or gratuitous perversity in Moscow which, on other grounds, can scarcely be imputed to the present rulers of the USSR. And this is a powerful argument for believing the hypothesis to be correct.

II

But whatever may be the theory of history which guides the Soviet Government's policy toward its agents abroad, it will not explain the zigzag movement of the Party line within the Soviet Union itself. This is the arm of Soviet policy of which its own citizens stand most in awe, in particular those whose professions cause them to be articulate in public – writers, artists, scientists, academic persons and intellectuals of every kind – since their careers and indeed their lives depend upon their ability to adjust themselves swiftly and accurately to all the alternating shapes of this capriciously-moving Protean entity. The principles of its movement are not always, of course, wholly inscrutable. Thus the adoption of the doctrine of 'socialism in one country' in the 1920s could not but alter the entire direction of the Party's activities. Nor could an intelligent observer have felt great surprise when the ideological followers of the earlier, so-called 'Trotskyite', line, or even the individuals personally connected with the banished leader, were, in due course, purged or ostracised. Similarly there was no cause for wonder at the ban on anti-German or anti-Fascist manifestations after the Nazi–Soviet Pact of 1939. Nor yet at the rise of a nationalistic and patriotic mood with strong official encouragement, during the war of national resistance against the Germans.

On the other hand, no one expected or could have foretold such curious incidents as the denunciation of the official Party philosopher, Georgy Aleksandrov, for maintaining that Karl Marx was merely the best of all Western thinkers, and not, as he should have pointed out, a being altogether different from, and superior in kind to, any thinker who had ever lived. The Party authorities maintained that Marx had been described inadequately – almost insultingly – by being called a philosopher; the impression was conveyed that to say of Marx that he was the best of philosophers was much as though one had called Galileo the most distinguished of all astrologers, or man himself the highest and most gifted among the apes. Again no one had, or perhaps could have, predicted the explosion of feeling (so soon after the mass murders and tortures of Jews by the Nazis) against the

older generation of intellectuals, mostly writers and artists of Jewish origin, as a gang of 'rootless cosmopolitans'[1] and petty Zionist nationalists; nor the summary disbandment, not long after, of the Jewish Anti-Fascist Committee. Nor, again, could any of the philologists who for so many years had faithfully subscribed to the highly fanciful (but officially approved) doctrines of the late Academician Marr be blamed for not foreseeing his sudden eclipse. How could anyone in the world have imagined that so much devoted sacrifice of knowledge and intellect upon the altar of duty to country and Party would be visited by so eccentric a fate as intervention by the Generalissimo himself, with an *ex cathedra* pronouncement on the real truth about the interrelationships of language, dialects and the social structure?

Everyone who has ever been in contact with Soviet writers or journalists, or for that matter with Soviet representatives abroad, is aware of the extraordinary acuity of ear which such persons develop toward the faintest changes of tone in the Party line. Yet this is of little ultimate avail to them, since it is accompanied by a helpless ignorance of the direction in which the 'line' is likely to veer. There are, of course, endless hypotheses about each individual lunge and lurch, some frivolous, some serious; in Soviet Russia itself they are at times characterised by the sardonic and desperate quality which belongs to the humour of the scaffold, that typically Soviet *Galgenhumor* which is responsible for some bitter

---

[1] The usual translation of 'bezrodnye kosmopolity' ('bezrodnyi' literally means 'without relations' or 'without a native land'), which was used to refer to Soviet Jews. Though Hitler called Jews 'rootless internationalists' ('wurzellos Internationalen') in a 1933 broadcast, this specific Russian phrase first appears in print (so far as I can discover) in an article by the editor of the journal *Ogonek*, A[natoly Vladimirovich] Sofronov, 'Za dal'neishii pod'em sovetskoi dramaturgii' ('For the Further Development of Soviet Dramaturgy'), *Pravda*, 23 December 1948, p. 3 – though 'kosmopolit' on its own had certainly been in use since the 1930s, if not before, as a derogatory tag for anyone who did not toe the official political line; it had also been used pejoratively of Westernisers by Slavophils in the nineteenth century. The *Pravda* article was preceded by an anti-Semitic letter to Stalin from Anna Begicheva, an arts journalist at *Izvestiya*, about 'enemies at work in the arts' (letter dated 8 December 1948, currently [November 2003] in the Russian State Archive of Socio-Political History [RGASPI] 17, 132, 237, 75–81), but this formulation does not appear there.

and memorable shafts of wit. But no general explanation seems to have been advanced to cover all the facts. And since it is, after all, unlikely that human beings so coldly calculating as the masters of the Soviet Union would leave the central line from which everything derives, and on which everything depends, to chance or the snap decision of the moment, we may find it a not altogether idle pastime to consider a hypothesis which may account for much of this peculiar situation.

<div align="center">III</div>

Our theory starts from the assumption that there are two main dangers which invariably threaten any regime established by a revolution.

The first is that the process may go too far – that the revolutionaries in their excessive zeal may destroy too much, and in particular exterminate those individuals upon whose talents the success of the revolution itself and the retention of its gains ultimately depend. Few, if any, revolutions bring about the ends for which their most fervent supporters hope; for the very qualities which make the best and most successful revolutionaries tend to oversimplify history. After the first intoxication of triumph is over, a mood of disillusionment, frustration and presently indignation sets in among the victors: some among the most sacred objectives have not been accomplished; evil still stalks the earth; someone must be to blame; someone is guilty of lack of zeal, of indifference, perhaps of sabotage, even of treachery. And so individuals are accused and condemned and punished for failing to accomplish something which, in all probability, could not in the actual circumstances have been brought about by anyone; men are tried and executed for causing a situation for which no one is in fact responsible, which could not have been averted, which the more clear-sighted and sober observers (as it later turns out) had always expected to some degree. Trials and penalties fail to remedy the situation. Indignation gives way to fury, terror is resorted to, executions are multiplied. There is no reason why this process should come to a stop without external intervention or physical causes, for there can never be enough victims to expiate a crime

which no one has committed, to atone for a crisis which must be attributed to a general and very likely inevitable failure to understand the situation correctly. But once the nightmare of mutual suspicion, recrimination, terror and counter-terror has set in, it is too late to draw back: the whole structure begins to crumble in the welter of frantic heresy-hunts from which scarcely anyone will escape. Every schoolboy knows of the violent climax of the Great French Revolution in 1794.

The second danger is precisely the contrary: and is often the natural sequel of the first. Once the original afflatus of revolution is exhausted, enthusiasm (and physical energy) will ebb, motives grow less passionate and less pure, there is a revulsion from heroism, martyrdom, destruction of life and property, normal habits reassert themselves, and what began as an audacious and splendid experiment will peter out and finally collapse in corruption and petty squalor. This, too, happened in France during the Directoire, and it has marked the end of the revolutionary phase in many other cases. It seems to be the unavoidable aftermath of many a romantic rising in Latin and Latin-American countries.

The avoidance of these opposite dangers – the need to steer between the Scylla of self-destructive Jacobin fanaticism and the Charybdis of post-revolutionary weariness and cynicism – is therefore the major task of any revolutionary leader who desires to see his regime neither destroyed by the fires which it has kindled nor returned to the ways from which it has momentarily been lifted by the revolution. But at this point Marxist revolutionaries find themselves in a peculiar predicament. For according to that element in Marxism which proceeds from the doctrine of Hegel, the world – everything animate and inanimate – is in a condition of perpetual inner conflict, mounting ceaselessly toward critical collisions which lift the battle on to a new plane – tensions and conflicts at a 'new level'. Consequently the 'dialectic' itself – for this is what the process is called – should in theory be a sufficient guarantee of the vitality of any genuine revolutionary movement. For since the dialectic is inexorably 'grounded in the nature of things' and can be neither stopped nor circumvented, the course of the post-revolutionary regimes must – cannot help but – obey its laws. And just as the French Revolution broke out in

obedience to those laws, so it declined and ran into the shallows of the Directoire, and, worse still, was followed by the Empire and the Restoration, presumably in obedience to the same dialectical process. Whatever degree of determinism Marx's historical materialism is held to entail (and the doctrine is far from clear, either in Hegel or in Marx, and grows particularly dark in the later works of Engels), Stalin seems to have resolved that the gloomy fate apparently in store for previous revolutions should not overtake his regime. Although the majestic self-fulfilment of the world pattern cannot be tampered with or deflected to suit capricious human wills, yet history (to judge by its past performances) did not seem too sure a guarantee of the survival of what Stalin and his Party considered the most desirable features of the Russian Revolution. Nature herself (although in general dependable enough) sometimes nodded; and some slight adjustments could perhaps be made to render her processes even more regular and predictable. Human skill would be employed in aiding the cosmos to fulfil even more faithfully its own 'inner laws'.

Consequently, Stalin made use of an original expedient, thoroughly in keeping with the inventive spirit of our time, and in particular with the new fashion of producing synthetic equivalents of natural products. As others produced artificial rubber or mechanical brains, so he created an artificial dialectic, whose results the experimenter himself could to a large degree control and predict. Instead of allowing history to originate the oscillation of the dialectical spiral, he placed this task in human hands. The problem was to find a mean between the 'dialectical opposites' of apathy and fanaticism.[1] Once this was determined, the

---

[1] The problem was not, of course, one of pure theory, and did not arise in the void – in the course of abstract contemplation of history and its laws on the part of Stalin or anyone else. When the excesses of the first Bolshevist terror and 'war Communism' were followed by the compromises of the New Economic Policy, the danger of repeating the pattern of the great French Revolution, or, for that matter, of the revolutions of 1848–9, must have appeared very real to Bolshevik leaders. They were certainly reminded of it often enough, especially by foreign critics. The technique of political navigation here described was therefore born, as most notable inventions are apt to be, of urgent practical need. I.B.

essence of his policy consisted in accurate timing and in the calculation of the right degree of force required to swing the political and social pendulum to obtain any result that might, in the given circumstances, be desired.

Let us apply this hypothesis to the conditions of the Second World War. In 1941, when the fate of the Soviet system seemed to be in the balance, full vent was given to patriotic sentiment. This acted as a safety-valve to the pent-up feeling which the population had had to repress during the two previous decades. The Party leaders clearly realised that this rush of national feeling acted as the most powerful single psychological factor in stimulating resistance to the enemy. The process clearly was not compatible with keeping Communist indoctrination at its full pre-war pressure; the war was won on a wave of patriotic rather than ideological fervour. A certain loosening of bonds began to be felt. Writers wrote more freely; there was, temporarily at least, the appearance of a slightly less suspicious attitude towards foreigners, at any rate those connected with the Allied countries. Old-fashioned, long-disused expressions of Great-Russian sentiment, and the worship of purely national heroes, once more became fashionable. Later, however, the victorious Soviet troops who came back from foreign countries, filled (as so often after European campaigns) with a favourable impression of foreign customs and liberties, began to give cause for anxiety; after all, the great Decembrist revolt of 1825 sprang from a similar experience. It became clear to the authorities that a powerful re-inoculation with Communist doctrine – ultimately the sole cement which binds together the ethnically heterogeneous peoples of the Soviet Union – was urgently required. The returned soldiers – both victors and prisoners of war liberated in Germany and elsewhere, as well as those likely to come into contact with them at home – would need careful supervision if centres of resistance to the central authority were not to spring up. Unless such re-indoctrination were done swiftly, the entire pattern of Soviet life, depending as in all totalitarian States on ceaseless discipline and unrelaxing tautness, might soon be in danger of sagging – notoriously the beginning of the end of all such regimes. Toward the end of 1945, a call was issued for stricter orthodoxy.

The policy of encouraging nationalism was halted sharply. All were reminded of their Marxist duties. Prominent representatives of various nationalities were found to have gone too far in glorifying their local past, and were called to order with unmistakable severity. Regional histories were suppressed. The all-embracing cloak of ideological orthodoxy once more fell upon the land. The Party was commanded to expose and expel the opportunists and riff-raff who had, during the confusion of war, been permitted to creep into the fold. Heresy-hunts were instituted once more (though not on the appalling scale of 1937–9).

The danger of this kind of move is that it places power in the hands of a class of zealots dedicated to the unending task of purifying the Church by severing all offending limbs – and presently of anything remotely capable of promoting growth. Such men will be effective only if those, at least, who compose their central nucleus are fanatically sincere; yet when this happens their activity will inevitably go too far. After purging major and minor dissentients, the inquisitors are perforce carried on by their own sacred zeal until they are found probing into the lives and works of the great leaders of the Party themselves. At this point they must be swiftly checked if the whole machine is not to be disrupted from within. An added reason for stopping the purge and denouncing its agents as deranged extremists who have run amok is that this will be popular with the scared and desperate rank and file, both of the Party and of the bureaucracy (not to speak of the population at large). A mighty hand descends from the clouds to halt the inquisition. The Kremlin has heard the cry of the people, has observed its children's plight, and will not permit them to be torn limb from limb by its over-ardent servants. A sigh of relief goes up from the potential victims; there is an outpouring of gratitude which is sincere enough. Faith in the goodness, wisdom and all-seeing eye of the leader, shaken during the slaughter, is once more restored.

Something of this kind occurred after the great purge of 1937–9. It occurred again, in a much milder fashion, in 1947, when purely doctrinal persecution was somewhat relaxed and gave way to a period of national self-adulation and a violent assault on the very possibility of foreign influence, past and

present. However grotesque this ultra-chauvinism may have looked when viewed from abroad, and however ruinous to the few representatives of a wider culture still surviving in the Soviet Union, it was probably not ill-received by the mass of the population (when has nationalist propaganda been unpopular among any people?); and it did stay the hand of the Marxist inquisitor in favour of the more familiar national tradition. On this occasion the pendulum was swung in the direction of Russian pride and *amour propre*. But just as the earlier ideological purges went too far in one direction, so this reaction in its turn duly overreached itself.

The Soviet Government wishes to preserve a minimum degree of sanity at least among the élite upon which it relies; hence any violent swing of the pendulum always, sooner or later, demands a corrective. In normal societies a movement of opinion, whether spontaneous or artificially stimulated, does not occur in a vacuum. It meets with the resistance of established habits and traditions and is to some degree swallowed, or diluted, in the eddying of the innumerable currents created by the interplay of institutional influences with the relatively uncontrolled trends of thoughts and feelings characteristic of a free society. But in the Soviet Union this random factor is largely absent, precisely because the Party and the State are engaged in sweeping away the smallest beginnings of independent thought. Hence there is a kind of empty region in which any artificially stimulated view (and in the USSR there can scarcely be any other) tends to go too far, reaches absurd lengths, and ends by stultifying itself – not merely in the eyes of the outside world but even within the Soviet Union itself. It is at this point that it must be swung back by means which are themselves no less artificial. This is what occurred when the nationalist-xenophobic campaign reached a point almost identical with that of the most violent phases of the brutal policy of 'Russification' of Tsarist days. (The recent denunciations of cosmopolitan intellectuals were framed in language almost identical with that of the reactionary, anti-Semitic, fanatically anti-liberal press and police after the repressions following the Revolution of 1905.) Something had evidently to be done to restore the fabric of Soviet unity. The Party can, *ex*

*hypothesi*, never be mistaken; errors can occur only because its directives have been misinterpreted or misapplied. Again, no serious alteration of the bases of the Marxist theory itself is feasible within a system of which it is the central dogma. An open attempt to modify – let alone cancel – any Marxist principles in such central and critical fields as political theory, or even philosophy, is therefore out of the question: for there is too serious a danger that, after so many years of life in a straitjacket, confusion and alarm might be created in the minds of the faithful. A system which employs some hundreds of thousands of professional agitators, and must put their lessons in language intelligible to children and illiterates, cannot afford doubts and ambiguities about central truths. Even Stalin cannot disturb the foundations of ideology without jeopardising the entire system.

Hence safer areas must be found for the ideological manoeuvres required in situations which seem to be moving slightly out of control. Music, poetry, biography, even law, are peripheral territories in which doctrinal pronouncements modifying the 'line' can be made without disturbing the vital central region. The moral of such public statements is very swiftly grasped by the (by now) highly sensitised eyes and ears of intellectuals working in other and often quite distant fields. Philology is still remoter from the centre and, consequently, even safer. Perhaps that is why Stalin chose the theory of language, in what seemed to the uninitiated so whimsical a fashion, to indicate that the 'clarion call' for Marxist purity had had its full effect and must be muted. The mild rectification of the line ordered in the field of linguistics was no sooner made than other relatively 'non-political' specialists must have begun hopefully to ask themselves whether their windowless worlds too might not expect some small relief – perhaps a chink into the outer universe, or at least a little more breathing-space within. Bounty to grammarians and linguists means that musicians and acrobats and clowns and mathematicians and writers of children's stories and even physicists and chemists cower a little less. Even historians have raised their heads; a writer[1] in a Soviet historical journal in the

---

[1] Presumably the Professor Kon mentioned in the note on the next page.

summer of 1951 argued timidly that since Stalin had said nothing about historical studies, might not they also, like linguistics, be excluded from the Marxist 'superstructure', and possess an 'objectivity' and permanent principles which Stalin had so sternly refused to artistic or juridical institutions? Physicists, chemists, even the harassed geneticists whose studies lie so unhappily close to the heart of the historical dialectic, may presently be afforded some relief; certainly the vagaries of the 'line' in their subjects seem to spring from internal political needs more often than from metaphysical considerations or from an incurable penchant for this or that philosophical or scientific 'materialism', to which some of their more hopeful or naïve Western colleagues, in their anxiety to understand Soviet scientific theory, so often and so unplausibly try to attribute them.

The themes of 'peace' and 'coexistence' indicate unmistakably which way the dialectical machine is veering after the Korean misadventure: hence faint and pathetic attempts to hint at 'Western' values again on the part of professors whose love of their subject has not been completely killed. And if such first timorous feelers are not too brusquely discouraged, those who put them forth know that they may at last begin to look to a period of relative toleration. But the more experienced know that this is unlikely to last for long. Presently symptoms begin inevitably to indicate that the ties have been loosened too far – too far for a machine which, unless it is screwed tight, cannot function at all. Presently new calls for conformity, purity, orthodoxy are issued; elimination of suspects[1] begins, and the cycle repeats itself.

Yet something depends on the force with which the pendulum is swung: one of the consequences of driving the terror too far (as happened, for example, during the Ezhov regime in the late 1930s) is that the population is cowed into almost total silence. No one will speak to anyone on subjects remotely connected with 'dangerous' topics save in the most stereotyped and loyal

---

[1] These are as often as not the orthodox of yesterday. One wonders what is to be the fate of Professor Kon [unidentified], who sought, in the summer 'breathing spell' of 1951, to protect history from the fanaticism of the ultra-Marxists of 1946–7. I.B.

formulae, and even then most sparingly, since nobody can feel certain of the password from day to day. This scared silence holds its own dangers for the regime. In the first place, while a large-scale terror ensures widespread obedience and the execution of orders, it is possible to frighten people too much: if kept up, violent repression ends by leaving people totally unnerved and numb. Paralysis of the will sets in, and a kind of exhausted despair which lowers vital processes and certainly diminishes economic productivity. Moreover, if people do not talk, the vast army of intelligence agents employed by the government will not be able to report clearly enough what goes on inside their heads, or how they would respond to this or that government policy. When the waters are very still, and their surface very opaque, they may be running much too deep. In the words of a Russian proverb, 'Devils breed in quiet pools.' The government cannot do without a minimum knowledge of what is being thought. Although public opinion in the normal sense cannot be said to exist in the Soviet Union, the rulers must nevertheless acquaint themselves with the mood of the ruled, if only in the most primitive, most behaviouristic, sense of the word, much as an animal-breeder depends on his ability to predict, within limits, the behaviour of his stock. Hence something must be done to stimulate the population into some degree of articulate expression: bans are lifted, 'Communist self-criticism', 'comradely discussion', something that almost looks like public debate is insistently invited. Once individuals and groups show their hand – and some of them inevitably betray themselves – the leaders know better where they stand, in particular whom they would be wise to eliminate if they are to preserve the 'general line' from uncontrolled pushes and pulls. The guillotine begins to work again, the talkers are silenced. The inmates of this grim establishment, after their brief mirage of an easier life, are set once more to their back-breaking tasks and forbidden to indulge in any interests, however innocent, which take their minds off their labours – the great industrial goals which can be accomplished only with the most undivided attention and by the most violent exertions. Communication with the outside world is virtually suspended. The press is recalled to a sense of its primary purpose – the

improvement of the morale of the public, the clear, endlessly reiterated sermons on the right way of living and thinking. When this state of things grows too dreary even for Soviet citizens, the 'line' oscillates again, and for a very brief period (the penultimate state of which is always the most dangerous moment) life once more becomes a little more various.

<div align="center">IV</div>

This – the 'artificial dialectic' – is Generalissimo Stalin's original invention, his major contribution to the art of government, even more important, perhaps, than 'socialism in one country'. It is an instrument guaranteed to 'correct' the uncertainties of nature and of history and to preserve the inner impetus – the perpetual tension, the condition of permanent wartime mobilisation – which alone enables so unnatural a form of life to be carried on. This it does by never allowing the system to become either too limp and inefficient or too highly charged and self-destructive. A queer, ironical version of Trotsky's 'permanent revolution', or, again, of his 'neither peace nor war' formula for Brest-Litovsk, it forces the Soviet system to pursue a zigzag path, creating for its peoples a condition of unremitting tautness lest they be caught by one of the sharp turns made whenever a given operation begins to yield insufficient or undesirable returns.

Naturally, the need to keep the population on the run in this way is not the sole factor which shapes the ultimate direction of the line. This is determined in addition by the pressures of foreign policy, national security, internal economic and social needs, and so on – by all the forces which play a part in any organised political society, and which exert their influence on Soviet policy too, albeit in a somewhat peculiar fashion. The Soviet Union is not a Marxist system working in a total vacuum, nor is it free from the effects of psychological or economic laws. On the contrary, it claims to recognise these more clearly and shape its policies more consciously in accordance with the findings of the natural sciences than is done by 'reactionary' policies doomed to be victims of their own irreconcilable 'internal contradictions'. What, then, makes the political behaviour of the Soviet Union

seem so enigmatical and unpredictable to Western observers, whether they be practical politicians or theoretical students of modern politics? Perhaps this perplexity is due in some measure to the failure in the West to realise the crucial importance attached by the makers of Soviet policy to the zigzag path upon the pursuit of which they assume that internal security and the preservation of power directly depend. This technique of determining the 'general line' in accordance with which all the means available to the Soviet State and to Communist Parties at home and abroad are to be used is a genuinely novel invention of great originality and importance. Its successful operation depends on a capacity for organising all available natural and human resources for completely controlling public opinion, for imposing an ultra-rigid discipline on the entire population; and, above all, on a sense of timing which demands great skill and even genius on the part of individual manipulators – especially of the supreme dictator himself. Because it requires this – because the exactly correct 'line', undulating as it does between the equally unavoidable and mutually opposed right-wing and left-wing 'deviations' (extremes out of which it is, like the Hegelian synthesis, compounded, and which, in the shape of its individual human representatives and their views, it destroys) – it cannot be determined mechanically. It is an artificial construction and depends on a series of human decisions; and for this reason its future cannot be regarded as altogether secure. So long as someone with Stalin's exceptional gift for administration is at the helm, the movement of the 'line', invisible though it may continue to be to many both within and outside the Soviet Union, is not altogether unpredictable. Its destiny when he is no longer in control (whether or not the Soviet Union is involved in a general war) is a subject for hope and fear rather than rational prophecy. For it is certainly not a self-propelling, or self-correcting, or in any respect automatically operating piece of machinery. In hands less skilful or experienced or self-confident it could easily lead to a débâcle to which human societies are not exposed under more traditional forms of government.

Will Stalin's successors display sufficient capacity for the new technique, which calls for so remarkable a combination of

imagination and practical insight? Or will they abandon it altogether, and, if so, gradually or suddenly? Or will they prove unable to control it and fall victim to a mechanism too complicated for men of limited ability – a mechanism whose very effectiveness in the hands of an earlier and more capable generation has so conditioned both government and governed that catastrophe is made inevitable? We cannot tell; all that seems certain is that Generalissimo Stalin's passing will sooner or later cause a crisis in Soviet affairs – a crisis which may be graver than that caused by the death of Lenin, since in addition to all the other problems of readjustment peculiarly acute in a tight dictatorship, there will arise the agonising dilemma created by the future of Stalin's elaborate machinery of government, too complex to be used save by a great master of manipulation,[1] and too dangerous to interrupt or neglect or abandon.

One other thing seems moderately clear: those who believe that such a system is simply too heartless and oppressive to last cruelly deceive themselves. The Soviet system, even though it is not constructed to be self-perpetuating, certainly bears no marks of self-destructiveness. The government may be brutal, cynical and utterly corrupted by absolute power: but only a moral optimism, fed by passionate indignation or a religious faith rather than empirical observation or historical experience, can cause some students of the Soviet Union to prophesy that such wickedness must soon itself erode the men who practise it, render them incapable of retaining power and so defeat itself. The governed, a passive, frightened herd, may be deeply cynical in their own fashion, and progressively brutalised, but so long as the 'line' pursues a zigzag path, allowing for breathing spells as well as the terrible

---

[1] I do not wish to imply that Stalin is solely responsible for all of even the major decisions of Soviet policy. No system so vast, however 'monolithic', can literally be directed by any single individual, whatever his powers. But, on the other hand, we have no reason for supposing that Stalin's henchmen, however competent under his leadership, will prove any more capable of carrying on his methods after him than were the companions of Ivan the Terrible or Peter the Great, in whose hands the system of their master disintegrated very fast. On the other side we must place the opposite experience of Kemal's Turkey. Time alone will show. I.B.

daily treadmill, they will, for all the suffering it brings, be able to find their lives just – if only just – sufficiently bearable to continue to exist and toil and even enjoy pleasures. It is difficult for the inhabitants of Western countries to conceive conditions in which human beings in Eastern Europe or the Soviet Union (or for that matter India or China) can not merely survive but, being surrounded by others in no better plight, and with no alternative forms of life visible through the Curtain to attract and discontent the imagination, adapt themselves to conditions, look on them as normal, contrive to make arrangements, like soldiers in an unending campaign, or prisoners or shipwrecked mariners. Such arrangements may seem intolerable to the average citizen of a civilised community, yet because, if not liberty, then fraternity and equality are born of common suffering, a human life can be lived – with moments of gaiety and enthusiasm, and of actual happiness – under the most appalling and degrading conditions.

And it should be remembered that the art of manipulating the 'general line' consists precisely in this – that human misery must not, taking the population as a whole, be allowed to reach a pitch of desperation where death – suicide or murder – seems preferable. If the citizens of the Soviet Union cannot be permitted a degree of freedom or happiness which might make them too unruly or insufficiently productive, neither must they be permitted to fall into a state of panic or despair or indifference that would in turn paralyse their activity. The oscillations of the 'general line' are designed to be a means which avoids precisely these extremes. Hence, so long as the rulers of the Soviet Union retain their skill with the machinery of government and continue to be adequately informed by their secret police, an internal collapse, or even an atrophy of will and intellect of the rulers owing to the demoralising effects of despotism and the unscrupulous manipulation of other human beings, seems unlikely. Few governments have been destroyed by a process of inward rotting without the intervention of some external cause. As the Soviet Government is still conspicuously in the full possession of its political senses, the experiment of a nation permanently militarised has, in the long terms of historical periods, hardly reached its apogee. Beset by difficulties and perils as this monstrous machine may be, its

success and capacity for survival must not be underestimated. Its future may be uncertain, even precarious; it may blunder and suffer shipwreck or change gradually or catastrophically; but it is not, until men's better natures assert themselves, necessarily doomed. The physical and nervous wear and tear exacted (to no purpose, at least no discernible human purpose, beyond the bare self-perpetuation of the regime) by the system is appalling: no Western society could survive it. But then, those finer organisms in which, before 1917, Russia was no poorer than the West have perished long ago. Many decades may be required to recreate them – as recreated one day they surely will be, when this long, dark tunnel is nothing but a bitter memory.

In the meanwhile, the astonishing invention itself surely deserves the more careful study, if only because it is as mechanically powerful and comprehensive an instrument for the management of human beings – for simultaneously breaking their wills and developing their maximum capacities for organised material production – as any dreamt of by the most ruthless and megalomaniac capitalist exploiter. For it springs out of an even greater contempt for the freedom and the ideals of mankind than that with which Dostoevsky endowed his Grand Inquisitor; and being dominant over the lives of some eight hundred million human beings, is the most important, most inhuman and still the most imperfectly understood phenomenon of our times.

# FOUR WEEKS IN THE SOVIET UNION

## *1956*

I SPENT FOUR MONTHS in Moscow towards the end of 1945 and returned after eleven years' absence, in August 1956. The changes which I found, although considerable, did not seem to me to be as far-reaching or radical as the reports of some Western observers had led one to believe. During my relatively short stay[1] I had less opportunity of observing either institutions or individuals than in 1945, and the impressions which follow are therefore inevitably somewhat more superficial.

I entered the USSR via Leningrad, which physically has vastly improved since the immediate post-war days of 1945. The streets were cleaner, the buildings better cared for, the Winter Palace repainted, Peterhof restored, indeed over-restored; the trams no longer chock-a-block with passengers, a good many inexpensive restaurants and 'buffets' (inexpensive, that is, by local standards) open once more, reasonably clean and capable of providing better meals than most similar establishments in England (although less good than, say, their equivalent in Italy, even in the poorest southern towns). There were a great many obvious tourists in the streets and I met a number of my old students from Harvard who had been supplied with Carnegie travel grants for 'twenty-nine days' in the Soviet Union; these grants are at present responsible for a regular influx of young graduate social and historical researchers from the United States, energetic, ubiquitous and determined to collect the maximum quantity of information by means of 'field work' – that is, conversations with the maximum

---

[1] 1–29 August. This account appears to have been written soon afterwards.

number of citizens of the Soviet Union conducted in quite a passable imitation of their language.

I visited Professor Alekseev, the head of Pushkin House, the principal institute of literary history in the Soviet Union. As I was not a member of any official delegation he was a trifle cagey at first, but mention of various common acquaintances in the world of Slavic studies gradually changed his manner, and he became courteous and informative. The second desk in his room was always occupied by someone – if the colleague whom I met on entering the room left, someone else came and sat at the desk, ostensibly engaged upon reading a book for ten minutes or so, but in fact doodling inconsequently.

Professor Alekseev said that things were much better than during the bad Stalin days, which were over, he hoped, for ever. Literary research was, however, still suffering, because of the obvious bias of the government in favour of the natural sciences, in particular physics; still, this was paradise compared with the years 1940–53. He informed me that he was delighted to see me, and to be discussing problems of Russian literary history, which he would scarcely have been allowed to do in 1945 or 1950. Indeed, he had known of cases where the most innocent contacts with the members of foreign embassies, especially the British (who, he remarked, seemed particularly interested in *littérateurs*), had compromised their Russian acquaintances, and led to disgrace, and worse. A return to these horrors was unthinkable, save in so far as in Russia nothing was unthinkable. He then gave examples of the persecution of scholars and writers; I asked whether he thought that the poets Pasternak and Akhmatova, chosen for pillory by Zhdanov, would be 'rehabilitated'; Professor Alekseev gazed for a moment at the watchdog at the other desk, and said that he did not know. The atmosphere grew sensibly cooler and I left shortly afterwards.

I found that this was the kind of line taken by almost every official person that I met: the past had been terrible and the new freedom was full of promise: we were terrified, we are out of danger now. This was repeated by keepers of museums and of national monuments, professors of the universities, 'responsible

secretaries' of academies, officials of the Ministry of Culture and Education, Higher and Lower, in fact everyone entitled to conduct conversations with foreigners. The distinction between those so entitled and those not entitled seemed to me to be crucial, and to mark the difference between the situation now and that of 1945. At that time, although more contacts between foreigners and Russians were possible than during subsequent years, such contacts tended to be informal and carried a greater or smaller degree of risk to those engaged in them, except of course for purely official relationships between officials representing governments for defined purposes. This time I found that there was a sharp difference in attitude, depending both on the position of the Soviet individuals in question, and on the recognised status of the foreigners to whom they spoke. It was clear that specific instructions had been given to high academic and cultural officials – heads of institutions, secretaries and responsible members of such institutions – if not to seek, at any rate to promote, relationships with suitable foreign visitors. Indeed, I was told by no fewer than three Soviet scholars that VOKS had in November of 1955 sent emissaries to the various academies of learning in Moscow to say that it had been decided to renew cultural contact with foreigners; that those who had foreign languages would do well to brush them up; that foreign delegations in particular were to be welcomed warmly, and that provided foreigners came as members of such delegations, they were to be entertained in a generous and informal manner; one of my informants specified that this meant that the hosts were to avoid giving the impression that they were any longer unduly secretive or reluctant to welcome visitors from abroad.

There is no doubt that members of delegations and even persons who, like myself, carried sufficient recommendations to define their status clearly, could count upon a greater degree of informal contact and free conversation – within very obvious limits – with their colleagues or persons selected to meet them than had been the case previously; at the same time it was also clear that (unless one's Russian 'contact' felt reasonably sure that he had been guaranteed in advance against allegations of undue

fraternisation) they were still not too eager to meet foreign visitors. The most welcome visitors were physicists and other natural scientists, to whose Russian hosts instructions had probably been given (this was the impression I had been given by a young physics student) to be as open with them as was possible within the bounds of normal security, and not to give them the impression that things were obviously being kept from them. This is also true in the case of other delegations to which it had been decided to show special favour. Indeed the very degree of affability and ease of conversation shown by Soviet 'hosts' seemed to reflect the degree of their importance, licence to associate with foreigners, and lack of fear of censure from above. This attitude altered, and altered sharply, in the case of contacts with those foreigners whose status was in some way unclear – casual students, private visitors, tourists not in official parties, persons who were not members of identifiable delegations. Unless the status of the foreign visitor was absolutely clear and he belonged to a category to be officially welcomed, all the old suspiciousness and evasiveness was once more in full evidence.

I did meet some old friends whom I had met on my previous visit, and learned from them, as I expected, far more of what is going on than from the agreeable, courteous, but at times excessively bland, official representatives of institutions of various kinds. I met with comparatively humble persons, a good many students writing theses in the library in which I spent ten days on my own work, and some old acquaintances and their friends, who showed the greatest eagerness to see me, but had to adopt considerable precautions for this purpose, in sharp contrast with the apparently open, easy manner with which I was greeted by the directors of the Philosophical Academy and the heads of academic institutions (apart from the head of the Pushkin House in Leningrad I visited the heads of various sections of the Lenin Library, the head of the Academy of Literature, and met the editor of *Kommunist* – the chief ideological party organ – at the house of a member of the British Embassy, to whom I am grateful for this far from uninteresting encounter).

My general impressions may be summed up as follows.

The deepest cleavage in Soviet society is that between the governors and the governed. On the whole, I saw more of the latter, but a few conversations with important Communists – including a member of the Presidium – leaves a very clear impression of the general tone and quality of this class of person. The governed are a peaceful, courteous, gentle, resigned, infinitely curious, imaginative, unspoilt population, whose moral convictions, aesthetic tastes and general outlook are strongly Victorian, and who look upon the outside world with wonder and a little hostility, even fear. They tend to think the Americans may wish to make war upon them, but they do not, so far as my experience goes, think it very strongly, and when it is pointed out to them that much of what they believe – for example that there are three million unemployed in England, or that armament merchants are in total control of United States policy – may not accord with the facts, they accept this with a kind of ironical acquiescence, as being part of the lies with which all publicity is inevitably filled, the Soviet newspapers and radio no less than those abroad.

This attitude of amiable cynicism, which assumes that all governments are engaged in insincerity to hoodwink their publics, I found to be very widespread, together with a deep lack of interest in political issues, especially on the part of the students I talked to – a desire to acquire greater material benefits, to have jobs, to travel, to fall in love, to earn large salaries, to enjoy themselves, but very little ambition, or ideological passion, or nationalism, or strong feeling about public issues of any kind. In this respect the much criticised Muscovites who spend their time in listening to jazz music and wearing Western clothes are merely an extreme case of a general trend towards individualism, against which the perpetual propaganda of the Communist Party in the direction of greater collective endeavour, tightening up of ideological enthusiasm, and so forth seemed to me, at any rate, to beat in vain.

One cannot, of course, generalise. I speak merely of such members of the urban populations as I came across. Students in the reading rooms of libraries (I did not visit the universities), taxi drivers, casual acquaintances in restaurants, a photographer in Leningrad, a teacher of English but lately returned from a long

Siberian imprisonment as a British spy – all conveyed the same impression: namely, that their principal desire was to survive and lead more agreeable personal lives; that the official ideology of Marxism – while its foundations, in a very primitive form, were taken for granted (namely that class structure was important, that ideas were influenced by economic factors, that Western capitalism was in its decline, that Lenin was a great and benevolent genius, and so forth – nothing much more specific than this) – and more specific developments of Marx's doctrine, what is called dialectical materialism, more specific philosophical, economic, sociological and historical doctrines, concerning which such battles were fought in the 1920s and early 1930s, and heresies in regard to which cost their adherents so dear, were no longer actual, and in fact were regarded as tedious forms of mechanical catechism – the sooner got over the better – and neither those who were paid to teach it nor those who were forced to listen to it suffered from illusions about it.

More than once I received amusing accounts of lectures on ideology in which the lecturer could hardly suppress a yawn and the audience covered their faces with their notebooks, out of politeness, not to reveal the fact that their thoughts were wandering elsewhere. It is ironical, in the face of this, to reflect on the effort made by Western scholars to trace the development of Marxism in the USSR during the last twenty years, to discriminate trends and tendencies, doctrines and sub-doctrines, to attribute them to their source, to examine, analyse, refute. It may have significance with regard to the satellite countries or foreign Communist parties, where such ideological issues are taken seriously in themselves and perhaps reflect important developments in other regions. In the Soviet Union ideological pronouncements from on high are important in indicating political and economic policies, but the textbooks on the subject and the teaching of it have reached an ebb the low level of which no one is prepared to deny. I was entertained quite hospitably by the Academy of Philosophy and found that, while their interest in philosophy beyond their frontiers was acute – and well-informed in so far as books and articles are sufficient to make them so –

their attitude towards the subject in which they were all suppos-
edly experts was one of ill-concealed boredom; they neither
believed nor disbelieved in the propositions which they uttered –
it was their business to pronounce such theses and they did so to
the best of their ability, with as little thought during the process
as they possibly could afford to put into it.

Among the governed there is a good deal of benevolent feeling
towards people abroad; hope to be able to meet them, to travel,
coupled with a none too indignant realisation that this is prob-
ably impracticable; and the kind of happiness and misery which
occurs in an occupied country where the occupying power is not
actively engaged in destroying and terrorising the population, or
in an army on the march whose miseries appear far more intoler-
able to outward observers than, after a time, they are felt to be
by the soldiers themselves, relieved of many civilian responsibili-
ties, and plunged into a routine which is accepted as inevitable
and develops its own pattern of life with its pains and pleasures,
in their own way as acute and as important as those of normal
peaceful existence.

Among the governed there are, of course, one or two older
writers and even theatrical actors who have not genuinely
accepted the regime at all, or have rejected it in their hearts dur-
ing the Stalin period. These can be very bold and violent and
fearless in what they say. They read what they can obtain from
abroad and have their own closed circles, are difficult to meet,
speak freely and conceal little. They are not referred to officially,
although they are known to exist and are admired and looked up
to in wide circles of the intelligentsia not themselves independent
or discontented enough to imitate them.

The governed have accepted the regime, but they welcome
every step towards liberalisation with pathetic pleasure; they do
not believe their condition to be superior either materially or spir-
itually, either intellectually or morally, to that in countries abroad.
They do not reflect about such topics over much. They are
Russians, and the younger generation in particular have never
known any other state of things. I did not myself come across
strong expressions of political attitude of any kind; even the

dethronement of Stalin did not, at any rate among the students to whom I talked, produce any great strength of reaction. They did not believe that he was either much worse or much better than those who were governing them at present; they thought that he had made mistakes, especially during the war, and was a tough and violent despot, but they believed that no government could, in principle, be efficient that was not, in some measure, despotic, and did not believe in the genuineness of democracy abroad, although they did believe in its vast superiority of material culture and the greater contentment of its citizens.

They were gay, talkative, enthusiastic about the details of private life, delighted to meet foreigners, but all appeared to be arrested mentally somewhere between sixteen and seventeen years of age. Their chief desire was not to be ploughed under in the acutely competitive system which, paradoxically enough, the Soviet regime has produced. The most discontented were, among those I met, the Jews and the Georgians, the first because they complained of continued discrimination against them, although not on the scale and with the violence of the last years of Stalin. They said that only the ablest Jews could get jobs at all after leaving the university, that occupational unemployment was rife amongst them, and that whenever persons of even remotely similar ability presented themselves as candidates for the same post, non-Jews were more liable to be chosen, although less well qualified, than Jews. They were passionately interested in Israel, and the perpetual insistence – by Kaganovich, for example – that Soviet rulers either took no interest in Israel, or regarded it with hostility as the instrument of Anglo-American imperialism, is perhaps itself an indication of the opposite.

The Georgians were worried because they too have begun feeling a certain degree of discrimination among great Russians, and gave lurid accounts of the destruction in which the post-Stalin riots had involved them, in Tiflis and elsewhere in Georgia. They showed no particular passion for Stalin, and indeed the general tone, of the ones I spoke to, markedly lacked any note of hero-worship and tended towards the somewhat cynical quietism which obviously did not make them less obedient or less efficient servants of the regime.

The governors are a very different story: it seemed to be relatively easy to distinguish not merely between successful aspirants to power and their victims but even those who had set their minds upon obtaining high position and were using their elbows to do so, as against those who had given up or had never begun. Those in power in the Soviet Union take their colouring from their masters in the Presidium and the Central Committee of the Party. They are a tough, ruthless, militantly nationalistic group of proletarian roughnecks, whose resentment of what can broadly be described as 'Western values', or indeed of their own intellectuals, springs as much from their social origins and feelings as from any ideology which they may have imbibed. They resent refinement, civilised behaviour, the intelligentsia and so forth, very much as any power group sprung from those particular origins, with the accumulated resentment of the bosses because of their middle-class upbringing, would feel towards such phenomena. And naturally enough, those members of Party cadres who seek advancement and are astute enough and sensitive enough to adjust themselves to all the convolutions of the Party line take their tone from the top, and, like their supreme masters, at once exploit and humiliate members of the liberal professions, and at the same time desire them to show advances and develop discoveries and inventions, to compete with and surpass those of the West.

In this sense the tradition and policy of Stalin continues unabated; the culture of the Soviet Union, so far as it exists, is not that of a classless society (in the sense in which, say, New Zealand is an approach, at any rate, to a classless society), but that of a class of liberated slaves who still feel an unabated hostility to the whole culture of their masters and acute social discomfort in its presence, particularly when exemplified in the appearance and manners of diplomatic representatives and other visitors from the West.[1] In this respect their feelings are not wholly dissimilar to

---

[1] The governors, except at the technical level, certainly regard foreigners as potential foes, and adjust their conversation in a more conscious, cruder, more brutal manner to their interlocutor than is done by similar persons in other countries. I.B.

those of the rawer elements in the American Middle West. And it appears to me that this kind of social and moral attitude is responsible for far more of the persecution of intellectuals, for example, or friction with the West, than conscious ideological policy, or great Russian patriotism.

The ideologists of the governing class – with whom I met principally at official receptions, and on one occasion privately – repeat the set pieces which they have learned by heart, with relish and with skill, for indeed they owe their positions to the degree of skill and effect with which they can develop official theses. It is difficult to say that they either believe or disbelieve; this is the common currency in terms of which the governing class of Russia communicate with each other. It is too late in the day now to enter into the question whether this is or is not the best kind of doctrine to promote their ends, whether it is an obstacle or a stimulus to material or educational progress. It has by now become the only binding cement of the entire Soviet Union, in terms of which the bosses of Communism can do their work; it has also become the vocabulary in terms of which communication occurs, and to try to reform it radically now, even if it could be shown that it would lead to a better political or economical, or even to a more effective ideological, result, is obviously unthinkable.

One can distinguish in any Soviet society those who belong to the class of the governed – who use normal language, display no undue ambition, behave as human beings do everywhere, and represent certain of the Russian traditional characteristics, which they carry over in a very pure form from the kind of Russians described by the great novelists and writers of short stories – on the one hand, and a governing class at whatever level, with its tough talk, its false bonhomie, the particular expression on their faces when once launched upon one of those great rhetorical turns which is essential to Communist discourse, and the obvious cynicism and opportunism, the ability to catch with half a glance what their superiors really require. A combination of unction and flattery to those above, and ruthless bullying to those below, disqualify this group of persons. They are feared, admired,

detested and accepted as inevitable by the entire population. The gulf between them seemed to me almost unbridgeable.

These are the two nations that today compose the Soviet Union.

# SOVIET RUSSIAN CULTURE

## *1957*

I

ONE OF THE most arresting characteristics of modern Russian culture is its acute self-consciousness. There has surely never been a society more deeply and exclusively preoccupied with itself, its own nature and destiny. From the 1830s until our own day the subject of almost all critical and imaginative writing in Russia is Russia. The great novelists, and a good many minor novelists too, as well as the vast majority of the characters in Russian novels, are continuously concerned not merely with their purposes as human beings or members of families or classes or professions, but with their condition or mission or future as Russians, members of a unique society with unique problems. This national self-absorption is to be found among novelists and playwrights of otherwise very different outlooks. An obsessed religious teacher like Dostoevsky, a didactic moralist like Tolstoy, an artist like Turgenev regarded in the West as being dedicated to timeless and universal psychological and aesthetic patterns, a 'pure' unpolitical writer like Chekhov, careful not to preach, are all, and throughout their lives, crucially concerned with the 'Russian problem'. Russian publicists, historians, political theorists, writers on social topics, literary critics, philosophers, theologians, poets first and last, all without exception and at enormous length, discuss such issues as what it is to be a Russian; the virtues, vices and destiny of the Russian individual and society; but above all the historic role of Russia among the nations; or, in particular, whether its social structure – say the relation of intellectuals to the masses, or of industry to agriculture – is sui

generis, or whether, on the contrary, it is similar to that of other countries, or, perhaps, an anomalous, or stunted, or abortive example of some superior Western model.

From the 1880s onwards a vast, now unreadably tedious, mass of books, articles, pamphlets began to flood upon the Russian intelligentsia, mostly concerned to prove either that Russia is destined to obey unique laws of its own – so that the experience of other countries has little or nothing to teach it – or, on the contrary, that its failures are entirely due to an unhappy dissimilarity to the life of other nations, a blindness to this or that universal law which governs all societies, and which Russians ignore at their peril. The writers of Western countries, as often as not, produce their works of art or learning or even day-to-day comment (even in America, where there exists similar self-consciousness, though not on so vast a scale) without necessarily tormenting themselves with the question whether their subject-matter has been treated in its right historical or moral or metaphysical context. In Russia, at any rate since the second half of the nineteenth century, the reverse obtained. There no serious writer could think of taking a step without concerning himself with the question whether his work was appropriately related to the great ultimate problems, the purposes of men on earth. The duty of all those who claimed to have the insight to understand, and the moral courage to face, their personal or social or national condition was always the same: in the first place to relate the relevant problems to the path which the given society (that is, Russia; and only after that, humanity) was inexorably pursuing (if one was a determinist), at the particular historical (or moral or metaphysical) stage of its development.

No doubt the romantic doctrines that dominated European literature and journalism in the 1830s and 1840s, particularly in Germany, with their emphasis on the unique historical missions of different groups of men – Germans, or industrialists, or poets – are partly responsible for this pervasive Russian attitude. But it went further in Russia than elsewhere. This was partly due to the fact that the effective advance of Russia to the centre of the European scene (after the Napoleonic wars) coincided with the impact of the romantic movement; it derived partly from a sense

of their own cultural inferiority which made many educated Russians painfully anxious to find a worthy part of their own to play – worthy, above all, of their growing material power in a world that was apt to look down upon them, and cause them to look down upon themselves, as a dark mass of benighted barbarians ruled by brutal despots and good only for crushing other freer, more civilised peoples. Again there may be, as some writers maintain, a strong craving for teleological and indeed eschatological systems in all societies influenced by Byzantium or by the Orthodox Church – a craving that the Russian priesthood, lacking as it conspicuously did the intellectual resources and tradition of the Western Churches, could not satisfy, at any rate in the case of the better-educated and critically inclined young men.

Whatever the truth about its origins, the state of mind of virtually all Russian intellectuals in the nineteenth century and the early twentieth (there were some exceptions) was dominated by the belief that all problems are interconnected, and that there is some single system in terms of which they are all in principle soluble; moreover, that the discovery of this system is the beginning and end of morality, social life, education; and that to abandon the search for it in order to concentrate upon isolated or personal ends, say the pursuit of knowledge, or artistic creation, or happiness, or individual freedom for their own sakes is wilful, subjective, irrational, egoistic, an immoral evasion of human responsibility. This attitude is characteristic not merely of the left-wing Russian intelligentsia, but of the outlook of civilised Russians of all shades of political opinion, spread widely both in religious and in secular, in literary and in scientific circles. Almost any philosophical system that affected to give a comprehensive answer to the great questions found a marvellously, indeed excessively, enthusiastic welcome among these eager, over-responsive, idealistic, impeccably consistent, sometimes only too rigorously logical thinkers.

And the systems were not slow in arriving. First came German historicism, particularly in its Hegelian form, which conceived of history as the essential, indeed the only genuine, science. True, Hegel looked on the Slavs with contempt as 'unhistorical', and declared that (like the 'extinct' Chinese civilisation) they had no

part to play in the march of the human spirit. This part of Hegel was quietly ignored, and adequate room made in the universal schema for the Slavs in general, and (on the authority of Hegel's formidable rival, Schelling) for the Russians in particular. After the infatuation with Schiller, Fichte, Hegel and other German Idealists came a similar faith in French social prophets – Saint-Simon, Fourier and their many disciples and interpreters, who offered cut-and-dried 'scientific' plans of reform or revolution for which some among their Russian disciples, with their will to believe in literal inspiration, were ready to lay down their lives. This was followed by many another *Lebensphilosophie* – inspired by Rousseau, by Comtian Positivism, Darwinism, neo-mediaevalism, Anarchism, which in Russia went far beyond their Western prototypes. In the West such systems often languished and declined amid cynical indifference, but in the Russian empire they became fighting faiths, thriving on the opposition to them of contrary ideologies – mystical monarchism, Slavophil nostalgia, clericalism and the like; and under absolutism, where ideas and daydreams are liable to become substitutes for action, ballooned out into fantastic shapes, dominating the lives of their devotees to a degree scarcely known elsewhere. To turn history or logic or one of the natural sciences – biology or sociology – into a theodicy; to seek, and affect to find, within them solutions to agonising moral or religious doubts and perplexities; to transform them into secular theologies – all that is nothing new in human history. But the Russians indulged in this process on a heroic and desperate scale, and in the course of it brought forth what today is called the attitude of total commitment, at least in its modern form.

Over a century ago Russian critics denounced European civilisation for its lack of understanding. It seemed to them characteristic of the morally desiccated, limited thinkers of the West to maintain that human activities were not all necessarily interconnected with each other – that what a man did as a writer was one thing and what he did as a citizen was another; that a man might be a good chemist and yet maltreat his family or cheat at cards; that a man might compose profound music and yet hold stupid or immoral political views that were no business of the critics or

of the public. This notion of life, according to Russians of almost all shades of opinion, was artificial and shallow and flew to pieces before the deeper insight of the all-embracing view, according to which the life of individuals and the life of their institutions was one and indivisible. Every faculty and element in the individual was in a state of constant interplay; a man could not be one thing as a painter and another as a citizen, honest as a mathematician and false as a husband; it was impossible to draw frontiers between any aspects of human activity, above all between public and private life. Any attempt to insulate this or that area from the invasion of outside forces was held to be founded upon the radical fallacy of thinking that the true function and purpose of a human being does not penetrate every one of his acts and relationships – or worse still, that men had, as men, no specific function or purpose at all. It followed that whatever most fully embodies this ultimate total human purpose – the State, according to the Hegelians; an élite of scientists, artists and managers, according to the followers of Saint-Simon or Comte; the Church, according to those who leaned towards ecclesiastical authority; an elected body of persons embodying the popular or national will, according to democrats or nationalists; the class designated by 'history' to free itself and all mankind, according to socialists and Communists – this central body had a right to invade everything. The very notion of the inviolability of persons, or of areas of life, as an ultimate principle was nothing but an effort to limit, to narrow, to conceal, to shut out the light, to preserve privilege, to protect some portion of ourselves from the universal truth – and therefore the central source of error, weakness and vice.

The doctrine that there is one truth and one only, which the whole of one's life should be made to serve, one method, and one only, of arriving at it, and one body of experts alone qualified to discover and interpret it – this ancient and familiar doctrine can take many shapes. But even in its most idealistic and unworldly forms, it is, in essence, totalitarian. Even those critical versions of it which permit doubts about the nature of the central truth, or about the best method of its discovery, or the title of its preachers, allow none about the right and the duty, once it is estab-

lished, to make everyone and everything obey it; they allow no intrinsic virtue to variety of opinion or conduct as such; indeed, the opposite. For there can be no more than one truth, one right way of life. Only vice and error are many. Consequently, when Marxism finally came to Russia in the 1870s and 1880s it found an almost ideal soil for its seeds.

## II

Marxism contained all the elements which the young *révoltés* in Russia were looking for. It claimed to be able to demonstrate the proper goals of human existence in terms of a pattern of history of which there was 'scientific' proof. The moral and political values which it preached could, so it claimed, be determined 'objectively', that is to say, not in terms of the subjective and relative and unpredictable attitudes of different individuals or classes or cultures, but in terms of principles which, being 'founded' on the 'objective behaviour of things', were absolute and alone led to the salvation and liberation of all men to the degree to which they were rational. It preached the indissoluble oneness of men and institutions. It claimed, just as the eighteenth-century French philosophers had in effect claimed, that all real, that is to say soluble, problems were fundamentally technological; that the ends of man – what human beings could be, and, if they knew their true interests, would necessarily want to be – were given by the new scientific picture of the universe. The only problem was how to realise these ends. This was not a moral or political problem but a technical task: that of finding and using the right means for the 'demonstrably' valid, universal goal; a problem of engineering.

Stalin's famous and most revealing phrase about intellectuals as 'engineers of human souls'[1] was faithfully derived from Marxist premises. The duty of intellectuals was to elucidate the correct

[1] Stalin used this phrase in a speech on the role of Soviet writers made at Maxim Gorky's house on 26 October 1932, recorded in an unpublished manuscript in the Gorky archive – K. L. Zelinsky, 'Vstrecha pisatelei s I. V. Stalinym' ('A meeting of writers with I. V. Stalin') – and published for the first time, in English, in A. Kemp-Welch, *Stalin and the Literary*

social goals on the basis of a 'scientific' analysis of society and history; and then, by means of education, or 'conditioning', so to attune the minds of their fellow citizens that they grasped demonstrated truths and responded accordingly, like the harmonious constituents of a properly regulated and efficiently functioning mechanism. The simile which Lenin used in one of his most famous statements of political doctrine – *The State and Revolution*[1] – according to which the new free society, liberated from the coercion of one class by another, would resemble a factory or workshop in which the workers did their jobs almost out of mechanical habit, was a piece of imagery drawn from this technocratic view of human life. The watchwords were efficiency, tidiness, security, freedom for the good to do what they wanted (this last being necessarily one and the same goal for all those who were rational and knew the truth), not freedom to do anything whatever, but only what is right – the only thing which any rational being can wish to do – that which alone will make for true, everlasting universal happiness. This is an old Jacobin doctrine, and indeed much older – in its essentials as old as Plato. But no one, perhaps, had believed it quite so naïvely or fanatically in any previous age.

During the decade that followed the October Revolution these principles – the moral and metaphysical foundations of totalitarianism – were genuinely accepted, at any rate by some among the Communist leaders. Whatever the personal shortcomings of Trotsky or Zinoviev or Bukharin or Molotov or the heads of the secret police, and perhaps even of Stalin at this stage, there is no reason for doubting the sincerity or depth of their convictions or principles. A great many disagreements arose, of course, but they were concerned not with ends but with means; when they went sufficiently far they were stigmatised as deviations. Thus Trotsky thought that there was a danger of a too-well-entrenched bureau-

---

*Intelligentsia, 1928–39* (Basingstoke and London, 1991), pp. 128–31: for this phrase see p. 131 – and, for the Russian original, 'inzhenery chelovecheskikh dush', I. V. Stalin, *Sochineniya* (Moscow, 1946–67), vol. 13, p. 410.

[1] *Gosudarstvo i revolyutsiya* (Moscow, 1918).

cracy which would function as a brake – like all vested interests – upon the progress of the Revolution, which needed agents who were more imaginative, more bloody, bold and resolute – men not tempted to stop half-way on the path of the world revolution. The so-called Workers' Opposition objected to the concentration of authority in the hands of the Central Committee of the Communist Party, and wanted more equality, and more democratic control exercised by workers' organisations. The right-wing 'deviationists' thought that over-rapid collectivisation of agriculture would produce a degree of economic dislocation, pauperisation and ruin likely to be more damaging to the Soviet economy than the adoption of a slower pace in the harsh process of liquidating peasant property and its defenders together with other so-called survivals of the capitalist regime; and advocated a less urgent tempo and milder measures. There were disagreements as to how far the army might be used in the regimentation of industry. There were memorable disagreements about foreign policy and the policy towards Communists abroad.

The acutest of all disagreements occurred, perhaps, on the cultural front: there were those who thought that any 'slap in the face' (as it used to be called) to the bourgeois culture of the West, in whatever form – aggressive futurism and modernism in the arts, for example, or any violent revolt against tradition – was *eo ipso* an expression of Bolshevism, in so far as it was a blow at the Western establishment, lowered its morale and undermined its moral and aesthetic foundations. A good deal of experiment, sometimes bold and interesting, at other times merely eccentric and worthless, occurred at this time in the Soviet Union in the guise of cultural warfare against the encircling capitalist world. This was the 'Cultural Bolshevism', particularly popular in Germany, against which Communist policy later so sternly set its face. For one thing the audacities of the cultural Bolsheviks were, as might be expected, the personal acts of individual artists, and therefore found little favour in the eyes of those members of the Party for whom Communism meant belief in the task of creating a specifically proletarian culture by means of collective action, and for whom the aberrations of the avant-garde poets, painters and

producers were merely so much individualist eccentricity – an *outré* and decadent perversion of the very bourgeois civilisation which the Revolution was out to destroy. Lenin, be it noted, disliked all forms of modernism intensely: his attitude to radical artistic experiment was bourgeois in the extreme. But he made no attempt to enforce his aesthetic views, and, under the benevolent patronage of the Commissar of Education, Lunacharsky, a failed critical playwright but a sincere opponent of open barbarism, the controversies continued unabated. There were splits within factions: the champions of 'proletarian' culture could not agree on whether it was to be produced by individual men of gifts who distilled within themselves the aspirations of the proletarian masses, actual and potential, acting, as it were, as their mouthpieces or rather megaphones; or whether, as the extremer ideologists proclaimed, individuals as such had no part at all to play in the new order, for the art of the new collectivist society must itself be collective. These latter in effect believed that works of art must be written collectively by groups, and criticism – reviews, essays, directives – by squads of critics, bearing collective responsibility for their work, each member being an anonymous component of a social whole. Again, some maintained that the business of proletarian art was to present the new reality in an intenser form, to heighten it if necessary by the inventions of the socialism-impregnated imagination. Others thought that the business of artists was strictly utilitarian: to help with the making of Communist society by documentary reportage of the new life – the building of factories, collective farms, power stations, the destruction of the old installations, the production of the essentials of the socialist economy – tractors, combines, uniform food, identical clothing, mass-produced houses, books, above all good, happy, uncomplicated, standard human beings.

One could go on to multiply examples; the point I wish to make is that these 'programmatic' controversies were, in the first place, genuine; that is to say, the contending parties, on the whole, believed what they were saying, and the disagreements between them could justly be described as real differences in the interpretation of an accepted Marxist doctrine. Moreover they were, to some degree, carried on in public; and, most important

of all, they were differences not about ends but about means. The ends had become universally accepted since the opponents and doubters had been eliminated or silenced. The intransigence of the Comintern in dealing with foreign Communist and still more Socialist parties, and the merciless heresy hunts, probably derived, for the most part, from the honest belief that these parties might compromise on the central truth – on the dogma of what constituted the desired society – or else that they had chosen, or might choose, paths that could lead away, however imperceptibly at first, from these sacred and undisputed goals.

It was its own conception of itself that divided Bolshevism so sharply from its parent, Western Marxism – a conception which made it not merely a set of political or social or economic beliefs or policies, but a way of life, all-penetrating and compulsory, controlled absolutely by the Party or the Central Committee of the Party in a way for which little authority can be found even in the most extreme pronouncements of Marx or Engels. This was the 'tsarism in reverse'[1] which Herzen, at the beginning of the 1850s, had gloomily and accurately predicted that Communism in Russia would become, and which it owes primarily to the personality of Lenin himself. No doubt the conditions of Russian life, which moulded both him and it, in part created the need for religious certainty and messianic doctrine which Marxism provided. But the authoritarian element is among Lenin's specific contributions – the conception of the Party as a sect ruled ruthlessly by its elders and demanding from its members the total sacrifice upon its altar of all that they most cherished (material goods, moral principles, personal relationships), the more defiant and horrifying to tender-minded morality the better. It was this streak of stony fanaticism enlivened by a sardonic humour and vindictive trampling upon the liberal past that unnerved some of Lenin's socialist colleagues and attracted such disciples as Stalin and Zinoviev.

---

[1] Herzen wrote that 'Communism is a Russian autocracy turned upside down' in the Epilogue to his *The Development of Revolutionary Ideas in Russia* (1851): A. I. Gertsen, *Sobranie sochinenii v tridsati tomakh* (Moscow, 1955–64), vol. 7, p. 123.

It was part and parcel of this vision of the millennium (disguised as a rational doctrine) to ignore the fact that as a scientific theory, claiming to be able to explain and predict social and economic change, Marxism had, by the beginning of the twentieth century, been decisively refuted by events in ways which have been described too often and too fully to be worth recapitulation. In the West, efforts to save the theory from intellectual bankruptcy, some orthodox, some heretical, were from time to time made by conscientious socialists and others. In Russia this was, by and large, not required. In Russia, especially after the October Revolution, Marxism had become a metaphysics, professedly resting on an analysis of history but stubbornly ignoring all awkward facts, designed by force or persuasion to secure conformity to a set of dogmatic propositions with its own esoteric, half-intelligible terminology, its own 'dialectical' techniques of argument, its own clear and rigid a priori notions of what men and society must, at whatever cost, be made to be.

One of the most striking differences between the Soviet Union and the West was (and is) that in Russia those who were defeated in these internal Soviet controversies were liable from the very beginning of the regime – even before the official beginning of the terror – to be at best silenced, at worst punished or executed. Yet even these draconian measures did not make the controversies less real. Indeed they had the opposite effect – the fact that the fruit of victory was power, and of defeat elimination, added an element of violent excitement to the duels in which the antagonists had so much to lose or win. I do not mean to assert that all or even the majority of those engaged in these febrile and perilous controversies were persons of integrity or moved by disinterested motives; a great deal of ruthless or desperate fighting for position or survival, with little regard for the professed principles of Marxism, was evident enough in Russia in the 1920s. But at least some sort of wage was paid by vice to virtue; the protagonists in these struggles still felt traditionally obliged to advance some kind of theoretical justification for their conduct, and since some of them seemed to believe deeply in what they said, the issues were at times matters of genuine principle. This was most obviously the case on the 'cultural front', which has at all times

yielded the most reliable symptoms of what was going on in other spheres of Soviet life. Moreover, among the controversialists, men of remarkable gifts and temperament were to be found, and their attitudes, whether honest or opportunist, were those of exceptional human beings. Lunacharsky, Vorovsky, Averbakh were not, by any possible standard, critics of the first water, but they possessed a genuine revolutionary eloquence; Bukharin, Trotsky, Radek were as thinkers negligible, but one of them was a man of genius, and the others were at the very least gifted agitators. And among the creative writers and artists there still were some figures of the first rank who had not emigrated, or had returned. This alone made the 1920s memorable, not only in Russian history but in Russian culture.

To all this Stalin put an abrupt end, and a new phase began.

### III

The ideological policy of Stalin's regime is a fascinating topic deserving separate study to itself, which no one has yet attempted seriously, and towards which I should like only to make one or two suggestions.

Once it had become clear to Stalin and his henchmen that an early world revolution was not to be expected, and that the doubtless inevitable fulfilment of Marxist prophecies in the capitalist world might take place at a time and in ways very different from those which the earlier, more optimistic, founding fathers had prophesied, he concentrated upon three interconnected purposes. Firstly, the perpetuation of the Bolshevik regime, and in particular of those of its leaders who were prepared to accept his own authority. Secondly, the maintenance and increase of Soviet power, political, economic and military, in a hostile world, by every possible means short of those entailing a radical change in the Soviet system itself. And thirdly, the elimination of all factors, whether at home or abroad, likely to jeopardise either of these two central purposes, whether or not such elimination was consistent with Marxism, socialism or any other ideological attitude.

Stalin has at times been compared to Napoleon. It is, on the whole, a fanciful and misleading comparison. Stalin did not

suppress or pervert the Bolshevik Revolution as Napoleon 'liqui-dated' the Jacobins. There never was a Thermidor (still less a Brumaire) in the Russian Revolution: neither in the mid-1920s (where Trotsky naturally placed it), nor after the assassination of Kirov, nor after the death of Stalin. But there is also something in this analogy that is illuminating. To ask whether Stalin was a faithful Marxist or even a faithful Leninist is like asking whether Napoleon believed in the ideals or ideas of the French Revolution. Napoleon was sufficiently a child of the Revolution to be instinctively opposed to everything connected with the pre-Revolutionary regime, and to wish to come to terms with some of its survivals solely for limited periods and for reasons of expe-diency. Just as Napoleon took it for granted that the relics of feudalism in Europe were doomed beyond recall, that the dynas-tic principle was not worth respecting, that nationalism was a force that must be used, that centralisation and uniformity were policies favourable to his rule and the like, so it may be assumed that Stalin was Marxist and Leninist enough to believe that capi-talism was inescapably doomed to be destroyed by its own 'inter-nal contradictions' (although it might here and there engage in a desperate struggle for survival), whether it realised this or not and however useless such a struggle might be. Similarly Stalin probably accepted the tactical corollary that wherever such 'con-tradictions' reached an acute stage, those who wished to survive and inherit the earth must seek to exacerbate these critical situa-tions and not to palliate them; whereas in situations where these contradictions had not yet reached a critical point the path of prudence on the part of the members of the new society, that is, the Communists, was not to promote premature risings but to bore from within and concentrate on popular fronts and Trojan horses of various kinds. It is clear that he genuinely believed that the future of human society was inevitably collectivist and not individualist; that the power of religion and the Churches was collapsing; that control of economic power was more important (that is, capable of effecting greater changes or stopping them) than, say, nationalist sentiment or political power; and in all these respects he was, of course, a true, if exceedingly crude, follower of Marx. But if it be asked whether he was a Marxist in the sense

in which Lenin undoubtedly was one – that is of believing that as the result of the dreadful birth-pangs a new world would be born in which men would in some sense be freer than before, capable of developing their faculties on a vastly more productive scale, living in a world without wars, starvation and oppression, it seems doubtful whether he troubled himself with such questions any more than the Emperor Napoleon reflected about the ultimate validity of any of the ideals of the French Revolution. And, to his intellectual credit be it said, Stalin paid little enough regard – even by way of lip-service – to the many Utopian elements in Lenin's outlook.

It is, perhaps, a second point of similarity with Napoleon that Stalin firmly grasped a truth which perhaps Napoleon was the first among secular rulers fully to realise and act upon, namely that discussion of ideas – disputes about issues apparently remote from politics, such as metaphysics or logic or aesthetics – was, by promoting the critical spirit, in principle more dangerous to despotic regimes engaged in a struggle for power than belief in any form of authoritarianism. Napoleon's open hostility to the Idéologues – the empiricists and positivists of his day – is well known. He openly preferred the implacable legitimist and ultramontane Bonald, who abused him and would have no truck with him, to the politically mild and conformist liberal, Destutt de Tracy. Similarly Stalin, when he felt himself securely in power, decided to put an end to all ideological controversy as such in the Soviet Union. He did this by proclaiming one school to be victorious over all others (it did not historically matter which). The new directive was that the business of the intelligentsia – writers, artists, academics and so forth – was not to interpret, argue about, analyse, still less develop or apply in new spheres, the principles of Marxism, but to simplify them, adopt an agreed interpretation of their meaning, and then repeat and ingeminate and hammer home in every available medium and on all possible occasions the selfsame set of approved truths. The new Stalinist values were similar to those proclaimed by Mussolini: loyalty, energy, obedience, discipline. Too much time had been wasted in controversy, time which could have been spent in promoting enforced industrialisation or educating the new Soviet man. The

very notion that there was an area of permissible disagreement about the interpretation of even unquestioned dogma created the possibility of insubordination; this, beginning indeed in spheres remote from the centres of power – say musical criticism or linguistics – might spread to more politically sensitive areas and so weaken the drive for economic and military power for which no sacrifice was too great or too immoral. The celebrated Marxist formula – the unity of theory and practice – was simplified to mean a set of quotations to justify officially enunciated policies. The methods taken to suppress the least symptom of independence on the part of even the most faithful Stalinist intellectuals (let alone so-called deviationists or unreconstructed relics of older dispensations) – and, let it be added, the success of these methods – are a phenomenon without parallel in the recorded history of human oppression.

The result has been a long blank page in the history of Russian culture. Between 1932 and, say, 1945, or indeed 1955, it would not be too much to say that – outside natural science – scarcely any idea or piece of critical writing of high intrinsic value was published in Russia, and hardly any such work of art produced – scarcely anything genuinely interesting or important in itself and not merely as a symptom of the regime or of the methods practised by it, that is to say, as a piece of historical evidence.

This policy was, perhaps, chiefly due to Stalin's personal character. He was a half-literate member of an oppressed minority, filled with resentment against superior persons and intellectuals of all kinds, but particularly against those articulate and argumentative socialists whose dialectical skill in the realm of theory must have humiliated him often both before the Revolution and after it, and of whom Trotsky was only the most arrogant and brilliant representative. Stalin's attitude towards ideas, intellectuals and intellectual freedom was a mixture of fear, cynical contempt and sadistic humour that took the form (a touch of Caligula) of discovering to what grotesque and degrading postures he could reduce both the Soviet and foreign members of his cowering congregation. After his death this policy has on occasion been defended by his heirs on the ground that when an old

world is being destroyed and a new world brought into being, the makers and breakers cannot be expected to have time for the arts and letters, or even for ideas, which must, at any rate for the moment, suffer what befalls them without protest.

It is interesting to ask how such absolute subservience, and for so long a period, could have been secured on the part of an intelligentsia which had after all not merely contributed the very term to the languages of Europe, but had itself played so prominent and decisive a role in bringing about the victory of the Revolution. Here was a body of persons the blood of whose martyrs had been the seed of the entire revolutionary movement, a body to which Lenin, far more than Marx, had assigned a leading role in the task of subverting the old order and of keeping the new one going; and yet, when it was crushed, not a mouse stirred: a few indignant voices abroad, but inside the Soviet Union silence and total submission. Mere intimidation, torture and murder should not have proved sufficient in a country which, we are always told, was not unused to just such methods and had nevertheless preserved a revolutionary underground alive for the better part of a century. It is here that one must acknowledge that Stalin achieved this by his own original contributions to the art of government – inventions that deserve the attention of every student of the history and practice of government.

IV

The first invention has been called by O. Utis 'the artificial dialectic'.[1] It is well known that according to the systems of Hegel and of Marx events do not proceed in direct causal sequence but by means of a conflict of forces – of thesis and antithesis – ending in a collision between them, and a Pyrrhic victory, in the course of which they eliminate each other, and history takes a 'leap' to a new level, where the process, called dialectical, begins once again. Whatever

[1]See Berlin's 'The Artificial Dialectic' above, pp. 98–118, originally published under the pseudonym 'O. Utis'.

may be the validity of this theory in any other sphere, it has a very specific applicability to revolutionary situations.

As every student of the subject must know, the principal practical problem before those who have successfully brought off a large-scale revolution is how to prevent the resultant situation from collapsing into one of two opposed extremes. The first – let us, following Utis, call it Scylla – is reached when the zealots of the revolution, observing that the new world which the revolution was meant to create has somehow not yet come to pass, seek for explanations, culprits, scapegoats, blame it on criminal weakness or treachery on the part of this or that group of their agents or allies, declare the revolution in mortal peril and start a witch-hunt which presently develops into a terror, in the course of which various groups of revolutionaries tend to eliminate each other successively, and social existence is in danger of losing the minimum degree of cohesion without which no society can continue to exist. This process tends to be checked by some form of counter-revolution, which is brought on by a desperate effort on the part of the majority, whose security is threatened, to preserve itself and achieve stability, an instinctive social recoil from some imminent-looking collapse. This is what occurred during the great French Revolution, to some extent during the Commune of 1871, in some parts of Eastern Europe in 1918, and might have occurred in 1848 had the extreme left-wing parties begun to win. The mounting spiral of terror was, in fact, what Trotsky was suspected of wishing to promote.

The opposite extreme – Charybdis – is subsidence into a weary indifference. When the original impetus of the revolution begins after a time to ebb, and people seek a respite from the terrible tension of the unnatural life to which they have been exposed, they seek relief, comfort, normal forms of life; and the revolution slides by degrees into the ease, *Schlamperei*,[1] moral squalor, financial chicanery and general corruption of the kind which marked, for example, the French Directoire; or else subsides into some conventional dictatorship or oligarchy, as has happened so often in Latin America and elsewhere. The problem for the mak-

[1] 'Sloppiness'.

ers of the revolution, therefore, is how to keep the revolution going without falling foul of either the Scylla of Utopian fanaticism or the Charybdis of cynical opportunism.

Stalin should be credited with having discovered and applied a method which did, in fact, solve this particular problem in a certain sense. Theoretically, history or nature (as interpreted by Hegel or Marx) should, by pursuing its own dialectical process, cause these opposites to collide at the crucial stage, forcing reality to ascend a creative spiral instead of collapsing into one-sided forms of bankruptcy. But since history and nature evidently tend to nod, man must from time to time come to the aid of these impersonal agencies. The government, as soon as it sees signs of the fatal hankering after the fleshpots of the older life, must tighten the reins, intensify its propaganda, exhort, frighten, terrorise, if need be make examples of as many conspicuous backsliders as may be required to stop the rout. Malingerers, comfort-lovers, doubters, heretics, other 'negative elements' are eliminated. This is the 'thesis'. The rest of the population, duly chastened, dominated by terror rather than hope or desire for gain or faith, throw themselves into the required labours, and the economy bounds forward for a while. But then the élite of the revolutionary purists, the fanatical terrorists, the simon-pure heart of the Party, who must be genuinely convinced of the sacred duty of cutting off the rotten branches of the body politic, inevitably go too far. If they did not, if they could stop in time, they would not have been the kind of people to perform the task of inquisition with the desperate zeal and ruthlessness required; hypocrites, half-believers, moderates, opportunists, men of cautious judgement or human feeling are of no use for this purpose, for they will, as Bakunin had warned long ago, compromise half-way. Then the moment arrives when the population, too terrorised to advance, or too starved, becomes listless, downs tools, and efficiency and productivity begin to drop off; this is the moment for clemency. The zealots are accused of having gone too far, they are accused of oppressing the people, and – always a popular move – they are in their turn publicly disciplined, that is, in Stalin's heyday, purged and executed. Some small increase of freedom is allowed in remote fields – say, that of literary criticism or poetry or

archaeology – nothing so near the centre of things as economics or politics. This is the 'antithesis'. The people breathe again, there is optimism, gratitude, talk of the wisdom of their rulers now that their eyes have been opened to the 'excesses' of their unfaithful servants, hope of further liberties, a thaw; production leaps up, the government is praised for returning to some earlier, more tolerant ideal, and a relatively happier period ensues.

This once more leads to the inevitable relaxation of tension, slackening of discipline, lowering of productive effort. Once more there is (the new thesis) a call for a return to ideological purity, for the re-establishment of fundamental principles and loyalties, for the elimination of the parasitical saboteurs, self-seekers, drones, foreign agents, enemies of the people who have in some way managed to creep into the fold. There is a new purge, a new spurt of ideological fanaticism, a new crusade, and the heads of the counter-revolutionary hydra (the new antithesis) have to be cut off once again.

In this way the population is, as it were, kept perpetually on the run, its development proceeds by a zigzag path, and individual self-preservation depends on a gift for perceiving at which precise moment the central authority is about to order a retreat or an advance, and a knack for swiftly adjusting oneself to the new direction. Here timing is all. A miscalculation, due to inertia or political insensitiveness or, worse still, political or moral conviction, causing one to linger too long on a road that has been condemned, must almost always, particularly if persisted in, mean disgrace or death.

It cannot be denied that by this deliberate policy of carefully timed purges and counter-purges of various intensities, of contraction and expansion, Stalin did manage to preserve in being a system that cannot be actively approved or felt to be natural by most of those concerned, and indeed to keep it going for a longer period than that for which any other revolution has, thus far, managed to survive. There is a full discussion of the method in the article by Utis already cited. Although, as the author there maintains, the method, to be successful, requires the master hand of its inventor, it appears to have survived him. Despite the grave shocks to the system caused by the struggle for power among

Stalin's successors, the emergence into the open of conflicts and factions, the risings of oppressed peoples in the West totally unforeseen in Moscow, what Utis calls the 'artificial dialectic' appears to be functioning still. The succession, in strict sequence, during the last five years, of 'liberal' and repressive moves by the Soviet rulers, both at home and abroad, although no longer conducted with the virtuosity (or the deep personal sadism) of Stalin, has too much regularity of pattern to be unintended. The hypothesis advanced by the author to explain only Stalin's own methods of government seems to fit his successors.

The method is an original political invention, and Stalin deserves full credit for it. One of its deliberate by-products has been the total demoralisation of what is still in the USSR called the intelligentsia – persons interested in art or in ideas. Under the worst moments of tsarist oppression there did, after all, exist some areas of wholly free expression; moreover, one could always be silent. This was altered by Stalin. No areas were excluded from the Party's directives; and to refuse to say what had been ordered was insubordination and led to punishment. 'Inner emigration' requires the possibility of the use of one's mind and means of expression at least in neutral ways. But if one's chances of sheer survival have been made dependent on continuous active support of principles or policies which may seem absurd or morally abhorrent; and if, moreover, the whole of one's mental capacity is taxed by the perpetual need to chart one's course in fatally dangerous waters, to manoeuvre from position to position, while one's moral fibre is tested by the need to bow one's head low not to one but to many capricious, unpredictably changing divinities, so that the least inattention, slackness or error costs one dear – then there is less and less possibility of thinking one's own thoughts, or of escaping into an inner citadel in which one can remain secretly heterodox and independent and know what one believes. Stalin went further. He forbade more than a minimum degree of official intercommunication between one academic faculty and another, between laboratory and institute, and successfully prevented the growth of any centre of intellectual authority, however humble and obedient, however fraudulent and obscurantist. No priesthood of dialectical materialism had been allowed

to arise, because no discussion of theoretical issues was permitted; the business of the Academy of Sciences or the Institute of Red Professors or the Marx–Engels Institute was to quote Marx in supporting Stalin's *acts*: the *doctrine* he, or some other member of the Politburo (certainly not a professor), would supply for himself.

Where there is an official Church or college of augurs, with its own privileges and mysteries, there is a relatively fenced-off area, with walls within which both orthodoxy and heresy can flourish. Stalin set himself to repress ideas as such – at a very high cost, be it added, not merely in terms of the basic education of Soviet citizens (not to speak of disinterested intellectual activity, 'pure' research and so on), but even in the useful and applied sciences which were gravely handicapped by the lack of freedom of discussion and suffered an abnormally high admixture of adventurers, charlatans and professional informers. All this was effective in stifling every form of intellectual life to a far greater degree than was realised by even the most hostile and pessimistic observers in the West, or, for that matter, by Communist Parties outside the Soviet orbit. To have created such a system is a very striking achievement on Stalin's part, whose importance should not be underrated. For it has crushed the life out of what once was one of the most gifted and productive societies in the world, at any rate for the time being.

<center>V</center>

There is yet a second consequence of this system which is worthy of remark, namely that most of the standard vices so monotonously attributed by Marxists to capitalism are to be found in their purest form only in the Soviet Union itself. We are familiar with such stock Marxist categories as capitalist exploitation, the iron law of wages, the transformation of human beings into mere commodities, the skimming off of surplus value by those who control the means of production, the dependence of the ideological superstructure on the economic base, and other Communist phrases. But where do these concepts best apply?

Economic exploitation is a phenomenon familiar enough in the West; but there is no society in which one body of men is more firmly, systematically and openly 'exploited' by another than the workers of the Soviet Union by their overseers. True, the benefits of this process do not go to private employers or capitalists. The exploiter is the State itself, or rather those who effectively control its apparatus of coercion and authority. These controllers – whether they act as Party officials or State bureaucrats or both – act far more like the capitalists of Marxist mythology than any living capitalists in the West today. The Soviet rulers really do see to it that the workers are supplied with that precise minimum of food, shelter, clothing, entertainment, education and so forth that they are thought to require in order to produce the maximum quantity of the goods and services at which the State planners are aiming. The rest is skimmed off as surplus value far more conveniently and neatly than it can ever have been detached in the unplanned West. Wages are regulated in the most 'iron' way possible – by the needs of production. Economic exploitation here is conducted under laboratory conditions not conceivable in Western Europe or America.[1] It is again in the Soviet Union that official professions of 'ideology' – principles, slogans, ideals – correspond least to actual practice. It is there, too, that some intellectuals can most truly be described as lackeys (some sluggish and reluctant, others filled with a kind of cynical delight and pride in their own virtuosity) of the ruling group. It is there, far more obviously than in the West, that ideas, literature, works of art act as 'rationalisations' or smokescreens for ruthless deeds, or means of escape from the contemplation of crimes or follies, or as an opium for the masses. It is there that the State religion – for that is what the dead and fossilised 'dialectical materialism' of the official Soviet philosophers has, in effect, more or less avowedly become – is nothing but a consciously used weapon in the war

[1] Milovan Djilas corroborates this forcibly in his book, *The New Class* (New York, 1957). Whether the system is to be called State capitalism (the State being anything but a democracy) or a 'degenerate workers' State' or a naked autocracy is a question of the most appropriate label. The facts themselves are not in doubt. I.B.

against the enemy, within and without; and lays no claim to 'objective' truth.

The materialist theory of history teaches us that the primary factors that determine the lives of individuals and societies are economic, namely the relationships of human beings in the productive system; while such cultural phenomena as their religious, ethical, political ideas, their judicial and political institutions, their literature, arts, scientific beliefs and so forth belong to various tiers of the 'superstructure', that is, are determined by – are a function of – the 'base'. This celebrated and justly influential doctrine, embodying as it does a great deal that is new, important, illuminating and by now very widely accepted, has, nevertheless, never been easy to fit in detail to any given society or period of history in the past. Every attempt to apply it narrowly[1] always encountered too many exceptions: if these were to be explained away, they usually had to be stretched till the theory became too vague or encrusted with too many qualifications to retain any utility. But it holds only too faithfully of Soviet society. There it is absolutely clear to everyone what is part of the base and what is part of the superstructure. Writers and architects can have no illusions about which level of the pyramid they constitute. Economic, military and other 'material' needs really do wholly determine – because they are deliberately made to determine – ideological phenomena, and not vice versa. It is not nature or history that has produced this situation, but a piece of highly artificial engineering, by which Stalin and his officials have transformed the Russian empire.

It is an extraordinary irony of history that categories and concepts invented to describe Western capitalism should turn out to fit most closely its mortal enemy. But this is scarcely an accident, a *lusus historiae*. Every student of the Russian Revolution knows that the issue that divided the Bolsheviks most deeply from the orthodox Marxists – the Mensheviks – was the practicability of

[1] Say, to demonstrate that the writings of Thomas Love Peacock could not possibly have arisen save in the economic conditions of early nineteenth-century England; and that these in their turn made some such writings as those of, let us say, Aldous Huxley (or others like him) quite inevitable a century later. I.B.

an immediate transition to socialism. The Mensheviks maintained that, according to any interpretation of Marx, genuine socialism could be established only in a society which had reached a high degree of industrialisation – where the organised proletariat formed the majority of the population, and was, through the working of the 'inexorable' and mounting 'contradictions' of economic development, in a position to 'expropriate the expropriators' and initiate socialism. No one could maintain that this stage had yet been reached in the Russian empire. But the Bolsheviks, mainly under Trotsky's inspiration, claimed that instead of semi-passively waiting for capitalism (a bourgeois republic) to do the job – leaving the workers insufficiently protected from the free play of 'history', 'nature' and so forth – this process could be controlled by a proletarian dictatorship; Russia could be made to go through the stages demanded by the 'dialectic of history' under hothouse conditions regulated by the Communist Party. This was to be the famous 'transitional' period of the dictatorship of the proletariat, the artificial or controlled equivalent of 'natural' capitalist development in the West: two roads leading equally to full-blown Communism, but the Russian corridor less painful because not left to the vagaries of 'nature', but planned by men in control of their own fate because of their possession of the 'scientific' weapon of Marxist theory, and able, therefore, to 'shorten the birth pangs' by a well-executed revolution. If, like Lenin, one begins with fanatical faith in the truth of the Marxist analysis of history, the fact that it does not too well fit even the capitalist West, which it was designed to describe, will make little difference. If the pattern does not correspond to the facts, the facts must be made to tally with the pattern. There was relatively little capitalism, and a feeble proletariat, in Russia in 1917. But the dialectic of history cannot be cheated. Unless Marxism rested on a gigantic fallacy there *could* be no salvation without the equivalent of the capitalist phase. Hence the corresponding phenomena had to be synthetically produced – made to emerge by artificial means.

This can sometimes be done with success, as in Japan, for example. But the Japanese followed the light of reason and experience. They modernised themselves by the methods that seemed to

work best, without being chained to a dogmatic theory. They achieved their purpose not without brutalities, but rapidly and with spectacular success. This course was not open to Lenin and his followers. They were compelled by their fidelity to the Marxist classics to subordinate their practical judgement to the demands of theory: the social and economic development of Russia had to proceed by fixed steps whose order was laid down by the Marxist manuals. This created fantastic handicaps that were overcome at a terrible human cost. Russia *had* to go through phases which, according to Marx, Western capitalism passed during and after its Industrial Revolution. Russian reality had to be altered to resemble a model constructed, not too competently, to account for the progress of a society very unlike itself. A society was vivisected, as it were, to fit a theory which began life as no more than the explanation of its evolution. Something which began as descriptive became normative: a theory intended to account for the development and behaviour of Western Europe in the nineteenth century had been turned into a blueprint for Eastern Europe in the twentieth.

Actions founded upon errors of social observation do not necessarily end badly. There is, for all to see, that part of American constitutional development which was inspired by Montesquieu's mistaken interpretation of British political theory and practice. Lenin's error proved more costly. Russia was precipitated into unheard-of horrors of industrialisation largely because Marx had drawn a dark picture of Western capitalism and said that no society could escape something analogous. The imposition of the Bolshevik system upon an economically retarded country is a unique and monstrous monument to the power of a few men's wills and their sovereign contempt for history and empirical evidence; and a bloodcurdling interpretation of the unity of theory and practice.

<div align="center">VI</div>

Faced with crises and the possibility of collapse, Lenin executed a partial retreat. And his successors, under the pressure of events, substituted various practical makeshifts and realistic devices and

policies in place of the extravagant Utopian design which dominates Lenin's thinking. Nevertheless the violent break with reality that is at the heart of the Bolshevik Revolution can evidently not be eliminated without causing the regime to collapse; at any rate no serious attempt to do so has ever been made. For this reason Soviet society is not, in the normal sense, a civil society at all.

The purpose of normal human societies is in the first place to survive; and, after that, to satisfy what Mill regarded as the deepest interests of mankind, that is to say, to satisfy at any rate a minimum number of men's normal desires after their basic needs are satisfied – say, for self-expression, happiness, freedom, justice. Any government which realises these values to a reasonable degree is held to fulfil its function. These are not the principal ends of Soviet society, or of its government. Conditioned by its revolutionary origins, it is organised to achieve objectives, to respond to challenges, win victories. Like a school, a team of players, still more like an army on the march, it is a specialised institution designed for specific purposes that must be made explicit to its members by the leaders. Soviet life is constructed to strive for goals. It makes little difference what the particular goals may be – military or civil, the defeat of the enemy within or without, or the attainment of industrial objectives – announced goals there must be, if Soviet society is to continue in existence. The leaders understand this well, and whether or not they are to be regarded as prisoners of their own system, they know that they must continue to exhort their subjects to greater and greater endeavours if they are to avoid the disintegration of the regime. They are in the position of army commanders in a war, who realise that unless their troops see a minimum amount of active service, the discipline, the esprit de corps, the continued existence of the armies as fighting units cannot be guaranteed.

The leaders of the Soviet Union, for all we know, may by now be secretly hankering after a peaceful existence, to abandon the exiguous splendours and unending cruelties and miseries of the regime and subside into 'normal' existence. If they harbour any such desires, they know that in the short run, at least, this is not practicable. For Soviet society is organised not for happiness, comfort, liberty, justice, personal relationships, but for combat.

Whether they wish it or not the drivers and controllers of this immense train cannot now halt it or leap from it in mid-course without risk of destruction. If they are to survive and above all remain in power, they must go on. Whether they can replace parts of it while it is moving and so transform it (themselves) into something less savage, less dangerous to themselves and mankind, remains to be seen. At any rate that must be the hope of those who do not think war inevitable.

In the meanwhile this caricature of *dirigisme* has discredited the tradition of social idealism and liquidated the intelligentsia connected with it, perhaps more decisively than unaided persecution could have done. Nothing destroys a minority movement more effectively than the official adoption and inevitable betrayal and perversion of its ends by the State itself. There are cases where nothing succeeds less well than success.

<center>VII</center>

It might be supposed that the new Soviet man – the result of so many years of Stalinist conditioning – would be similarly altered, a new creature adjusted to the new artificial dialectic, and as different from his Western counterpart as the Soviet system differs from Western forms of government. But this has not, in fact, turned out to be so. In so far as recent conversations of mine with students, clerks in shops, taxi-drivers and stray acquaintances of all sorts can convey a just impression, the result is a kind of arrested infantile development, not a different kind of maturity.

In the Soviet Union today one finds the conditions that are often found to prevail in organisations in which degrees and types of responsibility are very sharply defined – strictly disciplined schools, armies or other rigid hierarchies in which the differences between the governors and the governed are extremely precise. Indeed, the chasm between the governors and the governed is the deepest single division noticeable in Soviet society; and when one speaks to Soviet citizens it soon becomes quite clear to which of the two groups they belong. Honest public discussion, either of the ends for the sake of which the new society

supposedly exists, or of the most important means supposedly adopted for the forwarding of those ends, is equally discouraged on both sides of this great dividing line. The work of the anthill must be done, and anything that wastes time or creates doubts cannot be permitted. But the consequences in one case are somewhat different from those in the other.

Let me begin with the governed. Those who have no ambition themselves to become governors, and have more or less accepted their position in the lower ranks of the Soviet hierarchy, do not seem to be deeply troubled about public issues. They know they cannot affect those issues in any case, and discussion of them is, moreover, liable to be dangerous. Hence when they touch upon them at all they speak with the gaiety, curiosity and irresponsibility of schoolboys discussing serious public issues outside their ken, more or less for fun, not expecting to be taken too seriously, and with a pleasing sense of saying something daring, near the edge of forbidden territory. Such people cultivate the private virtues, and retain those characteristics that were so often noted as typically Russian by foreigners before. They tend to be amiable, spontaneous, inquisitive, childlike, fond of pleasure, highly responsive to new impressions, not at all blasé, and, having been kept from contact with the outside world for so long, essentially Victorian and prudishly conventional in their outlook and tastes. They are not as terrified as they were in Stalin's day, when no one knew what might not happen to him, and no effective appeal to any institution of justice was possible. The tyrant is dead, and a set of rules and regulations rule in his place.

The rules are exceedingly harsh, but they are explicit, and you know that if you transgress them you will be punished, but that if you are innocent – if you live a very careful and circumspect life, take no risks, see no foreigners, express no dangerous thoughts – you can reasonably count on being safe and, if arrested, on a reasonable chance of clearing up the misunderstanding and regaining your freedom. The justice of the rules themselves is not, one finds, much discussed. The question is not asked whether they are good or bad. They appear to be taken for granted, like something from on high, on the whole disagreeable, and certainly not believed in with the kind of religious devotion

expected of good Communists, but, since they are clearly not alterable by the governed, accepted by them almost like the laws of nature.

Taste remains simple, fresh and uncontaminated. Soviet citizens are brought up on a diet of classical literature – both Russian (which is almost unrestricted now) and foreign – mainly of authors held to be of 'social significance': Schiller, Dickens, Balzac, Stendhal, Flaubert, Zola, Jack London, plus 'boy scout' novels celebrating the social virtues and showing how vice is always punished in the end. And since no trash or pornography or 'problem' literature is allowed to distract them, the outlook of the pupils in this educational establishment remains eager and unsophisticated – the outlook of adolescents, sometimes very attractive and gifted ones. At the marvellous exhibition of French art in the Hermitage in Leningrad, Russian visitors (according to at least one foreigner who spoke to several among them) admired few pictures after the 1850s, found the Impressionists, particularly Monet and Renoir, difficult to like, and quite openly detested the paintings of Gauguin, Cézanne and Picasso, of which there were many magnificent examples. There are, of course, Soviet citizens with more sophisticated tastes, but few and far between, and they do not advertise their tastes too widely.

Students are encouraged to take interest in scientific and technological studies more than in the humane ones, and the closer to politics their fields of study are, the less well they are taught. The worst off are, therefore, the economists, modern historians, philosophers and students of law. A foreign student working in the Lenin Library in Moscow found that the majority of his neighbours were graduate students, preparing theses which consisted largely of copying passages from other theses that had already obtained doctorates and, in particular, embodying approved quotations from the classics – mainly the works of Lenin and Stalin (still Stalin in 1956) – which, since they had stood the test of many examinations, represented the survival of the fittest. It was explained to this foreign student that, without these, no theses could hope to pass. Evidently both examinees and examiners were engaged in an unspoken understanding about the type of quotations required, a quota of these being a sine qua

non for obtaining a degree. The number of students reading books was very small in comparison with those reading theses, plus certain selected copies of *Pravda* and other Communist publications containing quotable official statements of various kinds.

In philosophy the situation is particularly depressed. Philosophy – that is, dialectical materialism and its predecessors – is a compulsory subject in all university faculties, but it is difficult to get any teacher of the subject to discuss it with any semblance of interest. One of these, perhaps in an unguarded moment, went so far as to explain to a puzzled foreign amateur of the subject that under the Tsarist regime a clergyman was expected to visit every form in the school, say, once a week, and drone through his scripture lesson, while the boys were expected to sit quiet. They were scarcely ever asked to answer questions; and, provided they gave no trouble, did not interrupt or give vent to aggressively anti-religious or subversive thoughts, they were by tacit consent permitted to sleep through the hour – neither side expecting to take the other seriously. The official philosophers were the cynical clergy of today. Lecturers on dialectical materialism simply delivered their stock lectures, which had not altered during the last twenty years – ever since debates between philosophers had been forbidden even within the dialectical materialist fold. Since then the entire subject had turned into a mechanical reiteration of texts, whose meaning had gradually evaporated because they were too sacred to be discussed, still less to be considered in the light of the possibility of applying them – except as a form of lip-service – to other disciplines, say economics or history. Both the practitioners of the official metaphysics and their audiences seem equally aware of its futility. So much could, indeed, be admitted with impunity, but only by persons of sufficient importance to get away with it: for example, by nuclear physicists whose salaries are now probably the highest of all, and who apparently are allowed to say, almost in public, that dialectical – and indeed all – philosophy seems to them meaningless gibberish upon which they cannot be expected to waste their time. Most of those who have spoken to teachers of philosophy in Moscow (and a good many Western visitors have done so by now) agree that

they are one and all passionately interested to know what has been going on in the West, ask endless questions about 'Neo-Positivism', Existentialism and so on, and listen like boys unexpectedly given legal access to forbidden fruit. When asked about progress in their own subject, the look of guilty eagerness tends to disappear, and they show conspicuous boredom. Reluctance to discuss what they know all too well is a dead and largely meaningless topic, before foreigners who are not expected to realise this, is almost universal. The students make it all too clear that their philosophical studies are a kind of farce and known to be such, that they long to be allowed to interpret and discuss even such old-fashioned thinkers as Feuerbach or Comte, but that this is not likely to be found in order by those in authority. Clearly 'the governed' do not seem to be taken in by what they are told. The philosophy students know that the philosophy dispensed to them is petrified nonsense. The professors of economics, for the most part, know that the terminology they are forced to use is, at best, obsolete.

At a wider level, it is difficult to find anyone with much belief in the information that comes from either their own newspapers or radio, or from abroad. They tend to think of it as largely propaganda, some of it Soviet, some of it anti-Soviet and so to be equally discounted; and they avert their thoughts to other fields in which freer discussion is possible, mainly about issues of personal life, plays, novels, films, their personal tastes and ambitions and the like. On all these subjects they are fresh, amusing and informative. They suffer from no noticeable xenophobia. Whatever they might be told by the authorities they hate no foreigners. They do not even hate the Germans, against whom there really was strong feeling of a personal kind in 1945–6, and certainly not the Americans, even though they fear that, because of the quarrels of governments, the Americans may make war upon them; but even this is viewed like the possibility of an earthquake or some other natural cataclysm than something to which blame attaches. Those who ask questions about current politics usually show little bias, only the curiosity of bright elderly children. Thus the taxi-driver who asked his passenger if it was true that there were two million unemployed in England, and upon learn-

ing that this was not so, replied philosophically, 'So they have lied about this too,' said so without the slightest indignation, not even with noticeable irony, very much like someone stating a fairly obvious fact. It was the Government's business to dispense these lies, he seemed to say (like that of any Ministry of Propaganda in wartime), but intelligent persons did not need to believe them.

The amount of deception or illusion about the external world in large Soviet cities is not as high as is sometimes supposed in the West – information is scanty, but extravagant inventions are seldom believed. It seems to me that if by some stroke of fate or history Communist control were lifted from Russia, what its people would need would be not re-education – for their systems have not deeply absorbed the doctrines dispensed – but mere ordinary education. In this respect they resemble Italians unde-luded by Fascism, rather than Germans genuinely penetrated by Nazism.

In fact, the relative absence of what might be called Com-munist mystique is perhaps the most striking fact about the ersatz intelligentsia of the Soviet Union. No doubt many con-vinced Marxists exist in Poland and Yugoslavia and elsewhere; but I cannot believe that there are many such in the Soviet Union – there it has become a form of accepted, and unresisted, but infi-nitely tedious, official patter. What writers and intellectuals desire – and those who have made their protests at recent meetings of writers' unions and the like are symptomatic of this – is not so much to be free to attack the prevailing orthodoxy, or even to discuss ideological issues; but simply to describe life as they see it without constant reference to ideology. Novelists are bored, or disgusted, with having to put wooden, idealised figures of Soviet heroes and villains into their stories and upon their stages; they would passionately like to compose with greater – if still very naïve – realism, wider variety, more psychological freedom; they look back with nostalgia to what seems to them the golden age of the Leninist 1920s, but not beyond. This is different from seething with political revolt. The writers – or, at any rate, some of them – wish to discuss or denounce bureaucracy, hypocrisy, lies, oppression, the triumphs of the bad over the good, in the

moral terms to which even the regime ostensibly adheres. These moral feelings, common to all mankind, and not heterodox or openly anti-Marxist attitudes, are the form in which the Hungarian revolt seems to have been acclaimed or condemned, and in which the new novel (almost worthless as literature, but most important as a social symptom) that has stirred everyone so deeply – *Not by Bread Alone*, by Dudintsev – is written and discussed.[1]

The governed – the subject population – are for the most part neither Communist believers nor impotent heretics. Some, perhaps the majority, are discontented; and discontent in totalitarian States is ipso facto political and subversive. But at present they accept or at any rate passively tolerate their Government – and think about other things. They are proud of Russian economic and military achievements. They have the charm of a sheltered, strictly brought up, mildly romantic and imaginative, somewhat boyish, deeply unpolitical group of simple and normal human beings who are members of some ruthlessly ruled corporation.

As for the governors, that is a different story. Individually ruthless and anxious to get on, they seem agreed that Communist language and a certain minimum of Communist doctrine are the only cement that can bind the constituent parts of the Soviet Union, and that to modify these too greatly would endanger the stability of the system and make their own position excessively precarious. Consequently they have managed to translate the thoughts in their heads into a reasonable imitation of Communist terminology, and seem to use it in their communication with each other as well as foreigners. When you ask them questions (and it is always clear whether or not one is talking to a member of the upper tiers of the hierarchy or someone who is aspiring to get there, if only from his looks and the tone of his voice and the clothes he wears and other less palpable things) they launch into something which at first seems a mere propagandist turn; then gradually one realises that they believe in what they are saying in

---

[1] Nor does the 'oppositionist' literary almanac *Literaturnaya Moskva* do more than this: it is neither for 'pure' art nor for some alternative policy, however covertly. Its 'suspect' articles cry out for human values. I.B.

much the same way as a politician in any country can be said to believe in a performance which he knows that he manages well, which he has adjusted to his audience, upon which his success and career depend, which has patently become bound up with his whole mode of self-expression, possibly even to himself, and certainly to his friends and colleagues.

I do not believe that a double morality prevails in the Soviet Union: that the Party leaders or bureaucrats talk in the consecrated mumbo-jumbo to their subjects, and then drop all pretence and talk cynical common sense to each other. Their language, concepts, outlook are an amalgam of both. On the other hand, again perhaps like that of the Russian bureaucrats of old, and of certain types of political manipulators and power-holders everywhere, their attitude toward their own official doctrine, but still more toward the beliefs of the outside world, is often sceptical and, indeed, cynical. Certain very simplified Marxist propositions they certainly do hold. I think they genuinely believe that the capitalist world is doomed to destruction by its own inner contradictions; that the proper method of assessing the power, the direction and the survival value of a society is by asking a certain type of 'materialistic' economic or sociological questions (taught to them by Lenin), so that the answers to these questions play a decisive part in the conception and formulation of their own most crucial political and economic policies. They believe that the world is marching inexorably towards collectivism, that attempts to arrest or even modify this process are evidence of childishness or blindness, that their own system, if only it holds out long enough against capitalist fury, will triumph in the end, and that to change it now, or to retreat too far simply in order to make their subjects happier or better, might mean their own doom and destruction, and – who knows? – perhaps that of their subjects too. In other words, they think in terms of Marxist concepts and categories, but not in terms of the original Marxist purposes or values – freedom from exploitation, or coercion, or even the particular interests of groups or classes or nations – still less in terms of the ultimate ideals: individual freedom, the release of creative energy, universal contentment and the like. They are too tough and morally indifferent for that.

They are not religious; but neither are they believers in some specifically proletarian morality or logic or historical pattern.

Their attitude towards intellectuals can be compared in some degree to that of political bosses everywhere: it is, of course, largely conditioned by the tone set by the leaders – the members of the Central Committee of the Communist Party. The majority of these, in addition to their suspicion of those who are concerned with ideas in any form as a perpetual source of potential danger, feel personally uncomfortable with them, and dislike them for what can only be called social reasons. These are the kinds of reason for which trade unionists in all countries sometimes feel a combined attitude of superiority and inferiority to intellectuals – superiority because they think themselves more effective, more experienced, and with a deeper understanding of the world gained in a harder school; and inferiority socially, intellectually and because they feel ill at ease with them. The group of roughnecks who preside over Russia's fortunes – and one glance at the Politburo (now called the Presidium) makes it clear that they are men happier at street-corner meetings or on the public platform than in the study – look upon intellectuals with the same uneasy feeling as they look on the better-dressed, better-bred members of the foreign colony – diplomats and journalists – whom they treat with exaggerated and artificial politeness, envy, contempt, dislike, intermittent affability and immense suspicion. At the same time they feel that great nations must have important professors, celebrated artists, cultural trappings of an adequate kind. Consequently they pay the topmost practitioners of these crafts high salaries, but cannot resist – from sheer resentment – an irrepressible desire to bully, or – from a deep, jealous sense of inferiority – the temptation to knock them about, kick them, humiliate them in public, remind them forcibly of the chains by which they are led whenever they show the least sign of independence or a wish to protect their own dignity.

Some intellectuals do, of course, themselves belong to the upper rungs of the hierarchy; but these are looked on by the bulk of other intellectuals either as semi-renegades and creatures of the Government, or else as blatant political operators or agitators, required to pose as men of learning or creative artists. The differ-

ence between genuine writers who can talk to other writers in normal human voices, and the literary bureaucrats – a difference, once again, between the governors and the governed – is the deepest single frontier in Soviet intellectual life. It was one of the former – the governors – who, talking not ostensibly about himself but about intellectuals in general, told a visiting American journalist not to think that Soviet intellectuals as a class were particularly keen about the granting of greater personal freedom to the workers and peasants in the Soviet Union. He said, in effect, that if they began giving liberties too fast, there might be too much unruliness – strikes, disorder – in the factories and the villages; and the intelligentsia, a most respected class in Soviet society, would not wish the order from which they very rightly get so much – above all, prestige and prosperity – to be jeopardised. 'Surely you understand that?' he asked.

So far, then, have we travelled from the nineteenth century, when the whole of Russian literature was one vast, indignant indictment of Russian life; and from the agonies and enthusiasms and the bitter, often desperate, controversies and deadly duels of the 1920s and early 1930s. A few pre-Stalin men of letters survive, great names, but few and far between; they are half admired, half gaped at as semi-mythical figures from a fabulous but dead past. Bullying and half-cynical semi-Marxist philistines at the top; a thin line of genuinely civilised, perceptive, morally alive and often gifted, but deeply intimidated and politically passive, 'specialists' in the middle; honest, impressionable, touchingly naïve, pure-hearted, intellectually starved, non-Marxist semi-literates, consumed with unquenchable curiosity, below. Such is Soviet culture, by and large, today.

# THE SURVIVAL OF THE RUSSIAN INTELLIGENTSIA

## 1990

YOU ASK ME for a response to the events in Europe. I have nothing new to say: my reactions are similar to those of virtually everyone I know, or know of – astonishment, exhilaration, happiness. When men and women imprisoned for a long time by oppressive and brutal regimes are able to break free, at any rate from some of their chains, and after many years know even the beginnings of genuine freedom, how can anyone with the smallest spark of human feeling not be profoundly moved?

One can only add, as Madame Bonaparte said when congratulated on the historically unique distinction of being mother to an emperor, three kings and a queen, 'Oui, pourvu que ça dure.' If only we could be sure that there will not be a relapse, particularly in the Soviet Union, as some observers fear.

The obvious parallel, which must have struck everyone, is the similarity of these events to the revolutions of 1848–9, when a great upsurge of liberal and democratic feeling toppled governments in Paris, Rome, Venice, Berlin, Dresden, Vienna, Budapest.

The late Sir Lewis Namier attributed the failure of these revolutions – for by 1850 they were all dead – to their having been, in his words, a 'Revolution of the Intellectuals'.[1] However this may be we also know that it was the forces unleashed against these revolutions – the armies of Prussia and Austria-Hungary, the southern Slav battalions, the agents of Napoleon III in France and Italy, and, above all, the Tsar's troops in Budapest – that crushed this movement and restored something like the status quo.

[1] L. B. Namier, *1848: The Revolution of the Intellectuals* (London, 1946).

Fortunately, the situation today does not look similar. The current movements have developed into genuine, spontaneous popular risings, which plainly embrace all classes. We can remain optimistic.

Apart from these general reflections, there is a particular thing which has struck me forcibly – the survival, against all odds, of the Russian intelligentsia.

An intelligentsia is not identical with intellectuals. Intellectuals are persons who, as someone said, simply want ideas to be as interesting as possible. 'Intelligentsia', however, is a Russian word and a Russian phenomenon. Born in the second quarter of the nineteenth century, it was a movement of educated, morally sensitive Russians stirred to indignation by an obscurantist Church; by a brutally oppressive State indifferent to the squalor, poverty and illiteracy in which the great majority of the population lived; by a governing class which they saw as trampling on human rights and impeding moral and intellectual progress.

They believed in personal and political liberty, in the removal of irrational social inequalities, and in truth, which they identified to some degree with scientific progress. They held a view of enlightenment that they associated with Western liberalism and democracy.

The intelligentsia, for the most part, consisted of members of the professions. The best-known were the writers – all the great names (even Dostoevsky in his younger days) were in various degrees and fashions engaged in the fight for freedom. It was the descendants of these people who were largely responsible for making the February Revolution of 1917. Some of its members who believed in extreme measures took part in the suppression of this Revolution and the establishment of Soviet Communism in Russia, and later elsewhere. In due course the intelligentsia was by degrees systematically destroyed, but it did not wholly perish.

When I was in the Soviet Union in 1945, I met not only two great poets and their friends and allies who had grown to maturity before the Revolution, but also younger people, mostly children or grandchildren of academics, librarians, museum-keepers, translators and other members of the old intelligentsia who had

managed to survive in obscure corners of Soviet society. But there seemed to be not many of them left.

There was, of course, a term 'Soviet Intelligentsia', often used in State publications, and meaning members of the professions. But there was little evidence that this term was much more than a homonym, that they were in fact heirs of the intelligentsia in the older sense, men and women who pursued the ideals which I have mentioned. My impression was that what remained of the true intelligentsia was dying.

In the course of the last two years I have discovered, to my great surprise and delight, that I was mistaken. I have met Soviet citizens, comparatively young, and clearly representative of a large number of similar people, who seemed to have retained the moral character, the intellectual integrity, the sensitive imagination and immense human attractiveness of the old intelligentsia. They are to be found mainly among writers, musicians, painters, artists, in many spheres – the theatre and cinema – and, of course, among academics. The most famous among them, Andrey Dimitrievich Sakharov, would have been perfectly at home in the world of Turgenev, Herzen, Belinsky, Saltykov, Annenkov and their friends in the 1840s and 1850s.

Sakharov, whose untimely end I mourn as deeply as anyone, seems to me to belong heart and soul to this noble tradition. His scientific outlook, unbelievable courage, physical and moral, above all his unswerving dedication to truth, make it impossible not to see him as the ideal representative in our time of all that was most pure-hearted and humane in the members of the intelligentsia, old and new. Moreover, like them, and I speak from personal acquaintance, he was civilised to his fingertips and possessed what I can only call great moral charm. His vigorous intellect and lively interest in books, ideas, people, political issues seemed to me, tired as he was, to have survived his terrible maltreatment.

Nor was he alone. The survival of the entire culture to which he belonged, underneath the ashes and rubble of dreadful historical experience, appears to me a miraculous fact. Surely this gives grounds for optimism. What is true of Russia may be even more true of the other peoples who are throwing off their shackles –

where the oppressors have been in power for a shorter period and where civilised values and memories of past freedom are a living force in the still unexhausted survivors of an earlier time.

The study of the ideas and activities of the nineteenth-century Russian intelligentsia has occupied me for some years, and to find that, so far from being buried in the past, this movement – as it is still right to call it – has survived and is regaining its health and freedom, is a revelation and a source of great delight to me. The Russians are a great people, their creative powers are immense, and once they are set free there is no telling what they may give to the world. A new barbarism is always possible, but I see little prospect of it at present. That evils can, after all, be conquered, that the end of enslavement is in progress, are things of which men can be reasonably proud.

# GLOSSARY OF NAMES

*Helen Rappaport*

*This glossary is not intended to be exhaustive. Its main purpose is to identify and contextualise most of the Russian and Soviet personalities referred to by Berlin. Many of these fell victim to persecution, arrest and the suppression of their work during the Stalin years. Also included are some of the Western writers and political fellow-travellers in the text. The work of many of these has now fallen into neglect, though they promoted an interest in the Soviet experiment during the inter-war years and had a much higher profile at the time Berlin wrote about them. In general, better known nineteenth- and twentieth-century European literary and cultural figures have been omitted, as have the best-known Russian writers.*

Abakumov, Viktor Semenovich (1894–1954), has the dubious distinction of being one of Stalin's most toadying and long-serving secret police chiefs, as head of the Ministry of State Security, the MGB (Ministerstvo gosudarstvennoi bezopasnosti), 1947–51. He was closely involved in the renewed attack on Soviet Jews made during the last years of Stalin's rule, including the murder of prominent Jewish actor, Solomon Mikhoels, in 1948. He was also a major orchestrator of the 'Leningrad Affair', the mass purge of Communist Party members and government officials of the Leningrad Soviet during the years 1948–50. Inevitably, Stalin turned against his trusty acolyte, as he did against practically all the others, and Abakumov was arrested in July 1951. It was only Stalin's death in March 1953 that saved him, though only for a short while. A deeply sinister and sadistic figure, Abakumov was one of the first to be arraigned for his crimes by the new regime; he was tried in secret in December 1954 and shot immediately afterwards.

Adamovich, Georgy Viktorovich (1884–1972), Russian-born Acmeist poet and literary critic. His early poetry, such as the collection *Oblaka*

(Clouds, 1916) was influenced by Nikolay Gumilev and Akhmatova (qq.v.). Adamovich left Russia in 1922, joining émigré circles in Paris, where he became an influential figure, writing for journals such as *Poslednie novosti* (Latest News, 1928–39). His poetic oeuvre remained slight, and his critical work on Russian émigré literature became a major preoccupation, collected as *Odinochestvo i svoboda* (Solitude and Freedom, 1955) and *Kommentarii* (Commentaries, 1967).

Akhmatova, Anna Andreevna (1889–1966), Russian poet and national heroine, born in Odessa, Ukraine. In pre-Revolutionary Russia she was a leading light in the Acmeist group of poets during the 'Silver Age' of Russian poetry, publishing *Vecher* (Evening, 1912) and *Chetki* (Rosary, 1913) and the highly emotive *Belaya staya* (The White Flock, 1917) about the pain of disappointed love. Her first husband, the poet Nikolay Gumilev (q.v.) was shot in 1921 and Akhmatova herself came under attack a year later for her individualism and lack of political commitment. Vilified by the critics, she was unable to publish, until the brief relaxation of the strictures on writers during the Second World War. But a renewed and even more savage attack on her work was made by Zhdanov (q.v.) in 1946. During the long dark years of Stalinist repression she worked on her masterpiece, the poetry cycle *Rekviem* (Requiem) which was finally published in 1963. Her 1945 meeting with IB prompted allusions to him as the 'Guest from the Future' in her *Poema bez geroya: triptikh* (Poem without a Hero: Triptych, 1960).

Aksakovs, pre-eminent Russian family of Slavophil writers, ideologists and literary critics. Sergey Timofeevich (1791–1859) was a Russian bureaucrat, writer and theatre critic, famous for his fictionalised auto-biographical work, *Semeinaya khronika* (Family Chronicle, 1856), about life on the family estate in the Russian borderlands. His eldest son Konstantin Sergeevich (1817–60), became radicalised at the University of Moscow, where he was a devotee of the philosophy of Hegel, and a friend of Bakunin, Herzen and Belinsky. He later abandoned Hegelianism to become an outspoken Slavophil. His younger brother, Ivan Sergeevich (1823–86) studied law in St Petersburg (1838–42) and edited a succession of radical journals. After the death of Konstantin, Sergey assumed his leadership of the Slavophils, publishing increasingly extremist, nationalistic essays in journals such as *Den'* (Day) and *Moskva* (Moscow) and inciting Russia's war against the Turks of 1877–8.

Aldridge, (Harold Edward) James (b. 1918), Australian-born British Communist writer who settled in Britain in the late 1930s after having worked as a journalist in Melbourne. His best-known books, *Signed with their Honour* (1942) and *The Sea Eagle* (1944), were based on his experiences as a war correspondent, but were criticised for being Marxist in tone. He also wrote stories for children.

Aleksandrov, Georgy Fedorovich (1908–61), Soviet administrator, Hegelian philosopher and official Stalinist ideologist. As head of the Communist Party propaganda machine during the Second World War he wrote an official biography of Stalin and in 1946 published *Istoriya zapadno-evropeiskoi filosofii* (History of West European Philosophy). He was attacked for the latter work in 1947 by Zhdanov (q.v.), accused of attributing to Western philosophy too great an influence on the development of Marxism. He was removed from his post on the Central Committee of the Party in 1946, though he was that year appointed director of the Soviet Institute of Philosophy (until 1954); he also served briefly as Minister of Culture (1954–5).

Alekseev, Mikhail Pavlovich (1896–1981), Soviet literary historian and critic, with an international academic reputation. This was established through his encouragement of collaboration between Russian and Western academics, as head of Pushkin House, the Institute of Russian Literature. From 1959 he served as head of the Pushkin Commission. Alekseev made a particular study of the place in the history of world culture held by Russian and ancient Slavic literatures, and, himself multilingual, wrote extensively on the links between Russian and European literatures.

Annenkov, Pavel Vasil'evich, (*c.*1812–87), Russian writer, critic and memoirist, best known for his vivid reminiscences of his contemporaries, Herzen and Belinsky (qq.v.), Turgenev and Bakunin. During the 1840s he travelled in Europe, where he developed close friendships with Gogol (then living in Italy) and Marx. Returning to Russia and literary scholarship, he edited the first, seven-volume, collection of Pushkin's works, published in 1855; he also produced several notable studies on Pushkin, including *A. S. Pushkin v Aleksandrovskuyu epokhu, 1799–1826* (A. S. Pushkin in the Age of Alexander, 1874). He is now, however, mainly remembered for his vivid memoir, *Zamechatel'noe desyatiletie* (A Remarkable Decade, 1880) of Russian intellectual life in the 1830s and '40s, of which IB was a great admirer

(see his four essays published under the same title in *Russian Thinkers*).

Annensky, Innokenty Fedorovich (1856–1909), Russian poet, literary critic and translator. A classical scholar, Annensky taught Greek and Latin. He translated Euripedes (published 1907–21) as well as French and German poetry. His poetic oeuvre was inspired by the French rather than the Russian symbolist movement, which latter he rejected as being too mystical, and provided inspiration for Acmeist poets such as Akhmatova and Nikolay Gumilev (qq.v.). His major poetry collections were *Tikhie pesni* (Quiet Songs, 1904) and *Kiparysovyi larets* (The Cyprus Chest, 1910); he also produced two volumes of literary criticism, *Knigi otrazhenii* (Books of Reflections, 1906 and 1909).

Anrep, Boris Vasile′vich von (1883–1969), Russian-born émigré artist and mosaicist, who spent much of the period 1908–18 moving between Paris, London and St Petersburg. In the spring of 1915 he met and had a love affair with Anna Akhmatova (q.v.). She would dedicate more than thirty poems to him in her collections *Belaya staya* (The White Flock, 1917) and *Podorozhnik* (Plantain, 1921). During 1918–26 Anrep lived in London, where he established himself in artistic circles and mixed with members of the Bloomsbury Group, including Virginia Woolf, Maynard Keynes and Ottoline Morrell. His finest works, such as the mosaics in the Rotunda and the Blake Room at the Tate Gallery, and important commissions for the National Gallery, were executed in London, the most important being the mosaics for Westminster Cathedral (1956–62). He met Akhmatova once again during her visit to Paris in 1965; his memories of her were published after his death.

Aragon, Louis (1897–1983), French surrealist novelist, poet and editor of left-wing journals. In 1919 he co-founded the journal *Littérature* and published surrealist poetry and prose in the 1920s, including the novel *Le paysan de Paris* (1926, trans. 1950 as *The Night Walker*). He joined the Communist Party in 1927 and, after visiting the Soviet Union in 1930, adopted the socialist-realist style of writing. This was reflected in his four-volume novel series *Le Monde réel* (1933–51), and the six-volume *Les Communistes* (1949–51). During the Second World War his poetry collection *Le Crève-coeur* (1941) was the mouthpiece of the French resistance.

Arkhipenko (also known as Archipenko), Aleksandr P. (1887–1964), émigré Russian sculptor. Born in Kiev, he found his inspiration in artistic circles in the Paris of the 1900s while studying at the École des Beaux-Arts and became a pioneer of Cubism. He left Russia in 1921 to teach in Berlin and later settled in the USA, where he took citizenship in 1928. He opened a school of sculpture in New York in 1939, where he pioneered the use of Plexiglas and other new materials in sculpture, having coined the term 'Archipentura' to define the fluidity of his work. His best-known sculptures are *Walking Woman* (1912) and *Boxing Match* (1913).

Aseev, Nikolay Nikolaevich (1889–1963), Soviet poet and literary theorist. A leading futurist poet in the pre-Revolutionary years, he published his first collection, *Nochnaya fleyta* (Night Flute) in 1914. After spending the years 1916–21 in the Far East, he joined Mayakovsky's LEF group of writers and poets, producing stirring, propagandist verse such as 'Budenny' (1923) about the Civil War leader. When his enthusiasm for the new Soviet regime waned he expressed his political disappointment in the narrative poem *Liricheskoe otstuplenie* (Literary Digression, 1924). But his devotion to Mayakovsky remained undimmed, and he honoured him in the more conventional socialist-realist verse epic *Mayakovsky nachinaetsya* (Mayakovsky Begins, 1937–40), which won him the Stalin Prize.

Averbakh, Leopold Leonidovich (1903–39), Soviet literary critic. An intellectual leader of the Komsomol youth movement,[1] he edited its journal *Yunosheskaya pravda* (Youthful Truth) and *Molodaya Gvardiya* (The Young Guard). As a passionate advocate of and mouthpiece for proletarian literature, he was active in the Russian Association of Proletarian Writers (RAPP). He edited its journal *Na literaturnom postu* (At the Literary Post) in the 1920s, but fell out of favour after the dissolution of RAPP in 1932 and the inception of socialist realism. He was arrested and executed during the Stalinist purges.

Babel', Isaak Emmanuilovich (1894–1940), Soviet-Jewish short-story writer, journalist, screenwriter and playwright of great promise, a victim

---

[1] 'Komsomol' is an abbreviation of 'Vsesoyuzny leninsky kommunisticheesky soyuz molodezhi' ('All-Union Leninist Communist League of Youth'), the sole official Communist youth organisation for those aged 14–28.

of the Stalinist purges. Born in Odessa, Babel' was a protégé of Gorky (q.v.) in Revolutionary Petrograd, publishing his first journalistic pieces in his *Novaya zhizn'* (New Life) during 1915–17. His experiences as a newspaper correspondent attached to General Budenny's First Cavalry during the Civil War inspired the thirty-four stories of *Konarmiya* (literally 'horse army', 1926; translated as *Red Cavalry*). His *Odesskie rasskazy* (Odessa Tales, 1931) drew on his Jewish childhood, but by the early 1930s Babel' fell silent, unable to adjust to the demands of socialist realism. He turned to screenwriting, working with Eisenstein (q.v.) on the film *Bezhin lug* (Bezhin Meadow), suppressed by Stalin in 1937. Arrested in May 1939, he was held in the Lubyanka prison in Moscow for many months before finally being tried and shot in January 1940.

Bagritsky, Eduard (pseudonym of Eduard Georgievich Dzyubin) (1897–1934), Soviet-Jewish poet, close friend of Babel' (q.v.). His early romantic, revolutionary verse was inspired by both the Acmeist and futurist schools. He settled in Moscow in 1925 and joined the Constructivist group of poets, publishing his first collection, *Yugo-zapad* (South-West) in 1928. By 1930 he had come under pressure to join the official writers' organisation, RAPP, and produce more conformist poetry. He brought out two more collections, *Pobediteli* (The Victors) and *Poslednaya noch'* (The Last Night), in 1932, but died prematurely, of asthma, at the age of thirty-seven.

Bal'mont, Konstantin Dmitrievich (1867–1942), Russian émigré symbolist poet, writer and translator. He failed to complete his law studies and turned to poetry, publishing his best work, such as *Goryashchie zdaniya* (Burning Buildings), during 1900–17. During this time he travelled widely, before finally settling in Paris in 1920, where he lived out the remainder of his life in poverty and obscurity. An outstanding polyglot, Bal'mont eked out a living writing on poetics and literary culture, and translating romantic poets such as Shelley and Coleridge, the Americans Walt Whitman and Edgar Alan Poe, and a diversity of European and Oriental verse.

Baratynsky, Evgeny Abramovich (1800–44), Russian poet. A product of tsarist military school, he served in the imperial army, while pursuing his literary interests as a member of the Free Society of Amateurs of Russian Literature. A contemporary and admirer of Pushkin, he was one of the so-called Pushkin Pleiad of poets, producing narrative works such as *Eda* (1824) based on the six years he spent in Finland

(1820–6) and *Bal* (The Ball, 1825–8), in which he satirised Moscow high society. His later poetry became increasingly pessimistic and reflective, notably *Poslednaya smert'* (The Last Death, 1827) and *Osen'* (Autumn, 1836–7). After falling into obscurity for fifty years, Baratynsky's work was enthusiastically rediscovered by Akhmatova (q.v.) and her generation in the 1900s.

Barmine, Alexander Gregory (Aleksandr Grigorevich Barmin) (1899–1987), one of the most high-profile Soviet defectors of the Cold War era. After serving as an intelligence officer in the Red Army, in 1935 Barmin was posted to Athens, ostensibly as chargé d'affaires, but in reality to head Soviet intelligence-gathering in Greece. In 1937, at the height of the purges, he was recalled to the Soviet Union. Knowing he faced certain death, Barmin defected in Paris and in 1940 fled to the USA, where he turned to journalism and protested against the persecution of Soviet politicians and intellectuals by Stalin in the famous radio broadcasts known as *The Voice of America*. In 1945 he published his memoirs, *One Who Survived*.

Belinsky, Vissarion Grigor'evich (1811–48), Russian literary critic, philosopher and political thinker. He was a central figure in radical debating circles at Moscow University from 1829, where he was a friend of Herzen (q.v.), but was expelled for his radicalism. He joined the journal *Teleskop* (The Telescope) as a literary critic in 1833. After this was closed down in 1836 he eked out a living from tutoring and journalism and worked as literary critic of the journal *Otechestvennye zapiski* (Notes of the Fatherland) 1839–46. He finally set his stamp at Nekrasov's (q.v.) journal *Sovremennik* (The Contemporary), but by now was severely weakened by years of living in abject poverty and the onset of consumption, which killed him two years later. Despite his early death, Belinsky's legacy in Russia was, and remains, considerable, and marked the rise of a new breed of lower-class, non-aristocratic intellectual, the *raznochinets*. Berlin's essays on Belinsky are included in his *Russian Thinkers* (1978).

Bely, Andrey (pseudonym of Boris Nikolaevich Bugaev) (1880–1934), Russian symbolist writer, mystic and poet. He studied philosophy and mathematics at Moscow University, publishing his first poetry, in the 'decadent' style, in 1902. After he embraced anthroposophy his work became increasingly mystical, notably the religiose *Khristos voskres* (Christ Is Risen, 1918) which celebrated the 1917 Revolution. Bely

spent the years 1921–3 as an émigré, but returned to Russia. His orna-mentalist style of prose was never popular, although *Peterburg* (Petersburg, 1913) has since garnered considerable critical interest for its Gogolian and Dostoevskian resonances.

Berggolts, Olga Fedorovna (1910–75), Russian poet and writer, a close friend of Anna Akhmatova (q.v.). In the mid-1920s she joined the Smena literary group and worked as a journalist and children's writer. Her reputation after 1934 was built on her poetry, her best-known work being her verse diary about the siege of Leningrad – *Lenin-gradskaya tetrad'* (Leningrad Notebook, 1942). Berggolts struggled to meet the demands of socialist realism as a writer, producing *Pervorossisk* (1950) a narrative poem about industrial construction at the city of that name, which won her a Stalin prize in 1950. However, she continued to emphasise the need for artistic freedom in order to achieve true creativity, an attitude endorsed by the later publication of extracts from her diaries in Israel.

Blok, Aleksandr Aleksandrovich (1880–1921), revered Russian sym-bolist poet of the Revolutionary era, best known for his narrative poem *Dvenadsat'* (The Twelve, 1918), a vivid depiction of the turmoil of the October Revolution. Blok studied philology at the University of St Petersburg and published his first collection of poetry, *Stikhi o prekrasnoi dame* (Verses on a Beautiful Lady), in 1904. His dreams of a new moral and political world order inspired by the Revolution soon faded away, although he remained an officially sanctioned poet on the strength of *Dvenadsat'* throughout the Soviet era. In the last years of his life, he sank into a deep melancholia, writing little and dying in poverty. Berlin translated his 'The Collapse of Humanism': *Oxford Outlook* 11 (1931), 89–112, and discusses him in 'A Sense of Impending Doom' (1935; original title 'Literature and the Crisis'), *The Times Literary Supplement*, 27 July 2001, 11–12.

Blyumkin, Yakov Grigorevich (1898–1929), a member of the left wing of the Socialist Revolutionaries who baulked at Bolshevik domination of the new government after he had assassinated the German ambassa-dor Mirbach on their instructions in 1918. He was granted an amnesty from his three-year prison sentence and worked under Trotsky at the People's Commissariat for War, transferring to the GRU (military intelligence) abroad, where he remained in contact with the now exiled Trotsky. While based in Turkey, Blyumkin acted as a go-between for

Trotsky and his supporters inside the Soviet Union. He was arrested and shot soon after returning in 1929.

Bonald, Louis-Gabriel-Ambroise, Vicomte de (1754–1840), French historian, philosopher and statesman. The publication of his *Théorie du pouvoir politique et religieux* in 1796, in support of the Bourbon monarchy in France, forced him to flee to Germany. After the restoration of the Bourbons in 1814 he returned to France to serve as Minister of Instruction under Napoleon I.

Brown, Clarence Fleetwood, Jr (b. 1929), American scholar and literary critic. As Professor of Comparative Literature at Princeton from 1970 he became a specialist on the modernist movements in Russian literature of the period 1890–1920, on translation theory, and on the work of Mandel'shtam. He is the author of *The Prose of Osip Mandelstam* (1965) and *Nabokov's Pushkin and Nabokov's Nabokov* (1967), and co-editor with W. S. Merwin of *The Selected Poems of Osip Mandelstam* (1973).

Bryusov, Valery Yakovlevich (1873–1924), critic, literary scholar and a founder of the symbolist movement in Russian poetry. He produced his best work – the collections of poems *Tertia Virgilia* (1900) and *Urbi et Orbi* (1903) – before the First World War, and thereafter was better known for his academic work and his literary translations from Latin, Armenian and French, most notably of Virgil's *Aeneid*.

Bubnov, Andrey Sergeevich (1883–1938), a leading Bolshevist of the old guard, changed sides to support Stalin in the early 1920s. He was placed in charge of the Agitation and Propaganda Department of the Central Committee, and remained a loyal apparatchik, producing a string of standard works on the history of the Communist Party. In 1924 he took over the running of the Political Directorate of the Red Army until 1929, when he succeeded Lunacharsky as People's Commissar for Culture and Education. From 1929 to 1937 he was editor-in-chief of the newspaper *Krasnaya zvezda* (The Red Star). Despite being a prominent figure, he was arrested in December 1937, and shot on 1 August 1938.

Bukharin, Nikolay Ivanovich (1888–1938), charismatic Bolshevik leader and economist. An influential figure in the Politburo and Comintern, he edited *Pravda* from 1918 and became the major Soviet

theoretician of economic policy. His moderate stance under Lenin's New Economic Policy of the 1920s revealed a brand of socialist humanism that was rapidly crushed after he made the mistake of aligning himself with Stalin against Trotsky. He came under official attack in 1929 and was removed from his editorship of *Pravda*. An attempt to regain his position by recanting and praising Stalin at the 1934 Party Congress was rewarded with a role in the drafting of the 1936 Stalin Constitution. But in 1937 Bukharin was arrested and charged with espionage. In March 1938 he was subjected to ritualised character assassination at a show trial, and shot soon afterwards. He was not rehabilitated until 1988.

Bulgakov, Mikhail Afanas'evich (1891–1940), Soviet playwright and novelist, originally trained as a doctor in Kiev. He served as a field doctor during the Civil War, the experience of which was the basis of his first novel, *Belaya gvardiya* (The White Guard, 1924), which in 1926 he adapted as a stage play, *Dni Turbinykh* (The Days of the Turbins). Bulgakov's later stories and some of his plays became increasingly fantastical and satiric, notably his masterpiece, the long-suppressed novel *Master i Margarita* (The Master and Margarita, first published in 1967, in English), which was not published in full in the Soviet Union until 1973. With characteristic perversity, Stalin played a cat-and-mouse game with Bulgakov over many years. He was a great fan of *Dni Turbinykh*, despite its sympathetic portrayal of the anti-Bolshevik Whites, and saw it several times during its run at the Moscow Art Theatre. But by 1930 Bulgakov had run into trouble, after a succession of his controversial plays were quickly suppressed by the authorities. Stalin refused Bulgakov's personal appeal to be allowed to emigrate, but in 1939 he offered him the chance of redeeming himself by writing a play about his, Stalin's, early revolutionary activities in the Caucasus. The play was, inevitably, rejected and the stress took its toll on Bulgakov's already fragile health, killing him at the age of forty-nine a year later.

Bunin, Ivan Alekseevich (1870–1953), one of the least-known but most stylish short-story writers of the late tsarist era, came from an impoverished landowning family and worked as a journalist and librarian before turning to writing. He began publishing stories and poetry from the late 1880s, the exotic locations of many of his stories reflecting his frequent travels abroad, in North Africa, the Middle East and India. Violently antipathetic to the Revolution, he left Russia in 1918

and settled in France, becoming a leading émigré writer and an out-spoken critic of the Soviet regime. Bunin's poetic gifts resonate throughout his opulent and lyrical stories; in his more naturalistic tales he shared a disciplined economy of style with Chekhov, the best-known example being *Derevnya* (The Village, 1909–10) and his mas-terpiece, *Gospodin iz San Frantsisko* (The Gentleman from San Francisco, 1916). In 1933 he was awarded the Nobel Prize for Literature. His outstanding late work is his fictionalised autobiogra-phy, *Zhizn' Arsen'eva* (The Life of Arsenev, first published in Paris in two volumes, 1930 and 1939).

Chaadaev, Petr Yakovlevich (1794–1856), Russian philosopher, who prompted the Slavophil–Westerner debate among Russian intellectuals with his series of *Lettres philosophiques*, written between 1827 and 1831. He was born into the landowning gentry and served in the Imperial Army during the Napoleonic Wars, afterwards travelling in Europe. When one of his letters, containing an outspoken critique of Russia's cultural and intellectual backwardness, was published in the journal *Teleskop* (Telescope) in 1836, the journal was closed down, and Chaadaev, declared mad, was placed under house arrest. Although public discussion of his ideas was strictly forbidden, Chaadaev re-mained an inspirational figure to many of his generation.

Chukovskaya, Lidiya (1910–98), Soviet literary critic, writer, and edi-tor of juvenile fiction, daughter of Korney Chukovsky (q.v.). A notable defender of literary freedom and human rights in the Soviet Union, Chukovskaya was a close friend of Anna Akhmatova (q.v.), and published a memoir of her (*Zapiski ob Anne Akhmatovoi*) in Paris in 1976. She suffered from the Stalinist terror at first hand, her second husband being a victim of the purges, and published two novels on the subject abroad. When Akhmatova's work was suppressed in the Soviet Union, Chukovskaya memorised some of her poems in order to save them. Chukovskaya's moving novel about the Stalinist purges, *Sof'ya Petrovna*, described the impact they had on ordinary families. Due to be published in the Soviet Union in 1963, the book was withdrawn at the last minute on the grounds of its alleged ideological distortion. It was published in Paris in 1965. Chukovskaya's dissident activities led to her expulsion from the Writers' Union in 1974.

Chukovsky, Korney Ivanovich (pseudonym of Nikolay Vasil'evich Korneichukov) (1882–1969), eminent Soviet man of letters, literary

critic and translator, as well as a popular children's writer; father of Chukovskaya (q.v.). Self-taught, he worked as a newspaper correspondent before the Revolution. He published critical essays on Russian literature, his specialism being the poet Nikolay Nekrasov (q.v.), and later edited children's literature and wrote popular verse fairy tales, retelling the stories of others for children, including Defoe's *Robinson Crusoe*. As head of Anglo-American literature at the World Literature publishing house from 1918, he translated the works of Twain, Conan Doyle, Whitman, Kipling and others into Russian. His theories on translation were published as *Iskusstvo perevoda* (The Art of Translation, 1930) and *Vysokoe Iskusstvo* (The Lofty Art, 1941).

Ciliga, Ante (1898–1992), Croatian writer, political commentator and nationalist. He joined the Social Democratic Party in 1918, but decamped to lead the Croatian faction of the Communist Party of Yugoslavia. He travelled Europe as a Communist Party official, working for the Comintern in the Soviet Union in 1926. Arrested as a Trotskyite in 1930, Ciliga spent six years in the Gulag, followed by internal exile, before being allowed to emigrate. In the West he denounced Communism and published an eyewitness account of Stalinist repression, *The Russian Enigma* (1938). Resettling in Croatia in 1941, he was arrested and imprisoned till 1943. After the war he settled in Rome where he wrote extensively on Croatian issues until his death.

Deborin, Abram Moiseevich (pseudonym of Abram Moiseevich Ioffe) (1881–1963), Marxist philosopher and political theorist, leader of the school of so-called 'dialecticians'. Deborin's theories, based on Hegelian dialectics, dominated Soviet philosophy until they were denounced by Stalin in 1930 as 'menshevising idealism', shortly after publication of his *Filosofiya i marksizm* (Philosophy and Marxism). Forced into obscurity for eighteen years, Deborin began publishing again after the death of Stalin in 1953.

Derzhavin, Gavriil Romanovich (1743–1816), outstanding Russian eighteenth-century lyric poet, an important precursor of Pushkin. From impoverished nobility, he served in the army and in 1777 entered the civil service. The publication of his *Oda k Felitse* (Ode to Felitsa, 1793), a thinly disguised paean to Catherine the Great, followed by several others in the same mode, won him official approval, and appointment as her secretary in 1791. He also served Alexander I as

Minister of Justice, retiring in 1803. A master of the classical ode, Derzhavin's most famous works, such as 'Na smert' knyaza Meshcherskogo' (On the Death of Prince Meshchersky, 1779) and 'Vodopad' (The Waterfall, 1791–4), despite their moralising and didactic tone, also celebrate in vivid imagery the power of nature.

Destutt de Tracy, Antoine-Louis-Claude (1754–1836), French soldier during the Revolution; a notable academician, and founder of the Idéologie school of philosophy. Destutt was elected to the States General in 1789, but imprisoned during the Reign of Terror (1793–4). As a philosopher of the science of ideas, he is famous for coining the term *idéologie* in 1796 and for his description of conscious human behaviour. Destutt's advocacy of national education and his affirmation of individual liberty were increasingly seen as a threat by Napoleon, who suppressed his work in 1803. After the restoration of the French monarchy he was elevated to the rank of Count. Destutt's philosophical writings include the four-volume *Eléments d'idéologie* (1801–15) and *Commentaire sur L'Esprit des lois de Montesquieu* (1808).

Djilas, Milovan (1911–95), Yugoslav writer and politician, a partisan leader, with Marshal Tito, during the German occupation of Yugoslavia in the Second World War. Djilas was imprisoned in 1933–6 for his Communist activities against the royalist State in Yugoslavia. During the war he worked closely with Tito, travelling to Moscow, where he met Stalin, leaving a valuable eyewitness account in his *Conversations with Stalin* (1962). He was promoted to Yugoslav Vice-President in 1953, but a year later his growing criticism of Tito's regime led to his expulsion from the Communist Party, and three periods of imprisonment between 1956 and 1966. His critical study of the Communist oligarchy, *The New Class: An Analysis of the Communist System* (1957), was published in New York to considerable acclaim.

Dudin, Mikhail Aleksandrovich (b. 1916), Soviet poet from a peasant background, started writing poetry in the 1930s and took up journalism whilst serving in the Red Army during the Second World War. Thereafter he established a reputation as a much-published but conformist war poet, most famous for his poem 'Solovei' (The Nightingales, 1942). His now forgotten narrative and didactic poetry reflects the life of a hack artist of the Stalin years who opted for the safe route of membership of the Communist Party and the Writers' Union, in which latter body he rose to a prominent position.

Dudinskaya, Natal'ya Mikhailovna (1912–2003), Russian prima balle- rina, and wife of the dancer Konstantin Sergeev (q.v.). A graduate of the Leningrad School of Choreography, she joined the Kirov Ballet in 1930, where she was noted for her repertoire of classical roles, includ- ing Odette/Odile in *Swan Lake* and the title role in *Giselle*. Retiring in 1961, she was ballet mistress at the Kirov from 1951 to 1970, and in the 1970s choreographed several ballets with her husband, including *Hamlet* (1970).

Dudintsev, Vladimir Dmitrievich (1918–98), Soviet novelist. After graduating in law from Moscow University (1940) he served in the Red Army during the Second World War and then worked as a jour- nalist for *Komsomolskaya pravda* (Komsomol Truth). He depicted industrial progress in a short story collection, *U semi bogatyrei* (Among Seven Bogatyrs), in 1956, the same year as his novel *Ne khle- bom edinyn* (Not by Bread Alone) was published. This latter work was criticised at home for its negative portrayal of Soviet bureaucracy, although it was well received abroad. The remainder of Dudintsev's largely hack literary output is little known.

Ehrenberg, *see* Erenberg.

Eikhenbaum, Boris Mikhailovich (1886–1959), Soviet academician, lit- erary historian and Formalist critic. He lectured in philology at Leningrad University from 1918 till his retirement in 1949, publishing studies such as *Melodiki russkogo liricheskogo stikha* (The Melodics of Russian Lyric Verse, 1923), and writing extensively on Tolstoy, of whose collected works (1928–58) he was one of the editors. He famously condemned the poetry of Akhmatova (q.v.) in a review arti- cle of 1923, labelling her 'half nun, half harlot', and so fuelled what would be the longstanding Soviet antipathy to her work.

Eisenstein, Sergey Mikhailovich (1898–1948), Soviet film director, pio- neer of what he termed the 'montage of film attractions'. His career began as a set designer at the Aleksandrinsky Theatre run by Vsevolod Meyerhold (q.v.), and in 1922 he joined the short-lived cultural organi- sation Proletkul't as artistic director of its touring theatre. His first film, *Stachka* (Strike, 1925), bore all the hallmarks of his innovative use of montage, which he refined in his hugely influential *Bronenosets Potemkin* (Battleship Potemkin, 1925) and *Oktyabr'* (October, 1927).

After a disastrous trip to Hollywood in 1930 to work for Paramount Pictures, Eisenstein returned to find his avant-garde style under attack. Filming on *Bezhin lug* (Bezhin Meadow) was aborted in 1937 but Eistenstein regained favour with the huge popular success of *Aleksandr Nevsky* in 1938. In 1947 he once more ran into trouble with Stalin, for Part 2 of his *Ivan groznyi* (Ivan the Terrible), the strain of which led to his early death from a heart attack.

Erenburg (known in the West as Ehrenburg), Ilya Grigorevich (1891–1967), one of the most famous émigré Russian writers of the inter-war years. Born into a Jewish family in Kiev, he left Russia in 1909 and lived in Paris. He returned to Russia in support of the anti-Bolshevik Whites after the Revolution, but in 1921, at the end of the Civil War, went back to Paris, where he worked as a journalist and writer, producing a string of novels of no particular literary merit. His best work remains his critically acclaimed satire on the West, *Neobychainye pokhozhdeniya Khulio Khurenito* (The Extraordinary Adventures of Julio Jurenito, 1922). Erenburg remained a loyal Russian patriot and supported the Soviet anti-Nazi propaganda machine during the Second World War. His post-war novel about the Soviet war effort, *Burya* (The Storm, 1947), reflected his increasing antipathy to the USA and earned him a Stalin Prize. After the death of Stalin he became a leading literary figure during the years of the 'Thaw', a term adopted in the West after the appearance of the English translation of his best-selling novella, *Ottepel* (1954), as *The Thaw* (1956), a work which was one of the first from the Soviet Union to make mention of the purges. His memoirs, *Lyudi, gody, zhizn'* (People, Years, Life, 1960–5), provided an important portrait of Russian cultural life and a testimony to the persecution of the Russian intelligentsia under Stalin.

Ermolova, Mariya Nikolaevna (1853–1928), leading Russian stage actress, famous for her tragic roles, primarily at Moscow's Maly theatre. Ermolova was acclaimed for her performances in the title roles of Schiller's *The Maid of Orleans* (1884) and *Maria Stuart* (1886) and Racine's *Phaedra* (1890). After the Revolution she succeeded in adjusting to the new, anti-bourgeois roles of the Soviet era and was the first actress to be honoured with the titles People's Artist of the Soviet Republics (1920) and Hero of Labour (1924). The theatre IB refers to in 'The Arts in Russia under Stalin', which was named after her, was founded in Moscow in 1937.

Esenin, Sergey Aleksandrovich (1895–1925), Soviet poet and self-proclaimed artistic 'hooligan'. From a peasant background, he was one of the most erratic and unconventional figures in the early Soviet era, joining the Imaginist group of poets in Moscow in 1919, and becoming renowned for his drinking and rowdyism. Such a reputation was bolstered by his verse collections *Ispoved khuligana* (Confession of a Hooligan, 1921) and *Moskva kabatskaya* (The Moscow of Taverns, 1924). Having initially greeted the Revolution with enthusiasm, Esenin quickly became disenchanted; his best work remains the more lyrical, nostalgic poetry he wrote about the Russian countryside, and his despair over the destruction of the old rural way of life. His brief, turbulent marriage (1922–3) to the American dancer Isadora Duncan was followed by descent into madness, dissipation and despair, and a lonely suicide, by hanging, in a Leningrad hotel in 1925.

Ezhov, Nikolay Ivanovich (1895–1940). As architect of the 'Ezhovshchina' – the high point of mass purging that took place in 1936–8, Ezhov sought to impress Stalin with his spectacular over-fulfilment of execution quotas. He had served as a political commissar during the Civil War, but, lacking the intellectual qualities to rise through the Party leadership, he worked his way into Stalin's inner sanctum by dint of slavish loyalty and flattery. In 1935 he was rewarded with the secretaryship of the Leningrad Communist Party, replacing the murdered Kirov (q.v.), and in 1936 was promoted to head of the secret police, the NKVD. During his tenure Ezhov set about the decimation of the officer class of the Red Army as well as of the regional leadership of the Communist Party. But he overplayed his hand, and Stalin replaced him with Lavrenty Beriya in the autumn of 1938. Ezhov was arrested in April 1939 and shot on 4 February 1940.

Fadeev, Aleksandr Aleksandrovich (1901–56), Soviet novelist, a ruthless literary apparatchik under Stalin. A member of the Communist Party from 1918, he undertook work for the Party in the 1920s and scored his first critical success with the novel *Razgrom* (The Rout, 1925–6). *Molodaya gvardiya* (The Young Guard, 1945), about the work of Soviet partisans during the Second World War, was much touted as an exemplar of socialist realism, but only after Fadeev had heavily revised it in line with Stalin's instructions. During his hegemony as General Secretary and later Chairman of the Soviet Writers' Union (1946–54), Fadeev engineered the ostracism of writers such as Akhmatova and Zoshchenko (qq.v.). But his conscience finally caught

up with him; he was publicly censured after the death of Stalin in 1953 and committed suicide in 1956.

Fedin, Konstantin Aleksandrovich (1892–1977), Soviet essayist, writer and academician, a leading member of the Writers' Union. He served in the army during the Civil War, then took up journalism and writing short stories in the style of Chekhov. In 1924 he attempted to respond to the new post-Revolutionary world with *Goroda i godi* (Cities and Years, 1924), but was criticised for the negativity of his hero. His work thereafter became increasingly conformist, as he took on high profile public posts, latterly as a deputy to the Supreme Soviet. His two postwar novels, *Pervye radosti* (First Joys, 1945) and *Neobyknovennoe leto* (An Unusual Summer, 1948), are considered among the best examples of socialist-realist literature.

Fet, Afanasy Afanasievich (1820–92), Russian poet and translator, a friend of Tolstoy and Turgenev. He studied at Moscow University and began publishing his verse in the 1840s, while serving in the Imperial Army. A conservative and an aesthete, his work was attacked by radical intellectuals in the 1860s. Fet published nothing between 1863 and 1883, when he finally brought out several volumes of verse, collectively entitled *Vechernie ogni* (Evening Lights). His later poetry, which was metaphysical in tone, was a precursor of the symbolist movement in Russian poetry at the end of the century. An admirer of Schopenhauer, Fet translated his *Die Welt aus Wille und Vorstellung* into Russian in 1881; he also translated Latin poets such as Ovid, Catullus and Virgil.

Fischer, Ruth (pseudonym of Elfriede Eisler) (1895–1961), left-wing Jewish Communist activist, sister of the composer Hanns Eisler, and with him a friend of Bertolt Brecht. Fischer joined the Austrian Social Democrats in 1914, but left to co-found the Austrian Communist Party in 1918. She moved to Berlin, where she was chair of the German Communist Party 1921–4, before being expelled in 1926. In 1933 she fled to France, becoming an outspoken critic of Communism, notably in her 1948 book *Stalin and German Communism*. During the Second World War she went to Cuba and then lived in the USA, before returning to Europe; she died in France.

Gabo, Naum (pseudonym of Neemiya Borisovich Pevzner) (1890–1977), Russian-Jewish abstract sculptor, a pioneer with his brother Antoine Pevsner (q.v.) of kinetic sculpture. After studying in

Munich, he joined Antoine in avant-garde artistic circles in Paris 1913–14, returning to Russia in 1917, where together they formulated the *Realistic Manifesto* (1920), defining what would become the new Constructivist movement in Soviet art. When this movement came under increasing criticism Gabo emigrated, spending time in Germany, France and England before settling in the USA in 1946.

Gippius, Zinaida Nikolaevna (known as Hippius in the West) (1869–1945), émigré Russian poet and writer, author of literary criticism under the pen-name Anton Krainy. Gippius began publishing her symbolist verse in the late 1880s, and had her own literary salon in St Petersburg before the Revolution. She married the critic Merezhkovsky (q.v.) in 1889. A violent opponent of the October Revolution, in 1919 she left Russia with her husband, settling in Paris. While much of her poetry in collections such as *Stikhi* (Verses, 1922) and *Siyaniya* (Radiance, 1938) is highly self-analytical and full of self-loathing, she also produced trenchant satirical verse, novels and plays, as well as a body of illuminating literary criticism.

Gladkov, Fedor Vasil'evich (1883–1958), Soviet writer, from a peasant family. He first worked as a schoolteacher, moving into journalism in the 1920s. Gladkov was something of a celebrity in his day for his crudely propagandist, prize-winning novel *Tsement* (Cement, 1925), the first of its kind to glorify industrial progress in the Soviet Union. His follow-up, *Energiya* (Energy, 1932–8), about the construction of a hydroelectric station, was a relative failure. Gladkov's best writing remains his autobiographical *Povest' o detstve* (A Story of Childhood, 1949), inspired by the similar writings of Gorky (q.v.), for which he won a Stalin Prize.

Glier (Glière), Reingol'd Moritsevich (1875–1956), Russian conductor and composer. He studied violin and composition at the Moscow Conservatory 1894–1900 and conducting in Berlin 1905–7, after which he taught composition at the Kiev Conservatory 1913–20. His first international artistic success, the 1927 score for the ballet *Krasnyi mak* (The Red Poppy), was a forerunner of the developing genre of socialist realism. Glière's oeuvre, comprising symphonies, operas, concertos and chamber pieces, while often kow-towing to the demands of political and musical orthodoxy, also reflects a variety of national musical styles and traditions, such as the 1934 opera *Shah Senam*, which draws

on Azerbaijani music. Among his many notable pupils were Myas-kovsky and Prokofiev (qq.v.).

Gorky, Maxim (pseudonym of Aleksey Maksimovich Peshkov) (1868–1936), Soviet writer, journalist and dramatist from peasant stock. His early life was extremely impoverished, as reflected in his masterpiece, the autobiographical trilogy *Detstvo*, *V lyudyakh* and *Moi universitety* (My Childhood, 1915; In the World, 1916; My Universities, 1922) and his most successful play, *Na dne* (The Lower Depths, 1902). Originally highly critical of the Bolshevik stranglehold on political life after the Revolution, his controversial newspaper *Novaya zhizn'* (New Life) was repressed by them in 1918. In 1924 he went to live in Italy, where he became much feted. Stalin lured him back to the Soviet Union in 1928, with a combination of flattery and material inducements, to take the ideological lead in establishing uni-formity in Soviet writing under socialist realism. As chairman, from 1934, of the newly established Union of Soviet Writers, he was heaped with honours, but subservience to Stalin brought with it inevitable entrapment and ultimate isolation.

Greenwood, Walter (1903–1974), English novelist and playwright. Born into a working-class family in Salford, Lancashire, Greenwood had a succession of menial jobs, turning his experiences of poverty during the years of the Depression into an acclaimed novel, *Love on the Dole* (1933). Such was its popular and critical success that he adapted it for the stage (1934) and cinema (1941). Although he wrote several more novels, short stories and plays, and eventually moved into television, with scripts such as the *The Secret Kingdom* (1960), adapted from a novel of his own, none of them ever eclipsed the enduring suc-cess of his first work.

Griboedov, Aleksandr Sergeevich (1795–1829), Russian lyric poet and playwright, whose only enduring play, *Gore ot uma* (Woe from Wit, 1822–4), remains a standard in the Russian repertoire. After studying law and science at Moscow University, Griboedov served in the army and became a civil servant at the Ministry of Foreign Affairs. Although he wrote and adapted other plays, his reputation largely rests on *Gore ot uma* (often titled *Chatsky* in translation, after its hero), which was rejected by the tsarist censor and not published in full till 1861. In 1825, during Russia's war with Persia, Griboedov was sent to the

Caucasus on official business. After negotiating the peace settlement, he was appointed ambassador to Tehran, where he was murdered by rioters soon after his arrival.

Grossman, Leonid Petrovich (1888–1965), Soviet-Jewish scholar, Formalist critic and writer. He originally studied law in Odessa, but, after moving to Moscow in the early 1920s, turned to writing, and taught at the Bryusov Institute of Literature and Art. Bryusov produced notable studies of Russian literary figures, such as Dostoevsky in *Tvorchestvo Dostoevskogo* (Dostoevsky's Works, 1959), a biography of Pushkin (1936), and a considerable body of work on Turgenev and his plays. His historical and biographical novels were mainly based on nineteenth-century figures, such as Pushkin in *Zapiski D''arshiaka* (D'Arshiak's Notes, 1945).

Guéhenno, Jean (1890–1978), French essayist, literary critic and novelist. From a working-class, Breton family, Guéhenno wrote about the impoverished lives of the workers of Fougères, an industrial town in north-western France, in autobiographical works such as *Changer la vie* (1961) and *Le Journal d'un homme de quarante ans* (1934). He rose to pre-eminence as a specialist on the work of Jean-Jacques Rousseau, with studies including *Jean-Jacques en marge des Confessions* (1948), *Jean-Jacques, histoire d'un conscience* (1962). In 1962 he was elected to the Académie Française.

Gumilev, Lev Nikolaevich (1912–92), son of Russian poet Anna Akhmatova (q.v.). Gumilev suffered persistent persecution and arrest during the Stalinist era. Arrests in 1933 and 1935 were followed by a sentence to ten years in the Gulag in March 1938. Like many other prisoners who survived into the war years he was released to fight in the front lines of the Red Army, only to be arrested yet again in 1949 as part of a renewed campaign of persecution against his mother. Akhmatova described the agonies she suffered during her son's periods of arrest and imprisonment in her poetry cycle *Rekviem* (Requiem, composed 1935–43, published 1963). Gumilev was finally released in 1956 and cleared of all the charges against him in 1975.

Gumilev, Nikolay Stepanovich (1886–1921), leading Russian pre-Revolutionary poet. A literary theoretician and founder, in 1912, of Acmeism, Gumilev was also a literary critic, playwright and translator. He served in the Imperial Army during the First World War and in

1910 married the poet Anna Akhmatova (q.v.). Gumilev's interest in ethnography and his travels in Abyssinia and Somaliland lent an exotic tone to his best-known collections of poetry: *Zhemchuga* (Pearls, 1910), *Koster* (The Bonfire, 1918) and *Ognennyi stolb* (Pillar of Fire, 1921). He also worked for the World Literature publishing house, translating Coleridge, and taught poetry at the House of Arts. He was violently antipathetic to the October Revolution and was arrested and executed in 1921 as a 'counter-revolutionary'.

Hervé (pseudonym of Florimond Ronger) (1825–92), French singer, conductor and composer of over a hundred light operas, many of whose works were staged at the Folies-Concertantes in Paris. His most popular works were *Don Quichotte et Sancho Pança* (1848) and *Les folies dramatiques* (1853). He spent time in London writing and directing for the musical theatre in the 1880s.

Herzen, Alexander (Aleksandr Ivanovich Gertsen) (1812–70), Russian revolutionary thinker, journalist and writer, around whom gravitated many of the great minds of his generation. The illegitimate son of a wealthy nobleman, he was educated at Moscow University. His involvement in radical circles led to arrest in 1834 and exile until 1840. Back in Moscow he became a close associate of Belinsky (q.v.), but left Russia in 1847 for Paris, where he witnessed the 1848 Revolution. In 1852 he moved to London, his inherited wealth enabling him to set up a Russian press and publish the influential newspaper *Kolokol* (The Bell, 1857–67), through which he campaigned vigorously for political reform in Russia, especially the emancipation of the serfs (achieved in 1861). Herzen's seminal political essays, collected as *S togo berega* (From the Other Shore, 1847–50; published in English in 1956 with an introduction by Berlin), are the best-known of a considerable body of political and philosophical debate conducted by letter and in the radical press with his many émigré contemporaries. He remembered many of these friends, as well as his family, with great eloquence and affection in his masterpiece *My Past and Thoughts*, to the 1968 English edition of which Berlin also wrote an introduction. Berlin's pieces on Herzen are reprinted, respectively, in his collections *The Power of Ideas* (2000) and *Against the Current* (1979).

Huxley, Aldous (1894–1963), British novelist, essayist and editor. Born into a leading intellectual family, he was educated at Eton. He first published as a poet, turning to journalism to augment his income.

After contributing to literary journals such as the *Athenaeum* his fortunes changed with the publication, in 1921, of his first novel, *Crome Yellow*. By the end of the 1930s, a string of successful novels, including *Point Counter Point* (1928), and his most enduring work, *Brave New World* (1932), had transformed his former impecunious existence, and in 1937 he emigrated to the USA. His later works, such as *The Doors of Perception*, reflect his growing interest in mysticism and his experimentation with the drug mescalin. An essay by Berlin on Huxley appears in his *Personal Impressions* (1980).

Il'f, Ilya, and Evgeny Petrov: pseudonyms of Ilya Arnoldovich Fainzilberg (1897–1937) and Evgeny Petrovich Kataev (1903–42), Soviet writers, principally known for their collaboration on the classic novel *Dvenadtsat' stulev* (The Twelve Chairs, 1928). They were both born in Odessa, and worked as journalists before beginning their literary collaboration, in 1927, on a series of short stories and novels. The strong satirical strain in their work was reflected in the novel *Zolotoy zelenok* (The Golden Calf, 1932), a sequel to *Dvenadtsat' stulev*. They were allowed to travel abroad during 1933–6, publishing *Odnoetazhnaya Amerika* (One-Storied America, 1936), drawn from their experiences, but their partnership was cut short when Il'f died of tuberculosis in 1937. Petrov went back to journalism and took up screenwriting, but was killed in a plane crash in 1942, never having repeated the success of his partnership with Il'f.

Inber, Vera Mikhailovna (1890–1972), Odessa-born Soviet poet, short-story writer and journalist. She settled in Moscow in 1922 and joined the Constructivist school of poets. Her journalism took her to Europe during 1924–6 as a correspondent. Like Akhmatova (q.v.), she lived out the siege of Leningrad during the Second World War and was a winner of the Stalin prize in 1945 for *Pulkovsky meridian* (Pulkovo Meridian, 1942), her powerful narrative poem about the experience. Her war diary was the basis of *Pochti tri goda: Leningradsky dnevnik* (Nearly Three Years: A Leningrad Diary, 1945).

Ivanov, Georgy Vladimirovich (1894–1958), Soviet poet from a noble family, served in the Imperial Cadet Corps. His first poems, *Gornitsa* (The Living Room, 1914) and *Veresk* (Heather, 1916), were inspired by the decadent and Acmeist movements in poetry. He left Russia in 1923, settling in the artistic Russian émigré community in Paris, where he edited journals and worked as a literary critic. His later, lyric,

poetry, published in collections such as *Rozy* (Roses, 1931), was a considerable critical success, although his later work, published in Paris, New York and Berlin, was marred by his own increasing negativity.

Ivanov, Vyacheslav Ivanovich (1866–1945), émigré Russian historian and symbolist poet. He studied ancient history and classical philosophy in Moscow, Berlin and Paris, after which he spent time in the Middle East. His first collections of poetry, *Kormchie zvezdy* (Lodestars, 1903) and *Prozrachnost'* (Transparency, 1904), were published in Europe. Back in Russia in 1905 he published a series of mystical religious essays, as well as a notable discourse on Russian culture, *Perepiska iz dvukh uglov* (Correspondence between Two Corners, 1920). After teaching Greek in Baku 1920–4 he left Russia for Italy, where he converted to Roman Catholicism and taught at the University of Pavia (1926–34) and the Papal Institute for Eastern Studies (1934–43). Although he spent the remainder of his life in Italy, his work was published in Paris.

Ivinskaya, Olga Vsevolodovna (1912–95), Soviet editor and poetry translator, lover and literary collaborator of Boris Pasternak. A graduate of Moscow University, Ivinskaya was working as literary editor for the journal *Novyi mir* (New World) when she met Pasternak in 1946. She was twice arrested and sent to the Gulag (1949–53, 1960–4), probably as a result of her association with Pasternak. After Stalin's death in 1953, she moved to the writer's village of Peredelkino, working closely with Pasternak (who never divorced his wife Zinaida) as his literary assistant. Ivinskaya's memoirs of her life with Pasternak, *V plenu vremeni* (English title *A Captive of Time*, 1978), were published in Russian in Paris in 1978.

Kabalevsky, Dmitri Borisovich (1904–87), Soviet conductor and composer, leading figure in the Moscow section of the Union of Soviet Composers. Kabalevsky studied at the Skryabin Music School 1919–25, funding his studies by playing piano accompaniments to silent films. He was a pupil of Myaskovksy (q.v.) at the Moscow Conservatory 1925–9. His first compositions were for piano, the best-known being the *Second Piano Concerto* (1935). He also produced three symphonies and a body of instrumental and choral works, as well as opera; after the Second World War his output increasingly reflected the demands of socialist realism. From 1939 he was professor of composition at the Moscow Conservatory.

Kaganovich, Lazar Moiseevich (1893–1991), Stalin's 'Iron Commissar' and a leading member of the Politburo. Born into a Jewish family in Kiev, Kaganovich was a dutiful apparatchik who worked his way into Stalin's inner sanctum, from head of the organisational department of the Central Committee (1922) to First Secretary of the Communist Party in the Ukraine (1926–8), and in 1930 entered the Politburo. He supervised Soviet transport and heavy industry during collectivisation in the 1930s, for which he was awarded the Order of Lenin in 1935. After the death of Stalin he was removed from his influential positions by Khrushchev and expelled from the Communist Party.

Kandinsky, Wassily (Vasily Vasil'evich Kandinsky) (1866–1944), Russian-born pioneer of abstract painting. He gave up his law studies in Moscow to study art in Munich, where he was a founder of the Blaue Reiter group of artists in 1911. By the 1920s his experimentation with abstract forms had taken his work almost entirely from organic to geometric forms. He returned to Russia in 1914 and after the 1917 Revolution was head of the Moscow Museum for Pictorial Culture (1919) and a founder of the Russian Academy of Artistic Sciences (1921). In 1922 he returned to Germany as head of the influential Bauhaus School in Weimar, but the rise of Nazism forced him to move to France in 1933, where he took citizenship in 1939. By now internationally famous and an influential figure in the art world, Kandinsky developed in his final years a unique, pictographic style of work. He published important works on art theory, including *Uber das Geistige in der Kunst* (Concerning the Spiritual in Art, 1912) and *Punkt und Linie zu Fläche* (Point and Line to Plane, 1926).

Kataev, Valentin Petrovich (1897–1986), popular Soviet novelist, playwright and short story writer, author of the archetypal Five-Year-Plan novel *Vremya, vpered!* (Time, Forward!, 1932). He began writing fiction in 1922, publishing his first novel, *Rastrachiki* (Embezzlers), in 1926. His 1932 novel was a vivid, socialist-realist depiction of the race to construct the industrial city of Magnitogorsk, but the more lyrical and autobiographical *Beleet parus odinokii* (Lonely White Sail, 1936), set during the 1905 Revolution, has endured beyond the Soviet era as a classic. Kataev's play *Kvadratura kruga* (Squaring the Circle, 1928) was also a considerable critical success. By the Second World War he was a member of the Soviet literary establishment, enjoyed a dacha at Peredelkino, and was on the board of the Writers' Union.

Kaverin, Veniamin Aleksandrovich (pseudonym of Veniamin Aleksandrovich Zil'ber) (1902–89), Soviet novelist and children's writer. He studied Arabic languages and literatures in Moscow and Petrograd, in the 1920s taking up writing as a member of the Serapion Brothers literary group. His early novels invited criticism by questioning the political and ethical constraints placed on writers in Soviet society. He gained official approval with more orthodox work, such as the Stalin-Prize-winning novel *Dva kapitana* (Two Captains, 1938–44). As editor of the journal *Literaturnaya Moskva* (Literary Moscow) he lobbied for a relaxation of the constraints on Soviet writers in the post-Stalin years, and supported the dissident writers Andrey Sinyavsky and Yuly Daniel.

Khachaturyan (known in the West as Khachaturian), Aram Ilych (1903–87), Georgian composer whose work was strongly influenced by popular and folk melodies. Stalin approved of Khachaturyan's work, himself being Georgian and an aficionado of his national music and song. With such official approval, Khachaturyan achieved notable successes in the 1930s with symphonies, suites and concertos all drawing on Georgian, Armenian and Azerbaijani motifs. But in 1948 he became one of several sacrificial victims in Soviet music, when Andrey Zhdanov attacked a group of high-profile composers, accusing them of 'formalism'. Khachaturyan now turned to composing film scores and, from 1950, teaching at the Moscow Conservatory. After Stalin's death he was made a People's Artist of the Soviet Union and awarded the Lenin Prize (1959). One of his most beautiful and exhilarating works – the music for the ballet *Spartak* (Spartacus, 1956) – while not an initial success as a ballet, won considerable critical acclaim for Khachaturyan as a composer, and has since become a popular classic. At the Kirov Ballet in Leningrad, with Brenda Tripp, IB saw a performance of the new, definitive production (premiered on 20 February 1945) of Khachaturyan's other popular ballet score, *Gayaneh* (1942).

Khlebnikov, Viktor Vladimirovich (known as Velimir Khlebnikov) (1885–1922), Russian poet, etymologist and linguistic theorist, father-figure of Russian futurism. Born in Astrakhan, he studied mathematics and science and joined avant-garde circles in St Petersburg before the Revolution. His ambition to create a new poetic vocabulary inspired the Cubo-Futurist movement in poetry of that period, although Khlebnikov himself published very little beyond a few journal articles,

the narrative poem *Noch' v okope* (A Night in the Trench, 1921), and *Zangezi* (1922), a mythological-historical discourse. Although he published very little in his lifetime and his work was suppressed for many years after his death, Khlebnikov was an inspiration to other leading poets, including Pasternak and Mayakovsky (qq.v.).

Khodasevich, Vladislav Felitsianovich (1886–1939), Russian poet and literary critic of Jewish-Polish parentage. Nikolay Gumilev (q.v.) praised his first collections of poetry – *Molodost'* (Youth, 1908) and *Schastlivyi domik* (The Happy House, 1914) – but after the publication of *Tyazhelaya lira* (The Heavy Lyre) in 1922 he emigrated to Berlin, and then Paris. He published little poetry after 1927, turning increasingly to literary criticism for the journal *Vozrozhdenie* (Renaisssance). His poetry, while popular in émigré circles, was known in the Soviet Union mainly in samizdat copies until the advent of glasnost in the mid-1980s, when it became more widely available, along with his essays.

Kirov, Sergey Mironovich (Sergey Mironovich Kostrikov) (1886–1934), one of the most popular and glamorous Party figures of the 1930s, had had a copybook career in the Bolshevik Party since joining it in 1904. He quickly worked his way up to membership of the Central Committee (1923), and in 1926 Stalin gave him the plum job of leading the Leningrad Soviet. Here Kirov became a hugely popular figure, a fact which Stalin observed from Moscow with increasing discomfort. The accolades Kirov received at the 17th Party Congress in 1934 proved to be his downfall. That December he was shot dead in Leningrad by a lowly party official, who was quickly arrested and executed. Stalin was quick to use Kirov's murder to his own ends, as an excuse for unleashing a round-up of his own perceived political opponents which led directly to the show trials of 1936 and 1938. Whether he was complicit in Kirov's murder continues to be hotly debated.

Klyuev, Nikolay Alekseevich (1887–1937), Russian peasant poet, closely associated with Esenin (q.v.). His verse, published with the help of Blok (q.v.) in 1907, was rich in folklore, a fascination for the mystical powers of the peasantry, and rural religious tradition. Collections such as *Sosen perezvon* (The Chime of the Pines, 1912) were admired by Acmeist and symbolist poets of the day. Klyuev had at first welcomed the Revolution and its leader, Lenin, in the narrative poem *Lenin* (1924), but the depredation of the Russian countryside

under Communism alienated him. After bringing out his 'Plach o Esenine' (Lament for Esenin, 1927) in memory of his friend, who had committed suicide, he stopped publishing. He was arrested in 1934 and died in the Gulag. It was not until 1977 that Klyuev was republished in the Soviet Union.

Klyun, Ivan Vasil'evich (1873–1943), Russian sculptor and painter. A friend of Malevich (q.v.), he joined his group of Suprematist artists in 1915. His first work, inspired by the geometric forms of Cubism, was in sculptures, reliefs and murals. Between 1918 and 1921 he taught at the Moscow Free Art Studios and organised exhibitions for the People's Commissariat for Culture and Education. During the 1920s he moved away from the Suprematist school and perfected a simpler style known as Purism.

Kochubeys, an influential and wealthy family in tsarist Russia. Notable in particular were the wealthy Ukrainian landowner and military leader Vasily Leont'evich Kochubey (1640–1708) and Count Viktor Pavlovich Kochubey (1768–1834), a liberal politician and reformer. After serving as Russian ambassador to Constantinople 1792–7, Count Viktor became a close friend and advisor of Alexander I and also of fellow liberal Count Pavel Stroganov (q.v.). He served as Minister of Interior Affairs 1802–7 and 1819–23 and was given the title of prince in 1831 for his services to the State.

Koestler, Arthur (1905–83), Hungarian-born British writer, journalist and essayist. His early years were spent in Europe, where he worked as a journalist, editing a newspaper in Berlin in the 1930s. Having joined the Communist Party in 1931, he visited the Soviet Union and went to Spain during the Civil War, where, after narrowly evading arrest, he was captured and jailed by the Fascist government. He escaped execution by being exchanged for another prisoner. He later described his experiences in his 1937 book *Spanish Testament*. After a period of imprisonment in Vichy France during the Second World War, Koestler made his way to England, where he joined the British Army. By 1938 he had become disillusioned with Communism, and two years later he published his powerful anti-Soviet novel, *Darkness at Noon*, closely modelled on the arrest and show trial of Bukharin (q.v.) and others. Although he wrote some fiction, the majority of his work explored science and the arts, notably his history of Renaissance science, *The Sleepwalkers* (1959). A well-known advocate of voluntary

euthanasia, Koestler took his life (as did his loyal wife) when he became terminally ill with leukaemia.

Kuprin, Aleksandr Ivanovich (1870–1938), émigré Russian novelist and short-story writer who based many of his stories on his peripatetic life, first as an army officer and then in a succession of professions. His best-known works are the novels *Poedinok* (The Duel, 1905), the sensationalist *Yama* (The Pit, 1909–15), in which he set out to expose the evils of prostitution, and a romantic story, 'Granatovyi braslet' (The Bracelet of Garnets, 1911). His creative powers diminished after his emigration to Paris in 1919, and he eventually returned to the Soviet Union in 1937, dying a year later.

Kutuzov, Mikhail Illarionovich Golenishchev-, prince of Smolensk (1745–1813), legendary Russian military leader during the Napoleonic Wars. He entered military service at the age of fourteen, serving in campaigns against the Poles and the Turks, and for six years with Suvorov (q.v.). Rising through the ranks, to Major General in 1784, he had been blinded in one eye by the time he took command of the battle of Austerlitz in 1805. Blamed for the debacle, Kutuzov fell out of favour until Alexander I appointed him to command Russian forces at the Battle of Borodino in 1812. After Napoleon abandoned Moscow in October 1812, Kutuzov led the rout of the Grande Armée from Russia, triumphing over it at the battle of Smolensk and pursuing its remnants into Prussia, where he died.

Leonov, Leonid Maksimovich (1899–1994), leading establishment novelist and playwright during the Stalin years. His first literary efforts were in poetry; his early prose attempted psychological realism in the style of Dostoevsky, and reflected his disquiet with the new Soviet order of the 1920s. His first popular successes, *Barsuki* (The Badgers, 1924) and *Vor* (The Thief, 1927), were followed by more conformist, socialist-realist work that reflected the challenges of the Stalinist Five-Year Plans. By now an official in the Writers' Union, and, between 1946 and 1958, a member of the Supreme Soviet, Leonov turned increasingly to drama, producing several popular works in the Soviet theatrical canon, including *Polovchanskye sady* (The Orchards of Polovchansk, 1936).

Lepeshinskaya, Olga Vasil'evna (b. 1916), Russian prima ballerina. She trained at the Moscow Choreographic School, graduating in 1933, and

was a principal dancer at the Bolshoy Ballet from the mid-1930s until her retirement in 1963, notable for her performances as Quitri in *Don Quixote* and Tao Hoa in *Krasnyi mak* (The Red Poppy). She remained at the Bolshoy as a much-respected teacher, and also gave master classes in Europe and China. She was honoured with numerous awards, including the Stalin Prize (four times) and People's Artist of the Soviet Union.

Lerner, Nikolay Osipovich (1877–1934), Russo-Jewish literary historian and critic. A specialist on Belinsky and Pushkin, he was the author of *A. S. Pushkin* (1903), *Belinsky* (1922) and *Proza Pushkina* (Pushkin's Prose, 1923).

Leskov, Nikolay Semenovich (1831–95), Russian short-story writer, famous for his use of traditional fables and folklore. He grew up on a country estate and lacked any formal education, taking up journalism in the 1860s. As a traditionalist, wary of political reform, Leskov attacked radicalism in novels such as *Na nozhakh* (At Daggers Drawn, 1870–1). But such works remained little-read, his fame resting on his gifts as a storyteller of great popular appeal, in tales such as *Ledi Makbet mtsesnkogo uezda* (Lady Macbeth of Mtsensk, 1865) – the basis for Shostakovich's 1934 opera – and *Ocharovannyi strannik* (The Enchanted Wanderer, 1873). In later life Leskov became an adherent of the religious and ethical ideas of Tolstoy and his work took on an increasingly moralistic tone.

Lewis, (Henry) Sinclair (1885–1951), American novelist and winner of the Nobel Prize. Born in the Midwest, he worked as an editor and journalist. After writing a couple of undistinguished novels he achieved fame and considerable critical success with his best-selling 1920 novel, *Main Street*, about small-town America. His reputation as a leading American novelist was reinforced by a succession of popular, journalistic novels in the 1920s: *Babbitt* (1922), *Arrowsmith* (1925) and *Elmer Gantry* (1927), the latter of which – an exposé of evangelism in the Midwest – was turned into an Academy-Award-winning film in 1960. In 1930 he was the first American to win the Nobel Prize for Literature, although his literary creativity diminished thereafter.

Lipchitz, Jacques (Khaim Yakovlevich Lipshits) (1891–1973), Lithuanian-born Cubist sculptor, a contemporary of Picasso and Modigliani, and their friend in Paris in the 1920s. Lipchitz settled in Paris in 1909,

taking French nationality in 1925, and developed a three-dimensional style in Cubist sculpture in works such as *Sailor with a Guitar* (1914). He moved to the USA in 1941, where his reputation was finally secured with large-scale works such as *Prometheus Strangling the Vulture* (1944–53).

Litvinov, Maksim Maksimovich (Meir Wallach or Vallakh) (1876–1951), Polish-born Soviet Jew, a leading international diplomat as Soviet Foreign Minister 1930–9. He had fled Russia after being arrested for revolutionary activities in 1901, and lived in England from 1907, where he represented the Bolshevik government after the 1917 Revolution, until his arrest and deportation in 1918. Under the Soviets he became a leading figure in foreign affairs and was official representative at the League of Nations World Disarmament Conference of 1927–30. He was a prominent advocate of collective security in Europe, which, as leader of the Soviet delegation (1934–8), he urged the League to adopt during the rise of Hitler. He was dismissed in 1939 for opposing the Nazi–Soviet Non-Aggression Pact of 1939, returning as Deputy Minister for Foreign Affairs (1941–6), and also serving briefly as ambassador to the USA (1941–3).

London, Jack (pseudonym of John Griffith Chaney) (1876–1916), San Franciscan writer and journalist, born illegitimate and impoverished. He had a succession of jobs, including gold-prospecting in the Klondike, before setting about his own self-education. He took up writing and produced a trilogy of enormously popular novels about the natural world: *The Call of the Wild* (1903), *The Sea-Wolf* (1904) and *White Fang* (1905). His later works reflected his increasing politicisation and social awareness, notably his exposé of London's slums in *The People of the Abyss* (1903). His descent into alcoholism led to the squandering of his considerable literary earnings, described in the autobiographical *John Barleycorn* (1913). His death at the age of forty was the result of a morphine overdose.

Lopokova, Lydia (Lidiya Vasil'evna Lopokhova) (1891–1981), Russian-born wife of the British economist John Maynard Keynes, was a graduate of the Imperial Ballet School and danced at the Mariinsky Theatre before joining Diaghilev's Ballets Russes in 1910, with which she toured Europe. After settling in England, she performed in Frederick Ashton's ballet *Façade* (1931) and in *Coppélia* for the Vic-Wells Ballet (1933). With Keynes, whom she married in 1921, she

founded the Cambridge Arts Theatre in 1936, herself appearing in several acting roles at London's Old Vic during the 1930s.

Lunacharsky, Anatoly Vasil'evich (1875–1933), Soviet dramatist and literary critic, a visionary figure in early Soviet culture. As a young political activist he suffered arrest and exile in the 1890s, becoming the leader of Russian revolutionaries living in exile in Paris. Returning to St Petersburg in 1905 to edit the Social-Democrat newspaper *Novaya zhizn'* (New Life), he worked as a literary critic. Having been a Bolshevik organiser in Petrograd during the 1917 Revolution, he was given a key appointment in the new government as People's Commissar for Culture and Education (1917–29). During this period he initiated educational reforms and programmes in adult literacy under Lenin's New Economic Policy. Lunacharsky's encouragement of diversity in the Soviet arts soon came under suspicion; although he kept away from party politics, in 1933 Stalin removed him from office and hived him off to an ambassadorship in Spain. Lunacharsky died in Paris en route to his new post.

Lur'e (Lourié), Artur Sergeevich (1892–1966), Russian composer and musicologist, a member of the St Petersburg avant-garde circle known as Volfila (Volnaya filosofskaya assotsiyatsiya; Free Philosophical Association), active 1919–24. After the Revolution he was appointed commissar of the music division of the Ministry of Public Education. He emigrated in 1922 and lived in Paris until about 1941, after which he settled in the USA.

Makarov, Stepan Osipovich (1849–1904), Ukrainian-born Russian naval architect, ship-designer, inventor and commander. Makarov entered the Russian navy in 1869 and designed torpedo-boats used in the Russo-Turkish War of 1877–8. He pioneered oceanography, designed an ice-breaker for Arctic exploration, and developed shells capable of piercing armoured cladding. He was promoted to Vice-Admiral in 1896, and was in command of the Russian Pacific fleet when his ship was sunk off Port Arthur during the 1904 Russo-Japanese War.

Malevich, Kazimir Severinovich (1878–1935), painter and designer, born in Kiev of Polish extraction, an inspirational figure in early twentieth-century abstract art. He studied drawing in Kiev 1895–6, began experimenting with cubism in the 1900s, and went on to found the Suprematist school of Russian art. He refined his geometric style

of art to the simplest of styles in the famous sequence of 'white on white' paintings of 1918. He was director of the Vitebsk Institute of Practical Art 1919–21, and of Leningrad's Institute of Artistic Culture 1923–6. In 1927 he staged an exhibition of his work in Warsaw and Berlin, for which he was reprimanded and imprisoned after his return. Thereafter he found it impossible to conform to the demands of socialist realism and ceased exhibiting, dying in poverty and obscurity.

Malraux, André (1901–76), French novelist and essayist, as well as a notable art historian and critic. In the 1920s, while studying ancient artefacts in Cambodia, he was arrested and imprisoned by the colonial French authorities. His experiences prompted the political novels *Les Conquérants* (1928) and *La Condition humaine* (1933), which were highly critical of Far Eastern colonialism. He opposed the rise of Fascism in Europe and fought for the Republicans during the Spanish Civil War, producing a fictionalised account in *L'Espoir* (1937). During the Second World War he worked for the French Resistance. His postwar work includes his collected writings on art, *Les Voix du silence* (1951), and his autobiographical *Antimémoires* (1967).

Mandel'shtam, Nadezhda Yakovlevna (1899–1980), wife of the poet Osip Mandel'shtam (q.v.) and author of two memoirs of her life with him. She studied art in Kiev and met Mandel'shtam in 1919, marrying him in 1921. They moved to Moscow, where she worked as a translator, before going into exile with him when he was sentenced in 1934. Returning to Moscow in 1937, the couple were given great support by their friend the poet Anna Akhmatova (q.v.). Nadezhda found in Akhmatova a stalwart fellow victim in her grief and rage at the re-arrest of Osip in 1938 (Akhmatova's own son Lev Gumilev (q.v.) spent long periods in the Gulag). The remainder of her life was devoted to preserving and promoting her husband's poetry (much of which she had learned by rote) and writing her memoirs, *Vospominaniya* (Memoirs, 1970; translated into English as *Hope Against Hope*, the name Nadezhda meaning 'hope' in Russian), and its sequel *Vtoraya kniga* (Second Book, 1974; English version, *Hope Abandoned* ). As powerful indictments of the Stalinist terror – both on the personal level of her own husband's suffering and on the general level of the persecution of many artists and friends – they are considered seminal works in the history of Stalin's crimes against Soviet cultural life.

Mandel'shtam (often 'Mandelshtam'), Osip Emilievich (1891–1938), Soviet-Jewish poet and literary critic, with Akhmatova (q.v.) a member of the Acmeist group. He published his first collection of verses, *Apollon*, in 1910 but had to support himself with journalism and translation. His verse collection *Tristiya* (1922) and his essays *Egipetskaya marka* (The Egyptian Stamp, 1928), while brilliantly idiosyncratic, were criticised for being excessively arcane. Horrified by the imposition of collectivisation, which he witnessed as a journalist in the Ukraine and the Kuban, he wrote a savagely satirical poem about Stalin that circulated during the winter of 1933–4, for which he was arrested and sent into exile at Voronezh. Here he wrote three more collections of poems, *Voronezhkie tetradi* (The Voronezh Notebooks, 1980). After returning to Moscow, he was arrested again, in May 1938, and sent to the Gulag. Already frail and suffering psychological problems, he did not survive the harsh conditions at Kolyma in northeastern Siberia, and died within two months of his arrival. His poetry did not become widely available in the Soviet Union until 1987.

Marr, Nikolay Yakovlevich (1865–1934), Soviet academician, notorious for his spurious linguistic theories, which became the basis of Stalinist teaching. A specialist in Caucasian languages, Marr was professor at the University of St Petersburg. In the 1920s he published his Marxist theories on language, arguing that all languages stemmed from a common root, and that it was therefore entirely feasible to create a new hybrid, and specifically proletarian, language. Marr died in 1934 but the Marrist school of linguistics continued to promote his theories until 1950, when Stalin, in one of his unpredictable but characteristic voltes-face, denounced them.

Mayakovsky, Vladimir Vladimirovich (1893–1930), Georgian by birth, Soviet poet, designer and artist, was the figurehead of the early post-Revolutionary avant-garde. He joined futurist circles while studying at the Moscow School of Art, publishing his first verse in the artistic manifesto *Poshchechina obshchestvennomu vkusu* (A Slap in the Face of Public Taste) in 1912. His nihilism, braggadocio and declamatory style of verse – for example, in *Oblaka v shtanakh* (Cloud in Trousers, 1915) and the propagandist *150,000,000* (1920) – perfectly fitted the first heady days of Bolshevik power, for which he also produced brilliant propagandist posters. In 1923 he founded the futurist literary group LEF, and he pioneered new dramatic styles with *Klop* (The

Bedbug, 1928) and *Banya* (The Bathhouse, 1929), both staged by Meyerhold (q.v.). But his enthusiastic support for the Revolution rapidly faded under Stalin's hegemony and, long bedevilled by melancholia and stubbornly resistant to becoming an artistic conformist, he committed suicide.

Merezhkovsky, Dmitry Sergeevich (1865–1941), émigré Russian literary critic, religious philosopher and polemicist born into the Ukrainian aristocracy. He married fellow poet Zinaida Gippius (q.v.) in 1889. In Russia he had been a minor symbolist poet before the Revolution and had published a religio-philosophical trilogy, *Khristos i antikhrist* (Christ and Anti-Christ, 1896–1905). He left Russia in 1919 and became a leading figure among Russian exiles in Paris, gloomily predicting the spread of Communism in Eastern Europe. His historical novels remain largely unread; his philosophical essays and literary criticism, on Tolstoy, Dostoevsky and Gogol, are characterised by his erudition and his deep religious convictions.

Meyerhold (Meierkhol'd), Vsevolod Emilievich (1874–1940), Soviet-Jewish actor, producer and director. He had trained under Stanislavsky at the Moscow Art Theatre, and performed there in plays by Chekhov. But he soon rejected Stanislavsky's style of realism to explore new ideas as leader of the theatrical avant-garde. As director of his own Meyerhold Theatre, his innovative, expressionistic style, in productions of Mayakovsky's (q.v.) *Klop* (The Bedbug) and *Banya* (The Bathhouse) in 1929 and 1930 baffled Soviet critics with their unconventionality. Meyerhold was accused of 'formalism', and his later productions were suppressed by the authorities. After launching an open attack on the hidebound artistic conventions of socialist realism, Meyerhold was arrested in June 1939. He was tortured and interrogated in the Lubyanka prison in Moscow before being shot, not long after the writer Babel' (q.v.), in February 1940.

Mickiewicz, Adam Bernard (1798–1855), Polish romantic poet and nationalist leader. Born in Lithuania (then part of the Russian empire), he became embroiled in nationalist politics at the University of Vilna, and was exiled to Siberia 1824–9; while there he published the erotic *Sonety krymskie* (Crimean Sonnets, 1826). Thereafter he lived, taught and travelled in Europe. His most notable works include the narrative poem in support of Polish nationhood, *Konrad Wallenrod* (1828), and *Pan Tadeusz* (1834), an epic work about the Polish gentry, set at the

time of Napoleon's 1812 invasion of Russia. Inspired by the exploits of Byron in support of Greek nationalism, he went to the Crimea during the war of 1854–6 to rally Polish troops fighting for the allies against Russia, but died of disease contracted there.

Mirbach, Count Wilhelm von (1871–1918), German ambassador to Russia in the first turbulent months after the October Revolution of 1917. From a wealthy Prussian family, Mirbach had been a diplomat at the German Embassy in St Petersburg 1908–11. After arriving in Petrograd in December 1918 he became the target of extreme elements among the Socialist Revolutionaries, who had opposed the Bolshevik peace deal with Germany during the First World War. Mirbach's assassination by a member of the Cheka (the secret police), Yakov Blyumkin (q.v.), was orchestrated by the SRs in the hope of provoking renewed Russo-German hostilities.

Mirsky, Prince Dmitri Petrovich Svyatopolk- (1890–1939), Russian-born poet, Orientalist and literary critic. Mirsky left Russia in 1920 after serving as a guards officer in General Denikin's counter-revolutionary White Army during the Civil War. Settling in London in 1922, he took a lectureship at the School of Slavonic and East European Studies (until 1932). After joining the British Communist Party he decided to return to the Soviet Union, but his criticism of the regime and his defence of Pasternak (q.v.), who had come under official attack, led to his arrest in 1937. For decades Mirsky's fate was unknown, but it has now been established that he died in the Gulag in 1939. His *A History of Russian Literature* (1926–7) set the benchmark for Russian literary studies in the West.

Molotov, Vyacheslav Mikhailovich (Vyacheslav Mikhailovich Skryabin) (1890–1986), Soviet foreign minister under Stalin, was an unimaginative and inscrutable bureaucrat, whose pseudonym, 'Molotov' – meaning 'hammer' – turned out to encapsulate his obduracy and narrowness as a politician. Molotov assumed his alias after joining the Bolsheviks in 1906; he was a member of the Politburo by 1926. Once within this inner circle, he performed his duties with all the thoroughness of a dedicated apparatchik, during 1929–30 enforcing Stalin's draconian collectivisation programme. His heyday came during the Second World War, after his appointment as Soviet Minister of Foreign Affairs in 1939 (a post he held until 1949, and again in 1953–6); during the Cold War years his was the unco-operative face of Stalinism at the

UN. When, towards the end of his life, Stalin grew suspicious even of his most loyal servants, Molotov was dismissed (1949) and his wife imprisoned. They were both saved from death by Stalin's own demise in 1953. Finally stripped of all his political power in 1957, Molotov nevertheless remained an unrepentant Stalinist until his death, at the age of ninety-six.

Myaskovsky, Nikolay Yakovlevich (1881–1950), Polish-born Russian composer who studied under Rimsky-Korsakov and Glière (q.v.). He premiered the first of twenty-seven symphonies in 1908 and later became professor of composition at the Moscow Conservatory. With Shostakovich and Prokofiev, he was denounced as a Formalist in 1948 by Zhdanov (q.v.). He also composed concertos, quartets and piano music.

Nakhimov, Pavel Stepanovich (1803–55), Russian admiral who first saw action at the battle of Navarino Bay in 1827, and went on to command the Black Sea fleet during the Crimean War of 1854–6. He commanded the Russian fleet at the sea battle at Sinope in December 1853 at which the greater part of the Turkish fleet was destroyed, and which was the prelude to Britain's entry into the war the following year. For eight months he led the Russian naval forces during the heroic defence of the besieged Crimean port of Sevastopol, where he earned the hero-worship of his men, but he was killed by sniper fire in June 1855.

Nekrasov, Nikolay Alekseevich (1821–78), Russian poet and publisher, a patron of writers and critics, notably Turgenev, Tolstoy and Belinsky (q.v.). Though a member of the gentry, he had to write hack poetry and vaudevilles to pay for his university studies in St Petersburg, as his father refused to support him. He purchased the journal *Sovremennik* (The Contemporary) in 1846, and fought the tsarist censorship to keep it running until it was finally closed in 1866. He then acquired *Otechestvennye zapiski* (Notes of the Fatherland) in 1868, which he co-edited with Saltykov (q.v.). Nekrasov's most popular verse, such as 'Vlas' (1854) and the narrative poem *Moroz krasny-nos* (Frost the Red-Nosed, 1863), is drawn from Russian folklore. His long satirical poem *Komu na Rusi zhit´ khorosho?* (Who Can Be Happy in Russia?, 1873–6) celebrates the virtues of the Russian peasantry.

Neuhaus, Heinrich (Genrikh Gustafovich Neigauz) (1888–1964), celebrated Soviet pianist and professor of music at the Moscow Con-

servatory. He came from a family of Volga Germans, the son of gifted musical parents, who ran their own school. After studying music in Germany, Italy and at the Vienna Academy of Music, he returned to Russia, where he taught at the Kiev and Moscow Conservatories. As a performer and conductor, he was a notable exponent of the work of Skryabin (q.v.). His wife, Zinaida Nikolaevna, became Pasternak's second wife in 1934 (see Pasternak, Zinaida Nikolaevna).

Nijinsky, Vatslav Fomich (1890–1950), legendary Russian ballet dancer and choreographer. From a dancing family, he trained at St Petersburg's Imperial Ballet School and went to Paris to dance with Diaghilev's Ballets Russes in 1909, where he caused a sensation with his virtuoso performances in ballets such as *Le Spectre de la rose* and *Petrushka* (both 1911), created for him by Michel Fokine, and his own original choreography for *L'Après-midi d'un faune* (1912), and *Le Sacre du printemps* (1913). For all too short a time he dominated the world of ballet with a succession of spectacular, athletic performances that completely overturned balletic conventions. After the First World War Nijinsky toured with Diaghilev, but succumbed increasingly to paranoid schizophrenia, which forced his early retirement in 1919 and frequent retreats thereafter into mental hospitals. He is buried in Montmartre.

Odoevsky, Prince Vladimir Fedorovich (*c.*1803–69), Russian poet, philosopher, educator and critic. An admirer of Schelling, he led the Moscow-based philosophical group, the Wisdom Lovers, 1823–4. From 1826 he lived in St Petersburg, where he became a civil servant involved in public education and culture, as director of the Rumyantsev Museum and assistant director of the city's public library. An ardent Slavophil, Odoevsky criticised Western influence on Russian culture in his philosophical conversations *Russkie nochi* (Russian Nights, 1844). His short stories and fantastical tales, such as 'God 4338' (The Year 4338, not published in full until 1926) frequently reflected his interest in mysticism and scientific progress.

Orlov, Vladimir Nikolaevich (1908–96), Russian-Soviet literary scholar and critic who originally studied art history. He published a considerable body of critical work on the radical democratic movement in Russia of the late eighteenth century and the early nineteenth, including studies of the Decembrist poets, the liberal reformer Aleksandr Radishchev and the playwright Aleksandr Griboedov (q.v.).

He is best known as the editor-in-chief of the Biblioteka Poeta series and was a specialist on the poetry of Aleksandr Blok (q.v.), editing his collected works, which were published in 1936, 1955 and 1960–3. At the time of his death Orlov was Professor of Cultural Studies at the University of Teaching Skills, St Petersburg, and a member of the Russian Academy of Arts. IB met him at Gennady Rakhlin's bookshop in Leningrad in 1945 (see 'A Visit to Leningrad').

Ostrovsky, Aleksandr Nikolaevich (1823–86), Russian playwright who dominated the nineteenth-century theatre before Chekhov. He studied law and then entered the civil service as a clerk in the commercial courts. Many of his plays were drawn from his knowledge of the Russian merchant classes and his experiences in the civil service. His first play, *Bankrot* (The Bankrupt, 1847), an exposé of usury in the merchant class, was banned by the censor. But after the success of *Bednaya nevesta* (The Poor Bride) in 1852 his work became hugely popular. In the course of forty years Ostrovsky almost single-handedly established a vast repertoire of some fifty well-made comedies and dramas, including his best-known *Groza* (The Thunderstorm, 1859), which became the core of a new Russian national theatre. His play *Snegurochka* (The Snow Maiden, 1873) became internationally popular as an opera, with music by Rimsky-Korsakov.

Pasternak, Boris Leonidovich (1890–1960), Soviet poet, writer and translator, winner of the Nobel Prize for Literature; internationally revered author of *Doktor Zhivago* (1957). Born into a highly cultured Jewish family, he studied musical composition and then philosophy, publishing his first collection of poetry, *Bliznets v tuchakh* (Twin in the Clouds), in 1914. Critical acclaim came with his third collection, *Sestra moya zhizn'* (My Sister, Life, 1922), and his early prose such as *Rasskazy* (Short Stories, 1925). But Pasternak's continuing preoccupation in his poetry with the personal, with nature, life and love, and his refusal to produce conventional work brought him under attack, and by 1936 he had ceased publishing. He turned to translation, of Shakespeare, Goethe and Georgian poets – Tabidze and Yashvili (qq.v.) – and to work on his masterpiece, *Doktor Zhivago*, which he allowed to be published in Italy in 1957. He came under savage official attack for doing so, was expelled from the Writer's Union, and forced to decline the invitation to leave the Soviet Union to accept the Nobel Prize, awarded the following year. Although more of Pasternak's verse

was published in the Soviet Union soon after his death, *Doktor Zhivago* did not finally appear there until 1989.

Pasternak, Zinaida Nikolaevna (1894–1966), Russo-Italian second wife of the poet Boris Pasternak. She left her first husband, the concert pianist and composer Neuhaus (q.v.), for Pasternak in 1929. They married in 1934 and two years later settled at the writer's village of Peredelkino, outside Moscow. Their son Leonid was born in 1937. Pasternak and Zinaida had become increasingly estranged from each other by the time he met and fell in love with Olga Ivinskaya (q.v.) in 1946, but they remained married till his death.

Pevsner, Antoine (Natan Borisovich Pevzner) (1886–1962), Russian-Jewish Constructivist painter and sculptor, brother of Naum Gabo (q.v.). After spending the years 1911–17 in Paris and Oslo, Pevsner returned to Moscow to take up the professorship at the Academy of Fine Arts. In the early 1920s he pioneered Soviet Constructivist art with his brother, together publishing the *Realistic Manifesto* in 1920. But after the clampdown on experimentation in Soviet art Pevsner emigrated to Paris, where he took up sculpture, working particularly in metals and originating, with Gabo, the Abstraction-Création school of abstract art.

Pil'nyak, Boris (pseudonym of Boris Andreevich Vogau) (1894–1937?), Soviet writer of German-Tatar parentage; with Babel' (q.v.), one of the most talented, idiosyncratic voices in early Soviet literature. He published his first short stories in 1915, attracting interest with his novel *Golyi god* (The Naked Year, 1922), but was criticised for suggesting Stalin's implication in the murder of a Revolutionary general in *Povest' nepogashennoy luny* (Tale of the Extinguished Moon, 1926). He travelled abroad in the 1920s, and in Berlin in 1929 published his novel *Krasnoe derevo* (Mahogany), for which he was publicly vilified in the USSR. He rehabilitated himself with the socialist-realist novel *Volga vpadaet v Kaspiyskoe more* (The Volga falls to the Caspian Sea, 1930), and was allowed into the Writers' Union. But in 1937 he disappeared; it is still not certain whether he was shot immediately or died later in the Gulag.

Plekhanov, Georgy Valentinovich (1856–1918), Russian Revolutionary and leading Marxist thinker. His political activities began in the populist movement of the 1870s, but he soon rejected the terrorism of the

extremists and left Russia in 1880. He lived in exile in Geneva until 1917, founding a political group based on German Marxism in 1883. In 1898 this group would be renamed as the Russian Social Democratic Workers' Party. A close colleague of Lenin's, he edited the Marxist newspaper *Iskra* (The Spark) with him from 1900, but in 1903 their association ended with the split in the RSDWP between the Bolsheviks, led by Lenin, and the Mensheviks, led by Plekhanov. He returned briefly to Russia in 1917, but, being opposed to the Revolution, left soon after for Finland. Although he never held political power, and was profoundly disillusioned by the new Bolshevik hegemony in Russia, Plekhanov is still revered for contributing a massive body of theory – in twenty-six volumes – to European Marxism that remains an inspiration to Marxist thinkers worldwide. An essay on him by Berlin appears in his collection *The Power of Ideas*.

Pogodin, Nikolay (pseudonym of Nikolay Fedorovich Stukalov) (1900–62), conformist Soviet dramatist whose uninspiring propagandist plays have been rendered unperformable with the collapse of Communism. He began life as a journalist on *Pravda* 1922–9, turning in the 1930s to drama with *Temp* (Tempo, 1930), a Five-Year-Plan saga about the construction of a tractor factory. He also tackled issues such as delinquency in *Sneg* (Snow, 1932), and the rehabilitation of criminals and social outcasts in *Aristokraty* (The Aristocrats, 1934), as well as turning out a trilogy of plays on Lenin, written during 1935–41, which won him both Stalin and Lenin prizes. He served on the board of the Writers' Union 1934–62.

Preobrazhensky, Vladimir Alekseevich (1912–81), Soviet ballet dancer. A graduate of the Leningrad Ballet School in 1931, Preobrazhensky danced with the Kirov (1939–43) and Bolshoy (1943–63) Ballets, in later years partnering Lepeshinskaya (q.v.). He was awarded the Stalin Prize in 1946.

Prishvin, Mikhail Mikhailovich (1873–1954), Soviet naturalist and short-story writer. A trained agronomist who had grown up in the rural north of Russia, Prishvin published stories that were predominantly about the natural world. His first collection, *V krayu nepugannykh ptits* (In the Land of Unfrightened Birds, 1905), attracted little attention. The long gestation of his autobiographical novel *Kashcheeva tsep* (Kashchey's Chain), published between 1923 and 1954, brought

him to public attention, although his work remains little known in English. An opponent of the Revolution, Prishvin stayed determinedly out of the literary limelight, his stories developing a following among children for their vivid portrayal of animal life.

Pudovkin, Vsevolod Ilarionovich (1893–1953), Russian actor and film director, a leading film theoretician who is revered, alongside Eisenstein (q.v.), as a pioneer of Russian cinema. After serving in the army in the First World War and spending three years as a prisoner of war, he worked in a chemical plant before studying at film school and appearing in film classics such as *Novyi Vavylon* (New Babylon, 1929). His reputation rests largely on three seminal Revolutionary films entitled *Mat'* (Mother, 1926) – from the novel by Gorky (q.v.), *Konets Sankt-Peterburga* (The End of St Petersburg) – made in 1927 to celebrate the tenth anniversary of the Revolution, and the historical saga *Potomok Chingis-khan* (Heir of Genghis Khan, 1928), released as *Storm Over Asia* in the West, where it garnered considerable critical acclaim.

Radek, Karl Berngardovich (originally Sobelsohn) (1885–1939), Polish-Jewish revolutionary and advocate of the Trotskyist theory of 'permanent revolution'. Radek left his native Galicia after joining the Bolsheviks in 1917, but failed to ignite revolution in Germany after working under cover in Berlin in 1919. He worked for the Comintern in the 1920s, but with the rise of Stalin was expelled from the Communist Party as a Trotskyist in 1927. Recanting in 1929, he was re-instated, and enlisted to work on the drafting of the new Soviet Constitution in 1935–6. He was denounced and arrested in 1937, narrowly escaped the death penalty, and died in the Gulag in 1939.

Roerich, Nikolay Konstantinovich (1874–1947), Russian painter who was also a noted ethnographer, graphic artist, designer for Diaghilev's ballet *Knyaz' Igor* (Prince Igor, 1909) and archaeologist. At the St Petersburg Academy of Arts he studied archaeological sites, work which inspired historical paintings of old Russia such as *Rostov the Great* (1903). He became a leading exponent of the Slavic revival in Russian art before embarking on scientific and archaeological research expeditions in Central Asia, during which he collected rare manuscripts and artefacts and promoted his ideals of the preservation of cultural heritage.

Rossi (also known as Tasca), Angelo (1892–1960), Italian Communist and political writer, notable for studies of his political opponent the Italian anarchist Gramsci. He was expelled from the Italian Communist Party in 1929 and went to France, where he worked for the Vichy government's Ministry of Information, during the German occupation. In the 1940s he lectured on the notion of the 'Third Way', advocating that the middle classes held the key to social stability. He published studies on the French Communist Party, the Vichy regime, and the rise of Italian Fascism.

Ryazanov (Gol'dendakh), David Borisovich (1870–1938), Russian revolutionary and outstanding Marxist historian, best known for recovering and republishing lost Marxist works as founder and Director of the Marx–Engels Institute. He began his scholarly work before the 1917 Revolution, publishing collected editions of Marx and Engels for the German Social Democratic Party. During the 1920s he supported the independence of Soviet trade unions from Communist Party control, and had further disputes with the government over his support for the Marxist philosopher Deborin (q.v.) during 1929–30, whereafter Stalin engineered Ryazanov's removal from the Institute and his expulsion from the Party. He was arrested in 1931 and sent into exile in Saratov.

Ryleev, Kondraty Fedorovich (1795–1826), Russian army officer, poet and friend of Pushkin, leader of the Decembrist Revolt of 1825. A romantic poet, he celebrated civic pride in his revolutionary lyrics, satirised the autocracy in his so-called 'agitational songs', and in epic verse recounted the glorious martyrdom of past historical heroes, for example the Ukrainian nationalist Mazeppa in his poem *Voinarovsky* (1824–5). From 1823 to 1825 he edited the journal *Polyarnaya zvezda* (Polar Star). Prominent in the Northern Society, a group of republicans who plotted the overthrow of the imperial family, he was one of the five ringleaders of the abortive Decembrist Revolt, after which he was arrested and hanged in 1826.

Sadko, mythical Novogorodian traveller, merchant and minstrel, a much loved hero of traditional Russian folk literature. His story was originally written down in Russian epic verse, although it had probably been inspired by an ancient Brahmin tale. In 1898 it was the inspiration for the eponymous opera by Rimsky-Korsakov. In the opera, Sadko's magical powers as a minstrel take him to the underwater kingdom of the sea, after he falls in love with the daughter of the Sea King.

He eventually goes home to Novogorod a very wealthy man and uses his money to build the church of St Boris and St Gleb.

Sakharov, Andrey Dimitrievich (1921–89), Soviet scientist and academician, a leading dissident of the Brezhnev era. He studied physics at Moscow University. Having been closely involved in the development of the Soviet hydrogen bomb (1948–53), he expressed concern at the proliferation of nuclear weapons and began campaigning for a test-ban treaty in the 1960s. This, and his outspoken defence of human rights in the Soviet Union, led to the award of the Nobel Peace Prize in 1975. Nevertheless, he was stripped of his national honours and exiled to Gorky (now Nizhny Novgorod) in 1980. When Sakharov's health began to fail, Mikhail Gorbachev sanctioned his return to Moscow in 1986, and under the reforming policies of glasnost Sakharov was elected to the Congress of People's Deputies. He lived long enough to see the fall of the Berlin Wall, one month before his death.

Saltykov, Mikhail Evgrafovich (also used the pseudonym N. Shchedrin; sometimes referred to as Saltykov-Shchedrin) (1826–89), Russian novelist and satirist. He entered the tsarist civil service in 1844. Some early short stories critical of the regime led to his exile in Vyatka, although he remained a civil servant, returning to Moscow in 1855. Here he co-edited the journals *Sovremennik* (The Contemporary) and *Otechestvennye zapiski* (Notes of the Fatherland) with Nekrasov (q.v.), leaving the civil service in 1868. His satirical sketches, published from the 1850s, were the forerunners of his finest works, *Istoriya odnogo goroda* (History of a Town, 1869–70) and his bitter attack on the decaying Russian gentry, *Gospoda Golovlevy* (The Golovlev Family, 1876–80).

Samarin, Yury Fedorovich (1819–76), Russian Slavophil philosopher, essayist and civil servant. From the 1850s he contributed to the Slavophil journal *Russkaya beseda* (Russian Colloquy), collaborating with Konstantin Aksakov (q.v.) and other leading figures. In his capacity as civil servant he worked on Alexander II's Great Reforms of the 1860s, drafting the declaration under which the serfs were emancipated in 1861. He died in Berlin.

Seifullina, Lidiya Nikolaevna (1889–1954), Siberian-born Soviet novelist, short-story writer and journalist, notable for her depiction of peasant life. Seifullina was a member of the Fellow Traveller group of

writers of the 1920s, producing a string of popular stories about life in western Siberia. Her most successful work *Virineya* (1924) was also dramatised. Seifullina did much to promote Soviet education and wrote plays and stories for children. Although a member of the Writers' Union, she found it difficult to produce conformist work, laying herself open to attack from official critics.

Sel'vinsky, Il'ya Lvovich (1899–1968), Soviet Constructivist poet of the 1920s, a friend of Pasternak and Mayakovsky (qq.v.). His narrative poem *Ulyalaevshchina* (Ulyalaevism, 1927) tells the story of guerrilla fighters in the Russian Far East during the Civil War. Attacked for his unconventionality and his arcane language, he produced the play *General Brusilov* (1943) about a First World War military leader, written to encourage patriotism during the Second World War. His suggestion in 1947 of a new genre of 'socialist symbolism' to replace socialist realism did not garner him the official approval he hoped for.

Semenova, Marina Timofeevna (b. 1908), Russian ballerina and teacher. A star of the State Academic Theatre for Opera and Ballet from the mid-1920s, and then principal ballerina at the Bolshoy Ballet in Moscow. Between 1930 and 1952 she danced most of the great leading female roles, in ballets such as *Giselle, Swan Lake, Cinderella* and *The Sleeping Beauty*. Her ninety-fifth birthday was celebrated with a gala concert in her honour at the Bolshoy in 2003.

Serge, Viktor (1890–1947), Belgian writer, internationalist and revolutionary, went to the Soviet Union in the mid-1920s, but was arrested in the early 1930s as a Trotskyist. After he had suffered prison and internal exile the Soviet authorities agreed to deport him in 1935, thanks to a concerted campaign by his supporters in the West and the intercession of the pro-Stalinist writer Romain Rolland. He spent time in North Africa during the Second World War, where he produced a valuable study of Soviet politics of the 1920s and 1930s in his *Memoirs of a Revolutionary 1901–41* (first published in French 1951, in English 1963).

Sergeev, Konstantin Mikhailovich (b. 1910), Russian ballet dancer and choreographer. After graduating from the Leningrad Choreography School he created many leading roles at the State Academic Theatre for Opera and Ballet, notably partnering his wife Dudintskaya or Galina

Ulanova (qq.v.). As artistic director of the Kirov Ballet he took the company on its first European tours in the 1950s and 1960s.

Sergeev-Tsensky, Sergey Nikolaevich (1875–1958), Soviet writer and academician, famous in his day for his historical novels with a military setting. Sergeev served in the army before the Revolution. He took up writing in the 1920s, publishing short stories that were critical of the dislocations of the Revolution and Civil War, and which led to official reprimands. His military background inspired his most notable work, a trilogy about the Crimean War, *Sebastopolskaya strada* (The Ordeal of Sevastopol, 1936–8), which aspired to the scope of Tolstoy's *War and Peace* and received a Stalin Prize. Other works, such as *Brusilovsky proliv* (Brusilov's Breakthrough, 1943) echoed a desire to celebrate past Russian national achievements – but during the First World War rather than the Soviet present.

Shcherbakov, Aleksandr Sergeevich (1901–45), Soviet politician. A protégé of Stalin, and right hand man of Zhdanov (q.v.), he was appointed secretary of the Writers' Union in 1934 to ensure the imposition of socialist realism as the sole acceptable literary genre. During 1938–9 he travelled in the republics of the Soviet Union organising the purge of local Communist Party officials, and returned to Leningrad to serve as First Secretary of its soviet. During the war years he rose to political prominence, was promoted to the rank of colonel, and became a candidate member of the Politburo. After his death, as the recipient of three Orders of Lenin, he was buried in the Kremlin Wall.

Shebalin, Vissarion Yakovlevich (1902–63), Soviet composer who studied under Myaskovsky (q.v.) at the Moscow Conservatory 1923–8, and later became professor of composition there. His directorship (from 1942) of the Conservatory was cut short in 1948 when, along with his friend Shostakovich, he fell foul of the authorities, and was accused of 'formalism' in his work. He nevertheless carried on composing till his death; his oeuvre includes five symphonies (1925–62).

Shklovsky, Viktor Borisovich (1893–1984), influential Soviet literary critic, theoretician and writer. A founder in 1916 of the Society for the Study of Poetic Language known as Opoyaz, which promoted the Formalist school of criticism, he influenced the experimentation of writers such as Mayakovsky and Kaverin (qq.v.). Renowned for his

wit, Shklovsky produced important critical works during the 1920s, including *O teorii prozy* (On the Theory of Prose, 1925). He survived attack during the Stalin years to re-emerge as a leading critic in the 1950s. Shklovksy's admiration for the eighteenth-century English novelist Laurence Sterne was demonstrated in his autobiography, *Sentimental'noe puteshestvie* (A Sentimental Journey, 1923).

Sholokhov, Mikhail Aleksandrovich (1905–84), celebrated Soviet novelist and establishment figure who achieved unprecedented international success with his four-volume *Tikhiy Don* (The Quiet Don, 1928–40). Of Cossack and peasant origin, he first published short stories about his homeland in *Donskie rasskazy* (Tales of the Don, 1926). The scope of his historical novels, known in English as *And Quiet Flows the Don*, which deal with the turbulent years of the Civil War, was likened to Tolstoy's *War and Peace*. It would become the biggest-selling Soviet novel of all time – at home and internationally – earning Sholokhov the Nobel Prize for Literature in 1965. His reputation abroad was, however, tarnished in later life, when, as a Party official and member of the board of the Writers' Union, he expressed his reactionary, anti-Semitic views on fellow writers such as Pasternak (q.v.) and the dissidents Andrey Sinyavsky and Yuly Daniel.

Simonov, Konstantin Mikhailovich (1915–79), Soviet poet, playwright and novelist. His first literary efforts were love lyrics written in the 1930s. His heyday came in the Second World War, when he became a war correspondent for *Krasnaya zvezda* (Red Star) and turned his hand to romantic, patriotic verse. He produced a wartime play, *Paren' iz nashego goroda* (The Fellow from Our Town, 1941), that won a Stalin Prize and was the author of two prize-winning novels, among the most popular of the war, *Dni i nochi* (Days and Nights, 1944) and *Zhivye i mertvye* (The Living and the Dead, 1959). Such official approval spurred the writing of more propagandist and didactic plays and novels, but they did not match the artistic quality of his earlier writing. During 1946–54 he edited the journal *Novyi mir* (New World) and became a leading figure in the Writers' Union.

Sinclair, Upton Beall (1878–1968), left-wing American journalist, novelist and social reformer. He worked as a jobbing writer of pulp fiction before his fifth novel, *The Jungle* (1906), provoked a storm of controversy. With its shocking exposé of the exploitation of immigrant

labour and the adulteration of meat products in the Chicago meat-packing industry it led to the passing of the Pure Food and Drug Act (1906). His passionate socialist beliefs coloured his critique of capitalism in novels such as *King Coal* (1917) and *Boston* (1928) – about the Sacco and Vanzetti case – and went down well in the Soviet Union. But Sinclair's numerous attempts to gain political office all ended in failure, as did the short-lived Utopian community he founded in New Jersey in 1907. Of his output of over a hundred books, the epic, eleven-volume Lanny Budd saga (1940–53) was awarded the Pulitzer Prize, but *The Jungle* is the only work to have stood the test of time.

Skryabin, Aleksandr Nikolaevich (1872–1915), Russian pianist and composer. An infant prodigy, Skryabin studied at the Moscow Conservatory and began composing romantic works in the style of Chopin and Liszt. An enthusiastic patron funded a European tour in 1896, after which Skryabin became professor of pianoforte at the Conservatory until 1903, when he emigrated to Switzerland. He toured the USA 1906–7. His work took a new, ecstatic turn after he embraced theosophy in 1908. He toured continuously, in Europe and Russia, until his premature death from septicaemia. His most notable works are the Fifth Symphony, *Prometei – poema ognya* (Prometheus – Poem of Fire, 1909–10), and orchestral works such as *Bozhestvennaya poema* (Divine Poem, 1903) and *Poema extasa* (Poem of Ecstasy, 1907–8).

Slater, Humphrey (1906–58), American novelist who often wrote on Soviet themes and edited the short-lived political journal *Polemic* in the 1940s. His novels include *The Heretics* 1946 and *The Conspirator* 1948, the latter being turned into a Hollywood film in 1949.

Sologub, Fedor (pseudonym of Fedor Kuzmich Teternikov) (1863–1927), Russian symbolist poet, dramatist and novelist. Formerly a high-school teacher and school inspector, he did not publish his poetry and short stories, collected as *Teni* (Shadows), until 1896. He gave up teaching after the success of his novel *Melkii bes* (The Petty Demon, 1907), which satirised the banality of Russian provincial life. His request to leave Russia after the 1917 Revolution was refused, and he ceased publishing after 1922. Sologub wrote several plays in a fantastical, decadent style, one of which, *Dar mudrykh pchel* (The Gift of the Wise Bees, 1907), was staged by Meyerhold (q.v.). Many of his works were not republished in Russian until the 1970s.

Soutine, Chaim (Khaim Sutin) (1893–1943), Russian-born painter from a strict Orthodox Jewish family in the Pale of Settlement. Soutine emigrated to Paris in 1911, where he studied at the École des Beaux-Arts. A founder member of the Expressionist School, he joined Modigliani's artistic circle in Montparnasse. Experiencing bouts of severe depression followed by bouts of manic painting, he destroyed many of his works, despite living in penury. As a Jew, he went on the run from the Gestapo after the fall of France in 1940, but died after an operation just before the Liberation.

Stroganovs, a powerful noble family from the north-eastern region of Russia. They were granted vast tracts of land in the Urals and Siberia during the reign of Ivan IV (1530–84). Their considerable wealth was consolidated in the hands of Count Grigory Dmitrievich Stroganov (1650–1715) during the reign of Peter the Great. The family's business enterprises included control of major salt extraction at Solvychegodsk, and they dominated the iron, timber and fur trades in Siberia. They were also great patrons of the arts, built numerous historic churches, and funded the Stroganov school of icon-painting (1580–1630). Count Aleksandr Sergeevich Stroganov (1733–1811) was a notable patron of Russian arts and letters in the eighteenth century. His son Count Pavel Alexandrovich Stroganov (1772–1817) was a liberal reformer during the reign of Alexander I. The dish beef Stroganov is named after his gourmet grandson, Count Pavel Sergeevich Stroganov (1823–1911).

Suslov, Mikhail Andreevich (1902–82), Soviet politician and ideologist, member of the Politburo. He joined the Communist Party in 1921 and served as First Secretary in Stavropol 1939–44. Appointed to the Central Committee in 1941, he worked with the Soviet secret police, the NKVD, as the Party official supervising the incorporation of Lithuania into the Soviet Union during the Second World War. After the war he headed Soviet propaganda (from 1947 as secretary of the Central Committee of the Communist Party) until his death, and was editor of *Pravda* 1949–51. In 1955 he was raised to permanent membership of the Presidium (formerly Politburo), and served under Nikita Khrushchev (whom he helped unseat) and Leonid Brezhnev.

Suvorov, Aleksandr Vasil'evich (1729–1800), Russian field-marshal and military commander, created a count (1789) and then a prince (1799) for his services to the State. From the Moscow nobility, Suvorov entered the army at the age of fifteen, and served during the Seven

Years' War (1756–63), quelled insurrection by the Polish Catholics (1768–72), and proved an outstanding tactician during the Russo-Turkish war of 1787–91. He put down another nationalist revolt in Poland in 1794, and during the French Revolutionary Wars led Russian and Austrian troops against the French in northern Italy. He published his theories on warfare as *Nauka pobezhdat'* (The Science of Conquering).

Tabidze, Titsian Yustinovich (1895–1937), leading Georgian poet, with Yashvili (q.v.), in the Blue Horns group of symbolist poets whose hey-day was during 1918–21. He was a close personal friend and corre-spondent of his fellow Georgian Boris Pasternak (q.v.), who, with his companion Olga Ivinskaya (q.v.), translated Tabidze's verse into Russian. Along with many other artists and intellectuals from Georgia, Tabidze disappeared during the purges. It was not until 1955 that it was discovered that he had been summarily executed shortly after being arrested and tortured in 1937. His correspondence with Pas-ternak was published in English in *Letters to Georgian Friends* (1967).

Tairov, Aleksandr Yakovlevich (1885–1950), Soviet theatre director and founder in 1914 of Moscow's Kamerny Theatre, where he offered a more theatricalist style of performance, incorporating elements of bal-let and circus, and using Cubist sets. Tairov staged plays from the Western canon by Eugene O'Neill and G. B. Shaw, but was eventually forced to conform to socialist realism with productions such as Vsevolod Vishnevsky's *Optimisticheskaya tragediya* (An Optimistic Tragedy, 1932). He received acclaim for his 1939 stage adaptation of Flaubert's novel *Madame Bovary*, and in 1945 was decorated with the Order of Lenin.

Tarle (Tarlé), Evgeny Viktorovich (1875–1955), renowned old-school historian and academician based in Leningrad; notable for his studies of the Napoleonic and Crimean wars, including the two-volume *Krymskaya voina* (The Crimean War, 1942–3). When the first Stalinist show trial, of the alleged 'Industrial Party', took place in November–December 1930, Tarlé was accused of being one of this group of anti-Stalinist 'wreckers', who were supposedly bent on estab-lishing a military dictatorship, under which Tarlé was nominated as future foreign minister. Tarlé was, however, subsequently released from prison and reinstated by Stalin, to serve him as a leading histori-ographer of the regime.

Tatlin, Vladimir Yevgrafovich (1885–1953), pioneering artist, sculptor and designer of the early Soviet period. Tatlin founded the Constructivist movement after studying in Paris and Berlin. His innovative techniques in many media, including metal, glass and wood, won him the commission, in 1919, to design the Monument to the Third International. His design was, however, heavily criticised by Gabo (q.v.), and never constructed, and Tatlin's innovative drive seems to have evaporated under the pressure to conform to socialist-realist artistic principles. He turned to teaching and the applied arts at the Moscow Textile Institute, and in the 1930s took up stage design.

Tikhonov, Nikolay Semenovich (1896–1979), Soviet poet and literary official. He began writing romantic, revolutionary ballads while serving in the army during the First World War. In 1922 he joined the Serapion Brothers, celebrating the early post-Revolutionary years in ballads such as 'Ballada o sinem pakete' (Ballad of the Blue Packet, 1922). But from 1934 his poetry increasingly took second place to his duties as a literary official for the Writers' Union and his numerous trips around the Soviet republics. He received three Stalin prizes for his propagandist and jingoistic war poetry, such as *Kirov s nami* (Kirov is With Us, 1941). In the post-war years he was a deputy in the Supreme Soviet.

Tolstoy, Aleksey Nikolaevich (1883–1945), conformist Soviet poet, novelist and playwright whose overrated works were promoted as classics of the Soviet literature of the Stalinist era. He came from the Russian nobility, and was a distant relative of Leo Tolstoy. He briefly emigrated, returning to the Soviet Union in 1923. He cleverly manipulated his artistic success and maintained a lavish lifestyle with a series of officially approved historical works. *Khozhdenie po mukam* (1921–41) was successful in English translation as *The Road to Calvary*, and the trilogy *Petr pervyi* (Peter the First, 1929–45) rallied national pride during the war. Stalin was a great admirer of his two-part play *Ivan groznyi* (Ivan the Terrible, 1941–3), but many viewed Tolstoy as an apologist for the Soviet regime; his work has since fallen into neglect.

Tomashevsky, Boris Viktorovich (1890–1957), Soviet scholar, literary historian and Formalist critic. Originally an engineer, he studied philology and taught literary theory in Petrograd (1921–4). In the 1920s he published two seminal texts on Formalist criticism, *Teoriya literatury: poetika* (Theory of Literature: Poetics, 1925) and *Pisatel' i kniga: ocherk tekstologii* (The Writer and the Book: An Outline of

Textual Study, 1928). From the 1930s he worked mainly as an editor of the literary archives of Pushkin, Chekhov and others for the Literary Heritage series of academic publications.

Trenev, Konstantin Andreevich (1876–1945), Soviet hack writer and playwright. An imitator of Gorky (q.v.) in his early short stories, published in 1915, he subsequently turned to theatre. His historical drama *Pugachevshchina* (Pugachevism) was staged at the Moscow Art Theatre in 1924, but his only notable success was the drama *Lyubov' Yarovaya* (1926), set during the Civil War, which officialdom adopted as the benchmark for conformist socialist-realist theatre.

Trotsky, Leon (pseudonym of Lev Davidovich Bronstein) (1879–1940), international revolutionary and political theorist, born in the Ukraine into a family of Russified Jews. He abandoned his studies for revolutionary activities (1897–8) which resulted in the first of many imprisonments. In exiled revolutionary circles in London he sided with the Mensheviks against Lenin, and operated as a political freewheeler back in Russia in 1905, leading strikes and demonstrations and becoming an outstanding public speaker. In prison again in 1905, he worked feverishly on his theory of 'permanent revolution', and was at the centre of activities during the 1917 Revolution. He was appointed to the important post of Commissar for War (1918–25) and founded the Red Army, becoming notorious for his use of brutal coercive measures during the ensuing Civil War. He failed to seize power after Lenin's death in 1924, and Stalin rapidly marginalised him. Exiled to Central Asia, he was deported in 1928. He spent the remainder of his life pouring out invective against Stalin in a succession of political works. He found refuge in Mexico City in 1936, where an agent of the NKVD finally assassinated him in 1940.

Tsvetaeva, Marina Ivanovna (1892–1941), Soviet poet, writer and critic; with Akhmatova (q.v.) one of the most innovative voices in Russian women's poetry. Her first collection, *Vechernii al'bom* (Evening Album) was published in 1910. She experimented in verse drama and in narrative poetry, and published collections of her highly rhythmical, lyric verse as *Versty* (Mileposts, 1921 and 1922) and *Stikhi k Bloku* (Poems to Blok, 1922). Having rejected the Revolution, she emigrated in 1922, settling in Paris in 1925, taking up prose and criticism but continuing to write verse which, with its motifs from folklore, constantly harked back to her Russian roots. Isolation and

impoverishment in emigration exacerbated her sense of despair. Her ill-judged return to the Soviet Union in 1939 did not bring with it the acceptance as a poet that she craved, and, ostracised from official literary circles, she committed suicide two years later, in Elabuga, in the Soviet republic of Tatarstan. Her best-known collections of verse are *Remselo* (Craft, 1923) and *Posle Rossii* (After Russia, 1928).

Tukhachevsky, Mikhail Nikolaevich (1893–1937), Soviet marshal and national hero from the Russo-Polish nobility, nicknamed the 'Red Napoleon'. Tukhachevsky served with distinction in the First World War. His command of Bolshevik forces during the Civil War led to his elevation as one of the Soviet Union's most charismatic military leaders. During the 1920s he reformed and modernised the Red Army, transforming it into a major fighting force. Stalin promoted Tukhachevsky to marshal in 1935, but he was suspicious of his individualism and jealous of his popularity. In 1937 he dismissed Tukhachevsky from office and had him arraigned on a trumped-up charge of conspiracy together with seven other high-ranking Red Army officers. Tukhachevsky was shot soon afterwards; he was finally rehabilitated in 1988.

Tynyanov, Yuri Nikolaevich (1894–1943), Soviet literary critic, translator and scholar, a leading Formalist theoretician. After studying history and philology he worked as a French translator for the Comintern (1918–21), and in 1921 became a professor of literary history. His critical studies of writers and poets, including Pushkin, Dostoevsky, Tyutchev and Blok (qq.v.), became standard texts, as did his *Problema stikhotvoreniya* (The Problem of Verse Language, 1924). He also wrote scholarly biographical novels such as the three-part *Pushkin* (1935–43) and *Smert' Vazir-Mukhtara* (The Death of Vazir-Mukhtar, 1927–8) – about the murder of the writer Griboedov (q.v.).

Tyutchev, Fedor Ivanovich (1803–73), outstanding Russian nature-poet, ranked with Pushkin and Lermontov. Born into the nobility, he became a diplomat in 1822 and was posted to Germany and then Italy, living abroad until 1844. He corresponded with Heine, whose poetry he translated, while much of his own verse, inspired by Schelling's *Naturphilosophie*, was published anonymously in *Sovremennik* (The Contemporary) during 1836–7 under the rubric 'Poems Sent from Germany'. Returning to Russia, he worked as an official censor and

finally published work under his own name in 1854, having been dis-
covered by Nekrasov (q.v.). His nature- and love-lyrics gave way in
later life to more political verse which expressed his Pan-Slavist senti-
ments. Interest in his work fell into decline until he was rediscovered
by Russian symbolist poets at the end of the nineteenth century.

Ulanova, Galina Sergeevna (1910–98), internationally famous Soviet
ballet dancer, one of the few allowed to perform in the West during the
Cold War. Ulanova trained at the Petrograd School of Choreography
and became famous for her dramatic style of performance. She domi-
nated as prima ballerina at the Bolshoy Ballet from 1944, creating many
unforgettable roles such as Marya in *Bakhchiseraiskii fontan* (The
Fountain of Bakhchiseray, 1934) and Juliet in *Romeo i Dzhulietta*
(Romeo and Juliet, 1940), the latter with a score by Prokofiev. After
her retirement in 1962 she remained at the Bolshoy as ballet mistress.

Vakhtangov, Evgeny Bagrationovich (1883–1923), Armenian-born
Russian actor, director and teacher. At the Moscow Art Theatre, where
he worked as an actor from 1911, he studied the methods of Stanis-
lavsky, developing a technique midway between Stanislavskian imper-
sonation and the grotesque school of Russian theatre pioneered at that
time by Meyerhold (q.v.). An outstanding teacher and director,
Vakhtangov set his stamp on the Moscow Art Theatre's Third Studio
(renamed the Vakhtangov Theatre in his honour in 1926), directing
plays by Chekhov and Maeterlinck. His most acclaimed production,
before illness cut short his life, was a 1922 revival of Carlo Gozzi's
1762 play *Turandot*.

Varga, Evgeny Samoilovich (also Eugen[e] Varga in English transla-
tion) (1879–1964), Hungarian-born Soviet-Jewish economist, a leading
light of the Institute of the World Economy and World Politics in
Moscow. Varga is best known for his studies of the crisis of world cap-
italism, including a 1924 work on the subject co-authored with
Trotsky. In his *Kapitalizm posle vtoroi mirovoi voiny* (first published
in Russian 1974; English translation, *Changes in the Economy of
Capitalism Resulting from the Second World War*) Varga issued a brave
challenge to official Communist doctrine by warning against Soviet
expectations of the imminent post-war collapse of capitalism. This led
to official censure in 1947, when he was removed from his position in
the Soviet Academy of Sciences.

Vorovsky, Vatslav Vatslavovich (1871–1923), Russian literary critic and journalist, leading Bolshevik writer on the editorial board of the Party newspaper *Vpered* (Forward). A close associate of Lenin, after the Revolution he served in Stockholm as one of the first Russian envoys to the West. In 1922 he was a delegate at the International Economic Conference. He was assassinated in Lausanne by the Russian-born Swiss Maurice Conradi while attending an international conference on the Turkish question. Vorovsky published several books, including *Russkaya intelligentsiya i russkaya literatura* (The Russian Intelligentsia and Russian Literature, 1923).

Vrubel', Mikhail Aleksandrovich (1856–1910), Russian symbolist painter, member of the Itinerant school of artists. As well as executing set designs for the opera impresario Savva Mamontov, Vrubel' was a notable sculptor and mural painter, his work heavily inspired by medieval Orthodox art. A major project was his restoration work and murals at the twelfth-century church of St Kyrill in Kiev. Overtaken by mental breakdown and the onset of blindness in 1906, he descended into insanity and died in an asylum.

Yashvili, Pavle (Paolo) Dzhibraelovich (1895–1937), outstanding Georgian poet who, with Tabidze (q.v.), was a leader of the symbolist group of Georgian poets known as the Blue Horns, founded in Tbilisi in 1916. A translator into Georgian of the poetry of Lermontov, Mayakovsky and Pushkin (qq.v.), Yashvili was himself translated by Boris Pasternak (q.v.). His work was suppressed by the Bolsheviks, and he came under concerted attack during the 1930s. After hearing of the arrest of his friend Tabidze he committed suicide in 1937, knowing that the same fate awaited him. Ironically Stalin, as a Georgian, was particularly fond of Yashvili's poetry.

Zadkine, Ossip (Osip Zadkin) (1890–1967), Russian-born Jewish sculptor who lived between London, Paris and Smolensk before settling in Paris in 1909. He experimented with Cubism during the 1920s, and after a period in the USA returned to Paris in 1944. Best known for his bronze sculpture *To a Destroyed City* (1953), commemorating the bombing of Rotterdam during the Second World War, he also executed major works for the cities of Amsterdam and Jerusalem.

Zhdanov, Andrey Aleksandrovich (1896–1948), official Soviet spokesman on the arts, architect of the official Soviet arts policy of

1946–8 that came to be known as the *Zhdanovshchina*, under which writers and musicians who did not toe the official line were systematically persecuted. A lowly apparatchik, Zhdanov rose to prominence at the inaugural Congress of the Union of Soviet Writers in 1934, where he laid down the precepts of socialist realism. He was admitted to the Politburo in 1939. In 1946 Stalin rewarded his wartime work in the defence of Leningrad by appointing him to orchestrate the official vilification of Akhmatova and Zoshchenko (qq.v.), after which Zhdanov turned his attention to composers such as Shostakovich, Prokofiev and Myaskovsky (q.v.).

Zhirmunsky, Viktor Maksimovich (1881–1971), Soviet literary scholar and critic, a corresponding member of the Division of Literary History of the Academy of Science. As a lecturer in philology at Leningrad University, Zhirmunsky was, with Eikhenbaum (q.v.), a leading Formalist critic. He was noted for his *Vvedenie v metriku: teoriya stikha* (Introduction to Metrics: The Theory of Verse, 1966) and for his critical studies of Akhmatova (q.v.), Pushkin, and Blok (q.v.) as well as for his work on world literature.

Zhukovsky, Vasily Andreevich (1783–1852), poet and translator, whose poetry was influenced by English and German pre-Romantic literature. In 1808 he became editor of the literary journal *Vestnik Evropy* (Messenger of Europe). His appointment as tutor to the future Alexander II in 1825 allowed him the opportunity quietly to inject a liberal element at Court, and he frequently offered his protection to writers, including Pushkin, when they were in dispute with the authorities. After his retirement from Court in 1839, Zhukovsky settled in Germany, where he became a notable translator of Goethe and Schiller. He also translated the English poets Gray, Southey and Byron; his translation of Homer's *Odyssey* was a lifetime's labour of love. A melancholy preoccupation with the supernatural and the gothic in his work, which comprised mainly meditative elegies, reflected his own growing interest in mysticism.

Zinoviev (Zinov'ev), Grigory Evseevich (pseudonym of Ovsel Gershon Aronov Radomyslsky) (1883–1936), Ukrainian Jewish politician, a member of the Bolshevik leadership after the Revolution. He soon became critical of Lenin's stranglehold on political life, but lacked the courage to oppose him. By 1921 he was in the Politburo. In the 1920s he miscalculated by aligning himself with Stalin against Trotsky,

only to realign with Trotsky in 1926 after realising his error. In retaliation, Stalin played cat and mouse with Zinoviev over the next decade, expelling him from the Central Committee of the Communist Party in 1927, readmitting him and again expelling him from the Party twice more. Zinoviev was finally arrested in 1936 and tried as a Trotskyite with his colleague Lev Kamenev. He was shot soon afterwards.

Zoshchenko, Mikhail Mikhailovich (1895–1958), Soviet satirical writer, famous for his comic short stories about the dislocations of life after the Revolution. A member of the Serapion Brothers' literary group, he published his first collection, *Rasskazy Nazara Il'icha* (The Stories of Nazar Il'ich), in 1922. Although his work was hugely popular in the 1920s and 1930s, he fell foul of the Soviet authorities for his inability to conform to the demands of socialist realism. His autobiographical story *Pered voskhodom sol'ntsa* (Before Sunrise, 1943) was deemed tendentious and self-indulgent, and the humorous children's story *Priklyucheniya ob'ezyany* (The Adventures of an Ape, 1946) was pounced upon by Zhdanov as poking fun at Soviet citizens, thus providing the pretext for a concerted attack on Zoshchenko. Ostracised from the Writers' Union, he scraped a living from translation, but died a broken man.

# FURTHER READING

BERLIN WROTE numerous other pieces on Russian themes, some dealing with aspects of the Soviet regime, though most treat the pre-Soviet era; but even his celebrated studies of nineteenth-century Russian thinkers cast a sidelong glance at the future we now know to have been approaching, in part prompted by the endless intense discussions of the Russian intelligentsia. After some thought and consultation I decided not to dilute and extend the present volume by adding peripheral or minor pieces, but the following list may be useful for those who wish to track down Berlin's other relevant published writings,[1] tucked away off the beaten track as many of them are. They all appear in the bibliography of Berlin's writings published in *Against the Current* and posted on the website already referred to, and they appear on that site themselves; but their details are corralled together below for readers' convenience; and I have included one extract which seems to belong especially naturally in present company.

*Russian Thinkers*, ed. Henry Hardy and Aileen Kelly (London, 1978: Hogarth Press; New York, 1978: Viking; Harmondsworth and New York, 1979: Penguin):
    Introduction by Aileen Kelly
    Russia and 1848
    The Hedgehog and the Fox: An Essay on Tolstoy's View of History
    Herzen and Bakunin on Individual Liberty

---

[1] See also p. xxvii above, note 1. There are in addition a number of unpublished pieces that belong in this company, but I do not take these into account here. They are listed on the Berlin website under 'Unpublished writings', and their titles plainly announce their connection with this volume.

A Remarkable Decade [1838–1848]
  I  The Birth of the Russian Intelligentsia
  II  German Romanticism in Petersburg and Moscow
  III  Vissarion Belinsky
  IV  Alexander Herzen
Russian Populism
Tolstoy and Enlightenment
Fathers and Children: Turgenev and the Liberal Predicament

'Artistic Commitment: A Russian Legacy' in *The Sense of Reality: Studies in Ideas and their History*, ed. Henry Hardy (London, 1996: Chatto and Windus; New York, 1997: Farrar, Straus and Giroux; London, 1997: Pimlico)

Five essays in *The Power of Ideas*, ed. Henry Hardy (London, 2000: Chatto and Windus; Princeton, 2000: Princeton University Press; London, 2001: Pimlico):
  Russian Intellectual History
  The Man Who Became a Myth [Belinsky]
  A Revolutionary Without Fanaticism [Herzen]
  The Role of the Intelligentsia
  The Father of Russian Marxism [Plekhanov]

Review of Ralph Parker, 'How do you do, Tovarich?', *Listener* 38 (1947), pp. 543, 545

'Three Who Made a Revolution', review of Bertram D. Wolfe, *Three Who Made a Revolution*, *American Historical Review* 55 (1949), pp. 86–92

'The Trends of Culture', contribution to 'The Year 1949 in Historical Perspective', in *1950 Britannica Book of the Year* (Chicago/Toronto/London, 1950: Encyclopaedia Britannica, Inc.), pp. xxii–xxxi

'Attitude on Marxism Stated: Dr Berlin Amplifies His Remarks Made at Mount Holyoke' (letter), *New York Times*, 8 July 1949, p. 18

'Soviet Beginnings', review of E. H. Carr, *A History of Soviet Russia*, vol. 1: *The Bolshevik Revolution 1917–1923*, *Sunday Times*, 10 December 1950, p. 3

'Russian Literature: The Great Century', review of D. S. Mirsky, *A History of Russian Literature*, Nation 170 (1950), pp. 180–3, 207–8

'"A Sense of Reality" about Russia', review of Walter Bedell Smith, *My Three Years in Moscow*, *New York Times Book Review*, 8 January 1950, pp. 1–2; in this review Berlin writes of 'the obsession with the need for haste under which the Soviet rulers labour':

This derives from their belief that the capitalist world is fated to be torn by inner 'contradictions' which must grow sharper with every new stage of production. When the final crash comes the Soviet Union must be found prepared, else it may go under in the final battle of the worlds in which the proletarians may triumph and yet the Soviet Union be destroyed. To assume the possibility of peaceful coexistence of the two systems is to make nonsense of Marxism, and there may remain little time before the final duel which will settle the fate of mankind. If it is to survive the Soviet Union must be made as unconquerable as is humanly possible before the last and greatest fight, a climax towards which mankind is inexorably moving; unless, indeed, the capitalist world gives in without a struggle, which is considered unlikely.

General Smith quotes Stalin as saying in 1930: 'At times people ask whether we could not slacken pace and slow down. To slacken paces means to lag behind, and those who lag behind get defeated ... We have either to catch up with capitalist countries or die. We are fifty or one hundred years behind their leading countries. We must catch up within ten years. Either we do so or we shall be destroyed.'

If Soviet citizens are to face this formidable prospect they must be toughened ceaselessly. Thus, the atmosphere in Russia is that of a severe, half-militarised educational establishment in which the boys, more backward and in some more difficult than those elsewhere, are driven remorselessly to make up for centuries wasted by the Tsars. Perhaps humaner methods might succeed equally well or better, but there is not time for experiment: the rest of the world is advancing too rapidly and so force must be applied if the pupils of this institution are to make any showing at all; everything is directed toward this single end; no doubt the boys are cold and hungry today, but the resources are still lacking to remedy this and yet keep up the pace; the outside world is out of bounds because

the capitalist countries are doomed if Marx was a true prophet and they must grow increasingly hostile to the USSR.

Nor are foreign visitors welcomed, since even if their personal intentions are benevolent they merely interfere with the men and women who are undergoing training and who have no time for anything outside their appointed tasks. Strangers with their travellers' tales about conditions elsewhere merely disturb the workers, who only by making the most desperate effort can begin to hope to succeed where history and geography have placed so many disadvantages in their path.

As at school the central virtues are moral and not intellectual – character and especially loyalty are everything; if the pupils are not clever or proficient they will perhaps not be promoted, but if they are liars or disloyal or sceptical about the purpose of the school they must be punished or expelled.

This is the central fact about the tempo of development and the moral atmosphere prevailing in the Soviet Union – in the terms of which much that seems puzzling and is too easily ascribed to the vagaries of the 'Slav soul' or the 'Oriental despotism' or 'Byzantinism' – grows clearer.

Review of Edmund Hallett Carr, *Studies in Revolution*, *International Affairs* 27 (1951), pp. 470–1

'A View of Russian Literature', review of Marc Slonim, *The Epic of Russian Literature*, *Partisan Review* 17 (1950), pp. 617–23

Review of George L. Kline, *Spinoza in Soviet Philosophy*, *Oxford Magazine* 71 (1952–3), pp. 232–3

Review of Richard Hare, *Portraits of Russian Personalities between Reform and Revolution*, *English Historical Review* 75 (1960), pp. 500–2

(in paraphrase) Contributions to John Keep and Liliana Brisby (eds), *Contemporary History in the Soviet Mirror* (London, 1964: George Allen and Unwin), pp. 40–1, 89, 220, 330

'A New Woman in Russia', review of John Carswell, *The Exile: A Life of Ivy Litvinov*, *Sunday Times*, 6 May 1984, p. 41

H. H.

# INDEX

*Compiled by Douglas Matthews*

Russian names are given in the form used in the Glossary,
which gives further information on selected individuals.